Migraine Art

Migraine Art

The Migraine Experience from Within

Klaus Podoll
AND Derek Robinson

Foreword by Oliver Sacks

North Atlantic Books
Berkeley, California

Published by
North Atlantic Books
P.O. Box 12327
Berkeley, California 94712

Cover art courtesy of the Migraine Action Association
Cover and book design by Brad Greene
Printed in Singapore

Migraine Art images used by permission of the Migraine Action Association.

Migraine Art: The Migraine Experience from Within is sponsored by the Society for the Study of Native Arts and Sciences, a nonprofit educational corporation whose goals are to develop an educational and cross-cultural perspective linking various scientific, social, and artistic fields; to nurture a holistic view of arts, sciences, humanities, and healing; and to publish and distribute literature on the relationship of mind, body, and nature.

North Atlantic Books' publications are available through most bookstores. For further information, call 800-733-3000 or visit our Web site at www.northatlanticbooks.com.

Library of Congress Cataloging-in-Publication Data

Podoll, Klaus.
 Migraine art : the migraine experience from within / Klaus Podoll and Derek Robinson.
 p. cm.
 Includes bibliographical references and index.
 ISBN 978-1-55643-672-7
 1. Migraine. 2. Migraine—Treatment. 3. Migraine aura. 4. Outsider art. I. Robinson, Derek, 1928 Mar. 30-2001. II. Title.
 RC392.P63 2008
 616.8′4912—dc22
 2008020898
 CIP

1 2 3 4 5 6 7 8 9 TWP 14 13 12 11 10 09 08

We dedicate this book to *Miss Jean R. Butter* and
to the late *Dr. Kenneth Michael Hay*, MBE,
who inspired the Migraine Art competitions
and all that followed.

◆

No two cases of this disease present exactly the same features; every one is an illustration of the rest; and by the accumulation and comparison of accurate records we may hope that the transition from facts isolated to facts linked by the clue of theory will soon be attained.

—Hubert Airy, 1870

Acknowledgments

We offer our grateful thanks to the migraine artists who have made this book possible by allowing us to use and reproduce their works. Over the years we have lost contact with many of them, but we are sure that they will enjoy seeing their efforts published in a way that will promote further understanding of the problems experienced by migraine sufferers.

—Klaus Podoll, MD, and Derek Robinson
 Aachen, Germany, and Maidenhead, U.K.
 December 1999

Table of Contents

Foreword

by Oliver Sacks

When I was three or four years old, playing in the garden one day, a brilliant shimmering light suddenly appeared to my left—dazzlingly bright, almost as bright as the sun. It expanded, becoming an enormous shimmering semicircle stretching from the ground to the sky, with sharp zigzagging borders, and brilliant blue and orange colors. Then, behind the brightness came a blindness, an expanding emptiness in the field of vision, and soon I could see almost nothing on my left side. My sight returned to normal in a few minutes, but these were the longest minutes I had ever experienced.

I told my mother what had happened, and she explained to me that what I had had was a migraine—she was a doctor, and she, too, was a migraineur. It was a "visual migraine," she said, or a migraine "aura." The zigzag shape, she would later tell me, resembled that of a medieval fort, and was sometimes called a "fortification pattern." Many people, she explained, would get a terrible headache after seeing such a "fortification"—but, if I were fortunate, I would be one of those who got only the aura, without the headache.

I was indeed lucky here, and lucky, too, to have a mother who could reassure me that everything would be back to normal within a few minutes, and with whom, as I got older, I could share my migraine experiences.

It was not always the giant zigzag. Sometimes in a migraine aura I would see—vividly with closed eyes, more faintly and transparently if I kept my eyes open—tiny branching lines, like twigs, or geometrical structures covering the entire visual field. Sometimes there were more elaborate patterns, like Turkish carpets or complex mosaics; sometimes three-dimensional shapes like tiny pinecones or sea urchins. On two or

three occasions when objects moved, they seemed to leave a sort of smear behind them or a faint, persistent image of themselves. Sometimes even the sense of movement would disappear—this "cinematic" vision was the most disconcerting of all, because instead of normal movement, I would see a flickering series of "stills."

I was fascinated by all of this and years later, as a young neurologist, I jumped at the chance to work in a migraine clinic. I went on to write my first book about migraine, devoting a large part of it to the visual phenomena which so many patients described to me, and which I knew so well from my own experience.

In 1991, I saw a remarkable exhibition called "Mosaic Vision" at the Exploratorium in San Francisco; this consisted of ninety paintings by migraineurs of the visual disturbances they experienced during their migraines. Soon thereafter I visited its curator, Derek Robinson, and we spent many hours discussing the remarkable migraine art collection— nearly 600 paintings—which he had collected and organized with such care. I included a small handful of these as illustrations in a revised edition of my Migraine—but wished that there were a way to include many, many more, to reflect the enormous range of visual experiences that may be possible in migraine aura.

It has taken more than a decade and a half, but Migraine Art: The Migraine Experience from Within has been well worth the wait for all of us with an interest in visual phenomena and the brain. It contains more than 300 carefully selected (and beautifully reproduced) paintings and drawings by people with migraines. Most of these depict either "negative" visual phenomena: blurring or loss of vision in part of the visual field (scotomata, tunnel vision, hemianopsias, etc.), or "positive" visual phenomena: from simple, unformed sensations (flashes of light, dots, specks, splotches, etc.) to repetitive geometric figures (zigzags, herringbone patterns, crenellations, hexagons), or a miscellany of kaleidoscopic patterns.

Other paintings illustrate some of the highly complex hallucinations that may occur in migraine: of human figures (including "out-of-body" visions), of animate or inanimate objects, of scenes or cartoons or letters and numbers. Occasionally people experience odd multiple images of a

single object or person or strange disturbances of color or boundary. Some of the paintings in this book show a dozen or more of these visual phenomena occurring simultaneously. (Though the book is primarily devoted to the visual aura, there are, of course, nonvisual experiences in migraine, and these too are represented, in images symbolic of the pain or nausea, or acute sensitivity to light, noise, or smell that are so characteristic of classical migraine attacks.)

The sort of visual hallucinations and illusions that can occur in migraine may also occur in a variety of other conditions: occipital and temporal lobe epilepsies, the hallucinations associated with visual impairment or blindness, and the action of various drugs. The great physiologist Heinrich Klüver postulated that there were certain "hallucinatory constants" common to all of these. Podoll and Robinson follow Klüver's classification, as well as the notion that elementary hallucinations of this type may reflect and give insight into the functional architecture of the visual cortex and the waves of electrical activity (so-called "spreading depression") that may pass through this and—in complex hallucinations—the spreading of neural activation from an initial occipital lobe focus into the temporal and parietal lobes of the brain.

While neuroscientists have obtained a great deal of insight into the workings of the visual system using animal models, this is impossible when one comes to the higher levels of visual illusion and hallucination, for here, of course, only first-hand accounts will do. It is especially for this reason that Migraine Art, with its incomparable collection of case histories and visual art, will remain an essential and inspiring reference for neuroscientists for decades to come.

Though the pictures alone make this book outstanding, Podoll and Robinson also interviewed many of the artists, and include here hundreds of brief descriptions culled from their interviews as well as from historical accounts. Their very comprehensive bibliography lists nearly 700 books and articles, some going back to the eighteenth century.

"Migraine art," in its narrow sense, refers to literal depictions of the experience of migraine, but as the authors bring out, it has a broader meaning as well. While most of those who have contributed paintings

and drawings to this book are not professional artists, but have been driven to make accurate representations of their own inner visions, the authors also include some paintings by professional artists who have incorporated their migraine visions into their work, consciously or unconsciously. (There is much to suggest that this was the case with de Chirico, who had classical migraines, and often uses elements from these in his artwork.)

One also has to wonder, too, whether some of the pleasing and symmetrical elementary hallucinations of migraine might not have been a stimulus for the earliest forms of decorative art, or even the cave art of our ancestors tens of thousands of years ago.

Migraine Art thus stands as the definitive work of its kind—an incomparable collection of material on the visual and other phenomena of migraine, and, by implication, on the brain processes which underlie these. It will serve to reassure, enlighten, and inspire not only those with visual migraine and their physicians, but anyone with an interest in vision, imagery, and the brain.

—Oliver Sacks, MD, FRCP
New York City
July 2008

Introduction

Confirming Northrop Frye's notion that "literature comes from literature," Oliver Sacks's book *Migraine*[556] was the starting point for my own Migraine Art research, which I started in collaboration with Derek Robinson in 1997. At that time I was writing a medical paper[482] on the so-called Alice in Wonderland syndrome, presenting the case histories of two migraine sufferers reporting sensations of abnormal enlargement of parts of their bodies. In Sacks's book I noticed a particular illustration in the Migraine Art collection. I wondered whether this painting, depicting an abnormal elongation of spiraling legs, might be an illustration of the Alice in Wonderland syndrome, and whether the Migraine Art collection might include further representations of this rare syndrome. So I wrote a letter to Derek Robinson, curator of the Migraine Art collection, on November 15, 1996. I had the opportunity to view the Migraine Art collection and experience the hospitality of the curator at his home on March 1, 1997. I will never forget the strong impact of viewing the entire collection for the first time through the eyes of a neurologist. It was like entering an Oriental treasure cave full of papyri, fascinating both for their beauty and for the secrets of their hidden meanings. Beginning in 1997 we met regularly, spending one or two weeks working together intensely, part of the time in Maidenhead, England, and part of the time in Aachen, Germany. Although it was our original intention to produce two or three scientific papers, it soon became obvious to us that the Migraine Art collection merited greater consideration. Therefore, we began writing a monograph titled *Migraine Art: The Migraine Experience from Within*.

By the time the manuscript was completed after two years' work, we had experienced another literary truism—*Habent sua fata libelli*—a Latin saying meaning that books have their history. Since 1998 an increasing

number of papers have been published in renowned medical journals that confirm the interest the medical world has taken in the subject of Migraine Art, a phenomenon we have observed with pride and satisfaction. Alas, though publishers praised our book as "fascinating" and "a jewel," they shrank from publishing it because of their fear of the costs that would be incurred in reproducing the 337 color images. This was a source of increasing frustration to us that was not lessened by the almost complete lack of support from any of the parties approached for sponsorship of the book. However, Derek Robinson never lost confidence in the power of his "brain child," Migraine Art. "I think," he wrote me in a letter dated March 4, 2000, "that this is another example of the necessity to try all avenues before deciding that we are fighting an impossible battle. There must be someone out there who finds the subject worthy of exploitation." In talks I had with Derek Robinson in the year before his death on February 22, 2001, he maintained his sense of confidence about the book, but expressed the expectation that "this book will be published, in regards to myself, posthumously." Sadly, he was right.

Outsider art is generally narrowly defined as simply the spontaneous work of unschooled obsessive people, often religious fanatics, prisoners, and mental patients. But there are many variations, one of the more unusual of which is Migraine Art. Pharmaceutical executive and symposia and conference manager Derek Robinson pioneered the field in 1973 when he solicited graphic material for an ad campaign promoting a new drug for preventing migraines. This inspired public competitions in the 1980s encouraging both amateur and professional artists to illustrate the pain and the visual disturbances associated with migraines, as well as the effects migraines had on their lives. This book collects outstanding examples of such work, covering such topics as migraine signs, symptoms, triggers, and treatments, as well as numerous types of visual disturbances and somatic sensations and experiences. A discussion of the migraine aura experiences of famous historical figures, such as Hildegard of Bingen, Blaise Pascal, and Lewis Carroll, provides historical context. Apart from being the first in-depth study on the subject of Migraine Art, this book also provides the most comprehensive study currently

available on the symptoms of the migraine aura, taking this issue a step beyond what has been written on the subject in works from the nineteenth and twentieth centuries. It will undoubtedly attract the professional interest of medical doctors, psychologists, and researchers who will receive valuable information about both common and rare migraine aura symptoms, extensive reviews from European and American medical literature, including a list of references that cover the latest research, and fresh descriptions of the migraine phenomena in the words of the migraine patient-artists who participated in the four national Migraine Art competitions. "What makes the book particularly interesting," wrote Anne MacGregor in a review of an early draft, "is the follow-up that you had with the artists and their explanations. This really enhances the text and adds a unique touch." Moreover, it is expected that the book will also find its way into the hands of migraine sufferers, whose interest is confirmed by many letters we have received from migraine patient-artists. "I hope this information adds to your research," wrote a female migraine sufferer, "and I can't help wondering if this is something that the general public will see." We have written the book so that it is readable not only for doctors and scholars, but also for the informed migraine sufferer. All medical terms are explained up front, and the main body of the text is of a descriptive nature, so that lay readers will have no greater difficulty than if they were reading a popular scientific book.

The pages of this book will guide the reader through the strange and bewildering world of "the migraine experience from within," educating both those who experience migraines (whether they know it or not) and others in order to promote a better understanding of what it is like to be a migraine sufferer.

—Klaus Podoll, MD
 Aachen, Germany
 June 2008

Chapter 1

Historical Images of Migraine Experiences

The history of migraines is probably as old as the history of mankind. It has been suggested that the geometric patterns seen by some migraine sufferers during their attacks were a source of inspiration for the ornamental designs encountered in cave and rock drawings documented since the beginning of the Stone Age.[156] If so, this earliest evidence of graphic art would also represent the first recorded images of migraine experiences. According to physician Walter Clement Alvarez, the first reference to migraines in literature is in a Sumerian poem written in approximately 3000 BC,[9] in which the anonymous sufferer bewailed his "sick-headed" and "sick-eyed" condition and prayed for relief in some painless afterlife.[339] During the same period another Babylonian observed, "Headache roameth over the desert, blowing like the wind, flashing like lightning.... Flashing like a heavenly star, it cometh like the dew."[585] Early Greek and Roman medical authors who recognized migraines and the accompanying nausea, vomiting, and visual disturbances include Hippocrates, Aretaeus, Celsus, and Galen. Medieval authors made little progress in the area of migraine study, but in the seventeenth and eighteenth centuries milestones in the understanding of migraines can be found in the works of Willis and Tissot. In the nineteenth century scientific authors began to use migraine sufferers' artwork to analyze their visual experiences, as best exemplified in the studies of Airy[7] and Gowers.[217] In the twentieth century an outstanding paper by Lashley describes mechanisms of brain functions that can be inferred from images of the visual patterns experienced during personal migraine attacks.[352] Despite

the encouraging results of this approach, only a few investigators have pursued this line of research.

These medical records of migraine experiences are reviewed in more detail later in this chapter. In nonmedical literature there are also three well-documented examples of migraine images. It has been suggested that the religious visions of the twelfth-century abbess Hildegard of Bingen represent transformations of her visual experiences during migraines. A similar claim has been made for a sudden revelation and other spiritual experiences of the seventeenth-century scholar Blaise Pascal. In the nineteenth century Lewis Carroll, author of *Alice's Adventures in Wonderland,* is said to have used his personal migraine experiences as a source of artistic inspiration. In all three cases, discussed below, the evidence for these claims is considered by comparing them with images produced by diagnosed migraine sufferers.

The Visions of Hildegard of Bingen

The German abbess and mystic Hildegard of Bingen (1098–1179), one of the most remarkable women of the Middle Ages, is renowned for her writings, which include three major visionary works, as well as for her music and the spiritual tradition she founded.[177] In an essay titled "The Visions of Hildegard of Bingen," first published in 1917, British medical historian Charles Singer suggests that at least some of her visions were based on the visual effects of migraines, and that she saw spiritual significance in these effects.[587] To support this idea he draws on Hildegard's own accounts, the miniatures illustrating her visionary work *Scivias,* and the words of her contemporary biographers. Hildegard's medical history led Singer to the opinion that she had suffered from "a functional nervous disorder" compatible with a diagnosis of migraines. This conclusion was readily accepted by most neurologists,[110,133,192,554,654] although it was rejected by others.[245,473] According to Hildegard her visionary experiences occurred frequently from the age of five, suggesting childhood migraines with visual auras. In the introduction to her first visionary work, *Scivias,* Hildegard writes:

But I had sensed in myself wonderfully the power and mystery of secret and admirable visions from my childhood—that is, from the age of five— up to that time, as I do now.... But the visions I saw I did not perceive in dreams, or sleep, or delirium, or by the eyes of the body, or by the ears of the outer self, or in hidden places; but I received them while awake and seeing with a pure mind and the eyes and ears of the inner self, in open places, as God willed it. How this might be is hard for mortal flesh to understand.[244]

The main bone of contention surrounding Singer's thesis was the similarity between Hildegard's visions, as illustrated in the thirty-five miniatures in *Scivias,* and the distinct visual patterns that are characteristic of migraine sufferers' aura symptoms.[498,497] The miniatures in *Scivias* were painted during Hildegard's lifetime,[33,571] and though there is no direct proof, most authors assume that they were produced under her personal supervision.[198,305,447,568,587] The miniatures sometimes depict details that are not described in the texts, and given the great respect she commanded and the status of her work, which she claimed was derived from divine revelation, it seems unlikely that anonymous illustrators would have added any further details without Hildegard's prior approval.[569] The original illuminated manuscript of *Scivias,* called the Wiesbaden Codex, was lost during the Second World War, and only black-and-white photos of the original miniatures survive.[568] There is a color facsimile of *Scivias,* however, that was produced at the Abbey of Saint Hildegard in Eibingen, Germany, between 1927 and 1933. The following illustrations of Hildegard's visions are taken from that copy.[560]

According to the similarities between her visions and migraine aura patterns, the thirty-five miniatures in *Scivias* can be grouped under three headings (see table 1.1 in appendix B). The first group comprises sixteen miniatures in which, in Singer's words, "a point or a group of points of light, which shimmer and move, usually in a wavelike manner ... are most often interpreted as stars or flaming eyes."[587] Points or groups of points can be seen in ten pictures, stars in seven, and flaming eyes in two. Figure 1 shows a vision of stars falling into the waves, interpreted by Hildegard as the fall of the angels. She wrote:

▶ **Figure 1**

Hildegard of Bingen,
Scivias, Vision III, 1.[568]

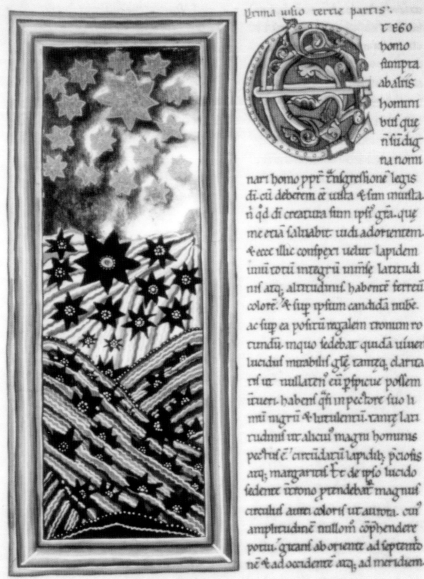

And then I saw a great star, splendid and beautiful, come forth from the
One seated on the throne. And with that star came a great multitude of
shining sparks, which followed the star toward the south, looking on the
One seated on the throne like a stranger; they turned away from Him and
stared toward the north instead of contemplating Him. But, in the very act
of turning away their gaze, they were all extinguished and were changed
into black cinders.[244]

In medical terms Hildegard's experience can be considered a shower of star-shaped visual hallucinations, first falling then ascending across her visual field and eventually blotted out by an all-obscuring spot. The miniatures from the twelfth century (see fig. 1) can be compared with the drawing of a visual aura by a twentieth-century migraine sufferer in figure 2. The striking similarities in these images are clear, which supports Singer's ideas.

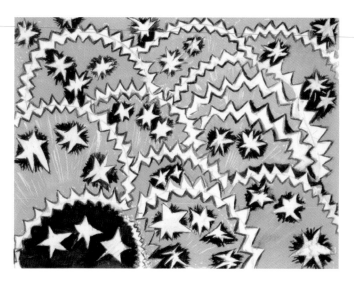

▲ **Figure 2**

Migraine Art collection.

In the second group of thirteen miniatures, the pictures show "a series of concentric circular figures of wavering form."[587] Together with star shapes, these concentric circles appear prominently in figure 3, representing the creation of the world and the fall of man. Singer considered it to be "the most beautiful of all the miniatures of the Wiesbaden Codex."[587] Again, a comparison of the miniatures with a twentieth-century representation of a migraine aura is revealing (see fig. 4).

According to Singer, the third group of nine miniatures shows "definite fortification spectra [visual effects that happen during a migraine aura] . . . radiating in some cases from a colored area."[587] As an example, the vision depicted in figure 5, which Hildegard said represents the zeal of God, shows a series of crenellated lines converging at a central point where a human head is situated. Closer inspection of the nine miniatures in this group shows that the crenellation pattern is approximately linear or only slightly curved in eight pictures, as seen in figure 5, and approximately circular or semicircular in three pictures, as in figure 6. The same crenellation patterns in linear (see fig. 7) and circular form (see fig. 8) can be seen in twentieth-century depictions of migraine auras. It may also be noted that in both Hildegard's vision in figure 5 and in the aura of a modern sufferer in figure 7, the crenellations are accompanied by mosaics formed by rectangular figures.

Singer was not justified in classifying the crenellations encountered in

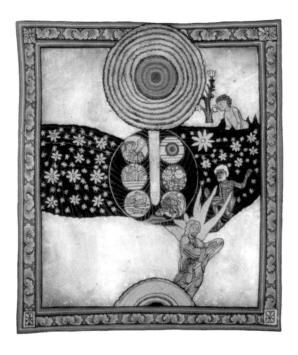

▲ **Figure 3**

Hildegard of Bingen, *Scivias*, Vision II, 1.[568]

▼ **Figure 4**

Migraine Art collection.

Hildegard's visions as fortification spectra, since *fortification spectra* was used in medical literature to indicate the similarity between migraine spectra and the zigzag shapes seen in a map of a fortress, rather than a similarity with the crenellated appearance of the tops of the walls of a fortress or castle.[473] In fact, Alvarez says that the crenellations in Hildegard's visions "are very different from migrainous zigzags" of fortification spectra, and should be considered "atypical scintillating scotomas,"[13] or shimmering arc formations on the visual field. Singer's misinterpretation of the term *fortification spectrum* even led to the suggestion by Elliot,[158] supported by Wilson,[654] that it should be reserved for crenellations and that zigzags should not be included in the meaning. Plant correctly proposed that the term *fortification spectrum* did not apply to the crenellations recorded in Hildegard's visions, but he was wrong in assuming that such patterns were "never reported in migraines"[473] because the paper by Elliot included a case history that describes such patterns.[158]

Elliot reported showing "the Reverend Mother Hildegard's pictures of fortification signs [crenellations] to a very intellectual and deeply interested sufferer, a priest of the Church of Rome":[158]

Her drawings of migraine phenomena, both fortification and other signs, are probably the earliest on record, and they are so faithfully executed that victims of the disease today recognize them as reproductions of their own trouble with an alacrity and a pleasure that show how truly she painted for after generations.... The very fact that she could draw these fortification signs so clearly and well that they are at once recognizable today bears out an observation that other sufferers of the same symptom have clearly confirmed.

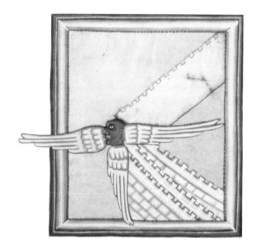

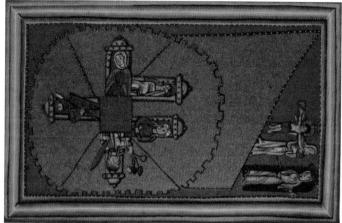

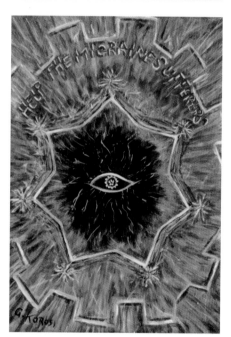

Where the people who see zigzags find them always in active and rapid movement, and very evasive when looked at, those who see fortification signs say that they move very slowly.

Had they not been stationary, or nearly so, I do not think she could have drawn them as she did.... The priest I referred to said the crenellations were not very regular, that they moved slowly from left to right as if they were alive but could be looked at and studied directly, whereas the zigzags were hazy and moved with extreme rapidity, sliding away when looked at. He described both signs as lasting about ten minutes, when the attack developed into numbness, headache, and so on. He made one more point which obtains some confirmation from other observers, namely that the fortifica-

▲ **Figure 5**

Hildegard of Bingen, *Scivias*, Vision III, 5.[568]

▲ **Figure 6**

Hildegard of Bingen, *Scivias*, Vision III, 3.[568]

▲ **Figures 7 and 8**

Migraine Art collection.

tion signs are horizontal and the movement is along the length of the signs,
whereas the zigzags are vertical and their movement is up and down them,
reminding one of the way by which light is transmitted.[158]

Elliot's report makes it clear that crenellations like those in the miniatures in Hildegard's *Scivias* have also been described by other migraine sufferers, who in turn recognized the miniatures as mirroring their own experiences, further confirming Singer's theory. With respect to Elliot's emphasis on the differences between crenellations and zigzags, it is important to bear in mind Wilson's statement that "such observed differences are not constant and may not be fundamental."[654]

Singer's essay[587] can be credited as "the first recognition of the phenomena of migraines as the basis of mystical visions."[588] Similar claims have been made for other religious figures, but the evidence has not been as convincing in any other case. Seeligmüller was the first to discuss a diagnosis of visual migraines[577] rather than epilepsy[341] in the apostle Paul. Similarly, Lennox and Lennox regarded the conversion of Saul of Tarsus, later Saint Paul, in Damascus as "an emotional reaction to the voice of conscience, possibly complicated by a migraine-like syndrome"[365] with fainting, blindness, and three days of being unable to eat. Indeed, a medical interpretation of the recorded history may lend some support to the notion that Saint Paul's thorn in the flesh was migraines.[212] The biography of Saint Teresa of Ávila, who experienced numerous visions, is remarkable in that she is said to have suffered from recurring headaches,[557] which would favor the diagnosis of migraines rather than temporal-lobe epilepsy, as suggested by Dewhurst and Beard.[130] Convincing evidence exists that the French mathematician, physicist, and philosopher Blaise Pascal suffered from visual migraines,[440] described in more detail in the following section. It is relevant to note that Pascal's sudden religious experience during the night of November 23, 1654, was accompanied by light sensations that he interpreted as fire. In his memorial he wrote: "Fire. / God of Abraham, God of Isaac, God of Jacob, / Not of the philosophers and the scientists. / Certainty. Certainty."[172] In *Mystics of Our Time,* Graef records the history of German mystic Hieronymus Jaegen (1841–1919), who experienced visual hallucinations, spontaneous possessions by the spirit of God,

and a "mystical marriage" in addition to "headaches and migraines."[223] Since the late nineteenth century, a number of clinical case reports have been published on visual migraine aura experiences with complex hallucinations of religious figures such as God, Jesus Christ, the Virgin Mary, angels, saints, and also the devil.[337,411,526] Foster recorded the story of a British clergyman in the 1930s:

> *During the exercise of a service of spiritual gifts, he suddenly saw a brilliant light in the form of a bow, the center being so high as to be out of sight, and the light dazzling to the eyes. Simultaneously he received the words of prophecy intimating that he had been called to the office of apostle. Since that time he had suffered from a slight dimness of the right eye due to an air bubble over the center of the pupil. He had also been accorded the gift of tongues.*[186]

Foster considered this case to be "one of the most interesting histories of migraines he had seen,"[186] remarkable for its religious associations and for the persistence of a visual aura after the migraine attack.

The Migraine Experiences of Blaise Pascal

Blaise Pascal (1623–1662) made outstanding contributions to mathematics, physics, and philosophy. He was one of the founders of probability theory, constructed a calculating machine, and came up with basic insights into the physics of air pressure. In his major philosophical work, *Thoughts on Religion*, published in 1670 after his death, he criticized reason and contrasted it with the logic of the heart. Pascal achieved this considerable amount of work despite having been in poor health since childhood. He suffered recurring severe headaches from his twenties and was troubled by a number of unusual ailments in later life, which led to rumors among his contemporaries that he was insane, a suggestion that many medical authors agreed with.[55,364,428,532] It was not until Onfray's study reported that visual migraines were likely responsible for some of Pascal's more bizarre experiences[440] that suspicions of his insanity were dismissed. The evidence

presented in Onfray's original paper was expanded in a later monograph titled *Pascal's Abyss*.[442] Critchley summarized Onfray's findings:

> *Seventeenth-century medicine holds another remarkable record which might well be an instance of a migraine: I refer to the chronic ill health of Blaise Pascal. He was a sickly individual all his life and was prey to periodic illusions of a terrifying character. From time to time he would imagine that a cavity or precipice was yawning on his left-hand side. To reassure himself he would often maneuver a piece of furniture to that side. This might have had something to do with an incident when, while crossing the bridge at Neuilly in a coach, the two wheeling horses crashed to their death at a point where there was no guardrail, while the leaders snapped the harness so that the vehicle came to a halt at the end of the bridge. This periodic illusion was spoken of by his contemporaries as Pascal's abyss. Dr. Onfray has brought forward some interesting evidence to suggest that this recurring precipice was actually a transitory left hemianopia [blindness in half the visual field]. A study of the manuscript writings of Pascal brings to light two features: Quite often one finds an inordinately broad margin on the right half of the page. The second peculiarity concerns the interpolation here and there of zigzag designs reminiscent of a [migraine aura]. Clinical experience shows indeed that patients afflicted with fortification figures not infrequently commit them to paper and even insert them upon a page of script like compulsive doodles. Perhaps this was so with Pascal.*[110]

Looking at the original manuscript of Pascal's *Thoughts on Religion*, a facsimile of which has been edited by Léon Brunschvicg,[77] confirms Onfray's observation of wide right margins, which indicates blindness in half of his visual field as he was writing these pages. His handwriting on these pages is poor and sometimes illegible when compared with other samples of his work, which shows an impaired ability to write as a further migraine aura symptom. Considering only the original manuscript's seventy-six pages, which consist of a single large piece of paper, three pages (Folios 179, 341, and 351) clearly indicate and two pages (Folios 187 and 361) suggest a right-sided blindness in half of his visual field, whereas only one page (Folio 185) suggests a left-sided half blindness.

The drawing in Folio 20 of the original *Thoughts on Religion* manuscript (see fig. 9) was considered by Onfray to represent "an absolute proof"[440] of Pascal's visual migraine aura experiences. He wrote:

> *On page 20 of the manuscript, on a sheet of paper where not a single word is written down, there is a drawing composed of two parts; at the upper right zigzags like those which migraineurs see, and a little deeper down, in the center, a constellation of signs and bars which recall both the letters that are dancing and the luminous spots that are fluttering about in the visual field obscured at the beginning of the attack.*[440]

Onfray's interpretation is that the zigzags in the upper right corner of the picture and also the pattern of predominantly curved forms in the lower half represent a visual migraine aura experience. The regular arrangement of the basic shapes in the pattern—in rows and columns—has to be emphasized as a feature rarely described in migraines. The basic shapes and their dimensions are reminiscent of the symbols used in stenography. Brunschvicg[77] and Terson[610,611] suggested that the basic shapes in the pattern represent "signs used for stenography" and that the zigzags are "an assemblage of these signs," but this interpretation is unlikely, if only on the grounds that none of the many shapes can be recognized as symbols used in stenography.[441] The pattern in the lower half of Pascal's drawing is similar to a migraine aura drawn by Ahlenstiel and Kaufmann[5] that shows multiple rows of basic shapes (see fig. 10), and to another aura depicted by a participant in the Migraine Art competitions that features two rows of "primitive orange roof shapes" appearing in the area of a "strong yellow cloud in the midst of a dark grayish cloud" (see fig. 11). These examples demonstrate that regular patterns like those in Pascal's drawing, although much rarer than the common zigzags of fortification spectra, can nevertheless be experienced as visual hallucinations during a migraine.

Onfray suggests that the two zigzag lines depicted in Folio 251 of the original *Thoughts on Religion* manuscript (see fig. 12) represented "zigzag cancellations,"[440] but the zigzags, drawn below and to the right of the handwritten text, show no overlap with any word of Pascal's statement of principle:

Nature acts by progress, itus et reditus. It goes by and returns, then goes farther on, then two times less, then more than ever, etc.

The flux of the sea comes about in this way; the sun appears to march thus

Brunschvicg added a colon after the last sentence of this statement,[77] suggesting that Pascal intended to illustrate the *itus et reditus* ("departure and return") of nature's progress with the zigzag figure. This interpretation does not account for the similar zigzags placed after the first word of the second sentence, however, so it cannot be thought of as a graphical element incorporated into the text referring to its content. If Pascal had intended the zigzag figure as an illustration of the to-and-fro movements of nature described in his statement, he would have drawn the zigzags horizontally to fit into the design of the text rather than at an angle. Indeed,

▲ **Figure 9**

Detail from Folio 20 of the original manuscript of Blaise Pascal's *Thoughts on Religion.*[77]

all printed editions of *Thoughts on Religion* have reproduced these zigzags oriented horizontally, clearly deviating from Pascal's original drawing.

Because of its simplicity, in our opinion Folio 251 (see fig. 12) represents a second, even more convincing example of a drawing by Pascal that illustrates the zigzags of a migraine fortification spectrum, which Pascal either experienced or recalled while writing or rereading his statement. Is there a connection between the to-and-fro movements of nature, which are described in Pascal's statement, and the zigzag patterns he drew? Perhaps the migraine aura experience might have acted as a source of inspiration for Pascal's philosophical reflections. Onfray thought this to be true for other statements that Pascal wrote: "Suffering is the natural condition of Christians," and "I have my fog and my fine weather within me." Pascal was certainly aware of the potential benefits of his illness, a topic which he discussed in about 1760 in his "Prayer to Ask God for the Good Use of Diseases."[46]

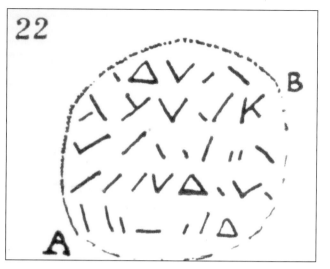

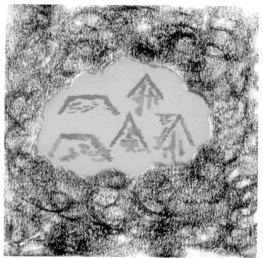

Onfray discussed two other folios of the original *Thoughts on Religion* manuscript as possible indications of visual migraine aura experiences, but in our opinion these examples are unconvincing. Folio 115 features two words crossed out with a series of arcs, and Folio 70 shows "a broad undulating cancellation with rounded festoons,"[440] crossing out an entire page (not shown). Onfray thought that Folio 279 (not shown), which contains a drawing of a spot with a central nucleus—perhaps hiding just another cancellation—represents images of floaters seen within the eye; we also consider this to be highly speculative.

◀ Figure 10

Visual migraine aura reported by Ahlenstiel and Kaufmann[5]

▲ Figure 11

Migraine Art collection.

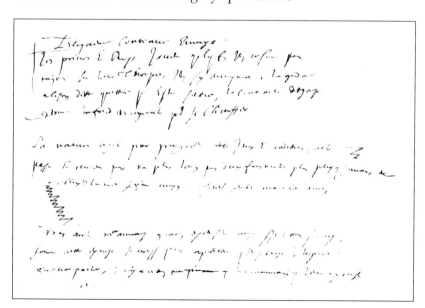

◀ Figure 12

Detail from Folio 251 of the original manuscript of Blaise Pascal's *Thoughts on Religion*.[77]

Nevertheless, there is evidence that Pascal suffered from visual migraines with recurring headaches, episodes of blindness in half of his visual field, zigzag fortification spectra, and other visual hallucinations. As noted in the previous section, Pascal's well-documented religious experience in 1654, which appears to have been accompanied by a luminous hallucination that he interpreted as "fire," may have been based on the effects of a migraine and given spiritual significance by him, similar to the religious visions of Hildegard of Bingen. This was first suggested by Onfray, who wrote:

> *Perhaps he had a scintillating scotoma followed by a migraine that memorable night of November 23 when he wrote the parchment found after his death sewn in his garment. In the center he wrote "FIRE," and he made a note of the time of the crisis, from about 10:30 p.m. to 12:30 a.m.; the lines are unfinished and certain words illegible.*
>
> *Surely Pascal had that evening an entirely spiritual illumination, but it is not inconceivable that this sudden religious clarity, which moved him to tears, appeared to him during his migrainous insomnia. Neither does it defile his great memory to know today that the spirit is never more alive, the intelligence more lucid, than at the end of a migraine, and it is entirely appropriate to say again, with Renan: "Who wouldn't rather be ill like Pascal than be in good health like the ordinary people?"*[440]

The Migraine Experiences of Lewis Carroll

Charles Lutwidge Dodgson (1832–1898), better known as Lewis Carroll, is renowned for his two novels, *Alice's Adventures in Wonderland*[88] and its sequel, *Through the Looking Glass*.[89] In the novels his young heroine has a number of strange and disturbing experiences that are very similar to certain hallucinations particular to migraines,[374] and the term "Alice in Wonderland syndrome" was coined to describe these symptoms.[615] Because Carroll suffered from migraines it was suggested that he had used his own migraine experiences as a source of inspiration for his two books,[374] so it

was said that "Alice trod the path of a wonderland well-known to her creator."[615]

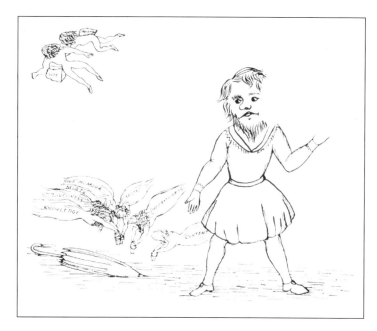

This idea was refuted by Murray[425] and Blau[62] on the grounds that migraine attacks were not mentioned in Carroll's diaries before 1885, when he wrote that he "experienced, for the second time, that odd optical affection of seeing moving fortifications, followed by a headache."[227] The implied first time he had this visual experience occurred at an earlier, unknown date. Between 1885 and 1891 he wrote about a total of five episodes with moving "fortifications" in his diaries,[227] with only the first episode having been accompanied by a headache. This strongly suggests a migraine aura without a headache as the predominant form of migraine attack in Carroll's experience, as has been suggested previously.[215,315]

As shown by Podoll and Robinson in a letter published in *The Lancet*,[485] two pieces of evidence—a drawing and a diary entry that previously escaped notice in the literature[95]—suggest that Carroll had already experienced visual migraine aura symptoms prior to the conception of his first Alice book, which was created orally in 1862, produced in a handwritten version titled *Alice's Adventures Underground* in 1864, and finally published as *Alice's Adventures in Wonderland* in 1865. Figure 13 shows the frontispiece of Carroll's family magazine *Mischmasch*,[90] compiled between 1855 and 1862, which depicts figures already shown in his previous family journal *The Rectory Umbrella* from 1854 and 1855. In the carefully executed drawing of the standing man, parts of the head, shoulder, wrist, and hand are missing on the right side of the picture, and the rounded border of the defect is similar to that seen with a negative spot on the visual field (scotoma).[90] Compare it to the negative spot on the visual field recorded by a migraine sufferer in figure 14.[207]

▲ **Figure 13**

Frontispiece of Lewis Carroll's *Mischmasch* (1855–1862).[90]

▲ **Figure 14**

Visual migraine aura reported by Garcin and Halbron.[207]

In a diary entry from January 17, 1856, Carroll noted, "Consulted Mr. Bowman, the oculist, about my right eye; he does not seem to think anything can be done to remedy it, but recommends me not to read long at a time, nor on the railway, and to keep to large type by candlelight."[227] Edward Wakeling, editor of the first complete version of Carroll's diaries, annotated this entry with the remark that "The nature of [Carroll's] sight problems is not known."[630] It seems clear that Carroll's complaint about his right eye, which prompted him to seek medical advice in 1856 from William Bowman, one of the most eminent ophthalmologists of his time, referred to a negative spot on his visual field near the center on the right side, as depicted in the drawing from *Mischmasch,* which he began compiling in 1855. The nature of Bowman's medical advice suggests he suspected a functional disturbance due to eye strain caused by reading too much or in poor conditions. Bowman apparently failed to clearly diagnose Carroll's visual problems in 1856; despite the existence of some earlier reports in medical literature,[187,454,632] the visual manifestations of migraines were not widely recognized in the medical profession before the 1870s, when Airy,[7] Latham,[353] and Liveing[380] wrote about them. Lewis Carroll's extensive reading also included a collection of medical books, and with Latham's writing[353] and Airy's illustrations[7] of typical migraine fortification patterns, Carroll was able to identify "that curious optical effect—of 'seeing fortifications'—discussed in Dr. Latham's book on 'bilious headache.'"[227]

Because Carroll had suffered from migraine aura symptoms before writing the Alice books, it seems that at least some of Alice's adventures were based on Carroll's personal migraine auras. In any case, the similarities between Alice's experiences and the aura symptoms of migraine sufferers are striking, as elegantly summarized by Todd:

> *It will be remembered that Alice, in her dreams, sometimes became remarkably tall or remarkably short. However, she was sometimes aware of changes of an altogether more subtle nature. Thus, there were occasions when she was conscious of some intangible change in herself and her environment. There were also times when she addressed herself as though she were two people, and others when she puzzled over her own identity. In technical*

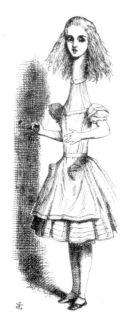

▼ Figure 15

Illustration by John Tenniel to Lewis Carroll's *Alice's Adventures in Wonderland* (1865).[88]

terms she had feelings of hyperschematia, hyposchematia [disorders of the body image in which the entire body or parts of the body are perceived as abnormally large or small], derealization [where the external world seems unreal], depersonalization [where one's sense of self seems unreal], and somatopsychic duality [feeling like two people]. There are good reasons for including certain other symptoms within the general purview of the [Alice in Wonderland] syndrome; they include illusory changes in the size, distance, or position of stationary objects in the subject's visual field; illusory feelings of levitation; and illusory alterations in the sense of the passage of time.[615]

Some of these experiences were impressively depicted by Sir John Tenniel's illustrations in the two Alice books. These closely followed Carroll's suggestions, as seen in the original drawings that accompanied his previous handwritten manuscript *Alice's Adventures Underground.* Figure 15 shows Alice's predicament in realizing that her body is lengthening, particularly in the neck. This compares with the depiction of a migraine sufferer's experience of body distortions in figure 16. Alice puts her hands over her ears to ward off a noise loud enough to be created by a legion of drums in figure 17. "Where the noise came from, she couldn't make out: The air seemed full of it, and it rang through and through her head till she

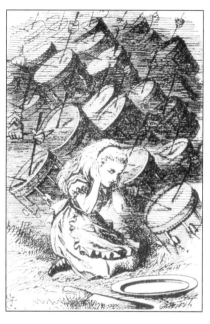

◀ **Figure 16**
Migraine Art collection.

◀ **Figure 17**
Illustration by John Tenniel to Lewis Carroll's *Through the Looking Glass* (1871).[89]

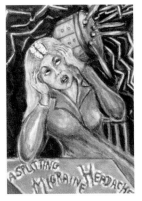

Figure 18

Migraine Art collection.

Figure 19

Visual migraine aura illustrated by Ruete.[551]

felt quite deafened."[89] A similar representation of hypersensitivity to noise accompanying a migraine attack is suggested by a female participant in the Migraine Art competitions (see fig. 18). Durham says that "it requires an elastic imagination to categorize as a medical syndrome the story of *Alice in Wonderland* by Lewis Carroll,"[151] but it has to be acknowledged that many of Alice's adventures, discussed here and in following chapters, are made more understandable and plausible by their similarity to migraine aura experiences.

The life and work of Lewis Carroll has attracted the interest of both literary and scientific scholars. Following the original suggestions of Lippman[374] and Todd,[615] a number of neurologists and psychiatrists have contributed to a fuller understanding of Carroll's work, pointing out the influence migraines had on his artistic career.[138,192,213,215,308,313,315,351,381,425,455,482,533,544,623]

Migraine Experiences in Medical Illustrations

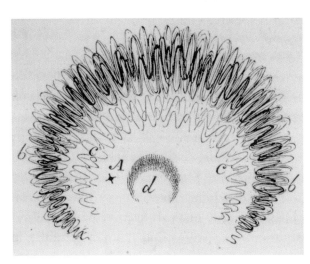

The first medical illustration of a visual migraine aura[570] is from the German ophthalmologist Christian Georg Theodor Ruete of the University of Göttingen.[668] In his 1845 *Textbook of Ophthalmology,* he included a drawing (see fig. 19) of three successive stages of a personal visual aura, where *d* denotes the blind spot, *A* the axis of vision or point of fixation, and *c* and *b* the last two stages of the aura. He described the general characteristics of these visual phenomena:

Most frequently they are half moon–shaped, but rarely circular, with zigzagged, silver- and gold-colored shimmering borders. The zigzags exhibit continuous, extremely intense scintillating movement.... They follow movements of the eye and with accommodation for distant objects increase in

apparent size and decrease in intensity, like all other scotomas [spots on the visual field].... They frequently remain the same size for only a short period, then begin to expand on the side and toward the rear.... Pressure on different parts of the eye does not influence their appearance. It retains its brightness with the eye open or closed, but if closed it is somewhat brighter and clearer. Eyesight is not affected, and during the vision one sees objects not encroaching upon the zigzags clearly and well-defined, but those objects which fall into the zigzags are seen as blurred and as if surrounded by a halo. As a rule, its disappearance is followed by an intense headache, a feeling of tension, and pressure in the eye.[551]

Ruete's *Textbook of Ophthalmology* is dedicated to his friend Johann Benedict Listing, professor of physics and optics at the University of Göttingen, who had brought to Ruete's attention his own experience of a recurring visual disturbance for which he coined the term *flimmerskotom* or "scintillating scotoma" (sparkling spot on the visual field).[550,671] The exact date of Listing's first use of the term in a personal communication was not recorded, but the first published reference was in an article by Zehender in 1867[669] that cited a letter from Listing describing his "little eye trouble" of a sickle- or half moon–shaped scintillating spot on the visual field as a "transient nervous scotoma."[378] Listing's letter was accompanied by a drawing of his visual disturbance, but unfortunately this was not published.[670] The term *flimmerskotom* emphasizes the shimmering movements of the visual hallucinations at the margins of the spot on the visual field during a migraine, implying *movement* in visual hallucinations. It was readily accepted in the German medical literature.[181,183,399,400,534,535,565,603,671,672] The French translation, *scotome scintillant*, was popularized by Dianoux[134] with such success that it was wrongly claimed that Dianoux rather than Listing had been "the first man to call this [spot on the visual field] a 'scintillating scotoma.'"[12]

In 1865 the British Astronomer Royal, Sir George Biddell Airy, published a picture of the typical zigzag formation of a visual migraine aura. Stimulated by the reports of Wollaston[659] and Brewster[74] on their personal experiences of transient half vision, Airy[6] described and drew what he considered to be a variant of these visual disturbances. These were

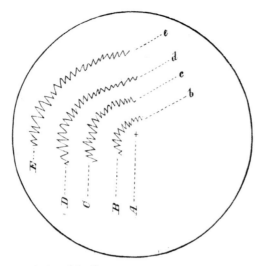

A, the beginning of the disease.
B*b*, C*c*, D*d*, E*e*, successive appearances, as the arch gradually enlarges.

▲ **Figure 20**

Visual migraine aura illustrated by Sir George Biddell Airy.[6]

characterized in his own recurring experiences, each lasting from twenty to thirty minutes, by "zigzags" which "nearly resemble those in the ornaments of a Norman arch"[6] (see fig. 20).

Five years later in 1870, the British physician Hubert Airy, son of the Astronomer Royal, released a paper titled "On a Distinct Form of Transient Hemiopsia," and it became one of the most influential and frequently cited publications on migraines of all time. He presented a detailed description of a distinct visual pattern that he experienced in half of his field of vision during his own migraine attacks, and he proposed naming it *teichopsia: teichos* meaning "town wall," and *opsis* meaning "vision." This word "represents the bastioned form of transient hemiopsia [losing vision in half the visual field] that I have been describing."[7] Airy[7] went on to compare the experience to words from Tennyson's 1833 poem "Oenone": "As yonder walls / Rose slowly to a music slowly breathed, / A cloud that gathered shape."[609]

Airy's[7] account of teichopsia is illustrated by two plates, one of which is a colored drawing (see fig. 21) that was later reproduced by both Latham[353] and Liveing[380] and subsequently used by several other authors as typical representations of this form of visual disturbance. Airy's term *teichopsia* emphasizes the "bastioned form" of the visual phenomena of migraine aura symptoms, implying *shape* in these visual hallucinations. It is important to note that Airy was already aware of the fact that the study of visual migraine experiences could provide clues to understanding brain function. He writes:

Regarded merely as a disease, teichopsia, though by no means unimportant, may be thought hardly deserving of the attention of scientific men; but regarded as a veritable "photograph" of a morbid process going on in the brain, its interest and importance cannot be too strongly insisted upon.[7]

Liveing's[380] work *On Megrim, Sick-Headache, and Some Allied Disorders* includes another drawing of a visual migraine aura (see fig. 22), which is described "in the patient's own words":

> *It commences with a slight dimness of light; then the lower half, rather inclined to one side, of the field of view appears as if hidden by some white (luminous?) object held close to the eye. Gradually a half ring formed by serrated lines of prismatic colors appears in the place of the blank whiteness, the alternate points seeming to revolve in opposite directions. In about three quarters of an hour, or an hour, this appearance ceases, and a violent headache succeeds.*[380]

In 1895 William Gowers[217] used a collection of migraine aura illustrations as the basis of his Bowman Lecture on "Subjective Visual Sensations." According to Gowers's biographer Critchley, the "original plates were presented by Gowers to the Ophthalmological Society,"[103] although Gowers "was prevented by illness from being present"[16] in person, so his lecture had to be "delivered by his proxy, Dr. Risien Russell,"[16] "though their present whereabouts are not known,"[103] which still holds true. Gowers's collection includes a series of five more drawings by Hubert Airy and two other sets of drawings, one from a distinguished watercolor artist (see fig. 23) and another from one of his patients (see fig. 24) who was peculiar in that he had no insight into the fact that what he was seeing was not real, but "was possessed with the idea that these spectra were objective things,"[217] so that he "always depicted them as objective things related to his figure."[218] Figure 24 shows a spectrum in the form of a rainbow-colored arch drawn by this patient as if the spectrum could actually be seen, together with the patient, by an outside observer. However, similar objective representations have also been drawn by migraine sufferers who knew that their

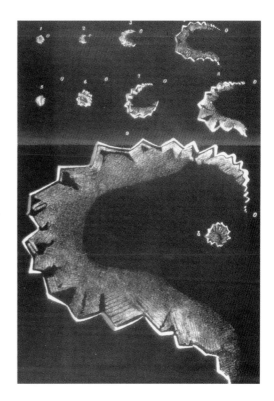

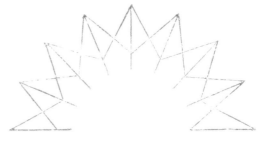

▲ **Figure 21**

Visual migraine aura ("teichopsia") illustrated by Hubert Airy.[7]

▲ **Figure 22**

Visual migraine aura reported by Liveing.[380]

▲ **Figure 23**

A watercolor artist's illustration of visual migraine aura reported by Gowers.[217]

▶ **Figure 24**

Mr Beck's illustration of visual migraine aura reported by Gowers.[217]

▼ **Figure 25**

Plan of the fortifications of the city of Lille, France, from Galeazzo Gualdo Priorato's Teatro del Belgio, 1673.

visions were not real. Gowers thought that an "involuntary sense of objectivity"[217] was a feature of the visual sensations experienced by migraine sufferers.

In his Bowman Lecture, Gowers introduced the term *fortification spectra*,[217] where *fortification* means a construction built for the defense of a town, and *spectrum* means an unexpected sight. This follows the terms used by earlier authors who had compared the visual disturbances of migraine sufferers with a map of a fortified town as viewed from above, thus emphasizing *shape* in the visual hallucinations of a migraine.[473] Like earlier French authors,[44,92] Gowers noted that migraine fortification spectra, with their "projecting and reentrant angles, bear a resemblance to the plan that the French engineer Vauban first devised as the most effective for the defense of a fortress."[217]

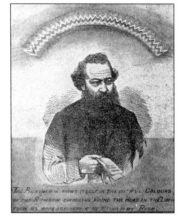

Sébastien le Prestre de Vauban was the head of France's military forces for Louis XIV, the Sun King, and was the greatest military engineer of the seventeenth century.[63] The zigzags characterizing the elaborate geometric structures of defense fortifications in Vauban's style can clearly be seen in figure 25, showing the fortifications of Lille, considered Vauban's masterpiece. Based on illustrations and verbal descriptions from his patients, Gowers proposed classifying fortification spectra into different groups, which we review in chapter 7. Confronted with the various forms of visual sensations that migraine sufferers experience, Gowers considered his study to be only a beginning, which:

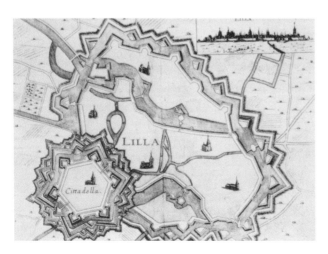

may constitute a nucleus around which facts may gather—facts carefully recorded, carefully scrutinized, carefully sifted, and carefully classified. Only by such a collection of facts and observations, with discernment of their character and relations, can come in time any real knowledge regarding them. At present the features are mysterious; but mystery often depends on isolation. The comparison of an adequate number may reveal the significance that is too profound for our present recognition.[217]

By making requests in medical journals, Gowers made a remarkable attempt to stimulate colleagues both in the United Kingdom and abroad to supply contributions to his "collection of facts and observations." During the Annual General Meeting of the Ophthalmological Society of the United Kingdom in July 1896, "on the suggestion of Dr. Gowers, a circular was issued to invite information upon and representations of subjective visual sensations,"[17] and a similar request was also published in a German ophthalmological journal.[18] The response to Gowers's international call for entries, however, was poor, judging by the lack of any further comment on the project in Gowers's published works.[103]

Gowers's hope in 1895 that his work may have "opened the path for the more systematic study of this self-revelation of cerebral function"[217] was not fulfilled until U.S. neuroscientist Karl S. Lashley published a study in 1941.[352] During personal migraine attacks with negative spots and sparkling spots on his visual field (scintillating scotomas), Lashley meticulously recorded the outline of the spots at regular intervals by starting from a mark on a sheet of paper and moving a pencil along different lines toward the blind area, and marking the places where the point of the pencil disappeared. For a better understanding of Lashley's procedure, you can use this method to demonstrate the retina's blind spot, which behaves much like a negative spot on the visual field during a migraine. Lashley was able to demonstrate that the characteristic shape of the migraine spot stayed the same during its drift across his visual field, as shown in figure 26. In Lashley's experience of scintillating scotomas, the size and shape of the fortification figures were constant in their direction in the visual field, the patterns being finer and less complicated in the upper quadrants, as

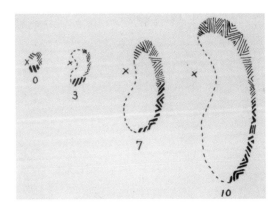

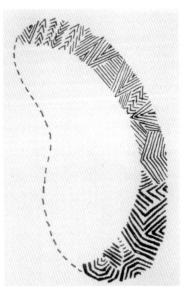

shown in figure 27. He noted that the time taken for the spectrum to spread from the macular area (a structure on the retina that provides sharp central vision) to the edge of the visual field was always about twenty minutes. Because the length of the part of the brain responsible for vision (the primary visual cortex) is about sixty-seven millimeters (2 3/4 inches), the spectrum's twenty-minute duration suggests it is caused by a wave of intense excitation moving at a rate of about 3.4 millimeters (1/8 inch) per minute across the visual part of the brain, followed by a complete inhibition of activity, and then recovery moving at the same rate. Lashley wrote:

> *Whatever the precipitating cause of the disturbance, these facts indicate that … an excitatory process, in the case of scintillations, is initiated in one part of the visual cortex and spreads over an additional area. As the process spreads, activity at the point where it was initiated is extinguished, and the process of extinction also spreads over the same area at about the same rate as does the active process.*[352]

Lashley's idea about the aura spectrum effect being a brain process, based on his own visual sensations, came three years before the phenomenon of spreading depression of activity in the cerebral cortex was demonstrated in animals.[359] This was suggested by Milner in 1958 as a likely explanation for the sparkling spots on the visual field of migraine sufferers,[407] and it remains today the major hypothesis for the mechanism of the migraine aura.[80,235,536] Several other authors have published personal

observations of the course of fortification spectra similar to those of Lashley.[235,243,402,515,536]

All this literature has dealt almost exclusively with the type of visual aura characterized by the typical zigzags of fortification spectra. There are also studies illustrating other shapes in the visual hallucinations of migraine patients: Miles,[406] Richards,[536] and Kaufman and Solomon[302] depict herringbone patterns and gratings at the margins of the spots on the visual field (scintillating scotomas) (see figs. 28, 29, and 30). Ahlenstiel[4] observed a regular arrangement of multiple rows of lines, angles, and triangles within a circular scintillating scotoma, as illustrated in figure 10.[5] When the migraine sufferer's attention was directed toward the visual sensation, the geometric patterns disappeared, leaving the shape of the spot, which progressively expanded. Shevell[582] published two drawings by an eight-year-old girl with a history of migraines with auras.[582] She described visual auras lasting ten to fifteen minutes and occurring at weekly to monthly intervals without an accompanying headache. Her drawings show colored dots, wavy lines, and rectangles clustered together in the visual field with some of the background obscured (see figs. 31 and 32). Pick[465] reports the experience of a medical student who first saw one, then multiple identical shimmering halos with symmetrical lines radiating from a central point, apparently falling slowly like snowflakes toward the patient[465] (see fig. 33). At a later stage of this severe migraine attack, the student observed an almost complete darkening of his vision together with multiple vibrating parallel sine waves in one half of his field of vision, intermingled with numerous scintillating points (see fig. 34). Jolly[295] illustrates an article on his personal migraine experiences that was, according to Lashley, "the most detailed description"[352] of spots on the visual field (scotomas) up to that time. Figure 35 shows an attack beginning as a foggy patch directly to the right of the fixation point,

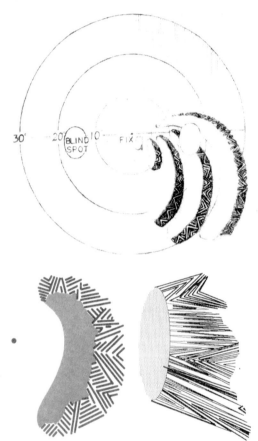

Figure 28

Visual migraine aura illustrated by Miles.[406]

Figure 29

Visual migraine aura reported by Richards.[536]

Figure 30

Visual migraine aura reported by Kaufman and Solomon.[302]

▶ **Figures 31 and 32**

Visual migraine aura of
eight-year-old girl
reported by Shevell.[582]

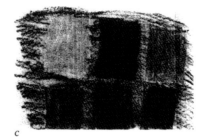

▶ **Figures 33 and 34**

Visual migraine aura of
medical student
reported by Pick.[465]

▼ **Figure 35**

Visual migraine aura
illustrated by Jolly.[295]

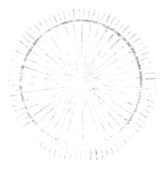
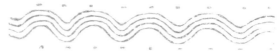

▶ **Figure 36**

Visual migraine aura
illustrated by Kupfer.[345]

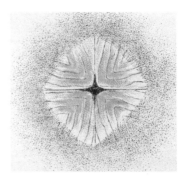

▶ **Figure 38**

Visual migraine aura
"drawn from life" by
Johnson.[293]

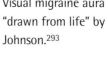

▲ **Figure 37**

Visual migraine aura
reported by Charcot.[92]

followed by horizontal silvery shimmering parallel waves below the patch, which then transform into a typical fortification spectrum. Kupfer repeatedly experienced a sparkling spot on his visual field (scintillating scotoma) with a polelike arrangement of parallel curves.[345] The effect started from exposure to direct sunlight or sunlight reflected off snow, and it lasted for up to half a minute without a headache or any other symptoms (see fig. 36). Charcot illustrates a fortification spectrum enclosing an area with a grating formed by parallel lines[92] (see fig. 37), and Johnson provides a similar illustration "drawn from life"[293] of a fortification spectrum enclosing an area filled by cross-hatching (see fig. 38). Morgenthaler published a schizophrenic patient's drawing of his recurring visual migraine aura[421] (see fig. 39), featuring expanding spiral zigzags, flame-like shapes, and curved forms likened by the patient to astrakhan fabric. He perceived all of these visual forms in continuous movement, and they invariably heralded intense two-sided headaches. One of Shevell's patients, a ten-year-old boy with a history of occasional mild migraine attacks, repeatedly experienced visual auras characterized by mosaics formed by black-and-white angular shapes that tended to cluster in one part of his visual field[582] (see fig. 40). These visual auras, which would occur monthly and last about

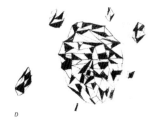

Figure 40
Visual migraine aura of
ten-year-old boy by
Shevell.[582]

▶ **Figures 41 and 42**

A professional artist's
illustration of visual
migraine aura reported
by Atkinson and
Appenzeller.[28]

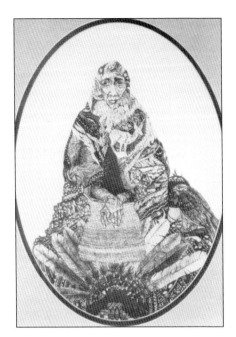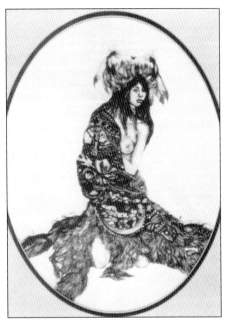

five minutes, were never associated with a headache. Atkinson and Appen-
zeller published two drawings by a professional artist who saw the com-
plex forms of female human figures as a symptom of her migraine attacks[28]
(see figs. 41 and 42).

In a lecture presented during the fourth Migraine Symposium in Lon-
don in 1970, Hay suggested that a great deal of valuable information could
be gleaned from pictures drawn or painted by migraine sufferers.[247] His
report is interesting in that his patients had not only depicted visual dis-
turbances but also other migraine experiences such as pain or body image
disturbances. He wrote:

> *Some people, however, can draw and paint what they feel and we can gather
> from these illustrations something of what they suffer. The following points
> can be noted . . . : 1. The distortion of the body image. The head, and the cra-
> nium in particular, is large in comparison to the rest of the body. 2. The red
> throbbing pulses along the temporal artery, the tight bands around the head,
> and the occipital pain. In some pictures one gains a better understanding of
> the expression "a splitting headache." 3. Some of the areas illustrated so
> vividly by the patient are where one can find localized tender points that
> are often slightly boggy to touch.[247]*

In his acknowledgments, Hay expressed thanks to "those patients who have contributed their art, which is the basis of this paper."[247] One of these patients later became the inspiration for the Migraine Art competitions, as described in chapter 2. Hay published a paper with some of his patients' artistically skilled "visual portrayals of migraines"[248] (see fig. 43).

A major limitation to be found in all these studies is that they relied on either just one or a small number of patients. The first attempt at a larger study was made in 1973 by a group of three neurologists, Hachinski, Porchawka, and Steele, who published a paper titled "Visual Symptoms in the Migraine Syndrome."[240] In their study, 244 children with migraines, one hundred of whom had experienced visual phenomena associated with their headaches, were examined at the Hospital for Sick Children in Toronto between 1959 and 1971. Of the hundred children reporting visual disturbances, sixty-seven were recalled and interviewed independently

▲ **Figure 43**

Visual protrayals of migraine reported by Hay.[248]

by a doctor and a medical artist about their visual experiences. The children were encouraged to draw what they had seen during an attack. The visual phenomena included various forms of visual impairment in one or both eyes and spots on the visual field (scotomas) similar to those discussed in earlier literature. Some children drew visual illusions such as micropsia (where objects appear smaller than their actual size) and inverted vision, which had not previously been recorded in migraines. One patient drew the hallucination of seeing herself from outside her body in one half of her visual field, which is discussed in more detail in chapter 6. The findings of the study suggest that drawing pictures could give some therapeutic benefit. In a personal communication to Oliver Sacks from one of the study's authors, John C. Steele, he emphasized "the immense relief shown

by these 'visionary' children when they were able to admit their strange experiences, and especially to depict them, and to encounter a friendly, sympathetic understanding—instead of the tellings-off and scoldings that they had previously met."[556]

In 1984 Anita Unruh and her associates published a study on children's drawings that illustrated their own pain.[621] Of the children who were selected from among patients at the Children's Hospital of Eastern Ontario in Canada, eighty-four suffered from recurring migraine headaches and twenty-five had musculoskeletal pain. They were asked to draw one picture of their pain and another of themselves in pain. It was found that all the children could draw their pain experiences and that the drawings could be reliably categorized by content and dominant color. The children's pain was most frequently symbolized by objects inflicting pain (thirty-two percent), by personification of the pain (nineteen percent), or by abstract representations of the pain (twenty-five percent), the last group including abstract shapes, arrows, and verbal explanations. In the drawings of the children in pain, those with recurring migraines more often drew themselves doing something to relieve their pain (forty-eight percent) than did the children with musculoskeletal pain (thirty-one percent). The most common actions depicted were the use of pressure, quiet, and sleep. The colors red and black were most frequently used to portray the pain, confirming the results of a previous study by Scott,[576] who found that red was commonly used in four- to ten-year-old children's cartoons representing the pain inflicted by a self-administered hammer blow or by a doctor-administered needle.[576] The significance of the common use of black in the children's illustrations of pain is unclear; it may simply reflect the fact that children may choose black as a preferred color in all drawings. The authors suggested that children's pain drawings can be used in the treatment of recurring and chronic pain.

A further study demonstrating the impact of art therapy in a larger group of children with a history of recurring headaches was published in 1996 by Lewis et al.[369] They examined a series of one hundred children aged three to seventeen, ninety-three of whom had a diagnosis of migraines. All the children were asked to draw pictures of how they felt

when they had a headache. Of the seventy-five children who drew pictures, forty portrayed the symptoms of acute headache attacks, such as the throbbing and pounding pain, nausea and vomiting, hypersensitivity to light and sound, and a desire to sleep. Five children depicted visual migraine aura symptoms similar to those in the study by Hachinski et al.[240] One third of the children's pictures revealed striking depressive images of helplessness, crying, frustration, and anger, or illustrations of themselves dead, dying, or about to be killed by the pain. These perceptions expressing fear of death were most common in boys aged ten to fifteen. According to the authors, "Children are sometimes able to communicate more effectively through their drawings than they can verbally, and the headache drawings added further insight into the children's concerns,"[369] especially their deep-seated fears that cannot be relieved by laboratory tests, X-rays, or other technical investigations but only by sympathetic counseling with explanations about the nature of their migraine experiences and reassurance that they have no life-threatening illnesses.

In a study published in 2005, Stafstrom et al.[598] examined the use of children's drawings in the diagnosis of headaches. Before taking any history, 226 children who were seen consecutively for the evaluation of headaches were asked to draw a picture to show how their headaches felt. The pictures were then scored as representing migraines or not by pediatric neurologists who had no information about their clinical history. A clinical diagnosis of the type of headache was determined independently by another pediatric neurologist using the usual history and examination. The diagnoses of the type of headache based on the pictures drawn and the clinical findings obtained were then compared. In approximately ninety percent of cases, the drawing correctly predicted the clinical diagnosis of migraines versus other kinds of headaches. In a subsequent study, Stafstrom et al.[599] explored whether headache drawings correlate with clinical improvement after treatment in children with migraine headaches. In about ninety percent of 111 children, the drawing predicted whether or not their headaches had improved clinically. The authors concluded that children's headache drawings are a useful adjunct for the diagnosis of headache type and the monitoring of its course. The technique is simple,

inexpensive, and enjoyable for children and can be applied in a variety of clinical settings.

A summary of the medical literature reviewed indicates that only one type of visual aura, the fortification spectrum of migraines, appears to have received adequate attention.[570] Other forms of visual experience, such as simple geometric hallucinations, complex hallucinations, and visual illusions, have been depicted and studied, but only in isolated examples.[136,307] For other types of migraine experience, such as the various body image disturbances, assessment of pictorial records has not yet begun. Following Gowers's original suggestion that the "comparison of an adequate number" of pictures is necessary for any progress to be made in this field of research,[217] no such project has yet materialized.

The "collection of facts and observations" envisaged by Gowers[217] only became available for scientific study with the emergence of the Migraine Art concept, which provided the rationale for organizing the Migraine Art competitions[650] and inspired similar contests.[19,132,501,510,625,626,643,656]

The Migraine Art Concept

It seems appropriate to start with a definition of what the term *Migraine Art* means and, perhaps of equal importance, what it is not intended to mean, thus avoiding misunderstandings from the beginning. Migraine Art is the idea that pictorial art techniques may provide an adequate medium, sometimes the best medium, to express and communicate the experiences that occur as signs and symptoms of migraines or sufferers' reactions to the disease. The term *art* is used here in its most inclusive sense, with no implication of the work being judged aesthetically. This chapter traces the course of events that preceded the concept that Migraine Art could form the basis of several public competitions, considers the result of assembling a large collection of Migraine Art, and also describes the methods used in this study as tools to interpret pictorial representations of migraine experiences.

In the concept of Migraine Art, the relationship between a work of art and having a migraine is determined by the artist's spontaneous choice, or the request of someone else, for a personal migraine experience to be the subject matter. Not all pictures drawn or painted by an artist suffering from migraines are Migraine Art; only those that represent a form of migraine experience are included. Indeed, many pieces of Migraine Art presented in this book are from migraine artists and patients, both amateur and professional, who have produced many other pictures that are in no way related to having a migraine. The concept of Migraine Art is also not intended to imply that there is a form of art by migraine sufferers that has some unique artistic creativity because of their migraines. It is assumed that an art form of migraine sufferers does not exist, confirming

a conclusion by the painter Jean Dubuffet, who said that "there is no art of the insane any more than art of the dyspeptics or an art of people with knee complaints."[147] There is, however, an art of the migraine, or Migraine Art, as seen in the following chapters.

History of the Four Migraine Art Competitions

Two chains of events explain the origins and development of the Migraine Art concept and the competitions that followed. One of these began with a meeting in 1973 between the late Dr. Kenneth Michael Hay, MBE (see fig. 44), a general practitioner in the United Kingdom with more than a passing interest in migraines,[249] and the late Derek Robinson (see fig. 45), a marketing executive employed by the multinational pharmaceutical company Boehringer Ingelheim Limited UK. Robinson was "desperately searching" for ideas that would help him illustrate an audiovisual program that would educate and entertain medical audiences while

▲ **Figure 44**
Dr. Kenneth Michael Hay, MBE.

▶ **Figure 45**
Derek Robinson.

promoting Dixarit (clonidine hydrochloride), a drug to prevent migraines. The problem of producing a visually appealing program about migraines seemed insurmountable until an overheard chance remark offered a solution. The family doctor in the Midlands had a patient, a forty-two-year-old teacher with a history of basilar migraines since childhood, who had illustrated her attacks with sketches and paintings in order to help her doctor understand the stress caused by her migraines.[476,491,499,504] With the full agreement of both doctor and patient, a tape-recorded meeting was arranged between the artist-patient and the marketing man. The impact of the paintings and drawings by this patient, who frequently sketched her visual migraine experiences and bodily sensations immediately after

they happened, even at night, and often accompanied them with notes describing the circumstances and further symptoms of the attack, was immediate. As she spoke into the microphone, the script for *In the Picture: A Personal View of Migraine* was being written:

> Like most people suffering from migraines, I get visual disturbances. I've tried to depict these in my paintings, although it's a little difficult at times, as the patterns change in form.... If the colors are strong, they're super-imposed and tend to blot out my field of vision. On the other hand, the wavering gray patterns—they're like shimmers of light crisscrossing and swirling round each other—you can be right in the midst of these but still see through them. Then there are cellophane patterns. It's like watching shallow waves rippling across the sand. The ripple is there, yet you can see right through and below it.[650]

However, the time was not yet ripe for this opportunity, and another chain of events six years later resulted in a wealth of opportunities that favor, according to Louis Pasteur, he who is prepared for it.

The second chain of events began in 1958 when the late Peter Wilson, MBE (see fig. 46), became concerned that migraine sufferers were not getting the support they deserved or the treatment they needed. He arranged a small group meeting in a private house in the southern English city of Bournemouth, and from such humble beginnings the British Migraine Association was born—it has been said with a cash float of £18. The British Migraine Association became a registered charity in 1962 and now has over fifteen thousand members. In 1997 the society's name was changed to the Migraine Action Association, as this was felt better to embody its aims and functions. The association has three main aims: (1) to encourage and support research and investigation into the migraine, its causes, diagnosis, prevention, and treatment; (2) to gather and pass on information about treatments available for the control and relief of migraines and to facilitate an exchange of information on the subject; and (3) to provide friendly, positive reassurance, understanding, and encouragement to migraine sufferers and their families. By following these aims the association tries to bridge the gap between the migraine sufferer and the medical

▼ **Figure 46**

Peter Wilson, MBE.

profession. Support for members includes a Web site, a postal information service, a quarterly newsletter, and numerous leaflets covering all aspects of the migraine, which are distributed to clinics, hospitals, doctors' offices, and the media both in the United Kingdom and overseas. Members of the association, both migraine sufferers and physicians or other professionals, participate in research and product trials and also collect and donate considerable sums of money to support migraine clinics and fund research. These days the association is committed to raising general awareness about migraines and is recognized as a valuable source of information by the media.

These two chains of events were linked in 1979 when Derek Robinson and a marketing colleague from WB Pharmaceuticals, a sister company of Boehringer Ingelheim Limited UK, were invited to meet Peter Wilson at his home in Woolacombe. Over coffee, the visitors were asked if they could suggest how the goals of the British Migraine Association could be brought to a much wider section of the public. In the past the association had organized both essays and poetry competitions, but the resulting publicity had been negligible and had not attracted many new members. Asked by his colleague to give some thought to this problem, Robinson recalled the intriguing pictures that he had used some years before in preparing an audiovisual program. Acting on the assumption that if one patient could paint a migraine, it should be possible for other sufferers to produce similar pieces, the idea was born to encourage migraine patients, on a large scale made possible by a public competition, to represent their migraine experiences with drawings, paintings, or other illustrations—the Migraine Art concept. The idea was readily embraced by Wilson, and it was agreed that the British Migraine Association would design a competition entry form that could be circulated to members with the association's quarterly newsletter. At the same time a press release would be prepared in the hope of attracting entries from migraine sufferers who were not yet members of the association. The suggestion that WB Pharmaceuticals and the British Migraine Association should become cosponsors of the competition was readily accepted by

both parties: The British Migraine Association saw the opportunity to get the benefit of considerable marketing experience as well as a fifty percent contribution to the prize money, and WB Pharmaceuticals saw the competition as a potential source of visually striking material that could be invaluable in promoting of their migraine drug Dixarit (clonidine hydrochloride).

In the August 1980 issue of the *Migraine Newsletter*, Peter Wilson, the founder and then honorary secretary of the British Migraine Association, made a call for contributions to what became the first of a total of four Migraine Art competitions. This text, which provides a summary of the original intentions of the competition organizers, is reproduced here in full:

> *National Migraine Art Competition*
>
> *With so many millions of people afflicted by the phenomena of the six forms of visual disturbance which precede the classical migraine attack from the shimmering stars of teichopsia; the half vision of hemianopia; the bright-edged castellated lines of fortification spectrum; of scintillating scotoma and tunnel vision to forms not even yet recorded by medical illustration, we hope we can attract the artistic skills mixed evenly with the natural, even primitive depiction of just what young and old experience visually and mentally from this Earth-borne inheritance which has visited man since earliest recorded history. If this competition alerts just a few hundred more people into a more realistic understanding of what migraine really means in terms of astronomical human suffering, then it will have been worthwhile. Unreasonable to expect a massive impact on the media while rape, thuggery, vandalism and the more sensational attractions of human interest rule the headlines, but the odd byline report will always be appreciated—and it is our duty to make the effort.*[652]

Attached to the August 1980 issue and subsequent issues of the *Migraine Newsletter* was an entry form prepared by the British Migraine Association that specified the conditions of entering the contest (reproduced in appendix A). The competition was open only to migraine sufferers, implied by the fact that participants were asked to illustrate their *own* migraine

experiences on any material and in any medium, including crayon, charcoal, oils, and watercolors:

Competitors are asked to draw or paint their own *impressions of any of the six forms of visual disturbance which herald a classical migraine attack OR to depict the effect migraine has on their lives. The six forms of visual disturbance are described in the August 1980 issue of the* Migraine Newsletter.

In the first condition of entry, the organizers' major goal of publicity was reinforced by reference to "the more dramatic aspects of migraine," which was likely to impose a bias on respondents to represent in their pictures the more uncommon and spectacular manifestations of the disorder:

1. The competition is open to all residents of the British Isles, and it is intended that publicity in connection with the competition will draw attention to the more dramatic aspects of migraine that separate the condition from the more common forms of headache.

Following the first call for entries and a subsequent press release prepared by the British Migraine Association, the initial returns were modest—there were just thirty pictures. It also soon became apparent that the entries received were not confined to the six specified visual disturbances or to the effect migraines have on sufferers' lives, as requested in the entry conditions. The pictures also illustrated the pain and other more common symptoms of migraines. It was therefore felt strongly that headaches should be included, rather than limiting pictures to visual disturbances and social implications. This was realized in a further press release prepared by the marketing man and tailored to reach a much larger audience through local and national newspapers, magazines, and local radio and television stations. It was obviously a good decision because following this press release far more entries were submitted: Over a period of nine months more than three hundred pictures were received. Judging of the competition took place at the City of London Migraine Clinic in July 1981. Competition entries were divided into three categories: a children's section for five- to ten-year-olds, a children's section for eleven- to sixteen-year-olds, and an

adults' section. First, second, and third cash prizes and consolation prizes of premium bonds were awarded in each group. The panel of judges consisted of Dr. J. Nathan Blau, the honorary director of the City of London Migraine Clinic; John Liddell, representing the British Migraine Association; Richard Calvocoressi, curator of the Modern Art Collection of the Tate Gallery, who was also a migraine sufferer; and Derek Robinson, representing WB Pharmaceuticals. Prizes valued at £800 were presented to the winners by Dame Vera Lynn, who delighted everyone by agreeing to be photographed with each of the winning entrants.

The first Migraine Art competition in 1980 was followed by three more competitions in 1982, 1984, and 1987, the results of which are summarized in table 2.1 in appendix B. As a consequence of the experience of the first competition, a number of modifications were introduced in the subsequent events. In the first condition of entry, cited above, the restriction to residents of the British Isles was removed, since international interest came with unexpected entries from Germany, Spain, Switzerland, Sweden, South Africa, Hong Kong, and New Zealand. References to "publicity" and "the more dramatic aspects of migraine" were also deleted, as seen in the entry form for the second Migraine Art competition (see fig. 47), reproduced in appendix A. The entry forms for the third and fourth competitions did not differ from the second entry form, so these have not been included. Adding "pain" to the suggested topics, which had been introduced during the follow-up press release for the first competition, was now reflected in the wording of the competition entry form:

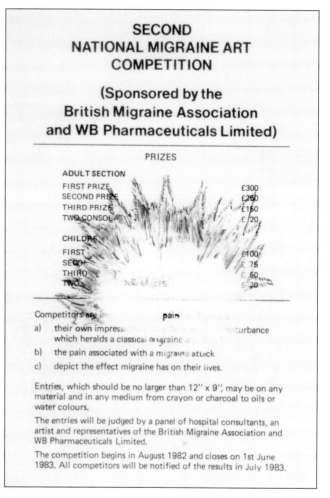

▲ **Figure 47**

Migraine Art collection.

Competitors are asked to draw, paint, or illustrate

 a) their own impressions of any form of visual disturbance which heralds a classical migraine attack

 b) the pain associated with a migraine attack

 c) the effect migraine has on their lives

Because of the relatively poor response from five- to ten-year-olds in the children's section of the first Migraine Art competition, it was decided to exclude this group from future competitions. Thus for the second, third, and fourth competitions there were only two categories, one for children between the ages of eleven and sixteen and one for adults. Other changes were a slight increase in the total prize money available and a more permanent panel of competition judges, including Dr. Marcia Wilkinson, honorary director of the City of London Migraine Clinic; John Liddell, representing the British Migraine Association; and Derek Robinson, representing WB Pharmaceuticals. They were joined in judging successive competitions by representatives of the art world: Sheila Payne, Ashley Luft, and Matthew Gale. It is worth noting that an attempt was made to recruit a well-known actress who suffered from migraines for the panel of judges. This effort was not successful, however: Her explanation was that if producers knew she was a migraine sufferer, opportunities for work would be considerably reduced because of the fear that she might need days off due to her condition.

As seen in table 2.1 in appendix B, the number of entries for the third and fourth competitions was decidedly lower than for the earlier events. This decline in interest was attributed to the reluctance of the media to publicize yet another Migraine Art competition, and a feeling by association members that "if they hadn't won a prize by now, they never would." It seemed as if Migraine Art had run its course, so it was mutually agreed by the cosponsors that the fourth competition was the last.

In his August 1980 call for entries to the first Migraine Art competition, Peter Wilson had foreseen that scientific advances were likely to result from the endeavor, anticipating that some entries would show forms of visual disturbances "not even yet recorded by medical illustration." Even

so, the four competitions were not accompanied by formal scientific data acquisition and analysis because achieving publicity was the declared major goal of the organizers at that time. Except for the personal information needed to place respondents in the appropriate section of the competition, no other personal or clinical data was collected, and the artists were not asked to explain the sometimes enigmatic contents or details of their pictures. In a few cases, even the basic personal data is not available because the entry forms were lost when the pictures were mounted at the competitions or during subsequent exhibitions. About one third of the approximately nine hundred competitors requested the return of their works once the judging of the competitions had taken place, which meant an irreparable loss; reproductions were made of only twenty-six of the three hundred or so items that were returned. Fortunately, about two thirds of the nine hundred patient-artists were prepared to leave their entries in the hands of the sponsors to contribute to a library of pictures that now consists of 562 pieces—the Migraine Art collection. Nevertheless, even taking into account its limitations, the various uses and assessments of this unique collection have produced magnificent results.

Numerous exhibitions have provided opportunities for the general public and medical professionals to view many original pieces of Migraine Art, allowing them to experience the visual and emotional impact of what sufferers see and feel during an attack. Through this art, physicians can better understand the patient's condition, and the public can better appreciate the migraine experience. Following the first Migraine Art competition, a selection of drawings and paintings was shown to doctors and migraine sufferers in the United Kingdom through three touring exhibitions that visited many of the country's postgraduate medical centers at their request. In September 1982 a selection of the best entries to the first Migraine Art competition was exhibited during the Migraine Trust's fourth international symposium in London, which attracted more than 250 migraine specialists from nearly thirty countries.[546] Exhibitions have also been held in the United States and Europe. In 1987 the Headache Research Foundation at Boston's Faulkner Hospital presented an exhibition titled "The Art of Migraine,"[600] and in 1991 ninety Migraine Art pictures were

shown in an exhibition titled "Mosaic Vision" at the Exploratorium, a unique hands-on museum in San Francisco.[606] Among the visitors to the exhibition was Oliver Sacks, who subsequently visited Derek Robinson's Bracknell, U.K., office to view the complete Migraine Art collection. Stimulating thoughts and insights from Oliver Sacks's sophisticated thoughts on Migraine Art can be found in the revised and expanded edition of his monograph on migraines.[556] In 1997 the first exhibition of Migraine Art in Germany was held at the Department of Neuropediatry of the Evangelical Hospital in Oberhausen with the title "Art Inside the Head." In 2004 a Migraine Art exhibition was organized in Norway at the Pain Unit of the Hospital Telemark in Skien.[67]

Reproductions of Migraine Art have been used and distributed in different ways. In 1984 WB Pharmaceuticals produced two slide folders, "The Art of Migraine" parts 1 and 2, each containing nine slides of Migraine Art pictures selected by Dr. Marcia Wilkinson and accompanied by her comments.[647] These folders were welcomed by U.K. neurologists as material to be used in postgraduate medical education. A number of Migraine Art pictures were also used in a series of mailings by WB Pharmaceuticals to promote the drug Dixarit (clonidine hydrochloride). A film titled *The Art of Migraine* won a Silver Award at the 1984 British Medical Association film competition. Migraine Art pictures have been selected to illustrate numerous articles in the popular press and the medical press, sometimes achieving a high standard of popular health education.[241,276,309,674] A scientific report on the results of the first Migraine Art competition, based on an analysis of 207 pictures, was published in 1985 by Wilkinson and Robinson in the journal *Cephalalgia*.[650] Migraine Art pictures were also presented in the contributions of Dr. Marcia Wilkinson to the *Handbook of Clinical Neurology*[649] and in the *Medical and Health Annual*[648] published by Encyclopedia Britannica in 1986. Selected pieces of Migraine Art were reproduced not only in medical papers and books[38,113,199,294,383,392,396,556,558] but also in a thesis on the art of the migraine from the point of view of an art therapist[86] and in textbooks on decorative art[156] and cultural anthropology,[246] reflecting the broad interest taken in this unique source of information. In September 1998 a selection of Migraine Art pictures was presented by one of the

authors[475] at the Peter Wilson Memorial Lecture,[498] held as part of the fortieth anniversary celebrations of the Migraine Action Association during the Migraine Trust's Twelfth International Symposium in London.

The Migraine Art Collection

In 1895 Gowers donated a number of illustrations from a distinguished watercolor artist and from one of his patients to the library of the Ophthalmological Society of the United Kingdom in London. Each piece of art represented the subjective visual sensations of migraines. According to Gowers, "These constitute a collection of facts unique in their character, and it may be reasonably hoped that this collection may attract other representations, which will constitute a source of information the importance of which cannot but increase with increasing knowledge."[217] The same can be said of the Migraine Art collection, which has emerged as the result of four Migraine Art competitions and which forms the biggest collection of such useful and revealing information ever assembled.

The Migraine Art collection currently consists of 562 pictures, 536 of them being original pieces submitted to the four competitions and twenty-six available only as photographic reproductions. As Peter Wilson anticipated in his original call for entries to the first Migraine Art competition in 1980, the collection comprises pictorial representations displaying a high degree of "artistic skills mixed evenly with the natural, even primitive depiction"[652] of the migraine sufferer's experiences, using a variety of media, including pencil on paper and oil on canvas and board. The Migraine Art collection was originally managed by Derek Robinson as its curator and is currently available for scientific purposes, for exhibitions, and to illustrate publications. The joint sponsors of the Migraine Art competitions hold the copyright on all pieces of art in the collection. Permission to use pieces of Migraine Art is granted providing that a fee is paid to the Migraine Action Association and appropriate credit is given to the Migraine Action Association and Boehringer Ingelheim Limited UK. Newspapers, journals, authors, and other parties interested in using Migraine Art to illustrate an article, book, or film are invited to contact the curator of the

Number of children

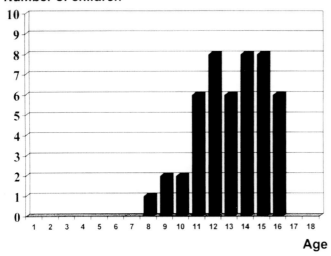

▲ **Figure 48**

Age distribution of children up to sixteen years who have contributed one or more entries to the Migraine Art collection.

collection in order to discuss the possible use of pieces from the collection.

The 562 pieces of Migraine Art were produced by 459 artists, sixty-seven of them having submitted more than one picture to the four Migraine Art competitions (see table 2.2 in appendix B). There were at least eight professional artists, three of whom became competition prizewinners, but the majority of patient-artists appeared to have had little or no formal art education beyond what they received in school. Of the 459 artists, 356 (seventy-eight percent) were women and 103 (twenty-two percent) were men, a gender ratio of 3.5 to 1 that indicates a clear-cut preponderance of females over males, as is characteristic for migraines. There were forty children aged sixteen and under (nine percent) and 419 adults over age sixteen (ninety-one percent). Twenty-three participants whose entry forms were lost during the competitions or during subsequent exhibitions were included with the female adults in these numbers. The age distribution of the children, ranging from eight to sixteen, is illustrated in figure 48. Although competitors in the adult category were requested only to confirm that their age was over sixteen, eleven adults specified their ages, which ranged from seventeen to seventy-three. There were four family groups of competitors: a mother and her three daughters, aged nine, twelve, and fourteen; another mother and her fourteen-year-old daughter; a mother and her twelve-year-old daughter; and a sister and brother aged fourteen and fifteen respectively.

During the preparation of this book, attempts were made to contact all the patient-artists by means of a letter and a photograph of their competition entry, advising the participants of the aims of the study and asking them to provide a description of the migraine experiences shown in their pictures submitted to the competitions ten to seventeen years earlier. Results of this postal follow-up are summarized in table 2.3 in appendix B.

Of the 459 artists, 136 (thirty percent) responded to the inquiry, some of them expressing surprise (nine artists) or amazement (two artists) to hear from the competition organizer again, but all of them confirming their interest and full agreement to cooperate in the study. Seven artists emphasized the emotional impact of confronting a picture drawn or painted at a much earlier time in their lives. Sixteen artists referred to difficulties remembering details of the migraine experiences depicted, and five artists had completely forgotten that they had produced the picture. However, for the majority of the respondents, vivid memories of their migraine experiences were reflected in their detailed reports, as seen in the quotations below describing individual Migraine Art pictures.

A Semeiological Approach to Migraine Art

There are various ways to analyze and understand works of art, as demonstrated by the numerous methods used in the science of art. In Migraine Art, the subject matter of the work is, by definition, the artist's personal migraine experience, represented by a picture rather than the more common medium of text. It therefore seems appropriate to use an analytical approach that allows interpretation of the artworks in terms of the migraine experiences depicted. This can be achieved by medical semeiology, which is the branch of medical science that deals with the signs and symptoms of diseases (see fig. 49). In this context, "symptoms" refer to the patient's subjective experiences presented in a verbal report or a picture, and "signs" are determined by the doctor making an objective assessment of the dysfunctions. For some symptoms, corresponding signs can be found during a physical examination, but for other symptoms no such objective signs exist. An analysis of the patient's subjective experiences is the only way these manifestations of disease can be studied. This is particularly relevant with migraines, which may manifest in a variety of purely subjective experiences. Heinrich Klüver writes, "A historian will be aware of the fact that, aside from psychology chiefly interested in obtaining information that can be used for influencing and controlling behavior, there has always

▼ Figure 49

Semeiological approach
to Migraine Art.

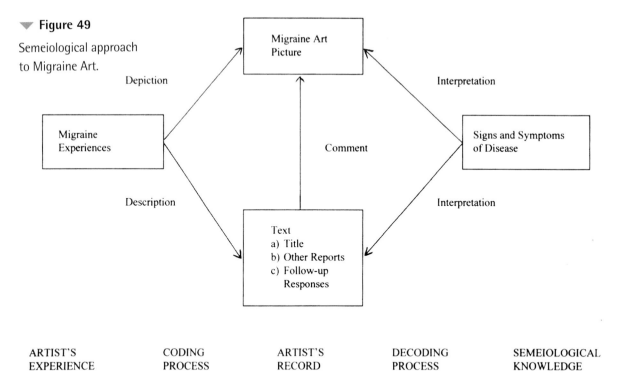

| ARTIST'S | CODING | ARTIST'S | DECODING | SEMEIOLOGICAL |
| EXPERIENCE | PROCESS | RECORD | PROCESS | KNOWLEDGE |

been a psychology that is singularly free of such ambitions and content with determining the structure of the subjective world without reference to problems of great medical, social, or political significance."[324] In this tradition, the investigations presented in the following chapters are attempts at describing and specifying the migraine sufferer's subjective world during a variety of migraine experiences, which provides a view of the migraine experience from within.

In addition to using medical science's semeiological technique to interpret the Migraine Art pictures, texts from the artists were available as an additional source of information for 272 pictures, representing forty-eight percent of the total collection. A title was provided either on the picture itself (sixty-four pictures) or on its back (six pictures). Other comments accompanied competition entries either incorporated into the artwork (forty-eight pictures) or on the back (thirty-one pictures). Retrospective information was provided for 178 pictures by the artists in response to the follow-up inquiry.

Chapter 3

Childhood Migraine Experiences

The onset of migraines can occur during infancy, the earliest recorded case being that of a one-year-old boy,[622] but in the majority of patients symptoms start between age six and ten.[54] A family history of migraines is common in these patients, reflecting the inherited nature of the disorder (see fig. 50). According to Alvarez:

> *It is questionable whether a person can have migraines without the proper inheritance. In those cases in which one cannot learn of typical migraines in the family history, one can sometimes get the story of one relative with a typical temperament or one who had an occasional scotoma [spot on the visual field]. Thousands of persons have migraines so mild or atypical that they never know what it is that bothers them.*[11]

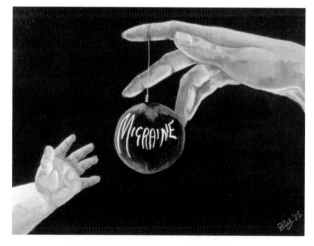

▲ **Figure 50**

Migraine Art collection.

In preschool children, symptoms may be dominated by vomiting and abdominal complaints, and they do not usually have headaches; if they do, it can only be inferred from behavioral changes such as head banging or holding the head. A typical migraine episode in infancy, as described by Fenichel, is "crying, irritability, photophobia [hypersensitivity to light], pallor [paleness], and vomiting followed by sleep."[164] Although studies suggest that migraines will strike about five percent of school-age children, it is not frequently diagnosed in that age group because the pain,

47

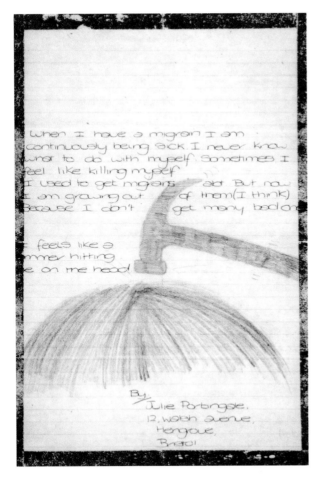

When I have a migrain I am continuously being sick. I never know what to do with myself. Sometimes I feel like killing myself.
I used to get migrains ... but But now I am growing out ... of them (I think) Because I don't ... get many bad ones

... feels like a ... mmer hitting ... e on me head

By Julie Portingale,
12, Woath avenue,
Hengrove,
Bristol

▲ **Figure 51**

Migraine Art collection.

visual disturbances, and other subjective experiences are difficult to elucidate in children, who are generally not sufficiently observant and aware of their symptoms.

The studies by Hachinski et al.,[240] Unruh et al.,[621] Lewis et al.,[369] and Stafstrom et al.[598,599] have demonstrated the value of paintings and drawings in obtaining a report on the visual aura and symptoms of acute migraine attacks experienced by childhood migraine sufferers. The Migraine Art collection includes forty-seven pictures by children, which provides an opportunity to study not only the visual symptoms and pain of migraines but also the effect migraines have on their lives, according to the three suggested topics in the competition rules. The forty-seven pictures were produced by forty children, twenty-seven of them girls and thirteen boys, with seven children having submitted two entries to successive competitions. The gender ratio of 2.1 to 1 shows that a preponderance of females also prevails in childhood migraines. The ages of the forty children ranged from eight to sixteen, with a mean of 12.8 years. As can be seen from the age distribution in figure 48, most of them were teenagers.

Signs and symptoms of an *acute migraine attack* feature in thirty of the children's artworks. As found in previous studies, it is difficult to differentiate between the varying intensities of pain in children's pictures.[346,369,621] Considering only the representations of pain that indicate the side the headache is on, it is one-sided in eleven pictures and on both sides in nine pictures. In fourteen pictures the headache experience is expressed by images of pain inflicted by the action of man-made instruments. For example, in a simple drawing by a thirteen-year-old girl (see fig. 51), the pain "feels like a hammer hitting me on the head." The girl adds, "When I have

a migraine I am continuously being sick. I never know what to do with myself. Sometimes I feel like killing myself."

Interestingly, except for the stylized portrait of a twelve-year-old boy's face with split halves of yellow and green (see fig. 52), none of the pictures include a reference to *nausea* or *vomiting* as a feature of acute migraine attacks, although these symptoms are said to be the most distressing in children's attacks[82] and are depicted in several drawings in the study by Lewis et al.[369] A possible explanation for this omission is self-censorship by the children participating in the Migraine Art competitions.

Photophobia and *phonophobia*, meaning hypersensitivity to light and noise, are represented by three children. Figure 53, by an eleven-year-old girl, is explained by the artist:

> *As far as I remember my eyes were sensitive to light, all curtains have to be closed, and I would lie with a cover over my head; this is why I had put sore eyes in the picture with lots of lights. The hammer and clashing gong were to represent the spasms of pain that I experienced. I would lie with my eyes closed because if I looked in a certain direction, and the light difference made my pupils adjust, that would trigger a pain in my head. The swirls in various colors I think are the feelings of the alternating tension and release that the muscles across my head experienced. I was also sensitive to*

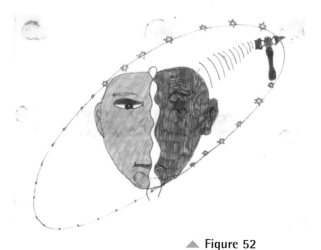

▲ **Figure 52**
Migraine Art collection.

▼ **Figure 53**
Migraine Art collection.

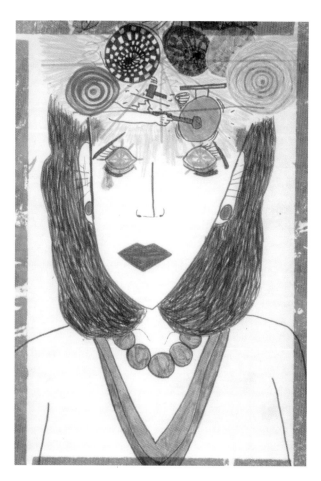

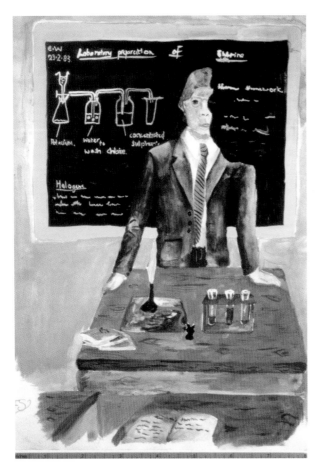

▲ Figure 54

Migraine Art collection.

sound levels, and so I put a shell to represent hollow amplification of noise. I was also trying to express the pulsation of the throbs that I felt, which was why I tried to draw spirals with an optical-illusion effect of movement and the two red patches on my temples. Finally, a tear was to depict the sadness at having another migraine.

As *minor physical signs* of the acute migraine attack, facial paleness is illustrated in one picture, bloodshot eyes in five pictures, and tears in six pictures.

The *visual aura* of a migraine attack is a major topic in thirty-four of the children's pictures, with almost all of them, thirty-three pictures, representing some kind of *loss of vision*. In one piece of Migraine Art a fourteen-year-old schoolgirl illustrates her perception of a negative spot on the visual field (scotoma) while looking at her teacher (see fig. 54). Hemianopia, a loss of vision in half of the visual field, is shown in six pictures. Figure 55, created by a thirteen-year-old girl, combines a mirror image of the artist's face with the left side obscured by loss of vision, and a full-size portrait of herself in the center of her eye. The artist, now twenty-seven years old, provides the following comments, reflecting on the picture she painted of herself as a child:

> I recall getting my first migraine when I was about eleven, no more than two years before I painted the picture. For the following few years I would have a migraine about once a month, each one lasting a day, starting with visual disturbance, moving from the left until it was almost central. After twenty minutes this would disappear and then the pain would start. Attacks later on also had the feeling of nausea, and my realization that vomiting helped relieve my general discomfort was a welcome discovery. The final

stage of my migraine would be excruciating pins and needles in my left arm, from my hand up to my elbow, in my mouth, and on the left side of my face. The sensation felt paralyzing although, of course, I never lost movement; there was just the desire to move the parts that were affected. The pins and needles would last again for about twenty minutes. In many ways this was the worst part of the attack. Maybe it seemed like the icing on the cake, as if the intense pain in my head were not enough, though on a positive note I knew this was the last phase, after which I would be left feeling generally drained and unwell with a bad headache for the rest of the day. I remember never taking the name of "migraine" in vain. When trying perhaps to get a day off school because I didn't feel well, I never once tried to con my mother that I was having an attack. You wouldn't dare treat them with disrespect, mainly as you felt you might be punished with the worst attack of your life; besides, it would have been impossible to fake the effects—no one could act that convincingly unless they were truly in pain. As the attacks were monthly to begin with, the easiest explanation was to connect them with hormones. However, as I grew older, the attacks became less frequent and intense, about two to three a year and lasting for about two hours. Fortunately, since the age of twenty, when I suffered from two mild attacks a couple of days apart, I had no migraines with the exception of a single attack that occurred just recently.

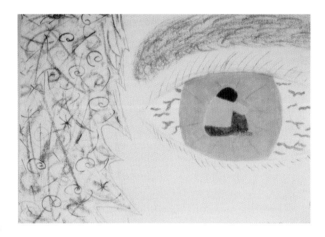

It is near impossible to say exactly what I was thinking at the age of thirteen when I painted this picture [see fig. 55], though I do recall when deciding on the image of a child at the center of the eye that it was "a good idea." However, looking at it now, perhaps my ideas as a child were not so simple, and maybe the images do have some deeper meaning. I believe I have created a fair static representation of what I would see. Also maybe there's the idea that the disturbance is hiding something, and in knowing that it cannot be pushed aside, there is that feeling that it is taking over your body from within, slowly engulfing you and making you very small, frightened, and powerless, which

▲ **Figure 55**
Migraine Art collection.

leads on further to the image of the child in the eye. The bloodshot veins in the eye are a blatant image of pain, but now when I look at the child I feel very sad for that person. I can remember feeling completely alone during the attack. I have the most wonderful loving family, but there was never anything anyone could do to make me feel better. You would feel very alone, but for me I would also want to be alone. You would have to ride out the experience on your own inside your head. Also the eye was a great focal point for my migraine picture as this is where the intensity of the pain was always focused, as I'm sure is the case for most sufferers.

Thankfully it is good that pain is something difficult to remember, though of course we can remember the feeling of distress and fear. However, seeing the picture again has made me remember emotions that I only associate with a migraine attack. To be reminded of all these feelings after all this time is quite a shock. As previously outlined, I no longer consider myself a sufferer of migraines, although the mild attack this year has questioned my outlook. I feel very lucky to stand no longer under the cloud that can control your life, never knowing when an attack may strike, but I will always sympathize with those who do while trying to ignore the fact that one day they may return.

▶ **Figure 56**

Migraine Art collection.

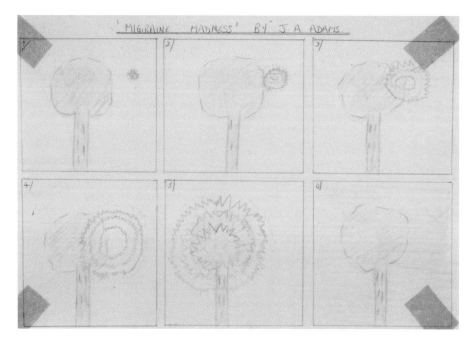

Visual hallucinations of various shapes are illustrated in thirty-two of the children's pictures (see table 3.1 in appendix B). The line shape is encountered most frequently, taking the form of the typical zigzags of fortification spectra in thirteen entries. Figure 56, by a sixteen-year-old boy and titled *Migraine Madness,* represents the development of a fortification spectrum in a series of six illustrations with first one, then multiple concentric circles formed by zigzags. The artist, now age thirty-one, writes:

Migraines began with a small flickering of light, always to the right. Gradually the flickering light grew and the concentric jagged rings became wider and more intense. I started feeling nauseated, but there was no headache at this time. Eventually, after approximately half an hour, my whole vision was clouded by the flickering jagged rings, as can be seen in picture 5 of my drawing, where the tree depicts disturbances on any objects. The headache then began. Even with my eyes shut I could still see the rings. After approximately one hour, the rings would go, but visibility was still limited due to a mist that occurred, as seen in picture 6. The headache of the bad migraine would take approximately two days to fully disappear. Nothing to add, except that, touch wood, I have not had a migraine with the flickering since my early teens.

A single picture (see fig. 57) by an eight-year-old girl depicts a variant of a rare *visual illusion,* described by Gloning et al. as concentrically arranged multiple images of the same object,[210] which is discussed more fully in "Polyopia" in chapter 7. This artist was the youngest competitor in the first Migraine Art competition and won a prize in the five- to ten-year-old category. Considering the extraordinary qualities of this representation of a child sufferer's visual experiences, it is regrettable that the category of very young competitors was dropped from the three subsequent competitions, based on the lack of entries (see "History of the Four Migraine Art Competitions" in chapter 2).

As an unexpected topic, two drawings, by a fifteen-year-old girl and a fourteen-year-old boy, illustrate *body image disturbances* with sensations of enlargement of parts of the body, affecting both the neck and the hands (see fig. 58) or one hand only (see fig. 59). Such disorders of the body image

▶ **Figure 57**

Migraine Art collection.

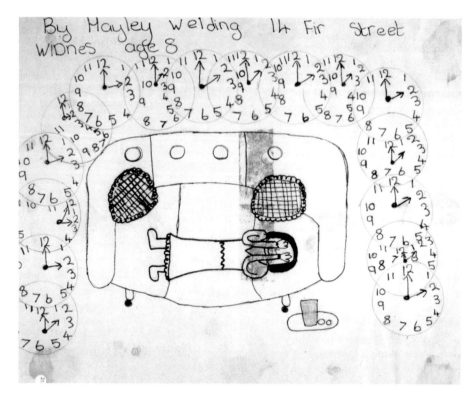

in which parts of the body are perceived as abnormally large (hyperschema-tia) are included in Todd's description of Alice in Wonderland syndrome,[615] discussed in "The Migraine Experiences of Lewis Carroll" in chapter 1. Similar cases in children with migraines have been recorded in medical literature.[54,213,240]

Nine pictures by child artists depict the *effects of the migraine attacks on the sufferers' lives.* In one picture an eleven-year-old boy shown in bed wishes that he were at school. In a similar drawing an eleven-year-old girl is seen lying in bed with a migraine headache, thinking of the many things she would rather be doing, such as playing, swimming, taking the dog for a walk, reading, or even attending school. Another eleven-year-old recalls her eighth birthday party, when her chair at the head of the table was empty. The reason for her absence is explained by a flap on the picture that, when lifted, shows her in bed with a headache. In another picture a broken mir-ror denotes the bad luck of a fifteen-year-old schoolgirl whose migraine attack means she cannot play her part in a fast-approaching theatrical per-formance. In another drawing the inhibiting and prohibiting effects of

migraines on the nine-year-old girl's daily life are shown by her imprisonment. The sufferers' heads are represented by skulls in four pictures, symbolizing the destructive and threatening effects migraines have had on the children's lives. This is reminiscent of the representations of children's fear of death found in a study by Lewis et al.[369]

Clinical follow-up studies show that childhood migraines can have a good prognosis, confirming a commonly held belief that children outgrow migraines.[54,99] Attacks may become less frequent with age or may disappear entirely in young adult life. However, Hockaday[266] questions whether it was ever safe to say that migraines were completely gone, since symptom-free intervals of four to ten years before a relapse have been recorded, and according to Alvarez migraines often fade out during the patient's twenties or thirties and then return in her fifties or sixties in a different and perhaps puzzling form.[10] Nevertheless, even in these cases, optimism is justified because the condition is painful and distressing but not life-threatening.

▲ **Figure 58**
Migraine Art collection.

▼ **Figure 59**
Migraine Art collection.

The Acute Migraine Attack

The main part of the acute migraine attack is the headache. Some of the features of the migraine headache, namely that it occurs on one side of the head and is accompanied by nausea and vomiting, have been described in the earliest records of migraines (see chapter 1). The word *migraine*, which is of French origin and has been widely used since the eighteenth century, is derived from the Greek word for "half headed," *hemikranios*, which the Romans translated into Latin as *hemicranium* and later into Low Latin as *hemigranea* and *migranea*. In the English literature the Latin derivative has been transformed into a variety of terms at different times, including the term *megrim*, used in Liveing's seminal monograph on the disease.[380] In addition to the features of acute migraine attacks already mentioned, more recent diagnostic criteria have included symptoms of hypersensitivity to light and sound (photophobia and phonophobia).

The following sections will present Migraine Art pictures illustrating typical and minor signs and symptoms of the acute migraine attack, its impact on daily life, the trigger factors precipitating the attack, and how the headache is treated.

Typical Signs and Symptoms

Typical characteristics of migraine headaches can be identified in the Migraine Art pictures according to the diagnostic criteria of the International Headache Society. These include headaches occurring on one side, pulsations, moderate or severe intensity, inhibited or prohibited daily activities, worsening with routine physical activity, nausea, and hyper-

▼ **Figures 60 and 61**
Migraine Art collection.

sensitivity to light and sound.[283] Although the illustrations of uncommon and rarely described migraine symptoms are more intriguing, part of the Migraine Art collection's value for education lies in the fact that it contains impressive visual representations of the typical signs and symptoms of the acute migraine attack.

The Sidedness of the Migraine Headache

In 173 Migraine Art pictures, pain is shown with various graphical means to be on one or both sides of the head, as summarized in table 4.1 in appendix B. A strictly *unilateral* or one-sided location as a typical characteristic of a migraine headache is shown in eighty-five Migraine Art pictures, while eighty-eight pictures use the same means to show a *bilateral* headache.

In seventy-nine Migraine Art pictures the sidedness of the headache can be seen in the pain reaction of holding one hand against the head (forty-four pictures) or using both hands (thirty-five pictures). The posture in figure 60 represents a one-sided headache, while figure 61 shows the severe pain of the crying sufferers on both sides.

Red is used to indicate where the pain is in eighteen Migraine Art pieces, representing one-sided headaches in eleven pictures and bilateral pain in seven pictures. One of these pictures (see fig. 53) was drawn by an eleven-year-old girl who used red, as in previous reports of children's pain drawings.[576,621] In figure 62, titled *Pain! Pain!! Pain!!!*, the intense red of the right side of the face denotes

a severe headache on that side, with the broken contours suggesting the feeling that the head is exploding on that side. The red painful area also extends to the neck and shoulders. According to the artist, "the neck pain was always the last ache to go."

Arrows are used to show where the pain is in seven Migraine Art pieces, one-sided in four pictures and both sides in three pictures. An example is seen in figure 63, where the artist depicted *The Five Ages of My Migraine*. Her migraines first appeared at the age of three, when the treatment for her headaches was the application of "vinegar rags." From school days to the age of fifty-nine, when she was widowed, her migraines were characterized by side-changing attacks accompanied by fortification spectra, with multiple arrows indicating the site of her one-sided headaches.

In eighty-four Migraine Art pictures the side with the pain is shown with the action of a variety of man-made objects, instruments, or weapons, which are shown inflicting pain on the sufferers' heads on one

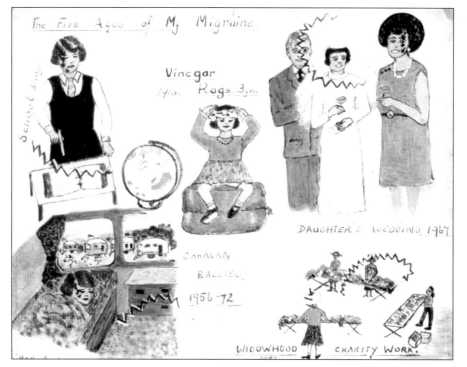

▲ **Figure 62**

Migraine Art collection.

◀ **Figure 63**

Migraine Art collection.

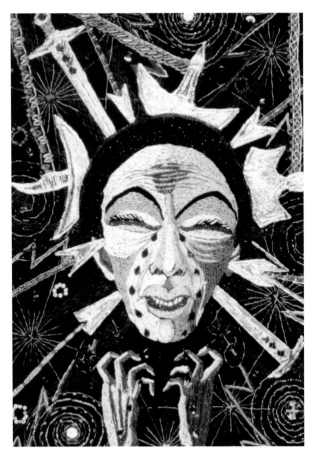

Figure 64

Migraine Art collection.

side (thirty-six pictures) or both sides (forty-eight pictures). The female artist shown in figure 64 comments on the metaphors used in her picture:

I was watching TV many years ago, possibly a program about the Romans fighting the tribes on Hadrian's Wall, and I saw these primitive weapons like axes, etc., being used. I immediately said to my husband, "They are the things that hit me on the head when I get a migraine." It was a huge joke, but not a joke at all because that's how it feels. I have never had any warning that a migraine is on its way. It is as if something in me is doing its best to hold it back until it can hold it no longer, and bang! All these weapons come down and hit me on the head, and the pain is tremendous.

Besides showing sidedness, the metaphors used in this large number of pictures suggest the presence of peculiar and unusual pain, which is considered in more detail in "Pain-Related Bodily Awareness" in chapter 6.

The major lesson from the Migraine Art depictions of the sidedness of pain is that although it most commonly occurs on one side, it may also be on both sides. This finding confirms the results of clinical studies of many migraine patients, and it must be emphasized for its practical diagnostic reasons: There is a common misunderstanding that a two-sided headache cannot be a migraine.[438,578] In recurring attacks, one-sided headaches may always affect the same side of the head, or either side may be involved and vary from episode to episode, as demonstrated in the Migraine Art picture titled *The Five Ages of My Migraine* (see fig. 63). In both one-sided and bilateral migraine headaches the parts of the head affected can vary considerably, so the location of the pain is not a decisive criterion for diagnosing migraines. For many sufferers the eye is the focal point of the pain,

but the face, forehead, top of the head, and back of the head may also be involved, and areas of pain projecting into the nose, ears, teeth, neck, and shoulders have also been recorded.

Other Common Migraine Characteristics

The *pulsating quality* of the migraine headache is shown in only two Migraine Art pictures, which probably reflects the difficulty of representing this effect in a still picture. In the first picture, figure 65, a pulse-synchronous hammering pain is represented by a mallet held in stylized hands emerging from a heart:

> *The picture shows feeling terribly sick and tormented by pain. The reason why I show the heart holding a mallet is because when I suffered from a migraine, with extremely painful headaches, every heartbeat was like a mallet smashing into the inside of my head. If I moved or tried to get up, this pain would increase. The pain was in rhythm with the beat of my heart, like an explosion of pain in each beat.*

The second picture (not shown) represents a migraine sufferer's body with mixed-up sections of a puzzle. The lower left section of the puzzle depicts a human heart with the *M* of *migraine* superimposed, representing the pounding of the migraine headache.

The *duration* of a migraine headache usually ranges from hours to days, but only rarely lasts longer than a week. In one picture, titled *The Silent Scream,* five vignettes depicting the sufferer's pain and visual disturbances illustrate a migraine attack of five days' duration, likened by the artist to "continuous performances Monday to Friday." In another picture, after seven days of "dizziness, fear, horror, sickness, weakness, and chaos," the artist dismisses the period as "the week that never was."

Migraine headaches may occur at any time of the day or night. The occurrence of migraine attacks during the night is not uncommon,[131] but other diseases such as cluster headaches, brain tumors, and glaucoma should be excluded by careful

▼ **Figure 65**

Migraine Art collection.

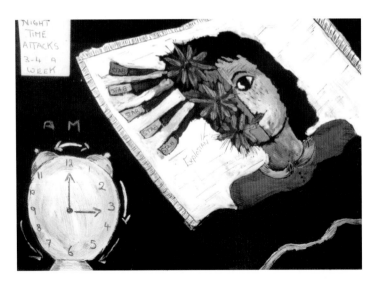

Figure 66

Migraine Art collection.

medical examination of these patients. Nocturnal headaches that wake the patient and prevent sleep are shown in four Migraine Art pieces. In figure 66 a woman who experiences three to four "nighttime attacks" a week lies in bed at three o'clock in the morning at the mercy of an intense one-sided headache. This experience is shared by another woman who notes in a lengthy text written around her picture that "3 a.m. is the usual time of attack." Another artist records staying awake at night, and another depicts herself forced by the pain to sit up "all through the night."

Migraines are characterized by recurring headache attacks, the *frequency* of which may show considerable variation. Fortunately, only a few patients would claim the frequency of attacks shown by a cinema employee in her picture titled *Nightmare on Elm Street Part 10,492.* It is important to note that the frequency of migraine attacks can successfully be reduced with various drugs that are available for preventive treatment of migraines, although misuse of acute migraine treatment can increase the frequency of attacks.

Nausea and Vomiting

Nausea or vomiting accompanying migraine attacks is depicted in forty-one Migraine Art pictures by means of verbal references to sickness (five pictures), nausea (three pictures), vomiting (two pictures), a yellowish or greenish complexion (seventeen pictures), a sick bowl or bucket (five pictures), by showing the patient vomiting (ten pictures), and other graphical representations (seven pictures). In figure 67 a kneeling female patient is seen vomiting into a toilet. "Being sick took some of the pressure from my head, and for a while I'd feel a little bit better, then my head would start pounding again and I'd vomit again."

The Migraine Art collection reflects the common occurrence of nausea or vomiting during an acute migraine attack. Because of the connection between the pain and nausea or vomiting, migraines have the popular names "sick headache"[187] and "bilious headache,"[216] the latter term "being derived partly from the fact that the bile is often vomited, partly from the old [system of attributing illness to bodily fluids] which regarded the bile as one of the chief [disease-causing] fluids of the body."[216] For some patients, these symptoms are the most distressing aspects of a migraine attack. Nausea usually starts some time after the onset of pain, but occasionally precedes the headache or may even be present without a headache. Vomiting most often occurs at the height of an attack, and in some patients is followed by relief or an end to the pain. A useful piece of advice for migraine sufferers whose attacks are accompanied by nausea or vomiting is that an antinausea drug be taken at the onset of an attack followed ten minutes later by a painkiller; this usually prevents the painkiller being vomited up.

▲ **Figure 67**

Migraine Art collection.

Hypersensitivity to Light

Photophobia or hypersensitivity to light accompanying the migraine attack is shown in different ways in a total of twenty-three Migraine Art pictures. In fourteen pictures hypersensitivity to light is represented by the patients' protective reactions to intense light, such as obscuring the sun with an outstretched hand or drawn curtains, placing hands in front of the eyes, and wearing sunglasses. In six pictures photophobia is shown with intense light together with various symbols indicating that it should be avoided, such as lines, crosses, and prohibition signs. Four pictures show intense light applied to the sufferers' eyes by imaginary external entities, such as a torch floating nearby, a floodlight inside the patient's eye, a tiny wet-suited man (see fig. 68), and a grinning devil-like matchstick man with a flashlight (see fig. 69).

The Migraine Art pictures show that sufferers frequently become hypersensitive to light. According to Lebensohn, this photophobia can take two forms: (1) a sense of glare or dazzle, or (2) an increase in pain in the presence

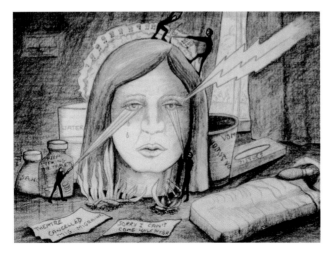

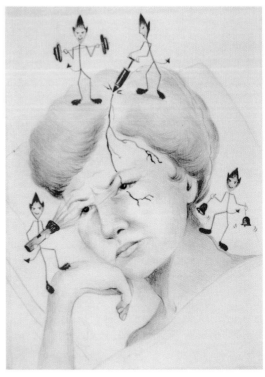

▲ Figures 68 and 69

Migraine Art collection.

of bright light.[360] Both forms of photophobia may motivate sufferers to avoid light, with retiring into dark places and wearing sunglasses the most frequent responses, as illustrated in pieces of Migraine Art. During attacks with a one-sided headache, hypersensitivity to light is usually greater on the side affected.[143] Photophobia can even persist during headache-free times, suggesting a "subclinical migraine" or a predisposition to migraines.[143,393] The mechanism that causes hypersensitivity to light during a migraine has been theorized as a loss of inhibitory processes in the subcortical part of the brain, which normally suppresses sensations of glare and light-induced pain.[144,145] This idea is consistent with medical findings in patients with brain lesions that suggest losing inhibitory processes in the brain's thalamus region can cause an exaggerated sense of glare.[118]

Hypersensitivity to Sound

Phonophobia or hypersensitivity to sound is shown in fourteen Migraine Art pictures through techniques similar to those seen in the previous section. In figure 70 hands are raised in protest at the various sounds depicted, including hammering, the revving of a motorcycle engine, the ticking of a

clock, the noise from a TV, the rumble of a train, children chatting, and a dog barking. In one picture, phonophobia is shown by the patient holding his hands against his ears to protect him from the noise of a radio. In three pictures hypersensitivity to sound is shown with lines around the ears, with one artist commenting that he feels "sound to be highly amplified, as if the ear has become more acute and can hear slight sounds." In two pictures phonophobia is represented by musical notes canceled with a cross and a prohibition sign indicating that music should be avoided. In four pictures hypersensitivity to sound is suggested by the sufferer's exposure to unpleasant sounds produced by imaginary external entities such as a drum immediately behind the patient's head beaten by free-floating drumsticks (see fig. 18), a drum, three bells, and a human shout (see fig. 71), a tiny human shouting, a miniature trumpet blowing into the sufferer's ears so that she "cannot bear any sound" because "any noise is deafening and accentuates the throbbing through my whole head" (see fig. 72), and a matchstick man ringing bells (see fig. 69).

The association of migraines with hypersensitivity to sound has long been recognized. This symptom can sometimes match the distress caused by the headache, and it has commonly been attributed to increased excitability[554] or hyperactivity of the special senses.[349] Migraine sufferers most often report an aversion to loud noise, as illustrated by the fact that

▼ **Figures 70 and 71**

Migraine Art collection.

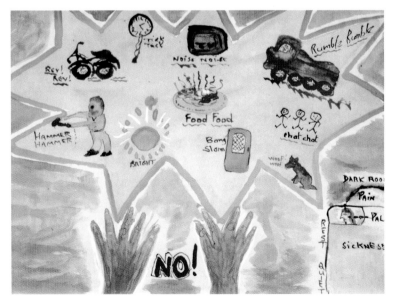
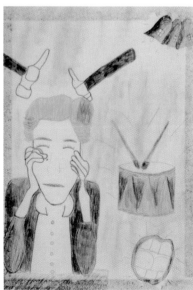

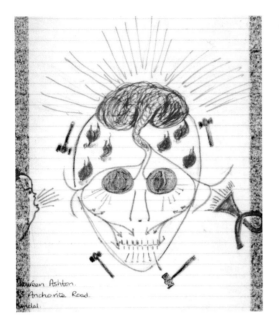

▲ **Figure 72**

Migraine Art collection.

five of the fourteen Migraine Art pictures featuring phonophobia depict sounds of extreme intensity, produced by a trumpet (see fig. 72), ringing bells (see figs. 69 and 71), drums (see figs. 18 and 71), and a motorcycle engine (see fig. 70). However, some patients describe their intolerance to noise as an increased sensitivity to quiet sounds, like the ticking of a clock (see fig. 70). Woodhouse and Drummond suggest that both aversion to loud noise and increased sensitivity to quiet sounds could be caused by the disruption of sensory processing mechanisms in the brain.[662] In rare cases, migraine sufferers may experience hypersensitivity to sound and at the same time have some hearing loss during their migraine attack, as recorded by Kayan and Hood in five cases from a group of two hundred migraine sufferers.[304] This seemingly paradoxical observation could be explained by a transient disturbance of the receptors in the inner ear.[304] The phenomenon can also be recognized in one of Alice's adventures in Lewis Carroll's *Through the Looking Glass,* where the noise from a multitude of drums "rang through and through her head till she felt quite deafened"[89] (see fig. 17 in chapter 1).

Minor Physical Signs and Symptoms

In addition to the typical features of the migraine attack described above, some patients may have minor physical signs and symptoms that are encountered less often. Some of these minor features are illustrated in the following sixty-one pieces of Migraine Art.

Facial pallor or paleness, which may be prominent during the migraine attack, has been described as "white migraine" or in medical terms "angiospastic migraine."[146] This sign is clearly visible in figure 73, in which the female sufferer, her eyes closed, is imprisoned behind bars, her facial paleness contrasting with the rosy-colored skin of her neck and trunk. The artist suggests an asymmetry of brain activity corresponding to her one-

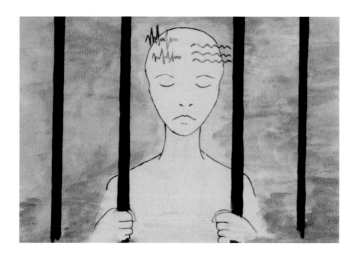

sided pain by drawing a stylized brain-wave readout on her forehead.

Facial flushing accompanying an attack has been described as "red migraine" or in medical terms "angioparalytic migraine."[161] In figure 74 this sign is depicted in the two representations of the sufferer's face during an attack: The right side shows the beginning, and the left shows a more advanced stage.

Figure 75, titled *The Mask of Migraine—Reverse Perspective*, illustrates the complete sequence of symptoms during a migraine with an aura. As two minor physical signs of the attack, the artist has shown a "red pulsating and bloated artery" on the side of his face together with "dilated pupils" in both eyes, which is called *bilateral mydriasis*. In addition to his artistic ability, this migraine sufferer demonstrates his sense of humor in his comment that his picture could have "other uses, for it gives my lovely wife an instant headache just looking at it. It should come in handy when necessary."

An enlarged pupil on only one side, called *unilateral mydriasis,* is a major feature of figure 76. The nature of this abnormality is emphasized by the bright lightbulb near the patient's eye, which fails to elicit the usual

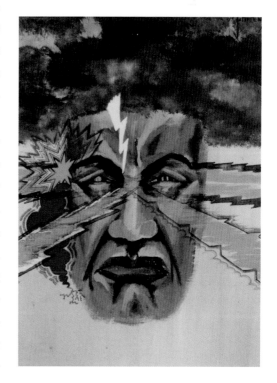

▲ Figures 73, 74, and 75

Migraine Art collection.

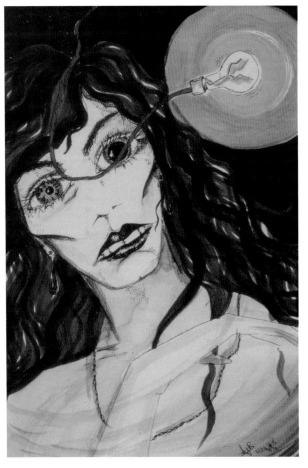

▲ **Figures 76 and 77**
Migraine Art collection.

response of the pupil contracting, which further increases the patient's sensitivity to light. A one-sided dilated pupil is a rare feature of migraine attacks, and it is considered a variant of the ophthalmoplegic migraine, in which the eye muscles are paralyzed.[155]

Bloodshot eyes, or in medical terms "conjunctival injection," is described as a minor eye sign by Kunkle and Anderson.[344] It can be seen in nineteen Migraine Art pictures, in both eyes in two pictures and in just one eye in the remainder. Four pictures represent the migraine victims' eyes as bloodshot together with the sufferers' portraits, the image of a skull held in one hand, and the word *help* written inside the pupil.

Tears are shown in thirty-six Migraine Art pictures. Figure 77 is a highly stylized representation of the head of a female migraine sufferer with tears falling to form a large pool.

As a *nasal sign*, one Migraine Art picture includes a verbal reference to a "sneezing catarrh." According to Raskin and Appenzeller, nasal stuffiness can occasionally happen during the course of a migraine attack, with heavy flow from the nose occurring only in some cases.[527]

Critchley cites a 1726 report by Wepfer, who observed "that in an attack the scalp hair may stand up to an end, a physical sign which finds no place in contemporary textbooks."[110] This sign, however, is illustrated in two Migraine Art pictures, both of which clearly show *hair standing on end* on the side affected by the pain.

Premature graying of hair, noted as a sign of migraines by Mendel,[403] is encountered in figure 78. The artist writes, "The effect migraines have on my life is shown by the hair parting, when at the age of thirty-five my hair went white," which "contributed to an early aging look."

Abdominal symptoms are depicted in two Migraine Art pictures, discussed more fully in chapter 5. In one of these, a "jagged line" drawn over the migraine sufferer's body indicates, according to the artist, her "abdominal discomfort plus the urge toward diarrhea" (see fig. 107). In a sequence of nine images the other picture illustrates a migraine attack during which the sufferer hurriedly visited the toilet, possibly for the same reasons (see fig. 124).

The Impact of Acute Migraine Attacks on Daily Life

One aspect of the migraine experience that is very rarely covered in the scientific literature is the effect that the headaches have on work, family, and leisure activities. As Wallace poignantly stated, migraines are an "unsocial malady ... because it often cruelly debars the sufferer from moving in society and enjoying family and friendly intercourse."[631] A pertinent description of these social consequences can be found in the report of the novelist Pamela Hansford Johnson, Lady Snow, during a migraine symposium, when she suggested:

> *Again, sufferers will try to* conceal *and* deny *an attack because of its effect upon others. When one has been suffering from migraine for a long time, and has observed the effect upon husband and children and friends, one knows that one is going to be a nuisance to them, however sympathetic they may be. A maddening thing is that whenever you have something important to do, or whenever there is something to which you are particularly looking forward, migraine may most likely rob you of the capacity to carry out your task or to get pleasure out of the treat.*[593]

Only recently have researchers begun to systematically study the social impact of migraines.[342,592] As a tribute to the importance of this previously neglected area, Migraine Art competition entrants were encouraged to illustrate, as one of the suggested subject matters, "the effect migraine has on their lives" (see "History of the Four Migraine Art Competitions" in

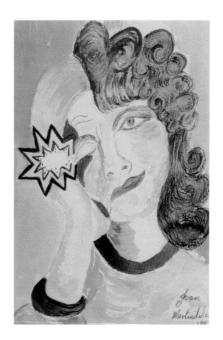

▲ **Figure 78**

Migraine Art collection.

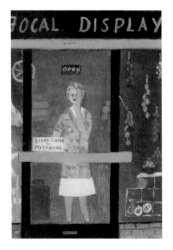

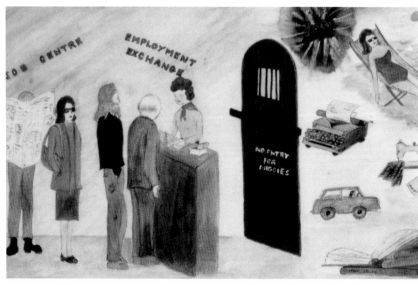

▲ **Figures 79 and 80**
Migraine Art collection.

▼ **Figure 81**
Migraine Art collection.

chapter 2). A number of the pictures submitted create a vivid impression of the impact that migraines have had on the men, women, and children involved.

Ten Migraine Art pictures illustrate severe headaches that interfere with work. Figure 79 shows "the effect of a migraine on a single-handed shop-keeper" who has been obliged to close her business. Figure 80 emphasizes the difficulties that migraine sufferers may experience with job hunting. The artist writes, "This is me, in the dark glasses, trying to find a job to

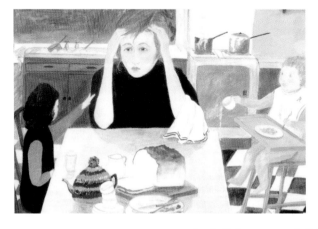

suit my migraine condition. The prison door is symbolizing how trapped I am, unable to do many things, particularly when my eyes are concerned, for example typing, driving, sewing, reading, etc. Now I'm older with a quieter lifestyle, and knowing my limitations I am much more able to cope." In figure 81, by the same artist, the pale homemaker sits with her hands on her forehead while pots on the stove boil over. The sink is full of unwashed dishes, one child is spilling his drink, and another is trying to get her attention. She writes, "This is me, as a young mother, with a migraine. The household chores are not getting done, and the children are

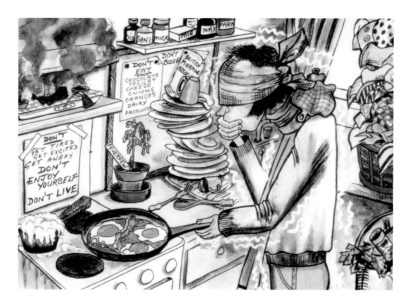

◀ Figure 82

Migraine Art collection.

▼ Figure 83

Migraine Art collection.

not being seen to. It seems a bit outdated now. She would be expected to manage a career, job, or study as well as the children and housework, plus the migraine, nowadays." It has been said that a homemaker's work is never done. This is certainly the experience of the migraine sufferer depicted in figure 82, resulting in her "sense of failure as a wife and mother as migraines deeply affected our activities together." Another homemaker describes her picture in figure 83: "I was seeking to portray the futility and despair of trying to cope while suffering a debilitating migraine attack.

Attempting to maintain a normal routine for the family with faulty vision, clumsiness, and pain that clouds all coherent and rational thought can only end in one result—chaos." As a postscript, she adds, "At least the cat was happy."

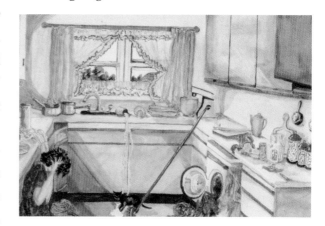

Seven pictures demonstrate the debilitating impact of headache attacks on family life and activities. Family gatherings that may be disturbed by a migraine include birthdays, weddings, and the celebration of Christmas. In figure 84, the enigmatic image of the migraine sufferer is surrounded by images of her husband and children who "were all affected each time I had a migraine."

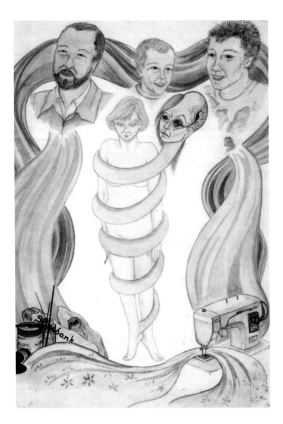 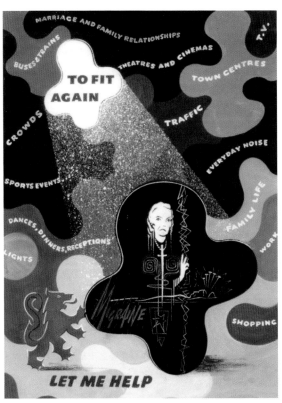

▲ **Figures 84 and 85**
Migraine Art collection.

Eleven pictures illustrate the impact of headache attacks on leisure activities. Figure 85 is seen as a jigsaw puzzle with pieces labeled "work," "marriage and family relationships," "shopping," "dances, dinners, receptions," "sports events," and "theatres and cinemas" to represent various aspects of the sufferer's life. Only one piece of the puzzle is missing, an enlarged image of which shows the artist suffering a migraine attack. She is in need of help "to fit again" into the pattern of normal life that has been disrupted by her attack. The female sufferer depicted in figure 86 has left early from a party. She writes, "I tried to show my misery compared with friends laughing, drinking, and eating nearby. I felt as if hammers were hitting my head, I was sick, and I could only lie quietly in a darkened room. I have my glass of water and pills nearby—also an ice bag to soothe my headache. My attacks often came on at, or after, social occasions, but they were also frequently there on waking—especially at weekends. The picture was painted in gray tones because that is how I felt: unable to join in, not wanting to talk, and really wretched."

The pictures reviewed so far have realistically depicted the consequences of a headache attack on sufferers' work, family, and leisure activities. In contrast, nineteen other pictures use metaphors to represent the impact migraines have on sufferers' lives. Figure 87 depicts a female sufferer in a glass box:

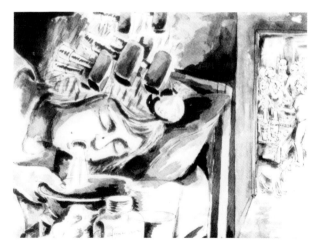

> to suggest the debilitating and all-powerfully negative effect of migraines on my life. It was a social comment more than trying to suggest the medical processes or physical attributes. The central figure, a portrait of me, was meant to suggest isolation, being cut off from normal society. The glass box I was caught in was a symbol of my reduced world, the restrictions confining me because of the migraine. The color went out of my life (not literally) and all I felt was that pain in the head.

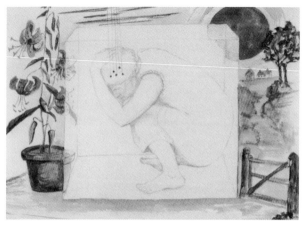

In six pictures the artists have used chains as a metaphor for the inhibiting and prohibiting effects of a migraine. This can be seen in figure 88, where the migraine sufferer is grasping with one hand at his throat, apparently seeking relief from the constricting chain around his neck. The artist writes:

▲ **Figures 86, 87, and 88**

Migraine Art collection.

> For me an oncoming migraine is a sickening, frightful journey, full of searing pain that one is forced to take. I resign myself to it when it comes, for nothing seems to cure it but time. All medication is vomited up—I think the nausea and very violent vomiting is the worst part of the whole sordid affair. My whole body swells up like a poisoned pup, the pain is indescribable, and I spend the whole time sitting on the loo with my head over a bucket on my lap. It's times like this that I am glad I live alone. Each time I believe I am going to die. The pain is mostly over my left eye, which goes blind for the duration. The lines going through the eye are the pathway of pain—the red is the blood draining away—I am usually as white as a sheet

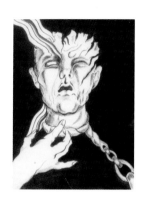

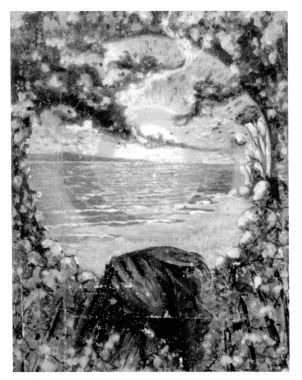

▲ **Figures 89 and 90**
Migraine Art collection.

at the time. The throttling chain is meant to signify being a prisoner to the migraine as all life goes on hold for the duration. The blackness represents despair or desperation and anger at having to suffer such indignity and pain. It is a very lonely and fearful time.

Similar metaphors are used in figure 89, where a female sufferer is surrounded by barbed wire attached to wooden stakes, and in figure 90, where the sufferer's head, face, and hands are seen tightly encircled by strands of barbed wire. Four pictures make use of a spiderweb to show the impact of migraines on the sufferers' lives. In figure 91 "the brightness and the loveliness of the day gradually diminishes as a web is spun over the light until the spider has turned everything into pain and darkness and you feel like death."

In addition to the four pictures by child artists that use human skulls to represent the destructive and threatening effects of migraines on their lives (see chapter 3), seven pictures by adult sufferers make use of the same symbol of death. Figure 92, by a female artist, "combines the physical and psychological aspects of a migraine":

The off-center, abstract background illustrates the shimmering distortion of vision that heralds an attack and shows the blind spot that grows into total blindness as the migraine develops. The lightning flash is the vibrating jagged line that seems partly within the skull as well as in the eyes. The protruding tongue indicates the accompanying nausea. The quiet face in the center represents the "eye of the storm" and the aloof serenity achieved once one stops fighting the symptoms. Stress, anxiety, and worry seem to trigger my attacks. The only effective relief I find comes when I refuse to respond to the causes and simply stop trying to beat it by willpower. I find that a tranquil mood is immune to a migraine. The skull also symbolizes death, which also calls for the same tranquil surrender that reduces the distress of a migraine.

Trigger Factors

A considerable body of literature exists on the significance of trigger factors that can precipitate a migraine attack. For obvious reasons, the subject is addressed in most books on migraines (see fig. 93), since the identification of personal triggers may offer the patient the opportunity

▲ **Figures 93 and 94**

Migraine Art collection.

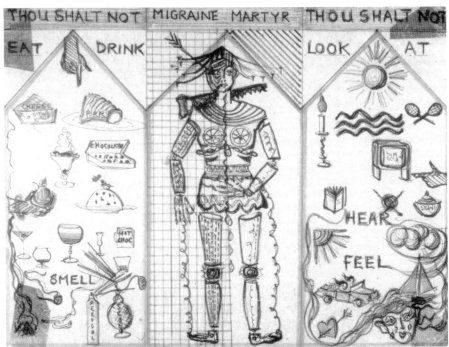

to take preventive measures. The migraine sufferer's experience of imbalance resulting from unusual sensitivity to external triggers is described in a personal account from West, who said, "Our lives are Möbius strips: The outside becomes the inside without much warning, and any slight tilt in the customary sensations . . . can herald a roller-coaster, wall-of-death vertigo of a full-blown attack."[639] The necessity of avoiding personal triggers is another part of the burden on sufferers. As Latham suggests, "Everything, in fact, must be avoided that the sufferers know from individual experience as exciting causes."[353] The female "migraine martyr" shown in figure 94 is depicted in the center panel of a triptych, the outer panels of which illustrate the numerous restrictions to be observed by the sufferer. A simple classification of potential triggers can be made by distinguishing between mental and internal triggers on one hand and environmental triggers on the other.[439]

Eight Migraine Art pictures represent a variety of mental and internal triggers that include stress, emotions, fatigue, sleep, and hormonal changes. As a constant reminder of the need to avoid such triggers, the homemaker depicted previously in figure 82 has taped a handwritten notice to her

stove, advising, "Don't: get tired, get excited, get angry. Don't enjoy your-self. Don't live." The artist adds, "I had no pleasure and seemed to be pun-ished if I veered from the narrow control I had to impose on myself."

Environmental triggers are represented in seventy-five Migraine Art pictures. This category comprises dietary triggers, visual and acoustic stimuli, fumes and odors, and adverse weather conditions. The various dietary triggers seen in thirty-three pictures are summarized in table 4.2 in appendix B. In some of these illustrations foods are presented as a major feature of the picture; in others they play an incidental role. Considering dietary triggers, a letter that accompanied an entry to one of the Migraine Art competitions is worth noting:

> I have suffered with migraines since my early teens, and I am now seventy. The only time that I have been free from them was during my three years as a prisoner of war with the Japanese. The stress there was often at the break-ing point, so I cannot think that this was a contributory factor. I therefore reached the opinion that it must be richer foods that caused them, as my own diet then was two small bowls of rice per day plus water.[650]

Visual stimuli as potential triggers of a migraine attack are shown in forty-nine Migraine Art pictures, as summarized in table 4.3 in appendix B. The female artist portrayed in figure 93 writes, "This is me with my dark glasses depicting what I see, for example lights or zigzags. The bright sun reflected off the sea at the beach, the colored disco lights, the pipe and cigarette smoke, and reading represent a few of the triggers of my migraine attacks." A number of pictures suggest that watching TV or going to the cin-ema are specific situations that may precipitate a migraine attack, proba-bly due to the flicker associated with these visual stimuli.[125] Disco lights are notorious in this respect, their effect most often being attributed to their flashing. However, the bright blue, yellow, and red of the disco lights illus-trated in figure 93, similar to the intense disco lights shown in two other pic-tures, suggest that color may be another relevant part of the triggers in these cases. One artist said that "certain colors are best avoided," for exam-ple orange, the yellow of bananas, and "the shade of lilac" found in a cer-tain type of nylon. She now avoids fruits like oranges and bananas "because

of the colors." Hollenhorst notes that "sometimes the light must be of a specific color"[271] to trigger a migraine attack, and Debney records the same thing in four migraine sufferers, three of whom reported being affected by the color red; the fourth said that color television sets, but not black-and-white ones, precipitated migraine attacks.[125]

Acoustic migraine triggers feature in twenty-two pictures, as shown in table 4.4 in appendix B. Music—especially loud music—is represented in the Migraine Art pictures by musical instruments and musical notes and is a frequent migraine trigger. It is no surprise that the pleasure of *The Gala Concert* illustrated in figure 95 is compromised by a visual aura heralding a full-blown migraine attack.

Smells as triggers are seen in nine Migraine Art pictures. The most frequent smell trigger is cigarette or pipe tobacco (see fig. 93), as illustrated in seven entries. "Sweet perfume," "fly killers," proprietary metal cleaners, "hairsprays, insecticides, diesel, gas, and exhaust fumes" are depicted in various pictures. One migraine artist shows the scent of the privet hedge she was trimming had induced her migraine attack (see fig. 96). An important thing to consider in cases of migraines said to be triggered by an odor, however, is the possibility that the sufferer has experienced an olfactory hallucination as an aura symptom preceding the migraine attack. These hallucinations may be so vivid that they are easily mistaken for

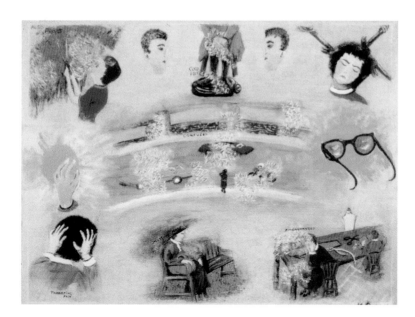

some external agent. Some cases have been reported where the patient experiencing an olfactory hallucination has searched for the source of the smell in their surroundings.[200]

Some migraine sufferers believe their headaches are triggered by adverse weather conditions. A male artist said in one picture that his "attacks come before the rain," and a female artist in another picture protects herself from the rain with an umbrella but cannot escape the migraine attack brought on by the weather.

Therapy

A darkened room and sleep, whenever possible, are the traditional relief measures sought by many migraine sufferers, as seen in seventeen Migraine Art pictures. For some patients, physical treatments such as applying an ice pack or immersing the head in cold water may be of help, as illustrated in two pictures discussed earlier (see figs. 63 and 86). However, most patients will either initially or eventually rely on the many medications that are currently available to treat migraine attacks, as seen in pictures showing tablets, capsules, bottles, and boxes of medications. The representation of a feverfew plant in one Migraine Art picture (see fig. 82) refers to the use of preparations derived from plant extracts, which mostly have

▶ Figure 97

Migraine Art collection.

▼ Figure 98

Migraine Art collection.

no known side effects; unfortunately their effectiveness is often unproven by scientific studies (see fig. 97). The reluctance of some patients to take prescribed drugs seems to be motivated not only by their concerns about possible side-effects and addiction but also by an irrational belief that their personality may be altered by the drugs, as dramatically depicted in figure 98. In addition to treating acute attacks, drugs may also be used to prevent headaches in sufferers who have frequent migraines, although the necessity to "keep taking the tablets" (see fig. 68)

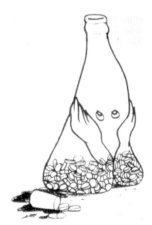

sometimes causes compliance problems. It has to be emphasized that any prescribed drug therapy must be accompanied by sympathetic counseling, which takes into account the sufferer's personality and individual triggers; only then can a satisfactory outcome be expected.

Somatosensory and Motor Disturbances

While the previous chapter dealt with the symptoms of an acute migraine attack, this is the first of five chapters devoted to the symptoms of the migraine aura. The Greek term *aura,* literally meaning "gentle breeze," means the transient symptoms that migraine sufferers can experience in addition to their headaches. It has to be noted that the same term, *aura,* is also used for the various signs and warnings that precede epileptic fits. It was first used by the ancient Greek physician, Pelops, Galen's teacher, when he was struck with the symptoms that many epileptic fits start with. When one of his patients described his sensation as "a cold vapor," he suggested he might be literally correct, since in those days physicians believed that blood vessels contained air and carried a "spirituous vapor" that flowed to the head. According to the diagnostic criteria of the International Headache Society, a migraine with an aura manifests "with attacks of neurological symptoms unequivocally localizable to the cerebral cortex or brain stem, usually gradually developed over five to twenty minutes and usually lasting less than sixty minutes."[283] The symptoms of an acute migraine attack—headache, nausea or vomiting, and hypersensitivity to light or sound—usually follow the migraine aura directly or after a free interval of less than an hour, but it is important to note that a migraine aura can also be unaccompanied by a headache.

Somatosensory symptoms, meaning symptoms affecting the sense of touch, and symptoms of motor functions, both of which can occur as a migraine aura, indicate a dysfunction in part of the brain or the brain stem. The part of the brain that deals with the sense of touch and the part

▼ **Figure 99**

Penfield's sensory hom-
unclus.[459] The size of the
depicted parts of the
body corresponds with
the comparative extent
of cerebral cortex
occupied by each part.
The order of the parts is
that found in the cortical
sequence.

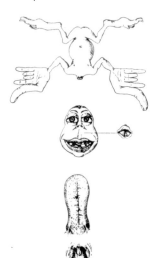

▶ **Figure 100**

Migraine Art collection.

that deals with motor functions are both organized according to Pen-
field's homunculus (see fig. 99), which is the figure of a man with a large
head and hands representing their disproportionate share of brain pro-
cessing space. The large share of the brain used for these body parts
explains why the head and hands are most frequently affected in a
migraine aura.[458,459,461] Loss of sensation and slight paralysis on one side
of the body are characteristic of a migraine with a typical aura, but symp-
toms of the sense of touch and motor functions simultaneously affecting
both sides of the body, which originate from the brain stem, are called
basilar migraines. Migraines that are characterized by partial or complete
paralysis on one side of the body (hemiparesis) are called hemiplegic
migraines; migraines with facial paralysis are called facioplegic migraines;
and migraines with paralysis of the muscles responsible for eye move-
ments are called ophthalmoplegic migraines.

Disturbances in the sense of touch and motor functions were described
by many artists in their responses to the follow-up questionnaire, which
means these symptoms are quite common. However, they are only clearly
represented in six of the Migraine Art pictures. These *somatosensory symp-
toms* are typically described as "numbness," in medical terms called hypo-
esthesia, or "pins and needles" (see fig. 100), in medical terms called
paresthesia (see fig. 101). The left side of figure 102 illustrates pricking

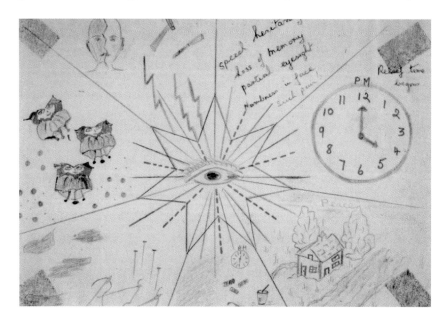

sensations in the migraine sufferer's hand, as if caused by numerous needles. The right side of the picture shows colored fortification spectra together with a variety of other visual hallucinations. This demonstrates that different kinds of symptoms can be experienced simultaneously or successively during a migraine aura, which is a common clinical observation. About figure 103 the artist writes:

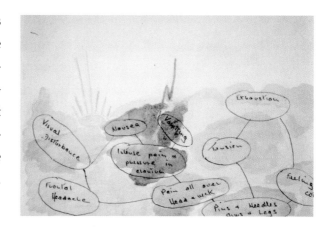

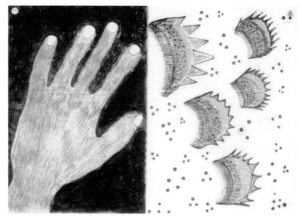

> *The picture of the left arm with the pins sticking out represents a warning sign to me of an imminent attack. Sometimes my whole arm would go numb, followed by a pins-and-needles feeling. The numbness would come on so quickly that sometimes I have dropped articles I have been holding because I had lost feeling down to my hands. The mug falling from the hand and breaking represents this.*

▲ **Figures 101 and 102**

Migraine Art collection.

◀ **Figure 103**

Migraine Art collection.

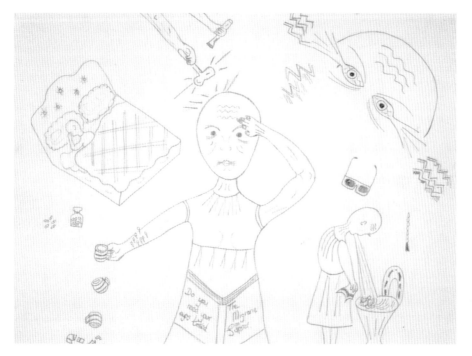

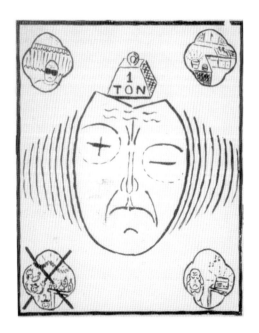

▲ **Figure 104**

Migraine Art collection.

This report demonstrates that symptoms of the sense of touch may lead to problems in motor performance, even when the sufferer feels no weakness or tremors. There are two illustrations of pure *motor symptoms* in the Migraine Art collection. During a severe migraine attack, represented in figure 104 by "the feeling of a heavy weight pressing on my head," the female sufferer experiences slight paralysis on one side of her face so that "one eye closes completely . . . and that side of my face seems to drop," indicating an example of a facioplegic migraine. "The four small vignettes depict the need to stay in a curtained dark room, the interminable pill-taking, the intolerance of noise, and sadly, no alcohol or whoopee partying. It is not pretty, but this is exactly how I feel when in the throes of a migraine." A similar representation of slight paralysis on one side of the face can be seen in figure 16 in chapter 1 together with the sufferer's Alice-in-Wonderland experience of her neck lengthening.

Abnormal Bodily Sensations

In chapter 4 it was shown that a migraine headache occurring on one side of the head, which is a typical migraine feature, is represented in a considerable number of Migraine Art pictures by numerous man-made weapons and instruments, suggesting sensations of a peculiar nature. It would not do justice to these pictures to consider them merely as responses to the request in the Migraine Art competition entry form to draw, paint, or illustrate "the pain associated with a migraine attack." The Migraine Art collection also includes pictures that illustrate abnormal bodily sensations, such as those of the Alice in Wonderland syndrome, which do not suggest the presence of any pain. It was a surprise to find that the migraine artists had represented such abnormal bodily sensations in their competition entries, as they could easily be mistaken for illustrations of visual experiences.[650]

Abnormal bodily sensations have been called *cenesthopathies,* a term introduced by the French psychiatrists Dupré and Camus to account for the peculiar and sometimes even bizarre bodily complaints, including abnormal pain, that they had encountered in patients who did not show evidence of disease.[150] It soon became apparent that cenesthopathies can occur for different medical reasons, including intoxication with hallucinogenic drugs, neurological diseases, and psychiatric disorders. Cenesthopathies are self-experienced abnormal bodily sensations that are perceived as totally different from sensations that have been experienced previously; they are therefore difficult to describe. In general these sensations vary greatly, appear suddenly or repeatedly, change quickly, and involve changes in emotions that are frequently negative.[279] A number of the experiences

labeled cenesthopathies have also been described in medical literature as disturbances of the body image or "body schema."[561,562] According to Benton and Sivan, "The concept of the body [image] arose out of diverse neurological and psychiatric observations that seemed to be explained most readily by hypothesizing the existence of a long-standing spatially organized model of one's body that provides a framework within which perceptual, motor, and judgmental reactions directed toward one's body occur."[43] The first written account of a body image disturbance was that of Ambroise Paré, the famous sixteenth-century French military surgeon, who noted that after an individual's limb had been amputated, a feeling of the missing limb's continued presence was often reported. The phantom limb was quite real to the individual and was a source of great pain. In the nineteenth century and the early twentieth century, a large number of doctors observed that patients with various brain lesions as well as some people with mental illnesses show a wide range of distorted body sensations. Various authors have proposed different classification systems for body image disturbances, and those of Critchley,[107] Lukianowicz,[389] and Frederiks[190] are currently the most comprehensive. It seems that from the different phenomena encountered by doctors, different views have arisen as to the nature and characteristics of the body image, which have not yet been adequately defined in medical literature. This is the main reason that major criticisms have been made of the body image concept.[126,513,514] However, there appears to be a consensus recently that the idea of body image disturbances is, at the very least, a useful label for a variety of perceptions relating to the patient's body as opposed to the external world.[43,119,589] The various disturbances of the body image that happen suddenly as part of migraine attacks represent a largely neglected source of data that is likely to contribute fresh evidence to the current medical discussions of the body image concept.[486,487,500]

Regarding the various types of abnormal bodily sensations that appear in Migraine Art, separate sections below are devoted to perceptions of the body as abnormally large or abnormally small and to the various forms of out-of-body experiences. Other types of body image disturbances are also summarized. A large number of the Migraine Art pictures illustrate

various types of pain-related bodily awareness, which are presented in another section. Moreover, electrical, thermal, and "vestibular" (sense of balance) sensations are also discussed.

Perception of the Body as Abnormally Large or Abnormally Small

There are a large number of terms in medicine that have been used to denote the sensation of the body being abnormally large or abnormally small. Bonnier called these experiences *hyperschematia* and *hyposchematia*,[69] and Todd listed them among the core symptoms of the Alice in Wonderland syndrome.[615] Numerous examples of these abnormal bodily sensations can be found in Lewis Carroll's first Alice book. On one occasion, Alice grew until "she found her head pressing against the ceiling,

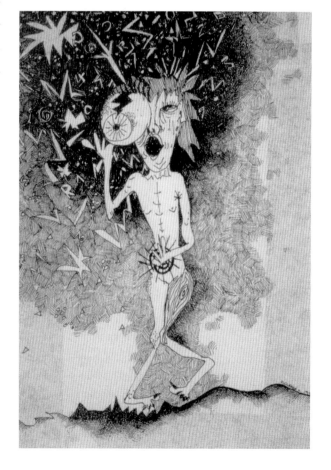

▼ Figure 105

Migraine Art collection.

and had to stoop to save her neck from being broken," and on another occasion it was only her neck that grew larger (see fig. 15 in chapter 1). In one adventure, as Alice's entire body shrank to ten inches (twenty-five centimeters) tall, she commented, "What a curious feeling! . . . I must be shutting up like a telescope!" Another time, "She felt a violent blow underneath her chin: it had struck her foot!"[88] Frederiks introduced the terms *macrosomatognosia* and *microsomatognosia*,[189] now widely used as names for these sensations. He defined these terms as disorders of the body image in which the entire body or parts of the body are perceived as abnormally large or small.

In the Migraine Art collection, the artists' perceptions of the body as abnormally large or small[487] can be identified by either the size of the body or body parts compared to an

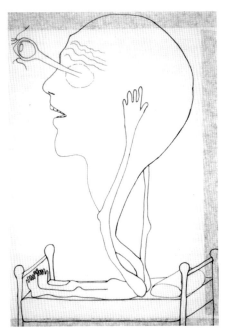 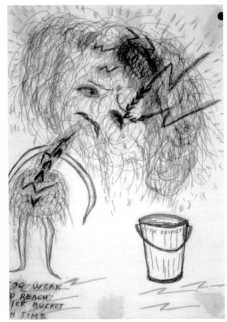

external object in the environment, or by the disproportionate size of body parts compared with the rest of the body. Examples of this body image disorder are shown in a total of eighteen Migraine Art pictures; seventeen show the body or body parts as abnormally large, and three as abnormally small.

The seventeen pictures featuring abnormally large sensations include one example of total body enlargement and sixteen illustrations where only parts of the body are affected (see table 6.1 in appendix B).

Figure 105 shows a male giant against a hilly background, an example of the entire body perceived as abnormally large. The feet are unsupported, as if the person were floating in the air. Additionally, there is a disproportionate enlargement of the right eye, the head, the right lower arm, the right hand, both feet, and the toenails.

In the center of figure 68 a greatly enlarged head appears to fill the room. Figure 106 shows a sufferer lying in bed with an enlarged head apparently floating toward the ceiling like a huge balloon. The neck, both arms, and the hands are elongated. The left eye appears to have left its socket, indicating severe pain with the feeling that the eye was being pressed out of the head. The artist, who had this experience on more than

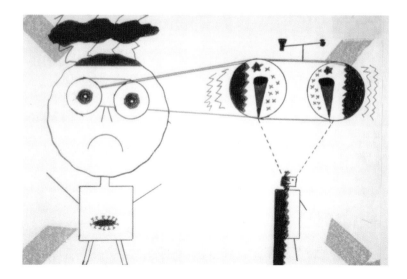

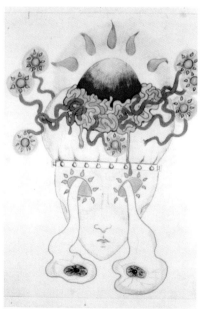

one occasion, described the experience as accompanied by a visual disturbance in which she viewed her body from a great height. "As I recall, it was at night, or at least in a darkened room. My head seemed very large and situated near the ceiling, looking down on a tiny body (my own) on the bed. The head was always connected with the body but somehow remote from it. It felt as if I was looking through a telescope the wrong way round." Figure 107 shows a patient with a very large head. The rest of the body, especially the hands, show a considerable lack of detail. According to the artist, during a migraine attack she felt that she "was all head with very little body and floppy useless hands." The left half of figure 108 shows a similar enlargement of the head. Figure 109 shows a stylized drawing of a migraine sufferer's head with both abnormally large eyes protruding. In figure 110 the female patient has depicted her experience that one eye—on the right side of the picture—"feels double the size" of the other. Although the size of her body compared to the tropical island she is standing on suggests the perception that her entire body is abnormally large, the artist said that this mismatch was intended to convey her "sense of isolation." The artist adds, "The two men in white coats on the edge of the picture indicate what I fear may happen one day—they take me away." In figure 111 a greatly

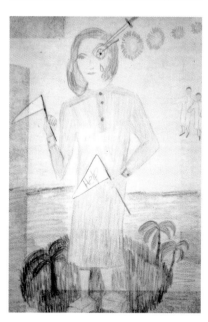

▲ **Figures 108, 109, and 110**

Migraine Art collection.

▲ **Figures 111
and 112**

Migraine Art collection.

enlarged mouth cries out, the disturbance accentuated in the lower lip and teeth on the right side of the picture. Greatly enlarged teeth, distributed on both sides of the upper and lower jaw, are the main feature of figure 112. In one of the three portraits included in figure 113, the artist has depicted his "tongue that feels too big for the mouth." He writes:

> *In this set of three portraits I was trying to convey how a migraine can start, and how it progresses, and how sufferers constantly worry about having migraine attacks. (1) Feeling relaxed and happy, but always knowing that the migraines are in the background, waiting to strike; and (2) thinking on how frustrating and annoying it is when the sufferer realizes the migraine is on its way, knowing there is nothing he can do to stop it, he must surrender to it and let it run its terrible course; and (3) still thinking on the terrible pain that will have to be endured, like an ever tightening band around the sufferer's head, which is sure to crack the skull, the tongue that feels too big for the mouth, and the sickening disruption to vision caused by the zigzag aura. For me the disruption to work and social activities played a major part in my suffering, which meant I was constantly worrying about having an attack.*

▼ **Figure 113**

Migraine Art collection.

The *Migraine Man,* portrayed in figure 114 by a professional artist, is aware of an "apparent enlargement" of the head, as indicated by "the balls on the face," and the hand "also feels larger than normal, a feeling conveyed by the image of the five sausages." An enlarged neck is seen in three pictures (see figs. 16, 58, and 115), two of them also displaying an enlarged hand with elongated fingernails (see figs. 58 and 115). The artist portrayed in figure 115 confirms, "With regards to the elongation of the neck, fingers, and nails—yes, on occasion it did feel as if this was really happening, particularly during the period of aura when I found it difficult to look at anything directly without it disappearing." Another example of an enlarged hand on one side is shown in figure 59, where the skin appears to have burst open below the thumb. The schoolteacher in figure 116 records classes when "I would see that some of the pupils were laughing at me, and I would realize that I was speaking complete rubbish. In addition to that, my arms and hands had dramatically increased in size. My hands, which I could see as normal size and holding an exercise book, nevertheless felt huge, and my arms nearly reached the floor. I kept looking to make sure they weren't as they felt." The picture illustrates the simultaneous experience of the perception of her upper limbs as abnormally large together with a normal visual perception of the size of her limbs. The transparency of the enlarged upper limbs are an artistic means to show a bodily experience that is only felt but not seen. The pencil and the exercise book held by the teacher are rimmed with luminous colors and a fringe of paler light, representing the visual illusion of a corona phenomenon (see "Corona Phenomenon" in chapter 7). Figure 117 shows greatly enlarged legs ending in spirals that are parallel to the spiral form of a fortification spectrum. The body is black, which suggests that the picture refers to an experience of bodily

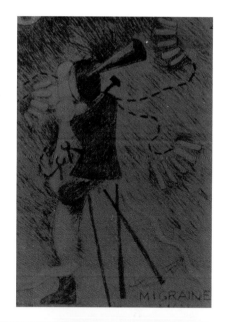

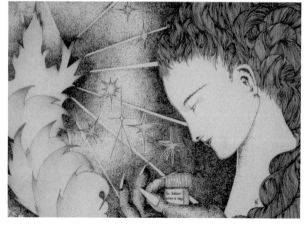

▲ **Figures 114 and 115**

Migraine Art collection.

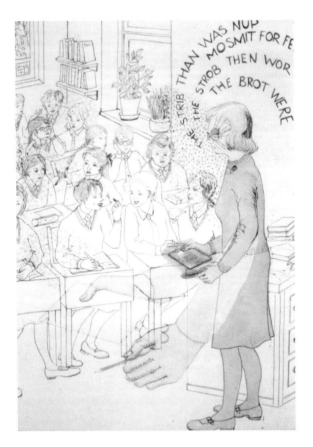

Figure 116

Migraine Art collection.

awareness that is felt when the eyes are closed, when no visual information about the body is available.

Three Migraine Art pictures illustrate perceptions of the body being abnormally small. In the lower right corner of figure 68 a patient is depicted lying in bed. The size of the patient and the bed appear to be reduced compared with the background wall and the view through the door. Similarly, the depiction of the tiny figure in the right half of figure 108 suggests the perception of the entire body being abnormally small. The patient's hands are clearly not the same size in figure 118, indicating a partial sensation of abnormally small size.

In two pictures there is evidence of the interesting phenomenon of objects adjacent to the body appearing to participate in the enlargement or reduction. In figure 116 the teacher holds a pencil in one hand and an exercise book in the other. Both of these objects and her clothing are depicted as if they are also increasing in size along with her body. It should be noted that the corona phenomenon depicted in figure 116 is only present on the real objects and not on the enlarged objects, which supports the idea that the corona phenomena corresponds to bodily awareness disturbances rather than to visual disorders. In one case with the perception of the entire body as abnormally small (see fig. 68), the bed, bedding, and the patient's clothing are depicted in the same reduced size. Klein reports the same phenomenon of objects outside the body being perceived as abnormally large or small.[316]

The illustrations of abnormal body-size perceptions in the Migraine Art collection confirm and expand on similar reports in the medical literature.[482] The migraine artists were able to represent these body image disorders clearly, which means that they occur in a state of consciousness that allows lucid self-observation. This has also been emphasized in Frederiks's

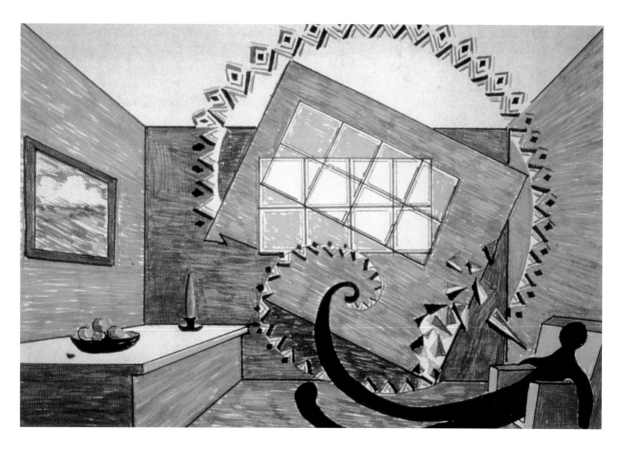

designation of the phenomena as "conscious body [image] disorders of cerebral origin."[189] The alterations in perceived body size are experienced as real and apparently objective. However, most patients learn from the outset not to mistake these experiences for reality. The migraine sufferer perceives physically impossible body dimensions but does not seem to need to correct the sensation by touching or looking at the body; through intellectual reflection the sufferer appears to reach the conclusion that the perception must be wrong.[374] Based on this judgment of the unreal and hallucinatory nature of the phenomenon, the patient may refer to it as an "as if" experience.[190]

Medical literature shows that negative emotions clearly dominate migraine patients' emotional responses to these abnormal body-size perceptions. Only one patient who perceived her body as abnormally large claimed that the experience did not bother her.[374] One patient described the experience as "very unpleasant"[37] and another as "very frightening and

▲ **Figure 117**

Migraine Art collection.

▼ **Figure 118**

Migraine Art collection.

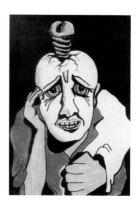

annoying" and "quite a shock."[374] A patient with alternating perceptions of the right side of his body as abnormally large and abnormally small described the experience as "a strange feeling, for it makes one feel disappointed when he doesn't find himself as he feels."[374] In one patient the perception of parts of the body as abnormally small was associated with an "anxiety state"[615] and two other patients said they were frightened by the experience.[213,381] A woman with sensations of her head being too small spoke of "odd feelings,"[389] and another woman with sensations of her right arm as too small described her experience as "strange and confusing."[391] In both the abnormally large and abnormally small perception disturbances, the psychological elements called "narcissistic features" are completely absent in the emotional reactions of the migraine patients, so the psychological interpretation that these symptoms are phallic symbols does not appear to apply to these cases.[229,234,563]

According to reports from migraine sufferers, the sensation of the whole body or parts of it being abnormally large is independent of visual information about the affected body part. Lippman[374] and Morrison[422] report five patients for whom looking into a mirror produced no change in their experiences of total or partial perception of body enlargement. This body-image disorder persisted when the affected limbs were moved voluntarily. Lippman reports one patient who felt that she was very tall and another who felt short and wide while walking down the street.[374] Yet another of Lippman's patients, with periodically alternating perceptions of the right half of the body as abnormally large and abnormally small, continued working during the experience.[374] This feature is confirmed by five Migraine Art pictures that show motor actions involving body parts affected by partial abnormal body-size perception, such as opening the mouth (see fig. 111), reaching up with the hands (see figs. 58 and 59), and holding a pen and an exercise book (see fig. 116) or a bottle of tablets (see fig. 115).

One Migraine Art picture (see fig. 116) displaying the perception of abnormally large body parts and one suggesting the perception of an abnormally small body (see fig. 68) illustrate the interesting phenomenon that objects adjacent to the body seem to participate in the enlargement or reduction. This extension of bodily awareness has been recorded in

medical literature on body image disturbances, as illustrated by the remark of Head and Holmes that "a woman's power of localization may extend to the feather on her head."[250] In the phantom limbs of amputees, patients may still feel objects attached to the limb, such as a ring on an amputated finger.[301] Objects like clothing are "incorporated" into the body image[85] (see fig. 116), as are other objects in close proximity to the body, like rings, necklaces, wristwatches, bedding, and a bed (see fig. 68). This also applies to objects held in the hand (see fig. 116) like a pen used for writing or a car being driven. These observations hint that some relationship exists between the brain mechanisms involved in the conscious perception of the body and those that perceive space beyond the body. The Migraine Art pictures vividly illustrate the clinical reality of such experiences, which are only poorly understood by the previously mentioned notion of an "incorporation"[85] of objects into the body image.

The single picture that shows the whole body perceived as abnormally large and the two pictures that show the whole body perceived as abnormally small confirm previous descriptions of these rare phenomena. Medical literature on migraines reports six cases of abnormally large whole-body perception[240,374,389,615] and ten cases of abnormally small whole-body perception,[54,213,374,615] suggesting that the disturbance of the whole body as abnormally small is more common. These disturbances argue in favor of the existence of a network of neurons in the brain involved with whole-body perception, and when it is activated abnormally it can produce the conscious experience of the entire body having the wrong size.[363]

The sixteen illustrations of the perception of part of the body as abnormally large and the single picture of the perception of part of the body as abnormally small clearly indicate that the former prevails over the latter in body image disturbances affecting the size of parts of the body, just the opposite to disturbances of the whole-body image. The distribution of these disturbances as seen in Migraine Art is summarized in table 6.1 in appendix B. For the sixteen pictures where part of the body is perceived as abnormally large, a clear preponderance of the head and hand can be seen, with a tendency for the prominent parts of the head and the furthest reaches of the arms to be affected in isolation. This confirms the findings

of a review of thirty-two case reports in the medical literature on migraines.[482] The same distribution has been demonstrated in a study of the hypnagogic hallucinations that appear while falling asleep,[502] in a study of body image alterations in people taking LSD,[26] and in a survey of body image disturbances in psychiatric outpatients with different diagnoses.[348] The frequency with which the different parts of the body are affected closely parallels the amount of brain tissue devoted to the different body parts in the sensory maps of the human brain, graphically shown in Penfield's homunculus, a map of sensory representation in the brain's cortex (see fig. 99). Although this does not necessarily imply that the brain's sensory cortex is responsible for the perception of abnormally large body parts, it does match with the principles of body parts corresponding to parts of the brain in sensory maps. The distribution of the perception of abnormally large body parts in migraine patients reflects the organization principles of the sensory maps in the human brain, which offers strong evidence for the notion that the body image is topologically organized and related to sensory maps in the brain.

The one picture in the Migraine Art collection that shows the perception of an abnormally small body part features the hand. Medical literature has five other cases referring to sensations of the head shrinking "until it becomes not bigger than a small orange,"[389] a feeling of an absurdly shrunken head,[79] a sensation that both hands "were made out of tiny twigs with a little mushy flesh on the outside,"[213] a sensation of the right arm shrinking, with the hand apparently moving closer until it stops at a point quite near the shoulder,[391] and a feeling of both legs being so shortened that the feet seemed to be attached just below the knees.[615] It should be noted that these last two cases show a great similarity to the telescoping phenomenon in the phantom limbs of amputees, which calls to mind again the analogy with Penfield's homunculus map of the brain's cortex in figure 99.[636]

Conscious perception of the spatial characteristics of one's own body, including its dimensions, configurations, and contours, have long been thought to be expressed in multiple topologically organized maps of neurons in the brain's thalamus and cortex. It is notable that animal experi-

ments on brain remapping[519] and studies using noninvasive techniques in humans[525] have shown that the brain has a considerable ability to remap the neural representation of the body surface in its cortex. In fact, the cortical maps of the body are dynamically organized and can be modified. Given the verbal reports and pictures of body parts perceived as abnormally large or small, it is tempting to speculate that these migraine aura experiences represent a reversible modification of the maps of the body in the brain.[487]

Out-of-Body Experiences, Seeing One's Own Body, and Duplicate Body Parts

Palmer and Vassar[450] define the out-of-body experience (OBE) as the feeling of literally being outside the physical body, and they emphasized the continuity of awareness of separation from the body, sometimes in the form of a duplicate body,[226] and the visual experience of perceiving the environment from a location in space outside of one's physical body. Many other definitions have been provided, some requiring stricter criteria for an experience to be accepted as an OBE, but as Palmer and Vassar suggest, it is unwise to restrict the definition of OBEs now when there is rather limited knowledge about them.[450] Such experiences appear to have led to numerous theories throughout the ages, from the ancient Egyptian concept of the *ka*, the Christian notion of the soul, the nineteenth-century psychic research theories of an "etheric double" and the "astral body,"[152] and twentieth-century parapsychological and psychological theories of OBEs.[58,226] It has been amply documented that OBEs can occur spontaneously in sane and healthy people, a number of whom have claimed the ability to produce such experiences at will.[188,418,423,666] OBEs can be induced in normal subjects by means of various psychological techniques,[58] by sensory deprivation,[47] by stress and near-death encounters,[226] and with hallucinogenic drugs.[231,608] Medical reports have provided anecdotal evidence that OBEs may occur as a symptom in diseases with lesions on the brain's temporal, parietal, or occipital regions.[129] More specifically, in a series of recent studies conducted by Blanke and associates,[61] it could be shown

that OBEs are related to a failure to integrate multisensory information from one's own body at the temporoparietal junction, an area of the brain where the temporal and parietal lobes meet, at the posterior end of the lateral sulcus that divides the frontal lobe and parietal lobe above from the temporal lobe below.

Possibly the first record in the medical literature of an OBE in a migraine patient is the unique case described by Oppenheim in which each headache attack was accompanied by a loss of muscle coordination (ataxia), vertigo, and the sensation that his body or individual parts of it had been duplicated.[443] According to Oppenheim's clinical notes, his patient was likely to have suffered from basilar migraines. Lippman presents a widely cited study of eight migraine patients with "hallucinations of physical duality"[375] that fit the definition of an OBE.[60,153,618] Two of Lippman's cases who had recurring OBEs since childhood admitted a variety of other migraine auras without headaches, but they developed typical migraine headache attacks at the end of their twenties. Single cases reported by other authors[240,381,389,615] have contributed other examples of a connection between OBEs and migraines.[98,388] Podoll and Robinson[486] recorded three cases of OBEs in migraine patients, two of them suffering from basilar migraines, suggesting that OBEs in these people represent aura symptoms originating from parts of the brain supplied by branches of the brain's basilar or posterior cerebral artery system (see table 6.2 in appendix B).

Not infrequently, reports of spontaneous OBEs mention an association with headaches[462] or a history of headaches[675] without referring to a diagnosis of migraines, so the frequency of OBEs as a migraine aura symptom is probably underestimated. Reports of OBEs in people experiencing a wide spectrum of migraine-aura perceptual disorders[640,660] raise the possibility that OBEs are migraine equivalents even in cases where no headache is present,[615] as in the histories of two of Lippman's patients[375] mentioned above. Spontaneous OBEs were reported to occur repeatedly,[59,225,449] to last from a few seconds to several minutes,[59] and to be associated with other types of hallucinatory experiences such as body image disturbances and visual hallucinations.[59] All these features of spontaneous OBEs are also common characteristics of migraine auras.[283]

Only a few studies have been conducted on the frequency of OBEs in migraine patients or on the prevalence of migraines in persons who have had OBEs. A collection of cases by Crookal[115] and a handbook by Mitchell[413] include reports of people with OBEs who had a history of migraines, and further anecdotal evidence was contributed by the author of a popular book on OBE phenomena who stated that "many of the people I talked with who experienced out-of-the-body sensations also suffered from migraines."[56] There are two reports of psychologists working with small groups of people with OBEs who felt that they were unable to establish a connection between OBEs and migraines.[225,285] However, the individuals had not been examined neurologically in those studies, and a closer inspection of the data presented by Green shows that the evidence is by no means unsupportive of an association between OBEs and migraines.[225] In a group of nineteen people with OBEs, four of them said they had had at least one migraine headache attack, and one person reported a positive family history of migraines.[225] Other studies also supported the link between OBEs and migraines. In a random-sampling community mail survey by Blackmore, six of thirty-nine people with OBEs said they had migraines or headaches as circumstances of their OBEs.[59] In questionnaire surveys of four introductory psychology classes conducted by Irwin, fifty of 101 people with OBEs reported a history of migraines, while only sixty-six of 271 people who had not experienced OBEs did so.[286] Irwin noted that all the people with OBEs in his four samples proved to have had at least one OBE that did not coincide with a headache attack;[288] this could be explained, however, as a migraine equivalent. In another survey of university students, Irwin suggested that the OBE-migraine link may be an artifact of independent relationships between lucid dreams, migraines, and OBEs.[287]

A similar phenomenon to OBEs, the complex hallucinatory experience called autoscopy[388] or heautoscopy,[404] is the sensation of the double. It can also occur as a migraine aura symptom.[123,404,616] According to Ask-Upmark, the eighteenth-century Swedish physician and botanist Carolus Linnaeus recurrently experienced a hallucinatory image of his double during migraines.[27] Critchley gave a vivid description of this case:

Often Linnaeus saw "his other self" strolling in the garden parallel with himself, and the phantom would mimic his movements, i.e. stoop to examine a plant or to pick a flower. Sometimes the alter ego *would occupy his own seat at his library desk. Once at a demonstration to his students he wanted to fetch a specimen from his room. He opened the door rapidly, intending to enter, but pulled up at once saying, "Oh! I'm there already."[110]*

One of Bruyn's migraine patients saw himself walking one pace behind him to the left.[79] Throughout the phenomenon of seeing one's double, the person remains identified with his own body and his normal point of view, while during an OBE the person views his physical body from outside.

In the Migraine Art collection, eight pictures can be identified that represent examples of OBEs, seeing one's own body, and duplication of body parts[486] similar to the descriptions of these experiences in medical literature as well as in psychic research and parapsychological literature. The latter sources are valuable for their wealth of information on the aspects of these experiences as they relate to consciousness and self-awareness, even if the reader does not share the metaphysical assumptions of these approaches.

The previously introduced *Migraine Man*, portrayed in figure 114 by a professional artist, experiences a reduplication of his hands similar to Oppenheim's patient who felt that individual parts of his body were duplicated during his migraine attacks.[443] The artist writes, "Sometimes I get the feeling that I have more than one hand, hence the multiple representations of the five sausages in the picture."

Figure 119 depicts a male migraine sufferer at the height of an attack. Triggers are illustrated, including various foods and drinks, the intense light from an electric bulb, and music from a radio. The patient has his right hand to his forehead and is hanging over the edge of the bed, vomiting into a bowl. His head is surrounded by zigzags, stars, angles, wavy lines, spirals, and exclamation marks. A large starlike irregular shape can be seen on his pajama jacket. The bedding and his hot water bottle are composed of multiple segments of various simple geometric forms, including zigzags, triangles, lines, angles, arcs, concentric curves, gratings, grids, and spirals. These multiple pieces are meshed together as in a mosaic. To

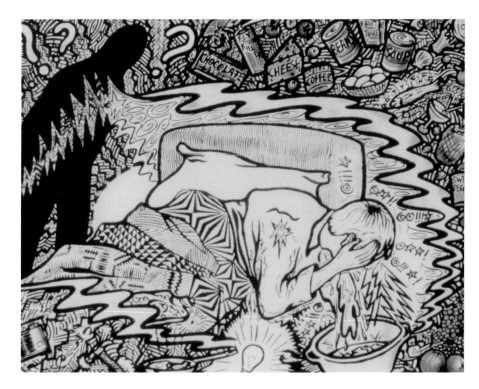

the left, the black shape of a complete, normal-sized human body stands alongside the bed and leans over it. A series of question marks surrounding the head and torso of the black figure suggest that the artist seeks an explanation for the ongoing experience. An answer is provided by the possibility that the picture illustrates a typical OBE. If this interpretation is correct, the black shadowlike human-shaped figure represents the duplicate body of the person experiencing the OBE,[226] reminiscent of a description by one of Todd's migraine patients,[615] who recorded becoming aware of "an invisible double, like a shadow" that seemed to contain her mind.[616] During this experience the patient may find himself in a duplicate or "parasomatic" body, most often resembling his physical one, in contrast with "asomatic" cases, in which the patient does not feel associated with any body or spatial entity.[226] The duplicate body in figure 119 is standing beside the physical body in the bed. This spatial arrangement suggests the patient's experience of looking down on his own physical body, which is one of the most striking and characteristic features of an OBE. It should be noted that in the patient's visual experience, seeing his double is associated with visual hallucinations of geometric shapes, including typical

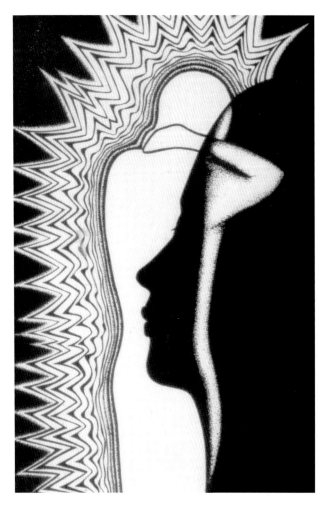

▲ Figure 120

Migraine Art collection.

migraine zigzags, and with a mosaic fragmentation of the images of the objects in his environment. The parts of the picture that represent the patient's visual experience show a considerable loss of color perception, in contrast to the triggers at the outer edges of the picture.

In figure 120 a female migraine artist depicts a rear view of an all-white human figure standing with one hand around the back of her neck. This stance is a typical pain reaction illustrated in many pieces of Migraine Art, and it identifies this figure as the physical body of the migraine sufferer. The head and the left side of the body are surrounded by multiple extra contours, the inner ones closely paralleling the contours of the body and the outer ones taking the form of the regular waves or the typical zigzags of fortification spectra. In the foreground the black profile of a woman's head and neck are shown, overlapping the white body in the background. However, all the contours of the white body are visible, suggesting that the black head is transparent. This picture appears to represent another example of an OBE. Again, the artist has illustrated the duplicate body as a shadowy black human form behind and to the right of the physical body. The transparency of this duplicate body echoes a description from one of Green's patients, who recorded an awareness of "my transparent body leaving my physical body."[226] The overall black background of the picture may indicate that the OBE is taking place at night or in other circumstances of darkness, with the physical body perceived from outside appearing as the source of illumination. This phenomenon is called "seeing in the dark" during an OBE.[226] The patient's experience of viewing the back of her own body is associated with visual hallucinations of

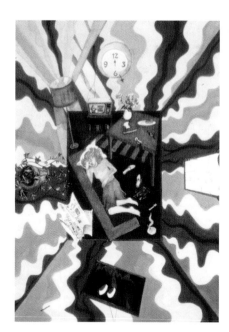 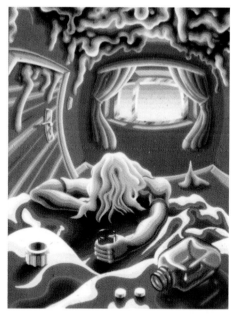

◀ **Figures 121 and 122**

Migraine Art collection.

multiple waves and zigzags surrounding the perceived body, similar to a corona phenomenon (see "Corona Phenomenon" in chapter 7).

Figure 121 shows a migraine sufferer inside a room viewed from a great height. One wall of the room has a hanging plant, the opposite wall a mirror, the third a clock, and the fourth a picture. The mirror is cracked, one hand of the clock is detached—similar to a visual illusion where objects appear distorted—and the picture, which features abstract geometric patterns like zigzags, is crooked. Overall the walls are decorated with vertical wavy lines. The migraine sufferer has removed her shoes and lies on a sofa with her head on a pillow and one hand resting on her forehead. The view of her physical body from above corresponds with the experience of seeing one's own body during an OBE, in which the great majority of people describe looking down on themselves.[226] This picture highlights the visual experience of perceiving the environment from a location in space outside one's physical body, but it does not include information about experiencing a duplicate body during an OBE.

A similar view of a patient seeing her physical body from above is illustrated in figure 122. The migraine sufferer is in a room in a prone position, holding a glass in her left hand. The walls of the room have taken concave and convex forms. The contours of the window, curtain rail, and door show

▲ Figure 123

Visual migraine aura
reported by Hachinski
et al.[240]

corresponding distortions. Formless shapes hang from the top of the door and the ceiling, dripping to the floor. In the patient's visual experience, seeing her own body from above is associated with geometric visual hallucinations and with distortions of her environment similar to those seen in metamorphopsia, a visual illusion where objects appear distorted.

Another example of an eighteen-year-old migraine patient seeing herself from above (see fig. 123) is reported by Hachinski et al.[240] An interesting feature is that her view was restricted to half of her field of vision. During her experience, which lasted ten minutes, she "saw herself lying on a railroad track with a train passing over her. . . . To her left side, against the bedroom wall, were irregular multicolored scotomas" (spots on her field of vision). The headache accompanying her symptoms lasted three hours.

In a cartoon sequence of nine pictures, figure 124 shows a fourteen-hour period starting at 4 a.m. with the migraine sufferer sitting up in bed with a headache. As the hours pass the severity of the pain increases, suggested by the number of arrows in his forehead. During this period he has left his bed, made a telephone call, vomited in the toilet, and returned to bed in tears at 11 a.m. By 4 p.m. he seems to be free from pain and sleeping. At 5 p.m. his body, depicted by wavy lines, appears to float upright in the air, the bed no longer visible. One hour later he is awake, his smile indicating relief: The migraine attack is over. This picture illustrates the illusion of levitation that occurred while the patient was asleep following a migraine headache attack. This illusion may be the first stage in the development of a full-blown OBE, as Green reports in a patient who said that "toward early morning I woke up, and instead of being in bed I was suspended in the air halfway toward the ceiling. I looked on the bed and I saw myself lying asleep."[226] In figure 124 the wavy lines used to depict the levitating body possibly represent the sensation of vibrations in the body that can sometimes be felt during an OBE.[202]

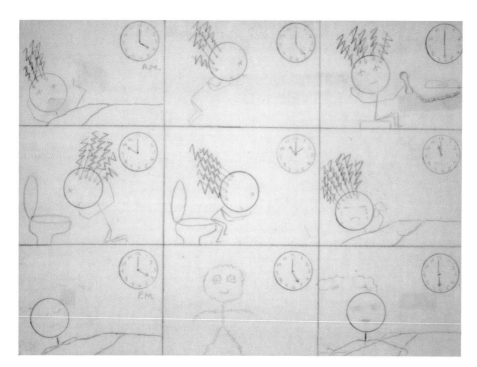

Figure 125 depicts an enigmatic dreamlike scene centered around a distorted human body. Unfortunately no explanation from the artist was available, so interpreting the whole picture was considered inappropriate. However, one detail is significant: A duplicate head, facing forwards, is shown in close proximity to the head of the distorted body. The duplicate head is grasped by a large severed hand that appears to have pulled it out of the head of the distorted body, which is suggested by lines linking the two heads. Usually there is no consciousness of any transition to or from the OBE state. People typically describe having found themselves in the OBE state, or suddenly realizing that they were in it.[226] However, some people report a conscious experience of separating from the physical body and returning to it.[640] It is suggested that figure 125 represents the beginning of such a separation, which has often been described as occurring in the region of the head. For example, a report from Muldoon and Carrington states that a person had on several occasions "been conscious of leaving her body from the top of the head."[424] Whiteman cites a patient who had experienced the "extraordinary sensation of being drawn out horizontally through a small hole in the centre of the skull,"[640] and Rogo reports

▶ **Figure 125**

Migraine Art collection.

▼ **Figure 126**

Migraine Art collection.

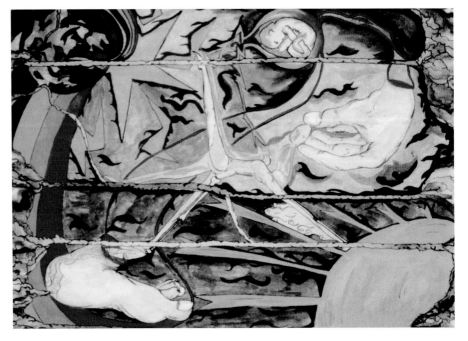

his personal experience that "I had the distinct and unpleasant feeling that I was being pulled out of my body through the head."[543] The person experiencing an OBE can perceive the separation as the effect of an external force acting on his physical body. For example, a person who had an OBE during a lucid dream said that "I seemed to see myself again being grasped and oppressed by 'forces,'" shortly after which she awoke, interestingly enough, "with an awful headache."[225] In the context of the dreamlike scenery in figure 125, it is suggested that this picture represents an OBE occurring during a dream.

Figure 126 is a self-portrait depicting a miniature female head in the center of the forehead. This picture may also illustrate the process of separation, with the miniature head representing the duplicate body, which here combines the features of an OBE and the perception of the body as abnormally small. This painting is reminiscent of Lukianowicz's description of a migraine patient who reported, "Often during an attack of

migraine, or towards the end of it, I *feel* as if my head would split into two parts, right in the middle. Then a miniature image of myself emerges from this fissure. It rapidly expands to the size of my real body, and then for a moment I have two separate bodies. They are both 'me' or 'I.'"[389]

The four Migraine Art competitions produced eight entries that illustrate features of OBEs and related phenomena, which indicates that these experiences may be more common than would be expected from the scarcity of medical literature on the subject. OBEs are not identified as a symptom of migraines largely because patients rarely report the phenomena. Their reluctance to admit these unusual experiences is motivated by the fear of being stigmatized as insane, as expressed by one of Lippman's patients: "I have never told anyone else, as I have not wanted to be called or thought of as queer, and even a supposedly understanding doctor might lift his eyebrows at some of the happenings of a migraine victim, who learns to keep things strictly to herself, excluding both family and physician from her confidence."[375] Lippman directly questioned his migraine patients as to whether they experienced a wide variety of hallucinations, which is somewhat contrary to the general principles of establishing a patient's medical history. The benefit of this approach is seen in the fact that eight of the seventeen cases of OBEs and related phenomena in migraine patients in medical literature were observed by this single author (see table 6.2 in appendix B).

A review of these seventeen cases provides a useful comparison with the features seen in the Migraine Art pictures. In this section, the numbers in parentheses refer to these cases, shown in table 6.2 in appendix B. All of these cases include a history of recurring headache attacks or a diagnosis of migraines. Ten of the cases have a family history of migraines. There are twelve females and four males, so the gender ratio of 3 to 1 shows a clear majority of females. When the cases were reported the patient's ages ranged from seventeen to sixty-six, and the mean age was 37.1 years. OBEs or related phenomena frequently began as early as childhood. The first occurrence of an OBE could precede or follow by several years the age when migraine headaches started. With the exception of two cases (9, 13), OBEs occurred repeatedly in all the migraine patients, and most cases

show remarkably stereotypical experiences. Two patients experienced more than a hundred OBEs in their lives (16, 17). OBEs occurred spontaneously as sudden or recurring events that lasted "an instant" (5), "a split second" (7), a few seconds (3), from one to five minutes (8, 9, 15, 17), and up to ten minutes (13, 16). One patient (16) reported that she was not able to induce the out-of-body state when she wanted, but she had some ability to direct it once it had started on its own, with her control of it varying from one episode to another. Only one patient (8) with frequent spontaneous OBEs claimed that he was sometimes also able to induce the OBE state "deliberately." In eleven cases OBEs were reported to occur shortly before (2, 3), during (1, 4–6, 11–13, 17), or after the headache (4, 6, 9). In six migraine patients the OBEs had no association with headache attacks (7, 8, 10, 14–16).

In the seventeen cases cited, OBEs or related phenomena occurred in a variety of situations. In five cases the OBE happened when patients were lying in bed (13, 15–17) or sitting in a chair (8, 17) awake and in a relaxed state, sometimes depending on the eyes being closed (16, 17). In seven cases the OBEs occurred while the patients were engaged in various everyday activities like standing (1), walking (1, 4, 6, 9, 12), "doing the ordinary chores of putting away things" (8), or performing "some accustomed mechanical action" such as "eating, reading, or sitting down" (7). In three cases the patients were able to perform complex and coordinated actions such as serving breakfast (2), teaching in a classroom (15), or driving a car (4) in the OBE state. It is implied that most of these cases were OBEs experienced with the eyes open. OBEs or related phenomena could occur when the patients were alone (8, 15–17) as well as in the company of others (2, 8, 15, 17).

In ten of the seventeen cases the patients reported experiencing a duplicate body[226] that more or less resembled the physical body (1–3, 6, 8–11, 16) or parts of the physical body (1, 12). In three cases a constant spatial relationship between the duplicate body and the physical body remained unchanged when the physical body moved (6, 10, 11). In six cases the presence of the duplicate body was felt intensely (1, 6, 9–12), like "an invisible double" (10, 11) without the patient viewing the physical body, and in

four cases the experience of the duplicate body included the sensation of seeing one's own physical body (2, 3, 8, 16). The duplicate body sometimes felt cold or chilly (3, 8). In other cases the duplicate body was experienced as abnormally large (16) or small (11). References to a duplicate body in some cases were only implied, with descriptions such as apparently floating through the air in a lying position during the OBE (16), "standing on an inclined plane" (2), "walking on ahead of myself" (6), or "hanging" with arms on a windowsill outside the doctor's office on the twenty-first floor, "trying to keep from falling" (8). In two cases the duplicate body was dissimilar to the physical body, described as "a little house" above the physical body that contained the "other self" (4), or as a black space that had shrunk to the dimensions of a sphere estimated to measure half a centimeter (a quarter of an inch) in diameter (17). One patient claimed to be temporarily unaware of being associated with any body or spatial entity during her OBEs (15). This has been called the "asomatic" type of OBE.[226]

In some cases the duplicate body was said to contain the mind (10, 16) and was experienced as more real than the physical body (3, 8, 16). Lippman's writes, "Not infrequently people who have migraines feel as if they have two bodies. This is a sensation of physical duality, during which such mental qualities as observation, judgment, perception, etc., are transferred to 'the other,' or 'second body,' which for the moment seems the more real of the two."[375] However, just the opposite was reported by one patient (9) who felt his awareness was confined to his physical body rather than to his duplicate body: "Suddenly I would become aware of a 'second self,' vaguer than and more tenuous than the original 'me.' I felt just like a double exposure looks." Another patient (5) reported that the center of her awareness rapidly alternated between her physical body and her duplicate body, similar to the "alternating location" of consciousness that Green documents as a rare feature of OBEs.[226] Two patients (11, 17) described a "dual consciousness" or an apparent "bilocation of consciousness," claiming that their awareness seemed to be located in more than one place at a time. This has been acknowledged as a rare feature of OBEs in the literature.[226,640] One of these cases (11) recorded that "for a moment I have two

separate bodies" which "are both 'me' and 'I,'" while the other (17) felt his mind at once located in his physical body and in a separate spatial entity in the form of a small sphere outside his body.

In nine of the cases (2, 3, 5, 7, 8, 13–16) patients reported the visual experience of viewing their own physical bodies from outside their bodies, usually from above (2, 3, 7, 8, 13, 15, 16). In some of these cases (2, 15, 16) it was clearly stated that the physical body's surroundings at the time of the OBE were seen in the visual OBE experience. Only one report (14) suggested that the patient may have perceived an environment during her OBEs that did not resemble normal experience. She said that on several occasions, "I feel as if I am outside myself looking in, and my mind comes from a different planet—and I do not belong to the world at all."

In two patients the emotions felt during OBEs were positive, described as a "very pleasant feeling" (16, 17) in one case associated with a certain relief from pain (17). However, seven patients reported negative emotions during most or at least some of their OBEs, including queer (2, 4), amazed (2), strange (6), or awkward (12) feelings, or intense anxiety (8, 15, 16) that was related to the fear of being unable to get out of the OBE state (8, 16) or not being able to get back into the physical body (15).

A few of these cases included reports of phenomena that occurred along with the OBEs. In one patient (16) sensations of abnormal lightness frequently occurred at the beginning of the experience. Another patient (7) noted that a sense of time appeared to be nonexistent during her OBEs: "Although I am aware that this feeling has taken place in a split second, I have a lingering impression that time ceased to exist while I was 'suspended above myself.'" Disorders of time perception have been recorded as a common feature of OBEs.[226] One patient (16) sometimes experienced paralysis mainly at the end of her OBEs, unable to move her physical body despite her efforts. This has been described as a rare phenomenon in OBEs[226] and bears some similarity to sleep paralysis, which can occur on its own or as a symptom of narcolepsy.[264] In two cases the OBEs were immediately preceded by typical visual migraine aura symptoms like bright sparkling points in the entire visual field (17) or sudden darkening then clearing of vision (13).

These cases from medical literature by and large agree with the elements of OBEs seen in the Migraine Art pictures, which compensates somewhat for the lack of verbal accounts from the migraine artists. Two Migraine Art pictures illustrate circumstances of OBEs that have not yet been described in migraine patients: Figure 124 depicts the start of an OBE while the patient was asleep, and figure 125 is an enigmatic scene suggesting an OBE while dreaming. Both are both common conditions for an OBE to occur.[226] The existence of nocturnal migraines is well-established,[131] and several authors have documented that migraine aura symptoms can be incorporated into the imagery of dreams (see "Complex Imagery" in chapter 7). Similarly, the OBEs in figures 124 and 125 can be considered manifestations of nocturnal migraines.

Based on the Migraine Art pictures where the artists view their own bodies, some inferences can be made on the hallucinatory nature of OBE perception. OBE perception means the visual experience that can occur as part of the OBE, consisting of images of one's own body and its surroundings as if seen from a new vantage point outside the body. According to the psychological theory of OBEs proposed by Blackmore, OBE perception is a hallucinatory experience based on imagination and memory.[58] The images of the physical body that are seen during an OBE state are a kind of "autoscopy," defined by Lukianowicz as "a complex … hallucinatory perception of one's own body image projected into the external visual space."[388] In an OBE perception of one's own body, the actual positions and movements of the physical body are seen (see figs. 119–122). A similar feature has been noted in the phenomenon of the double, where the double usually imitates all movements, in particular the facial expression, of the original.[388] The other important part of OBE perception is the physical body's surroundings. Blackmore argues that the images of the surroundings are hallucination information stored in the "cognitive map" of the surroundings.[58] In OBE perception it is not uncommon that there are inaccuracies and distortions in the visual representation of the environment, which has been interpreted as evidence that the experience is a hallucination.[58] OBE perception sometimes seems able to see in the dark, with sources of light that do not correspond to any sources that are actually

present,[226] as seen in one Migraine Art picture (see fig. 120). Question-naires by Osis show that people with OBEs commonly report that they see objects as transparent, glowing with inner light, or with auras around them.[445] In figure 120 the image of the migraine patient's duplicate body is surrounded by multiple waves and zigzags, resembling the visual illusion of a corona phenomenon (see "Corona Phenomenon" in chapter 7). According to Osis, objects seen in the OBE state may sometimes "look alive," change shape, move, or vibrate.[445] There are two Migraine Art pictures that show objects with wavy lines or surfaces (see fig. 122) and displacement of parts of an object (see fig. 121), similar to the perceptual distortions of metamorphopsia, the visual illusion in which objects appear distorted (see "Distorted Shapes and Outlines" in chapter 7). In another picture (see fig. 119), the image of the physical body's surroundings in OBE perception is fragmented into multiple pieces that are interlaced like a mosaic, similar to the broken images that are perceived in the mosaic illusion (see "The Mosaic Illusion" in chapter 7). In addition to these perceptual distortions of the body and its environment, all four Migraine Art pictures illustrating OBE perception (see figs. 119–122) show the visual experiences combined with geometric hallucinations like line, curve, spiral, and random shapes.[583] In three cases these geometric hallucinations include the typical zigzags of migraine fortification spectra (see figs. 119–121). This finding is a strong argument for Blackmore's idea that OBE perception is a hallucination.[58] If the images of the physical body and its surroundings are classified as complex hallucinations, OBE perception in migraine patients is a mix of complex and simple visual hallucinations.

Following Blackmore's assumptions,[58] a problem emerges in accounting for some OBE perceptions. An accurate view of one's own body and the unmoving environment can be explained by access to the brain's body image and cognitive maps, but OBEs have been reported where the person having the OBE has an accurate view of objects that are moving or people nearby who are acting independently. The medical literature (see table 6.2 in appendix B) includes two such cases of OBEs in migraine patients. A teacher (case 15) observed herself giving lessons to students in the classroom, and a homemaker (2) watched herself serving breakfast to her hus-

band and children. The first patient stated clearly that both eyes were open at the time of the OBE, which is also likely to be true of the second case. Nevertheless, none of the patients reported "seeing double" as though visual impressions were being received simultaneously from the position of the physical body and from the out-of-body point of view, and the same has been noted for OBEs in general.[226] Perhaps in cases where the person's eyes are open while experiencing OBE perception, he can make use of the visual impressions received by his eyes by subconsciously manipulating them to add to the hallucinatory image of the same events from a different point of view. The sources of OBE perception that are detailed by Blackmore—the body image and the brain's cognitive maps of the body's environment[58]—could then be added to the visual information received by the open eyes. There are several reports of people with OBEs who were able to carry out, with adequate motor skills, complex and coordinated activities that require visual input, such as bicycling, driving a car, talking, public speaking, performing as a singer or pianist, or in the odd case of a dentist, extracting a patient's tooth during an OBE.[226] These cases imply that some use can be made of the visual information received by the subject's open eyes during an OBE.

Because patients have migraines and OBEs together, it has been argued that OBEs represent a migraine aura symptom in these cases.[375] This implies a causal relationship between migraines and OBEs, but Blackmore makes the criticism that "a number of examples of people who have suffered both migraine, and autoscopy or OBEs, does not prove any particular kind of connection between the two.... After all, both migraine and OBEs are quite common and so a large number of people who have both would be expected."[58] It is certainly true that a survey is needed to scientifically assess the question of whether OBEs are more frequent in migraine patients than in the rest of the population. If that is the case, it could substantiate the idea that there is a causal relationship between migraines and OBEs.

However, from the recorded cases of people who have migraines and OBEs together, another argument can be made for a causal relationship between the two, and it cannot be disproved on the grounds of Blackmore's

criticism:[58] Most of the reported cases show that the OBE and the migraine headache attack happen at nearly the same time. In the seventeen cases from the medical literature (see table 6.2 in appendix B), eleven patients had OBEs or related phenomena shortly before, during, or after their headache attacks (cases 1–6, 9, 11–13, 17). In the Migraine Art collection, six of the eight pictures of OBEs or related phenomena show that the OBE states occurred during the headache attack (see figs. 114, 119–122) or after the headache attack (see fig. 124). Migraine auras are connected to acute migraine attacks in this way.[283] Moreover, in three cases from the medical literature the OBEs developed gradually, occurring after an initial feeling of abnormal lightness (16), after bright scintillating points in the total visual field (17), or in a sequence of the vision darkening, then clearing, followed by the hallucination of seeing one's own body and the multicolored spots on the visual field (13) illustrated in figure 123. In none of the migraine patients did the OBEs last more than ten minutes. In the cases where OBEs happened at nearly the same time as the headache attacks, the OBEs meet all the criteria of a migraine aura, thus providing a strong medical argument for a causal relationship between migraines and OBEs in these cases. In six cases from the medical literature the OBEs occurred without a headache (7, 8, 10, 14–16), which does not mean that the OBEs are not part of a migraine, since it is common for migraines with auras not to involve a headache, and patients may also suffer exclusively from migraine auras without headaches.[283]

If cases exist where OBEs occur as a migraine aura symptom, it follows that in these cases the OBE represents a reversible symptom of brain dysfunction caused by the mechanisms of the migraine aura. OBEs as part of migraine auras favor the idea that OBEs have an organic basis and represent a preformed functional response of the brain[401] that can be set off by various causes, including the mechanisms of the migraine aura. According to this idea, the basic similarity of all descriptions of OBEs from ordinary people, migraine patients, and sufferers of other neurological or psychiatric disorders is because of the similarity among their brains with their built-in networks of neurons with their preformed functional responses. This idea that the OBE is a preformed functional response of the brain,

which can be called a neuropsychological theory of OBEs, is compatible with the existing psychological theories of OBEs.[58]

The interpretation of OBEs as a brain dysfunction naturally leads to the question of where it happens. Bruyn thought that many, if not all, higher nervous system disturbances in dysphrenic migraines, also called hemicrania dysphrenica,[408] that involve the cognitive, emotional, volitional, and temperamental functions of the higher nervous system are based on spreading depression in the parts of the brain supplied by branches of the basilar or posterior artery system.[79] Bruyn suggests that "the cortex of the medial and basal temporal/occipital lobes apparently has a much greater significance for the mind-matter entity of the personality than has been previously realized."[79] These parts of the brain are candidates for the source of OBEs occurring as migraine auras. Podoll and Robinson[486] recorded three migraine patients who have had OBEs, two of whom can be diagnosed with basilar migraines. This suggests that OBEs are aura symptoms of basilar migraines, which fits with Bruyn's ideas about the brain structures responsible. In cases of OBEs occurring during epileptic attacks due to an identified focus of the seizure in the brain, the brain's temporal lobe is most frequently involved.[129] Furthermore, electrical stimulation of the brain's amygdala in a patient with epilepsy produced the sensation of "leaving the body."[292] The evidence available supports the idea that OBEs can result from brain dysfunction focused in the temporal region and the neighboring temporoparietal junction[61] and occipital areas.

Finally, interesting parallels can be drawn between the representations of OBEs used by the migraine artists and the iconic images associated with the soul in Western culture. Since the beginning of human history the soul has been represented as a shadow or as a small human form.[607] Both of these images recur in the Migraine Art pictures that portray OBEs. Figures 119 and 120 illustrate a black shadowlike human form, and figure 126 shows a miniature image of the head representing the duplicate body of the OBE. Images similar to the image in figure 126 of a small human figure emerging from the head were used in medieval paintings to show the soul leaving the body at death, for example in the triptych of the Passion Altar at Aachen Cathedral in Germany, painted around 1515–1520.[366] It is not

▶ **Figures 127
and 128**

"Transcendental photo-
graphy" of the "exter-
iorization" of the astral
body of a medium.[419]

surprising that authors have commented on the similarities between fea-
tures of OBEs and the Christian notion of the soul and its ascent to heaven,
suggesting that OBEs may have been a source of inspiration for the image
of the soul in human history.[163,202]

Other interesting parallels exist between features of the Migraine Art
pictures and illustrations published as "transcendental photography."[419]
Psychic and parapsychological researchers have used photography as a
way to detect the "astral body," and they have presented examples of this
transcendental photography as proof that OBEs are real and not just per-
ceived phenomena.[8] Although it is easy to conclude that these images are
faked,[340] they are worth examining because they are attempts to make a
visual representation of the typical features of the OBE. Figures 127 and
128 show examples of "experiments" performed publicly since the late
1930s by the occult circle called Fiat-Lux in Nice, France.[419] The photo-
graphs illustrate the "exteriorization" of a medium's astral body. The astral
body in figure 127 is floating in the air above and behind the physical
body, while the duplicate body in figure 119 of the Migraine Art is stand-
ing on the ground, but in both pictures the double appears to look down
on the physical body from above. Also noteworthy is the similarity between
the aura around the astral body in figure 128 and the similar light phe-

nomena around the migraine artist's physical body perceived as a duplicate body in figure 120. These similarities give rise to the suspicion that not only OBEs but also the so-called "aura vision" may represent, in some cases at least, migraine aura symptoms (see "Corona Phenomenon" in chapter 7) rather than paranormal phenomena.

Other Body Image Disturbances

In addition to the abnormal bodily sensations described in the previous sections, a variety of other body image disturbances have been reported as migraine aura symptoms. Lukianowicz introduced a classification of body image disturbances based on features of the subjective experience and expressed in clear descriptive terms. He based his classification on a definition of the body image as "a tridimensional concept of the body as a physical object, possessing a certain shape, size, and mass and occupying a certain space and position in the external world."[389] Various changes in the body image were classified by how they affected its shape, size, mass, and position in space, with each of these basic groups divided into several types. Various types of these disturbances are illustrated in a total of thirty-eight Migraine Art pictures, as summarized in table 6.3 in appendix B.

Disturbances of the body image affecting its shape are depicted in seventeen pieces of Migraine Art. Five pictures representing seeing one's own body (see figs. 106 and 119–122) and six illustrating duplication of the body or its parts (see figs. 114, 119, 120, and 124–126), with two of them showing both disturbances combined (see figs. 119 and 120), were discussed in the first sections of this chapter. The *Migraine Man* (see fig. 114), by a professional artist, experiences the body image dissolving, combining the features of the face and hands perceived as abnormally large (macrosomatognosia), multiple images of the hands, and the sensation of loss of the upper and lower arms. The artist writes:

> *In this picture I really sorted out what I felt about migraine. The balls on the face indicate loss of feeling and the sense of apparent enlargement. The cone represents the searing headache, the hammer the repetitive duller sort. The pincers indicate the stomach cramps of some attacks. Both hammer*

▼ **Figure 129**

Migraine Art collection.

▶ **Figures 130
and 131**

Migraine Art collection.

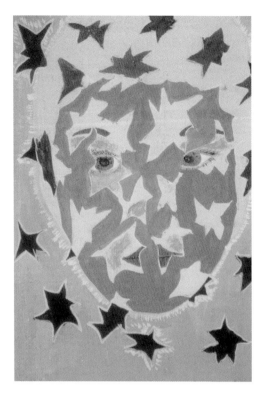

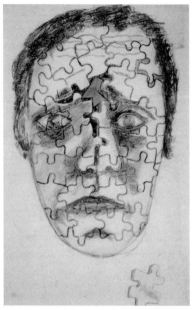

*and pincers are also religious
symbols referring to crucifix-
ion. During a migraine attack
I may have a sensation of separation of the hand, which also feels larger
than normal—a feeling conveyed by the image of the five sausages.
Although I am still aware of the hand, there is a gap between the shoulder
and the hand. There appears to be nothing between here and there, hence the
arm is represented by a dotted line. Sometimes I get the feeling that I have
more than one hand, hence the multiple representations of the five sausages
in the picture. The sticks that replace the left leg show the incapacitation,
the loss of confidence because I can't move and react as quickly as normal,
having a bad leg that can collapse and not be trusted. It's that sensation
of not trusting your body that is the most worrying thing to me. The
Migraine Man is holding a cloak around him to keep warm, as his body
temperature alters, and he wants to be protected. The small genitalia indi-
cate the feeling of shrinking and uselessness, both physically and overall
generally. Migraine Man has no facial features because he doesn't feel par-
ticularly human anymore. And he certainly can't see because of intense
scotoma [spots on the visual field] and loss of perceptual vision.*

A loss of shape of the body image is also seen in the following six Migraine Art pictures (see figs. 129–134). In four pictures, heads appear to fall to pieces, either on one side (see fig. 129) or both sides (see figs. 130, 131, and 132), with fragments flying apart like stars (see figs. 129 and 130) or pieces of a jigsaw puzzle (see figs. 131 and 132). In one of these pictures, there is the suggestion that the head is empty (see fig. 131). Figure 133 shows the masklike appearance of a migraine sufferer's head with a loss of facial features. In figure 134 the artist has depicted the sensation that the right half of his head is missing. Note that on the opposite half of the head the eye is closed, confirming the notion that the picture represents a bodily rather than a visual experience. Splitting of the body image[500] is encountered in three Migraine Art pictures. The female sufferer portrayed in figure 135 feels her "head split in half." The artist adds, "A migraine attack is almost impossible to describe to anyone unless they also suffer from them." In figure 136, titled *The Two Faces of Migraine,* a weight on the left side of the head shows the "feeling of heaviness and pressure making this side appear to be out of line with the other." The sensation of splitting and displacement of the two halves of the head is represented by the relative positions of the eye, nostril, mouth, and chin on either side. A similar midline splitting of the face together with considerable downward shift of the left side is illustrated in figure 134. Both eyes are closed, supporting the idea that this splitting of the face represents a splitting of the body image, which

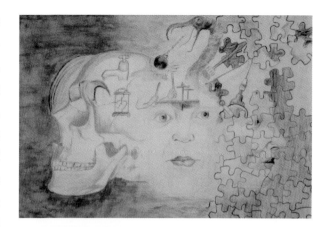

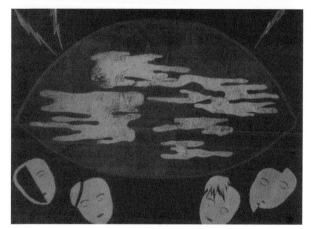

▲ **Figures 132, 133, and 134**

Migraine Art collection.

▲ Figures 135 and 136

Migraine Art collection.

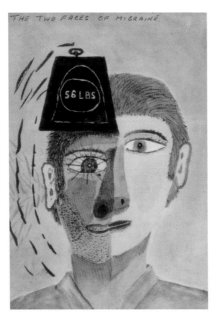

can be experienced as an abnormal bodily sensation with the eyes closed, rather than the visual illusion of splitting (see "The Illusion of Splitting" in chapter 7).

Disturbances of the body image affecting its size are encountered in eighteen Migraine Art pictures, discussed in detail above in the section "Perception of the Body as Abnormally Large or Abnormally Small." An increase of the whole body is shown in one picture, an increase of various body parts in sixteen pictures, a decrease of the whole body in two pictures, and a decrease of body parts in one.

Disturbances of the body image affecting its mass are represented in three pieces of Migraine Art. One picture, submitted by a seventy-eight-year-old female sufferer, shows a cutout figure of a scantily dressed model with an arrow pointing toward her head and the comment that it feels "like lead," suggesting the feeling of an increase in body mass during a migraine attack. Figure 137 depicts the head of a migraine sufferer with the brain represented by a map showing various symptoms of the migraine attack assigned to different areas of the brain. One of the symptoms labeled by the artist is "weightlessness," meaning a decrease in body mass. The third example, figure 131, illustrates emptiness of the head as another variant of body image experiences involving a decrease in body mass.

Disturbances of the body image affecting its position in space feature in five Migraine Art pictures. The migraine attack depicted in figure 124 ends with a nocturnal experience of levitating as the first stage of a full-blown OBE. In figure 105 a male giant appears to be floating in the air. A stylized representation of the symptoms experienced during a migraine attack is seen in figure 138. According to the artist, the "off-center focal point depicts distorted vision, sharp points denote the intensity of pains, and the wavy sea-like patterns on the edges show a sort of floating feeling as the attack

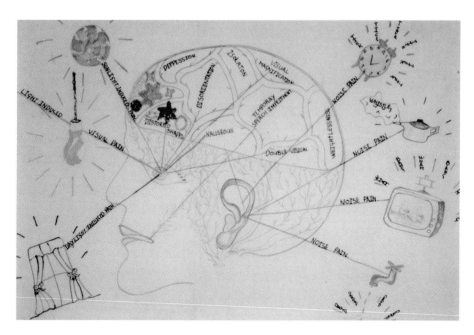

subsides." In figure 139 the artist has depicted a sensation of sinking experienced during a migraine attack:

> *The figure sinks into the depths, retreating from light, fearful of the menacing points that threaten to splinter the skull. The smallest sound, such as the movement of tissue paper, seems to pierce the skull to the point of shattering; the breakup is almost tangible. I can feel it—see it—hear it—so the hands attempt to protect the head, hold it together, and ward off the sickness that always accompanies a migraine.*

A similar sensation of sinking is illustrated in figure 140, where the old woman appears to be sinking into a tunnel.

The Migraine Art collection includes examples of a variety of body image disturbances that cover most of the clinical types described

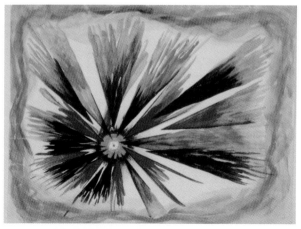

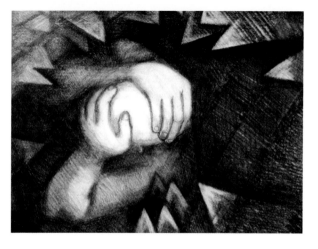

Figure 140

Migraine Art collection.

in Lukianowicz's classification.[389] These can be discussed with comparable cases from the medical literature.

Some of the *disturbances of the body image affecting its shape,* namely seeing one's own body and duplication of the body or its parts, were reviewed above. Another variant of body-part duplication in which extra body parts are perceived is described in the medical literature as "pseudopolymyelia,"[40] "delusional reduplication of body parts,"[637] or "supernumerary phantom limb sensation."[107] This rare illusion is not represented in the Migraine Art collection and has only rarely been described as a migraine manifestation. Bruyn briefly mentions a migraine patient who had the sensation of "a third buttock."[79] Todd and Dewhurst report the case of a thirty-two-year-old woman diagnosed with both migraines and epilepsy who experienced sudden episodes of perceiving her body as abnormally small, depersonalization (where the sense of self seems unreal), and the sensation of having a third arm:[616]

Her most singular symptom was the hallucination of a supernumerary phantom arm which developed from time to time. She would first become aware of a feeling that "something" was lying along the anterior surface of the left arm. When she looked to see what it was, she would observe an extra arm and hand lying on top of the real one. This phantom was thinner and slightly shorter than its companion; it was clad in a sleeve, the material being that of the real sleeve. Furthermore, the fingers of the phantom arm moved in unison with flexion-extension movements in her real arm. The phenomenon lasted about half an hour and was so realistic that she would hide the arm behind her back for fear that others might notice the phantom arm, although she really knew that it was but a product of her own fancy. If she attempted to touch the phantom arm, she found that there was nothing there. Clearly, the supernumerary phantom arm is in the nature of an autoscopic double of the real arm, *produced, no doubt, as a result of transient vascular disturbance affecting a portion of the right parietal lobe. A migrainous rather than an epileptic mechanism is favored by the*

fact that the hallucination lasted some thirty minutes. The fact that she felt *the phantom arm, before she saw it, points to the presence of* kinesthetic *[based on movements of the body] as well as visual and psychical compo-nents. This case, therefore, illustrates* par excellence *the tendency for kines-thetic elements to be projected in the autoscopic process.*

Yet another variant of body image disturbance involving the duplication of the body image has been described as the idea of a presence, which refers to an awareness of one or more persons in a room, and although they are not actually seen they are strongly "felt" to be present.[108] Such phantom impressions with "a sense of something or someone being pres-ent" have been recorded as migraine aura symptoms in several of Lipp-man's patients, not only referring to the presence of a living being or a malignant presence but also involving animals such as a mouse, a boa constrictor, or a bear.[373] Another patient of Lippman's was recurringly "awakened by a feeling that some terrible and evil form was inches away, surrounding and engulfing me. The pressure from this form was fiendish and suffocating. I have always likened this feeling to [the old tales of] the devil, because it has been, in its *recurring* infrequency, something inde-scribable which has not the shape or form of a human."[376] One of Klee's patients "was afraid that 'someone stood in the room' who seemed to her to be dangerous and threatening."[312] A particularly clear example of a felt presence preceding the visual symptoms depicted in figure 176 is described by a fifty-year-old female migraine artist in her letter responding to the follow-up inquiry. She writes, "Before the pain starts I have a feeling of emptiness and being able to see into the back of my eyes. [I have] a feeling of someone or something standing just behind my left shoulder, but when I turn round, it's still just behind me out of view."[495] The sufferer describes a constant spatial relationship between her own body and the body of the "someone" felt to be present just behind her left shoulder, and this spa-tial relationship remains unchanged even when she turns around. This is similar to the constant spatial relationship between the body and the dupli-cate body of OBE states, or the body and the double encountered in heau-toscopy, when one's own body is seen at a constant distance.

Splitting of the body image is an illusion with the feeling that the body is being split, usually on the midline, into two halves.[382] There may also be a sensation of displacement or separation of the split halves. A variant of this illusion is described as the sensation of the body parts being remote[254,390] or displaced,[109] when the patient has the impression that one of her limbs is completely detached from her own body and occupies some position nearby or farther away. This illusion, which is most frequently seen in patients with brain lesions involving the parietal lobe, was observed as a migraine aura symptom in a patient who had the feeling that in each migraine attack "one hand would seem to be a very long way off."[111] In three other migraine patients, splitting of the body image was reported along with other abnormal bodily sensations such as perceiving the body as abnormally large or small,[374] OBEs with hallucinations of physical duplication,[389] and sensations of falling.[374] The complaints of these three patients were as follows: One of Lippman's patients said, "Today my body is as if someone had drawn a vertical line separating the two halves."[374] Lukianowicz's patient said that often during an attack "I feel as if my head would split into two parts, right in the middle."[389] Finally, another of Lippman's patients said, "My head fell into a deep hole under the head of the bed—it was a very deep hole. I knew it wasn't true, but I was really worried as to my sanity."[374]

Loss of shape of the body image has only rarely been described in migraines. A patient of Determann's with dysphrenic migraines complained that his body, as well as objects in his environment, seemed to consist of a pulpy mass.[128] One of Lippman's patients repeatedly had "a feeling of being near to the ground, squashed down, my whole body mashed."[373] Fisher reported the case of a migraine patient who experienced, at the start of a severe attack, "a most peculiar and alarming sensation deep in his head associated with a feeling he would black out or his body would fly apart."[174] Four Migraine Art pictures (see figs. 129–132) suggest the experience of the body image dissolving with the metaphor of falling apart into the pieces of a jigsaw puzzle or star-shaped fragments, the latter probably chosen by the artists for the reference to the frequent star-shaped form of migraine visual hallucinations. The conscious expe-

rience that the body, half of the body, or part of the body is perceived as absent has been given several names in medical terms: "nonfunction of the somatopsyche,"[184] "aschematia,"[69] "ablation of the body schema,"[105] "absent body image,"[105] "conscious form of nonperception of the body,"[601] "asomatognosia,"[370] "amputation experience,"[404] and "delusion"[289] or "sensation of absence of part of the body."[254] Experiences of absent body parts are reported as migraine aura symptoms in a number of cases. Bruyn says that he knew migraine patients "who feel as having nothing where their liver or intestines should be" or "who feel that they have left a hand."[79] One of Todd's patients was often conscious of a feeling that "one or other of his arms was missing."[615] Similarly, three patients of Barolin and Gloning reported that they had the "sensation of absence of both hands"[37] during some migraine attacks. During the course of a severe migraine attack, a patient of Lunn's experienced:

> *the feeling that the contours of her arm and head become indistinct and blurred with their surroundings, and for a few seconds she feels she has no arm or head at all. In order to conquer this alarming "feeling of blankness" she has been accustomed to rubbing her face and massaging her right arm with her left hand. This procedure reduces the time the abnormal sensation lasts.*[391]

A patient of Klee's, suffering from a particularly severe migraine attack with psychotic behavior lasting a week, said that she "believed that her legs had been amputated."[312]

Disturbances of the body image affecting its mass can be subdivided into two groups, involving either an apparent increase or decrease of the body's mass. The first group involves sensations of an increase in the weight or density of the body or parts of it, and the second group involves feelings of lightness, emptiness, and hollowness of the body or parts of it. Mendel records that some migraine patients complain of a feeling that their heads were filled with lead.[403] One of Fisher's patients reported a "filling of the head" or "heavy feeling";[173] one of Schob's patients had a disturbing sensation of the heaviness of one hand, so that objects held in it slipped to the ground;[566] and another of Fisher's patients said that both legs felt

heavy.[174] A patient of Krafft-Ebing's complained of a sensation of hollowness in the head,[337] and one of Brackmann's migraine patients recorded a feeling of emptiness in the head that gradually turned into a sensation of pressure against the back of the eye.[72] Sensations of abnormal lightness of the head were described by several authors.[173,374,527,605,615] Sensations of abnormal lightness of the head may be associated with perceiving the head as abnormally large and with a sensation of floating. A patient of Todd's repeatedly had the "feeling that her head was double its normal size and half its normal weight," and another of his patients was often conscious of a feeling that his head was "twice its normal size and as light as a feather."[615] Lippman cites the report of a migraine patient who experienced "the sensation that my head had grown to tremendous proportions and was so light that it floated up to the ceiling."[374] One of Fisher's patients had repeated spells when he was "light-headed," both legs felt heavy, and he had a "floating, undulating feeling."[174] Analysis of the parts of the body affected by sensations of abnormal heaviness and lightness shows a clear majority of cases where the head is involved. This parallels the finding when body parts are perceived as abnormally large (macrosomatognosia), and it calls to mind again the analogy with Penfield's homunculus or sensory map of the brain's cerebral cortex (see fig. 99).

Disturbances of the body image affecting its position in space have been described in different ways as migraine aura symptoms. A migraine patient of Flatau's experienced both levitation and falling down during recurring attacks of vertigo.[179] He felt as if the chair he was sitting on was levitating, or as if he was falling into an abyss. Sometimes these feelings were so difficult that the patient cried for help, although the attacks rarely lasted longer than a minute. Butler gives a personal account of a migraine attack that happened while he was driving, when he had the experience that "the car appeared to levitate, rising up in the air and slowly sinking."[84] He said the same symptom was reported to him by another migraine sufferer. In Flatau's and Butler's observations, the chair and the car appeared to participate in the levitation, providing further examples for the idea that objects can be incorporated into the body image (see "Perception of the Body as Abnormally Large or Abnormally Small" above). Riley et al. men-

tion a female migraine patient who suffered from "an uncomfortable float-ing-away sensation"[539] during her headache attacks. Similarly, a patient of Livesley's said that "sometimes I feel as if I am floating."[381] In the med-ical literature, experiences of sinking are described in migraine patients in a relaxed waking state, in the hypnagogic state just before falling asleep, and in dreams. Lippman relates the case of a migraine patient who described his experience: "Often when I relax in a chair, the chair and I seem to be sinking through a hole in the floor. I know it isn't true, but it's very annoy-ing."[373] Another of Lippman's patients went to bed very tired and felt "the sensation of sinking into the bed far deeper than any bed could be."[373] Moersch reports the case of a patient with dysphrenic migraines who was haunted by recurring nightmares that the author thought were manifes-tations of migraines. During these nightmares "he had a prolonged sink-ing feeling, and at times a sensation of flying, sometimes slow, and again fast."[417] According to Lippman a recurring dream that frequently occurs in migraines "is a falling dream—but it differs from other falling dreams in that the dreamer floats gently down a 'long dark funnel with corrugated sides,' landing with a slow-motion bounce at the bottom. A few patients describe the funnel as 'spiraling.' They have no fear with this dream, only a sense of 'mild amazement.'"[376]

A variety of the body image disturbance affecting its position in space was impressively described in Lewis Carroll's books. In *Alice's Adventures in Wonderland,* Alice had an experience of falling. "The rabbit-hole went straight on like a tunnel for some way, and then dipped suddenly down, so suddenly that Alice had not a moment to think about stopping herself before she found herself falling down what seemed to be a very deep well."[88] In fact, Lippman notes that "the most effective description of my patients' falling dream can be read at the beginning of Alice's story, when she falls down a dark rabbit hole 'lined with shelves.'"[376] On one occasion in *Through the Looking Glass,* she joined the Red Queen in a "rapid journey through the air"[89] and on another occasion found herself "getting giddy with so much floating."[89] During an experience of levitation, Alice "felt the carriage rise straight up in the air,"[89] a description similar to Butler's report of a personal migraine aura when his "car appeared to levitate."[84]

▲ **Figure 141**

Migraine Art collection.

Pain-Related Bodily Awareness

Facing the many complaints of migraine patients describing their pain experiences, Labarraque suggests that "everyone suffers in his own way."[347] It is certainly true that migraine sufferers report a variety of pain sensations beyond the typical pattern of migraine headaches. Raskin and Schwartz record a sharp, jabbing, "ice pick–like" pain around the head, which was superimposed on the more common dull or pulsating migraine headache, in forty-two percent of a sample of one hundred migraine sufferers,[528] and Olesen records headaches with feelings of pressing and tightening in forty-two percent of 750 patients with acute migraine attacks.[438] From the medical point of view of descriptive phenomenological psychopathology, these pain sensations can be classified as pain-related bodily awareness (cenesthesia).[232] The Migraine Art collection includes an unexpectedly large number of 133 illustrations of this pain-related bodily awareness, which is defined in Huber's criteria.[233]

The first type of pain-related bodily awareness, *circumscript* or *limited pain sensations,* is characterized by painful feelings of drilling, piercing, or stabbing, but other varieties of abnormal limited pain can also fall under this designation. These are encountered in eighty-six Migraine Art pictures and can be divided into various forms according to the nature of the pain depicted. Limited sensations of pain of a *drilling* nature are represented in eleven Migraine Art pictures by images of screws (three pictures), screwdrivers (three pictures), corkscrews (two pictures), pneumatic drills (three pictures), electric drills (two pictures), and mechanical drills (one picture). As an example, figure 141 shows the path of a screw being driven into the head, then partially withdrawn from the channel formed. Limited pain sensations of a *piercing* character are seen in forty-five Migraine Art pictures with various man-made weapons or instruments, including nails (thirteen pictures), needles (seven pictures), axes (six pictures), pickaxes (four pictures), arrows (four pictures), bolts (three pictures), saws (three pictures), chisels (two pictures), handguns (two pictures),

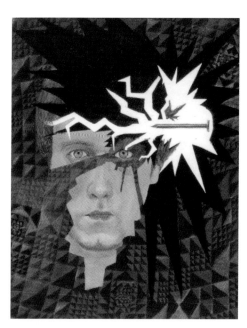 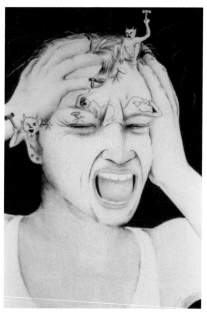

◀ **Figures 142 and 143**

Migraine Art collection.

▼ **Figure 144**

Migraine Art collection.

and a variety of other piercing instruments shown in single examples (fifteen pictures). About figure 142, the male artist writes:

The nail being driven into the side of the head is representational of the sharp penetrating nature of the pain. The jagged whiteness also symbolizes this. The pain tended to be focused on one side of my head and was associated with my eyes also. The pain felt fixed and embedded (like the nail). The face is miserable looking, which is appropriate for the experience of pain. Associated diffuse nausea feelings were often present in addition to the pain.

In figure 143, three demonic hammer-wielding figures pierce the sufferer's forehead, eyelid, and cheek with tin tacks. Circumscript or limited sensations of pain of a *stabbing* nature are illustrated in thirteen Migraine Art pieces, using daggers (eight pictures), knives (three pictures), and beaks (two pictures). The artist who created figure 144 writes:

The peacocks are depicting stabbing pain, pressure, and tightness. The chains around the body—tension and claustrophobia. The skull—fear of dying of a brain tumor. The bottle of pills—a desire to be calm and to sleep. The dead eyes, the gaunt look, the heavy-looking hair, the hunched shoulders—the whole expression of the sufferer shows tension, fear, sickness, plus a feeling of isolation.

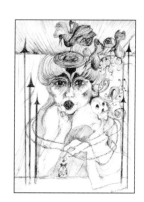

Figure 145

Migraine Art collection.

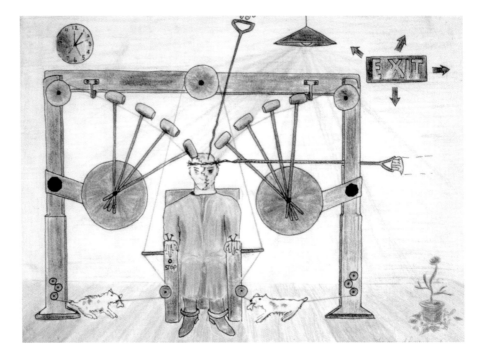

Limited pain sensations of a *hammering* nature are depicted in twenty-eight Migraine Art pictures by one or more hammers (twenty-five pictures) or mallets (three pictures). In figure 145, titled *The Pain of Migraine,* the victim is nailed into a chair forming part of a complex torture machine. Two dogs activate a closed-circuit system of wires and pulleys causing mallets to rain blows onto the victim's skull, which appears to have been fractured by these blows. A barbed-wire wreath, pulled by an external torturer, causes further pain, while another torturer bores down into the victim's skull.

The second type of cenesthesia or pain-related bodily awareness—*sensations of movement, pulling, and pressure*—is illustrated in a total of sixty-two Migraine Art pictures.

Sensations of pressure experienced on the *surface of the head* are represented in twenty-eight Migraine Art pictures with miscellaneous weights (twelve pictures), clamps (seven pictures), and rings around the head (ten pictures). Figure 146 shows a large brick pressing down on the sufferer's head. The migraine sufferer in figure 147 wears an ornate iron cap with a clamp-like device exerting pressure on the entire head. In figure 148 tiny black-winged devils fly toward, and gather around, an ever-tightening clamp on the head of the sufferer. While the majority of the demons are

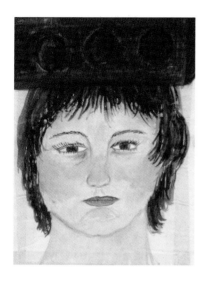 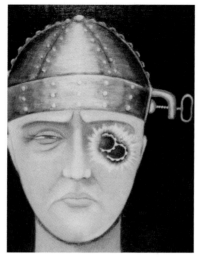 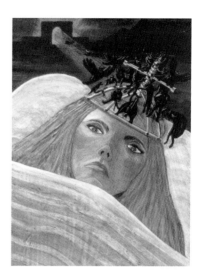

tightening the clamp, three are piercing and one is hammering the sufferer's head.

▲ **Figures 146, 147, and 148**

Migraine Art collection.

Sensations of pressure *inside the head* are illustrated in twenty Migraine Art pictures with mechanical devices exerting pressure on the eyeballs (two pictures), explosions inside the head (ten pictures), and other miscellaneous images (eight pictures). In figure 149 an explosion seems to blast the migraine sufferer's eye out of the head. The artist writes:

▼ **Figure 149**

Migraine Art collection.

> *The points at the rear of the distorted eye represent sharp penetrating pain in all directions, quite close to the surface, pushing the eye and surrounding area against the inner skull. The pain and pressure from the eye create an explosion of upper pain together with pain waves affecting every muscle, every nerve, every sinew, and every fiber in the head. The colors represent unbearable pain and pressure at varying degrees of depth, tremendous throbbing, and a deep inner disturbance, the intense strain of light. I also wished to interpret a cloud of despondency.*

The enigmatic picture in figure 84 also illustrates, according to the artist, a sensation of pressure inside the head. She writes:

> *Migraines are part of myself—hence the serpent grows from me. It limits me physically and emotionally, trapping me in its coils. The head of the serpent depicts the pain experienced—as if the head was about to explode. The surrounding images are of my family and the hobbies and occupations that*

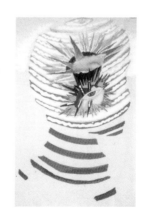

▶ **Figures 150, 151, and 152**

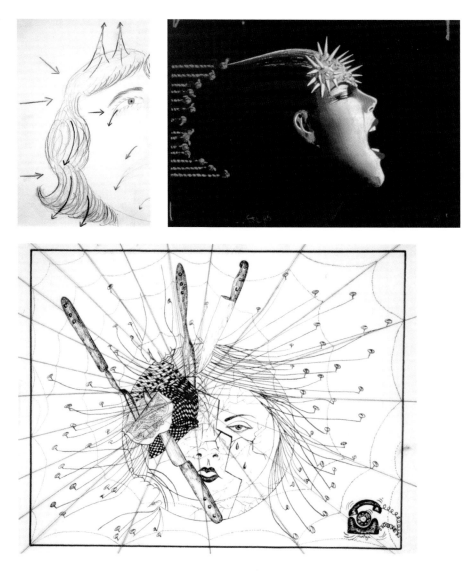

were all affected each time I had a migraine. I still feel the frustration expressed in my painting, in relation to the limitations migraines place on my life.

Sensations of pulling are illustrated in four Migraine Art pictures. Figure 150 shows a woman suffering the one-sided pain of a migraine attack indicated by straight arrows, together with sensations of pulling shown by curved arrows. "On the [affected] side it feels as if the hair is being pulled upwards from the scalp and being dragged down at the sides. It feels as if I have weights pulling down my eye, my nose, mouth, and chin on the [affected] side. In addition I feel my head is being hammered all

up the affected side, at the temple, over the top, and at the eye; also behind the eye." In figure 151 a pale-complexioned female sufferer, her mouth open in a cry of pain, is subjected to the action of fourteen knotted ropes strongly pulling her hair away from her head. Further pain is inflicted on the forehead by spiked instruments of torture similar to the medieval morning star. In the stylized portrait of a migraine sufferer in figure 152, individual hairs are pulled away from the head and pinned down by thumbtacks. Two knives, two forks, and the fists of two unknown individuals act on one side of the patient's head, representing different varieties of limited pain sensations. In figure 94 the hair of the armor-clad "migraine martyr" has been extended with "a feeling that my hair is being pulled or pinned out all around me." An arrow directed toward one eye and a saw piercing the neck indicate limited pain sensations, a number of "steel bands fixed around my neck" show sensations of pressure, and the automaton-like appearance of her body, with joints replaced by wires or totally absent, suggests a feeling of depersonalization, as confirmed by the now sixty-seven-year-old artist, who writes:

> *I had feelings of detachment and estrangement from myself since childhood. I was an* actress, *and even as a child I lived in different worlds. I did not know what was wrong with me. I didn't tell other children why I felt "different," and I didn't mind because I was popular. When I married I hoped being* real *would cure me, but I was deeply distressed to find that in reality people were* acting *(badly) all the time.*

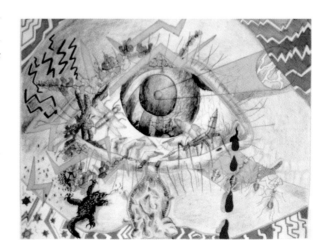

▼ **Figure 153**

Migraine Art collection.

Sensations of movement are depicted in twelve Migraine Art pictures. In the bottom left corner of figure 153 a large number of ants are seen crawling over the skin, pursued by a type of anteater. The sensation of insects on the skin, called formication, is also suggested by three larger ants carrying a leaf in the bottom right corner of the painting. A mosquito moves along the eyelid and a wasp-like insect hovers over the eyeball. Two

▲ **Figures 154
and 155**

Migraine Art collection.

human hands appear to be scratching points of irritation on the eye. Figure 154 shows a stylized profile of a head on which the hair has been replaced by four snakes slithering over the head and neck. The artist comments:

There are showers of gold lights in front of my eyes blocking my vision—always a first warning of an impending migraine. "Worms" are crawling about in the right side of the head. The right eye is the pain center, emphasized in the picture. The red "jewels" in the face and the snakes are the blood cells being constricted by Raynaud's [a blood-vessel disorder that causes skin discoloration], depicted by white areas. Limbs icy cold and white, quickly followed by the intensely cold face, nose, lips, ears, and throat. The eye is getting heavy and can't stand pain or light. Dark glasses are worn indoors and outdoors at all times, hence the black background. The whole life is spent enmeshed in a migraine "web" from which there is no escape.

Figure 155 shows three jack-in-the-box figures springing up and down on the head of the migraine sufferer, their trajectories indicated by lines. The artist writes, "I felt pain over one eye as though an external object or objects were attacking it (something sharp and bouncing off my head). I was sensitive to light and was seeing stars when the eyes were closed."

The third type of pain-related bodily awareness, *sensations of constriction and strangulation,* applies to the whole body or parts of the body and may involve an appalling sensation of respiratory distress and suffocation.

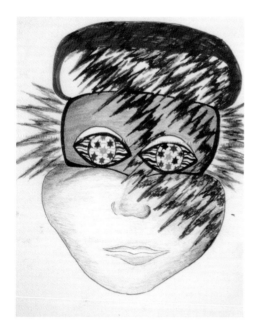

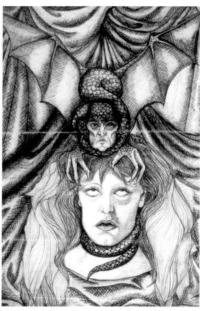

◀ **Figures 156
and 157**
Migraine Art collection.

The Migraine Art collection includes two examples of these sensations. In figure 156 a band with masklike holes for the eyes results in a considerable constriction of the migraine sufferer's head. In figure 157 a creature that appears to be part bat, part eagle, and part snake with a human face is depicted on the head of the migraine sufferer. It flaps its wings, digs its claws into the forehead, and squeezes the unfortunate victim in its coils.

The features of the three types of bodily awareness pain sensations (cenesthesia) studied in this chapter are summarized in tables 6.4 and 6.5 in appendix B. Limited pain sensations are most common on one side, sensations of pulling and movement occur at similar rates on one side or on both sides, sensations of pressure are usually on both sides, and sensations of constriction and strangulation are always on both sides. These feelings of pain-related bodily awareness are commonly experienced on the surface of the body, usually the head or the hair. Less frequently they are experienced inside the body, including pain localized on one or both sides of the head, at imaginary points inside the head, in the brain, on the surface of the brain, or on the interior surface of the skull. In a number of the pictures, the limited pain sensations and sensations of pressure and movement are represented as a feeling that the skull is being fractured, broken, or that parts of it are being removed (see table 6.4 in appendix B).

In many pictures the pain experiences are attributed to an external source, which is shown with various man-made weapons, instruments, or machines. A smaller number of pictures imply the pain comes from some other external entity, as listed in table 6.5 in appendix B.

The Migraine Art collection impressively shows that pain-related bodily awareness is by no means uncommon in migraines. This confirms earlier descriptions of these phenomena in medical literature. A number of varieties of *circumscript* or *limited pain sensations* have been recorded in medical case reports. Migraine patients described limited pain sensations of piercing[174,206] like a nail or an ice pick,[528] being "struck with a sledgehammer,"[174] a "red-hot spear" or a "knitting needle" driven through the head,[312] a knife,[411] or "thousands of knives"[466] in the head. Limited pain that feels like hammering[206,312,654] was described as the strokes of a hammer on the head.[179,415,537] Stabbing pain[179] was likened by migraine patients to a needle jabbing the head.[528] Pain that feels like drilling is recorded by Latham, who notes that some migraine sufferers "have said that the sensation was as though a point in the temple were being bored with a gimlet, the gimlet slowly increasing in size."[353] Drilling pain is also described by Möbius[415] and Flatau,[179] who compare the pain of the migraine attack to the action of a drill driven into the brain, and by Riley et al., whose migraine patient described her pain "as if a drill were going through the bone."[539] A similar form of limited pain was described by migraine patients as boring pain.[206,353,403,537,654] Other migraine sufferers described their pain as having a cutting character.[179,312] Beating pain is described as a feature of migraine attacks by Gans[206] and by Golden and French, who report the case of a child with basilar migraines who complained on several occasions that "my dolly hit me" or during other migraine attacks that "a bee bit me."[214]

Sensations of pressure have been described by migraine patients as a feeling of pressure on the surface of the head like an iron plate lying on it,[448] a vise,[415,654] and a pair of tongs acting on the head.[179] Aching and pressure pain was described as localized "like a cap on the top of the head."[312] Other migraine patients experienced a sensation of pressure like a ring or band, which they compared to the feeling of a ring around the forehead,[409]

"the pressure of an iron ring about the head,"[537] or "a sensation of an iron band pressing the head together."[206] Sensations of pressure inside the head were described by migraine patients as pressure exerted from behind the eyeballs[72] "as if the eyes were pressed out of the head,"[415] "a pressure behind both eyes which gradually increased in severity,"[174] "a feeling of distension within the skull,"[537] "like someone was blowing up a balloon within my head with a compressed air canister,"[65] and painful experiences as if the head,[415] the skull,[179,435,537] or the brain[179] were bursting. A patient of Golden's provided a graphic description of his experiences of pressure pain within the head: "Like you want to stop, but energy is keening up inside you. You feel like you're going to burst and your eyes are going to pop out—like you're going to explode."[213]

Brunton speculates that the ancient practice of drilling holes through the skull, called "cranial trepanation," may have been performed on migraine sufferers as a measure to relieve painful sensations of pressure within the head:[78]

Numerous examples have been found of skulls belonging to the Stone Age in which large holes have been bored with stone implements, and the patient has not only recovered, but has lived for a long time after the operation. This is shown by the edges of the bone not being sharp or rough, as they would be for some time after the operation, but smooth and beveled by slow absorption after the wound had healed. Some authorities have supposed that these openings in the skull have been made for purposes of priestcraft, and that the priests, by pressing hard on the brain through the opening in the skull, were able to induce epileptic fits in the patient, and then announce that he was possessed by a spirit, and in a fit condition to give oracular responses. It is possible that the openings in the skulls may have subserved this purpose, but to any sufferer from sick headache the first idea that suggests itself is that the holes were made at the request of the sufferers in order to "let the headache out," for when the pain of headache becomes almost unbearably severe, an instinctive desire sometimes arises either to strike the place violently in the hope of relieving the pain, or to wish that some operation could be done to remove the

pain; some of the South Sea Islanders actually make a hole in the skull for this purpose.[78]

Similarly, at the height of a migraine attack, the hero of the 1998 Darren Aronofsky film *Pi* performed trepanation on himself with a power drill.

West suggests as a symbol of migraine "the sliced eye from Luis Buñuel's *Un Chien Andalou*, a movie I cannot watch without marveling at its decipherment of the migrainee's longing to pluck out the sloven half of the jelly that offends."[639] Similarly, the sufferer portrayed in figure 75, who is shown in the throes of a severe migraine attack, said that "the experienced response to end such trauma was a tormented desire to gouge out the offending area with an apple corer, as likened to removing the bung from a great vat, butt, or barrel, whatever, and let the noxious material gush out to achieve similar relief."

Sensations of a *splitting headache,* the feeling that the skull is being fractured, is bursting, or that parts of it are being removed, may accompany a variety of other pain sensations, including limited pain sensations and sensations of pressure on the surface of the head or inside the head, illustrated in several Migraine Art pictures. The medical literature includes several migraine patients describing a splitting headache related to sensations of pressure, but no record of a splitting headache with limited pain sensations appears. According to Critchley, the French physician Charles Lepois, also called Carolus Piso, "likened the pain to a feeling as though the head were splitting in two, or as if the coronal suture were bursting apart."[110,472] According to Flatau some migraine patients have the feeling "as if the bones of the skull go apart" during their attacks.[179] A splitting headache associated with sensations of pressure inside the head is described by Riley as "a feeling of distension within the skull as if the bones of the head would spring apart."[537] Nielsen and Ingham cite a migraine sufferer who felt "sharp shooting pains which feel as though the skull is lifted off,"[435] a patient of Klee's had the feeling "as if my brain was being flayed out,"[312] and Barolin speaks of "a splitting, pressing headache."[36]

Sensations of movement on the surface of the body or inside the body have only rarely been reported as features of a migraine attack. A sensation

as if ants were crawling on the surface of the body is noted by several authors.[409,465,530] One of Ulrich's patients had the feeling of ripples all over the body at the beginning of the migraine attack.[620] According to Mendel some migraine patients complained that their heads seemed to move with a splashing sound, as if filled with water.[403] Bruyn notes that he knew migraine patients "who feel water droplets run through their brain or a creek through their abdomen."[79] A patient of Pässler's had unpleasant sensations "as if the intestines were moving in the body."[448] In the Migraine Art pictures, sensations of movement are represented most frequently by animals moving on the surface of the head or inside the head, including one example of the common phenomenon of formication or feeling insects crawling on the skin (see fig. 153).

Sensations of pulling have also only rarely been described in medical literature on migraines. The sensation of pulling may involve the whole body, as with one of Lippman's patients who felt, at infrequent intervals while walking, "a feeling as if a rope were attached between my legs, pulling me down into the ground."[373] The sensation of pulling can also apply to parts of the body, as in another patient of Lippman's who "had the feeling that my head was suspended on an invisible wire and was being pulled along from up above at a rapid pace,"[373] in a patient of Fisher's reporting "a feeling of pulling in the eyeballs,"[173] in a helicopter pilot reported by Cho et al. who described the pain of his migraine attacks behind his eye as "someone pulling his right eye out and sticking an ice pick on the nerve,"[96] and in a professional artist reported by Podoll et al. who had a sensation "as if the brain is being pulled out of the skull" and as if "six plungers" were pulling on his head.[503] Of the four Migraine Art pictures featuring this form of pain, all illustrate a sensation of the hair being pulled.

Sensations of constriction and strangulation are another rare manifestation of migraines in medical literature. One of Féré's patients had head pain together with a "sensation of constriction" of her head.[165] Mingazzini documents the case of a patient who complained of "a sensation of strangulation and pain in the throat,"[409] a patient of Pick's choked with emotion during the course of a migraine attack with visual symptoms and disturbances in her ability to speak,[465] and a patient of Schob's had the

sensation of constriction of the throat that sometimes preceded his headache attacks.[566] Fisher reports a migraine sufferer who reported that his "trousers often felt tight as if 'closing in on me.'"[173]

Rose and Gawel note that many migraine patients have the feeling that their headache attack is "something from outside,"[547] which seems to be especially true for the types of pain and other types of abnormal bodily awareness studied in this section.[547] The medical literature includes several reports of migraine patients describing their headaches with metaphors that imply the pain is caused by an external entity. The most common expression of this kind is a comparison of the headache attack with pain inflicted by some man-made object, as if there were a drill, spear, ice pick, nail, needle, pin, knife, hammer, sledgehammer, vise, pair of tongs, cap, iron plate, iron ring, or iron band acting on the head, as recorded in the medical case reports.[96,174,179,206,312,337,409,415,448,466,528,537,539,654] These and other man-made objects are seen in the Migraine Art pictures illustrating all types of pain-related bodily awareness (see table 6.5 in appendix B). Attributing the pain to animals appears to be a common way to express sensations of movement, as in the case from Mingazzini where the patient experienced the feeling of insects crawling on the legs,[409] and as illustrated in five of the Migraine Art pieces.

The Migraine Art collection shows other examples of the pain of migraine attacks being attributed externally that have not yet been described in medical literature, including images of natural forces like lightning and explosions, other human beings, and imaginary creatures resembling animals and humans that are often drawn using traditional images of monsters, demons, and devils. It is interesting that the Babylonians and ancient Persians thought migraines were caused by a specific demon, Tsihathe,[149] and that during the golden age of Greece migraine headaches were said to be caused by evil spirits called the Keres.[586] The Romans had the belief that headaches and other human discomforts were inflicted by the gods on people who had incurred divine displeasure.[192] The indigenous people of New Zealand believed in an array of demons who cause ills in various parts of the body, with a specific one named Tonga responsible for headaches.[57] These beliefs parallel the metaphors

used to attribute pain to humanlike supernatural agents in some of the Migraine Art pictures.

Only considering the content of these metaphors, they show close similarity to the processes of externalization observed in the formation of delusions in psychotic patients.[319] Migraine patients, however, use the metaphors verbally or in pictures to communicate their experience, in contrast to psychotic patients who experience them as reality despite the often impossible content of the experience. Only in children suffering from migraines[214] and in patients with dysphrenic migraines,[409] which can be associated with temporary psychotic episodes, does the migraine sufferer sometimes have the delusion of being the victim of some real external agent. For example, a patient of Krafft-Ebing's went into hospital to demand that a large stone be removed from his head,[337] a patient of Mingazzini's thought that mice were gnawing at his head,[411] and another Mingazzini patient, disoriented and confused during one of her psychotic states, complained that she had "a man" in her skull and that she could feel the man rotating inside.[409]

Circumscript or limited pain sensations and sensations of movement, pulling, pressure, constriction, and strangulation as well as other types of abnormal bodily awareness (cenesthesia) that occur as part of migraines show a great similarity to the "spontaneous sensations" seen in patients with disorders affecting the brain's thalamus region.[250,279,282,311,517,574,602] Spontaneous unpleasant bodily sensations based on a dysfunction of the thalamus are experienced as sudden disturbances that change rapidly—within a few minutes—in intensity and quality. These similarities to migraine pain sensations suggest that they involve a brain dysfunction in the thalamus. That means these bodily awareness pain sensations can be seen as migraine aura symptoms rather than as the pain of the migraine headache.[503]

Electrical, Thermal, and Sense of Balance Sensations

The abnormal bodily feelings in the last section are examples of bodily awareness closely related to pain experiences. Other types of abnormal

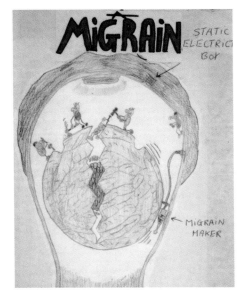

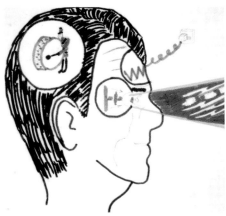

▲ **Figures 158 and 159**

Migraine Art collection.

bodily awareness (cenesthesia) occur without pain, or sometimes only allied with pain, as seen in three distinct types of abnormal bodily awareness described by Huber et al. as electrical, thermal, and "vestibular" (sense of balance) sensations.[233]

Electrical sensations, representing abnormal bodily sensations that sufferers call "electrifying" or "like electric current," are seen in two Migraine Art pictures. Figure 158 shows a "static electricity box" together with a power tool, labeled "migraine maker" by the twelve-year-old artist to show electrical sensations on the surface and inside the head. The brain is pierced, hammered, split, and forced apart by tiny men, the whole scene illuminated by an electric light on the inner surface of the top of the skull. In figure 159 the sufferer's forehead is connected to an electric socket, demonstrating "a feeling of electric shock treatment across your forehead." Other symptoms of this migraine attack include "someone in your head with a bass drum," "a force behind your eyes that feels like your eyeballs are being pushed out of your head," "general blurred vision during the waking hours," and a "fireworks display when your eyes are shut." Another migraine sufferer's attack includes, among other aura symptoms, electrical sensations that are clearly described in the artist's words but do not appear in her picture. She writes:

[I feel] a sense of increasing disconnection, isolation, and weakness. I start to tremble and feel lethargic. I become aware that my peripheral vision is affected. The world starts to dissolve and break up at the edges. I feel as if I am falling and spiraling away and everything outside is getting much smaller as if I am looking through the wrong end of a telescope. I feel electric shocks inside my head and see zigzags like lightnings closing in from all sides until they completely obscure my vision. I feel complete disengagement from reality and usually pass out and/or vomit. I then have a crushing headache on all sides of my head. At the time I did the painting

I was suffering from attacks with these recurrent symptoms at the rate of approximately once a month. I still sometimes get mild early warning signs, but I have not had a proper attack for many years.[490]

The rarity of these electrical sensations is confirmed in the medical literature, which includes only one case of this symptom in a patient of Fisher's who recorded "an electric burning feeling behind the right ear extending down along the spine."[173]

Thermal sensations feature in ten Migraine Art pictures: Seven show unpleasant feelings of heat, and three depict cold. One picture shows a red "burning ear," a second depicts a red ear that "aches" and is "inflamed," and a third shows a red forehead region to indicate the sufferer's "intense cranial burning sensation, sometimes on the right side, sometimes on the left side, but mostly over the whole head." Figure 72 shows a stylized human head with six flames burning inside the skull. The artist writes:

A terrible throb is in my skull, and my head is burning enough to dry out towels of cold vinegar put on it. The eyes are so sensitive that I cannot move my eyelids; they are just like burning holes. Any noise is deafening and accentuates the throbbing through my whole head, and all my teeth hurt as if they are being banged with hammers. I feel that my head is splitting and it is going to fall apart, it feels so delicate. I cannot lift it from my pillow without extra agony. I cannot bear any sound, any light, any touch. My head is going to explode or fall off. Sometimes it feels that my head will split or half of it will fall off; other times it is like this, all of it affected. Also my teeth chatter, which is agony; I have diarrhea, sickness, and my limbs shake. I feel, even now after all these years, that the picture shows the starkness and the invasion of a migraine attack.

Figure 160, by another artist, shows a severe attack with both eyes and one half of her head feeling on fire. She writes:

The left-hand side of the picture shows the lady on a good day, the flowing hair denoting feeling good—no pain. Also the forehead—no wrinkles of pain, but *the hand around the neck is just to remind one that you are never free, you never know when the next one will hit you, "it's always there."*

▲ **Figures 160 and 161**

Migraine Art collection.

On the right-hand side, the black face shows the eyes burning, and one side of the face where the pain hits is on fire. The pain is so hot. The hand tries to dig in the head and take the pain out. The cracks—you cannot stand any noise. The mouth open—crying for help to take away the pain.

In figure 161 the migraine sufferer's eye appears to be surrounded by a ring of fire emanating from the mouth of a dragon, standing with its tail around the edge of the iris. The dragon is being attacked by a knight in armor bearing a shield with the emblem of the British Migraine Association. According to the artist, "The migraine dragon has engulfed the eyeball, and the eyeball has been set alight," denoting "the feeling of a burning sensation." A long-standing migraine sufferer, he adds, "My dragon wants killing once and for all, and when medical science comes up with the answer, they will be remembered like Saint George." Figure 68 depicts a large isolated head being attacked in various ways by tiny black-clad figures. One of their methods of torture is two campfires burning beneath the migraine sufferer's chin.

As examples of thermal sensations of cold, figure 101 includes a note about "feeling cold," figure 110 shows a woman with her feet "enclosed in blocks of ice," and figure 96 shows "cold feet" with the presence of a large hot water bottle.

The representations of sensations of heat and cold in Migraine Art are similar to descriptions of these symptoms in the medical literature. A generalized sensation of heat,[403] a "burning sensation,"[417] and a "sensation of warmth over the entire body"[605] are recorded as manifestations of

migraines. Localized thermal sensations of heat were described as a feeling of heat confined to the head,[179] "a hot sensation over both sides of the face,"[605] a sensation that "one cheek felt sunburned,"[173] and a feeling of fire along the shoulders.[411] A general sensation of chill is recorded as part of a migraine by Mendel[403] and by Ulrich at the beginning of the patient's migraine attack.[620] A patient of Fisher's "began to shiver and to feel extremely cold"[174] at the beginning of a migraine attack. In a patient of Klee's the migraine headache was "accompanied by a feeling of cold."[312] Among a group of three hundred migraine patients studied by Elliot, several patients "definitely complained of a feeling of coldness during the attacks, either of hands or feet all over. Others said this chilliness preceded their attacks. Two had a cold feeling across their foreheads which warned them of the coming headache. In a recent case this symptom ushered in the close of each attack."[158] In an account of a personal migraine attack, Berger describes a sensation of feeling ice cold beginning in the right hand, ascending up the right arm, and wandering over neck and head to the left arm.[45] A patient of Fisher's had a feeling of "cold hands" at the beginning of a severe attack along with a sensation of pressure behind both eyes, hypersensitivity to light, and blurred vision.[174] Another patient of Fisher's felt that "he had icy, freezing, muddy pants on"[173] and a patient of Ulrich's reported that she had a feeling of cold feet preceding her headache attack,[620] a feeling echoed in two Migraine Art pictures (see figs. 96 and 110).

It is worth noting that some of the migraine patients' descriptions in medical literature and four of the ten Migraine Art pictures attribute the thermal sensations externally to natural forces like fire[411] (see fig. 72), the burning sun,[173] or ice (see fig. 110) and to man-made objects like "icy, freezing, muddy pants."[173] Adding two more categories of external attribution for thermal sensations, one Migraine Art picture shows an imaginary creature resembling an animal (see fig. 161) and another picture shows human-like imaginary creatures (see fig. 68). Similar metaphors have frequently been seen in the Migraine Art illustrations of pain-related cenesthesia (see "Pain-Related Bodily Awareness" above), so it is suggested that abnormal bodily awareness sensations in general are prone to be attributed by the migraine sufferer to "something from outside."[547]

▲ **Figure 162**

Migraine Art collection.

Vestibular sensations involving the sense of balance are defined as abnormal sensations of vertigo. It can be differentiated from common vertigo, where the environment or the subject seem to rotate, by its unusual and sometimes bizarre nature that makes the experience difficult to describe.[233] The Migraine Art collection includes only a single picture that fits this category. In figure 162 the migraine sufferer's posture shows that he has lost his sense of balance. His right arm reaches for the telephone, which seems to have slipped out of his hand, while his left arm reaches up toward the ceiling, which appears to be descending and closing in on him. The idea that abnormal bodily awareness sensations affecting the sense of balance are a rare manifestation of migraines is confirmed in the medical literature. In contrast to common vertigo, which has been reported by many authors as part of migraines and which is one of the symptoms used to diagnose basilar migraines, these vestibular sensations are only mentioned by a few authors as migraine aura symptoms. Mingazzini reports a patient with dysphrenic migraines who thought, during one of her psychotic episodes, that she was on a stormy sea and in danger of drowning.[411] Lippman records different varieties of "space-motion hallucinations" in migraine patients, who described them as sensations of an earthquake shock, various motions of the bed, acceleration of the entire body, and disturbances of balance and spatial sense while walking, with the "feeling that the left-hand side of an ordinary level floor or sidewalk gradually rises until I am forced to walk diagonally to keep my footing."[373] One of Todd's patients was occasionally conscious of a feeling "that she was going up or down a hill, when actually walking over flat ground."[615] Klee reports a female sufferer who felt, while lying in bed with a severe migraine attack, "as if the bed were rocking from side to side, and when she is of necessity obliged to walk for a short distance it feels as if the floor moves beneath her."[312] Fisher cites a patient who had "a sensation that the environment was rocking" and that the "floor seemed to be wavy as she walked."[173]

Chapter 7

Visual Disturbances

Visual disturbances are depicted in 426 Migraine Art pieces, accounting for seventy-six percent of the total collection of 562 pictures. The visual phenomena include various forms of visual loss, hallucinations, and illusions, either as isolated visual disturbances or occurring together, as enumerated in figure 163. *Visual loss* is the impairment of visual perception with areas of indistinct, obscured, or absent vision. *Visual hallucinations* are visual experiences occurring in the absence of external stimuli, and *visual illusions* are visual experiences resulting from the transformation of an external stimulus.

According to the picture's degree of realism, the Migraine Art pictures were divided into three categories illustrating visual symptoms (see table 7.1 in appendix B). The first category is a representation of what the artist sees during a migraine attack from the artist's own perspective. The seminal illustrations of Airy's visual migraine aura experiences[7] are the prototype of these "subjective representations" (see fig. 21), which have the greatest value as medical illustrations because they allow meaningful analysis of all the spatial features of the phenomena. The second category shows the visual experience together with the artist's eye, head, or whole body, as if both the vision and the artist could be seen by an outside observer, without deviating further from a realistic representation. The drawings of one of Gowers's patients[217] are the prototype of such "objective representations"[217] of visual migraine aura symptoms (see fig. 24). The third group, which can be labeled

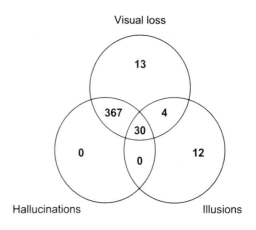

▼ **Figure 163**

Diagram representing the association between visual loss, visual hallucinations, and visual illusions in 426 Migraine Art pictures. The three overlapping circles depict the numbers of Migraine Art pictures showing the visual disturbances either alone or in combination.

"artistic representations," includes all illustrations of visual migraine experiences that deviate from realism in their composition, use of metaphors, or other artistic license, such as the use of visual patterns as background designs or figurative elements of the pictures. For medical study of migraines, however, realistic representations of the visual disturbances of migraine auras can be found not only in the subjective artworks but also in objective ones and even in the majority of artistic representations. The instructions in the four Migraine Art competitions were for participants to draw or paint "their own impressions" of "visual disturbance which herald a classical migraine attack" (see "History of the Four Migraine Art Competitions" in chapter 2), which encouraged a high degree of realism in the illustrations of the artists' "own impressions," meaning their subjective visual sensations.

By definition, subjective representations illustrate only visual symptoms. Objective and artistic representations provide the artist with the additional possibility of showing other manifestations of migraines. Table 7.2 in appendix B shows that visual disturbances can combine with all signs and symptoms of migraines with auras. For example, figure 101 shows visual disturbances along with a variety of other signs and symptoms. The artist writes:

Usually the migraine will start with a visual disturbance—then the headache comes on, starting in the frontal region and moving quickly across the top of the head, increasing in intensity of pain and settling in the back of the head slightly to one side. By this time I am conscious of intense pressure within my skull; nausea follows, the pain seems to be everywhere, and I wait to vomit. The act of vomiting I dread because the act of bending over is indescribable; I want to die. Then I feel very cold and start to sweat. Between bouts of vomiting I have "pins and needles" down my arms and legs. When the migraine finally starts to lift I am very exhausted but tense at the same time. In the picture I sought to describe in the bubbles the sequence of events as they occur. The dark area depicts the worst symptoms, the greatest pain. The sun represents the visual disturbance; the lightning, the feeling of the head being in two pieces.

The three categories of visual disturbances described above are considered in greater detail in the following sections on visual loss, visual hallucinations, visual illusions, and their impact on daily life.

Loss of Vision

Characteristics of Visual Loss

Various forms of visual loss have been reported in migraine sufferers as visual aura symptoms. *Blurred vision* refers to minor visual loss with difficulty focusing on objects. *Scotoma* means a spot of visual loss within the visual field that can vary in size and shape. *Absolute scotomas* are a complete loss of vision, and *relative scotomas* involve a partial loss of vision in the region of the spot. A *negative scotoma*[182] is when vision is absent in the area of the spot, often described by patients as a blank, a void, an emptiness, or nothingness.[584] It can best be perceived when it obscures an object viewed directly like a printed page, and it cannot be seen when the eyes are closed. The very beginning of a negative scotoma can only be detected when it starts during reading, initially obscuring just parts of a letter, then letters, and finally words and entire passages of the text. A *positive scotoma*[182] is when the vision is enhanced or enriched so that the spot is experienced as an area of darkness, a light, or an area of hallucinatory patterns, like a positive void. It can be seen with the eyes closed.[182] The term *scintillating scotoma*[134,378] refers to the pulsating movements of hallucinatory patterns appearing on the border regions of a negative or positive scotoma (see "Migraine Experiences in Medical Illustrations" in chapter 1). A scintillating scotoma either combines the features of a negative and a positive scotoma, qualifying as positive because of the hallucinatory patterns at the edges of the spot, or it is entirely a positive scotoma. An *asthenopic scotoma* is a spot on the visual field with "eye weakness," characterized by abnormal fatigue of visual function and after a time the disappearance of parts of objects or all objects in the visual field.[314]

These different forms of visual loss are illustrated in a total of 414 pieces of Migraine Art (see table 7.3 in appendix B). *Blurred vision* is seen in five pictures, three of them constituting the initial symptom of the visual aura.

Figures 164, 165, and 166

Migraine Art collection.

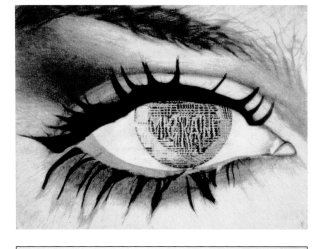

In figure 164 the artist was trying to convey "the blurred vision that a migraine sufferer experiences during (or before) an attack. Ordinary words will be blurred when trying to read them, and I chose the word *migraine* in the eye's pupil as the most suitable word to depict what the picture is all about."

Negative scotomas are shown in thirty-eight pieces of Migraine Art (see fig. 165). In twenty-four pictures, they appear in the center of a scintillating scotoma with its margins bordered by the typical zigzags of fortification spectra (twenty pictures) or visual hallucinations of other forms (four pictures). In ten pictures negative scotomas are shown without any other hallucinatory patterns; in three pictures they are masked by a completion phenomenon (see "Perceptual Completion" below) and in one picture by a "filling in" of the distorted image of a face (see "Distorted Shapes and Outlines" below).

Positive scotomas are shown in 405 Migraine Art pictures. They appear as black spots in forty pictures, as bright light phenomena in six pictures, and as spots enriched by a variety of visual hallucinations in 397 pictures. The difference between negative and positive scotomas can be seen by comparing figures 166 and 167. Figure 166 illustrates a scintillating scotoma on half of the visual field with typical zigzag formations at the margin of a blank, shown as a white area. This scintillating spot on the visual field combines the features of a negative and a positive scotoma. Figure 167 shows typical zigzag formations at the margin of a positive void depicted as a black area, so the scintillating scotoma here is a positive scotoma. The scintillating scotomas depicted in figure 168 are seen with the eyes closed, as shown by the sufferer's face inside the largest spot. The artist writes, "The migraine starts with a dark center, almost a

◀ **Figures 167 and 168**

Migraine Art collection.

hole with no depth, which changes to a vivid sparkling aurora that entirely fills my vision. I can even see it through the darkness of my closed eyes, but not so brightly. If it didn't bring with it headache and twenty-four-hour sickness, it would be a beautiful visual experience." In contrast to all the scotomas previously shown, which represent *absolute scotomas*, the spot on the visual field depicted in figure 169 is an example of a *relative scotoma*, with parts of the text and picture from a newspaper still visible inside the spot.

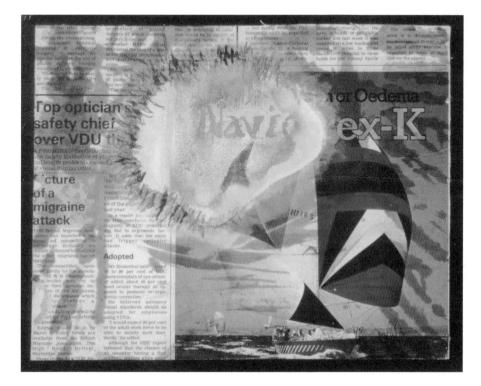

◀ **Figure 169**

Migraine Art collection.

▶ **Figure 170**

Migraine Art collection.

▼ **Figure 171**

The anatomic organization of the visual pathway from the retina to the visual cortex. Lesions of the visual pathway (a-g) produce defects in the visual fields as indicated in the right-hand portion of the drawing.

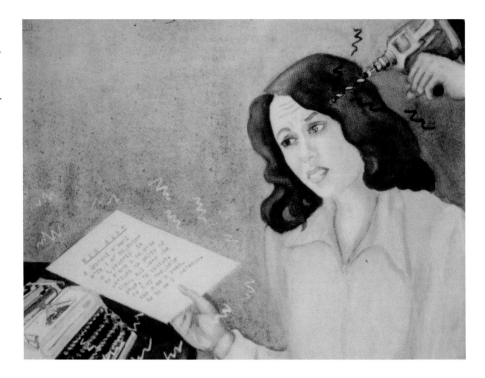

Asthenopic scotomas, which occur with vision fatigue, feature in five Migraine Art pictures. In figure 170 the artist is typing, experiences a severe migraine attack, and examines a sheet of paper from her typewriter. The text on the paper refers to the features of the visual disturbance that is apparent in viewing the text itself, namely an asthenopic scotoma: "A typical visual effect of migraine in typescript is to cause alternate letters or parts of them, all over the page, to vanish. As they reappear the same happens to those in between."

Loss of Vision in Specific Parts of the Visual Field

Disturbances along the visual pathways from the eyes to the back of the brain result in a number of typical defects in the visual field, as shown in figure 171. Almost all of these typical forms of visual loss, plus a number of additional ones, can occur as visual migraine aura symptoms.

Monocular Visual Loss

"Loss of vision of one eye" is described by one artist in text written on his picture as well as in three other Migraine Art pictures. The visual disturbances are represented in the shapes of the sufferers' eyes, suggesting that visual loss affects only one eye. It is a common medical experience that sufferers are often convinced that only one eye is affected, but further testing shows that visual loss is in both eyes and on one side of the visual field rather than in one eye. Nevertheless, visual loss in one eye rarely occurs as a migraine aura symptom. Visual loss in one eye can occur in a special form of migraine that has been called a "retinal migraine"[204] or an "ocular migraine."[100] Appleton et al. describe recurring episodes of sudden temporary loss of vision in one eye as a type of migraine in teenagers.[21] The other possible diagnosis to be considered in these cases is temporary blindness ("amaurosis fugax") from a blocked blood vessel as a warning of an impending stroke, so a thorough neurological examination is necessary in such cases.[663]

Heteronymous Hemianopias

As illustrated in figure 171, the optic nerve fibers partially cross in the brain's chiasm region, with half continuing on the same side and the other half crossing to the opposite side. A disturbance involving the site where the fibers cross results in loss of vision in the temporal or outer half of each visual field in each eye, called a bitemporal hemianopia. A disturbance of the optic-nerve fibers that do not cross, which rarely occurs on both sides, produces a binasal hemianopia, or loss of vision in the nasal or inner half of each eye's visual field. These types of visual field defects are called "heteronymous" because one eye's visual field shows loss in the right half, and the other eye's visual field shows loss in the left half. The migraine literature includes only few reports of bitemporal hemianopia[81,194,436,466] and a single report of binasal hemianopia, described by Féré in one of Charcot's patients.[165]

Each of these rare symptoms is represented by a single piece of Migraine Art. Figure 172 illustrates the sufferer's view of a rural scene constricted by loss of vision in the outer half of each visual field (bitemporal hemianopia),

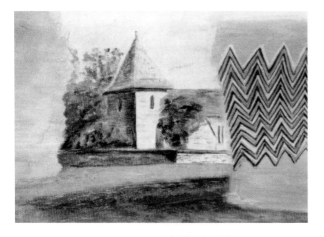

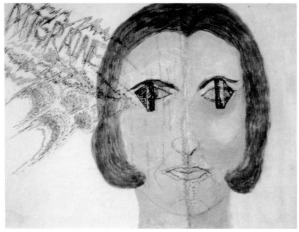

with the visual disturbance on the right having multiple parallel colored zigzags. The artist writes:

This picture shows partial blockage of vision, where a gray area actually blocks the sides of vision, leaving an area in the middle of vision. Then through the gray area, starting on one side, brightly colored zigzag lines appear, as shown in the picture. These lines—which I was not able to show in the picture—then arc over the top and travel round the other side, flickering all the time, so you end up with a half moon effect of flickering zigzag lines for up to forty-five minutes. Then it all fades, and normal vision is restored. This may or may not be followed by a headache of varying severity. Sometimes there is no real headache, and I just don't feel brilliant for an hour or two afterwards.

In figure 173 the sufferer's visual fields of both eyes are schematically depicted by separate diagrams indicating loss of vision in the inner half of each visual field in each eye (binasal hemianopia).

Homonymous Hemianopias

Disturbances of the visual pathways behind the part of the brain where the optic nerves cross—the optic chiasm (see fig. 171)—result in various forms of homonymous hemianopias, in which vision is lost in the same half of each visual field in each eye. The first description of temporary loss of vision of this kind was reported in 1723 by Vater and Heinicke in a medical thesis at the University of Wittenberg in Germany.[624] In a paper presented to the Royal Society of London in 1824, Wollaston described his own experience of temporary loss of vision in the same side of each visual field. He theorized that the optic nerves must cross,[659] as was later proved to be

the case, to explain "the long-agitated question of single vision with two eyes." His is a prominent instance where brain mechanisms could be understood based on migraine experiences.[361] Wollaston's account of losing vision in the same side of each visual field explained its effects on seeing faces, objects, and words: "I suddenly found that I could see but half the face of a man whom I met; and it was the same with respect to every object I looked at. In attempting to read the name JOHNSON over a door, I saw only SON; the commencement of the name being wholly obliterated to my view."[659]

Wollaston's paper[659] was cited in Brewster's *Letters on Natural Magic*,[73] dated 1842, in which the author commented on some of the effects of losing vision in the same side of each visual field, emphasizing the tendency of patients to attribute the visual disturbance externally:

> *That state ... in which we lose sight of half of every object at which we look, is more alarming and more likely to be ascribed to the disappearance of the object than to a defect of sight.... There are many occasions on which this effect ... might alarm the person who witnessed it for the first time. At certain distances from the eye one of two persons would necessarily disappear; and by a slight change of position either in the observer or the person observed, the person that vanished would reappear, while the other would reappear in his turn. The circumstances under which these evanescences would take place could not be supposed to occur to an ordinary observer, even if he should be aware that the cause had its origin in himself. When a phenomenon so strange is seen by a person in perfect health, as it generally is, and who has never had occasion to distrust the testimony of his senses, he can scarcely refer to it to any other cause than a supernatural one.*[73]

▼ **Figure 174**

Migraine Art collection.

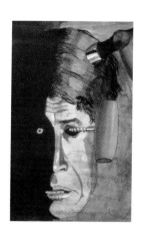

Loss of vision in the same side of each visual field (homonymous hemianopia) is illustrated in thirty Migraine Art pictures. This appears as an absolute loss of vision, with a blackout in half the visual field, in three pictures (see fig. 174) and with a variety of visual hallucinations in the lost visual field in twenty-three pictures (see fig. 55). A relative loss of vision, with blurred vision in half the visual field, is seen in two pictures (see fig. 175). Two other Migraine Art pictures show absolute or relative loss of vision in half the visual field with the visual illusion of several images

▶ **Figure 175**

Migraine Art collection.

▼ **Figure 176**

Migraine Art collection.

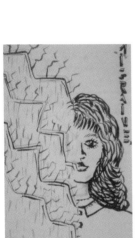

of the same object confined to the area of lost vision (see "Polyopia" below). Five Migraine Art pictures represent mirror images of loss of vision in half the visual field. Figure 176:

> *was of myself, looking into a mirror during a migraine attack. When looking straight ahead at a subject or person, their right side (in the left half of my field of vision) is obscured by lightening-like interference as represented in the picture; everywhere I look is only half visible. Closing my eyes does not get rid of the flashing lightening. After approximately thirty minutes, vision becomes normal and pain begins.*

Homonymous Quadrantanopias

A loss of vision restricted to one quadrant in the same part of each visual field has only rarely been reported as a migraine aura symptom.[84,240,352,356,542] The Migraine Art collection includes a single example of this type of visual loss, seen in figure 177, where the upper-right quadrant of the sufferer's visual field is obscured by a blank on the visual field (negative scotoma).

Altitudinal Hemianopias

An altitudinal hemianopia is defined as visual loss involving both upper or both lower quadrants of each visual field in each eye. Both upper and lower altitudinal hemianopias have been observed as migraine aura symptoms.[74,84,134,173,203,220,221,240,261,330,352,436,654] A patient of Koenig's, experiencing loss of vision in the lower part of both eyes' visual fields, was irritated by seeing only the heads of the people standing around him,[330] and one of Wilson's patients, with loss of vision in the upper part of both eyes' visual fields, complained that he "could not see above the waists of persons coming towards him."[654] Altitudinal hemianopia appears to be a rare disturbance, as seen in the personal experience of Lashley, who observed a complete blindness in both lower quadrants only once in more than a hundred migraine attacks.[352]

Loss of upper or lower vision of each visual field in each eye is illustrated in four Migraine Art pieces, involving two pictures of upper field loss and two pictures of lower field loss. Figure 96 shows the female sufferer sitting on a park bench and experiencing a "missing half" of vision in both upper quadrants. Similarly, figure 178 shows a mother trying to watch

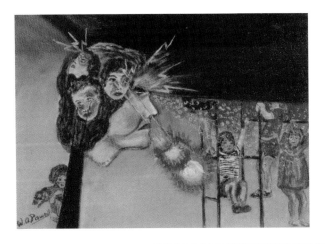

over her children despite suffering impaired vision in the upper part of her vision together with some zigzag hallucinations in the area of visual loss. In figure 179 the "half vision" depicted by another female sufferer involves a loss of vision in both lower quadrants. A lower-quadrants loss of vision is also illustrated in figure 141, seen in the shape of the sufferer's eye at the bottom of the picture.

▲ **Figure 178**

Migraine Art collection.

▶ **Figure 179**

Migraine Art collection.

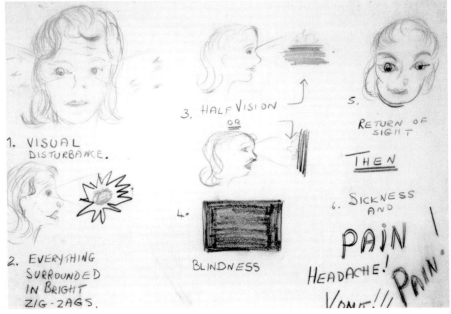

Cortical Blindness

Cortical blindness is a total loss of vision in both eyes. Elliot records complete blindness in twelve of three hundred migraine sufferers:

> *A more alarming symptom … was complete blindness. As far as one can discover, this, in the majority of cases, comes on gradually, though fairly rapidly, but in at least three of the twelve it was described as sudden. The complete failure of sight varied from five minutes to half an hour, and might follow general blurring of vision or hemianopia [loss of vision in half the visual field] or commence without any such warning.*[158]

Total loss of vision is unambiguously represented in three Migraine Art pictures. In figure 179 the sufferer experiences a sequence of visual disturbances terminating in complete blindness, similar to the gradual development described by Elliot.[158] In figure 178 one of the three children whose heads are superimposed on the head of their mother appears to be completely blind, indicated by the black area of the child's field of vision. In the stylized portrait of a migraine sufferer's head in figure 77, complete blindness is suggested by the same means. In another forty-five Migraine Art pictures, the complete visual field, represented subjectively in the picture, appears obscured by hallucinations, but it is not possible to determine whether this apparently complete visual loss represents cortical blindness or whether it is the sufferers closing their eyes.

Bilateral Central Scotomas, Ring Scotomas, and Concentrically Contracted Visual Fields

Spots on the center of each visual field in each eye (bilateral central scotomas), ring-shaped spots on the visual fields (ring scotomas), and tunnel vision (visual fields that contract concentrically) have all been described as visual migraine aura symptoms.[20,41,44,81,415,463,673] They are discussed together in this chapter because they may occur sequentially during a migraine attack. Only the bilateral central scotoma appears in the standard textbook diagrams of typical defects in the visual field caused by focused brain disturbances (see fig. 171). Before discussing the correlations with the two other types of visual loss, the evidence from the Migraine Art pictures warrants examining.

Figure 180 depicts a landscape with a white circular area in the center of the picture, representing the experience of a typical negative central spot on the visual field. In such central scotomas, the center of the visual field appears to be punched out, resulting in a condition called "doughnut vision" or "bagel vision."[554]

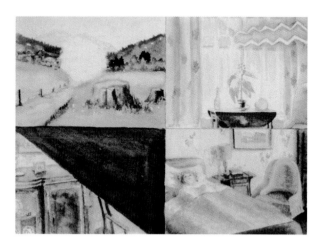

▲ Figure 180

Migraine Art collection.

▶ **Figure 181**

Migraine Art collection.

In a sequence of four pictures, figure 181 illustrates the symptoms experienced during a migraine aura, first with an expanding central spot on the visual field which is followed by a ring-shaped spot. The artist, who has a history of migraine auras without headaches, describes her picture:

The picture represents, in three stages, the total sequence of visual disturbances I repeatedly went through over a period of around twenty-five minutes, in this case illustrating a view of the field of vision while reading the newspaper, where I noticed it first occurring. The picture was a challenge. I enjoyed creating it as it was such a vivid and well-defined and predictable occurrence and followed always the same pattern and time span. Circle 1 shows a small "blind" circular area with a point at center "spinning," with pinpoints of color which gradually enlarge to give a larger circle of blindness with withering strands of bright colors revolving around central point and very intense around the circumference. Gradually, from the center the vision returns until a final, larger circle with spinning colors only on the periphery occurs and gradually fades, leaving pure unaffected vision. I tried to represent this weird process which in my case was unaccompanied by any other disturbance of vision or any other cerebral impairment. I even awoke on one occasion to find the process half way through. I suppose between

1959 and 1970 I had perhaps seventeen or eighteen attacks and never had one since, nor suffered from any form of headache.

Figure 182, consisting of a series of six pictures, illustrates a positive central spot on the visual field (picture 2), followed by a ring spot on the field (pictures 3 and 4), and then a concentrically contracted field (pictures 5 and 6), a sequence previously recorded by Möbius.[415] It is assumed that the artist has represented the central point of vision to be near the left lower corner of the picture, so that only parts of the field defects are shown. Figure 183, painted by a professional artist, represents a stage in the sequence of symptoms during a visual migraine aura, starting with a central spot on the visual field, followed by a ring scotoma which then appears to break on the left, as illustrated, then proceeding farther toward the edge of the visual field, as is typical with fortification spectra. The artist writes:

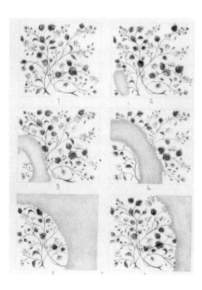

▲ **Figure 182**

Migraine Art collection.

▼ **Figure 183**

Migraine Art collection.

▲ **Figures 184 and 185**

Migraine Art collection.

I am made aware that a migraine attack is imminent by a small solid-blue spot in the center of vision. After a minute this spot enlarges and is encircled by a thin glittering bracelet; both merge, and over the course of twenty minutes or so, enlarge into a ring of glittering blue/white/yellow, through which I can clearly see. The ring usually breaks on the left, getting wider and wider until it disappears from the edge of vision to the right. The glittering, or flashing, is generally made up of angular, sharp, or pointed shapes, usually in the three colors but sometimes including red, although not often. The shapes within the ring are repetitive and fairly constant; where the ring breaks, there is intense activity and shapes that are difficult to see or formulate. Vision through the ring is clear and there is no apparent change in the actual colors seen through it. Colors and shapes contained within the ring are easier to see when looked at against a dark background; when looking at the sky, white and yellow virtually disappear and the blue almost turns to black.

The artist mentions that his visual symptoms are consistent during his recurring migraine attacks, and this is confirmed by two more of his pictures of essentially the same visual patterns (see figs. 184 and 185).

In the five pictures described above (see figs. 181–185), a ring-shaped spot on the visual field is preceded by a central scotoma, then followed by either a concentrically contracted field (see fig. 182) or by a broken ring

structure further expanding in the typical way that fortification spectra expand (see figs. 183–185). Representations of ring-shaped scotomas without information on the preceding and succeeding stages can be seen in Figs. 186 and 187, the second picture titled *Tunnel Vision* by the artist.

Concentrically contracted visual fields, also referred to as tunnel vision, peephole

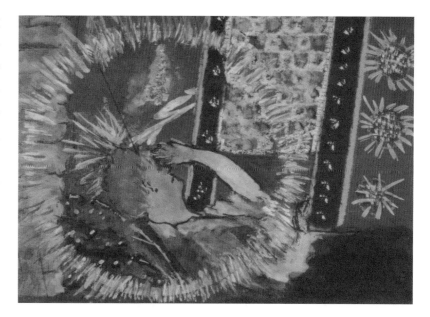

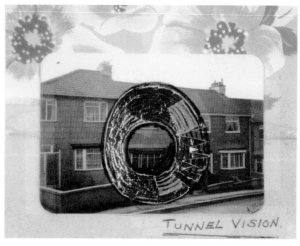

vision, or pinhole vision, are shown in ten Migraine Art pictures. As in the previous examples, a visual aura that starts with a central spot on both visual fields and then a ring-shaped spot on the visual field may terminate in tunnel vision (see fig. 182). Figure 188 depicts the sufferer's concentrically contracted field of vision while reading a newspaper article on migraines. The border of the tunnel is formed by a ring-shaped zone of decreased vision. A single silvery, glimmering random shape can be seen in the lower part of this border. The same artist illustrates concentrically contracted fields experienced while reading (see fig. 189) and driving a car (see fig. 190), with a fortification spectrum (see fig. 189) and further visual loss (see fig. 190) in the area of the tunnel. Three other pictures illustrate tunnel vision with multiple images of the same object (see fig. 191), loss of vision in half the visual field with perceptual completion (see fig. 192), and loss of vision in half the visual field with gratings formed by parallel zigzags (see fig. 193) in the area of the tunnel. About figure 194 the artist writes:

▲ **Figures 186 and 187**

Migraine Art collection.

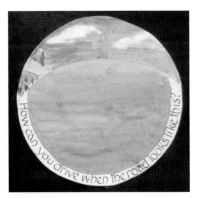

▲ **Figures 188, 189, and 190**

Migraine Art collection.

▶ **Figure 191**

Migraine Art collection.

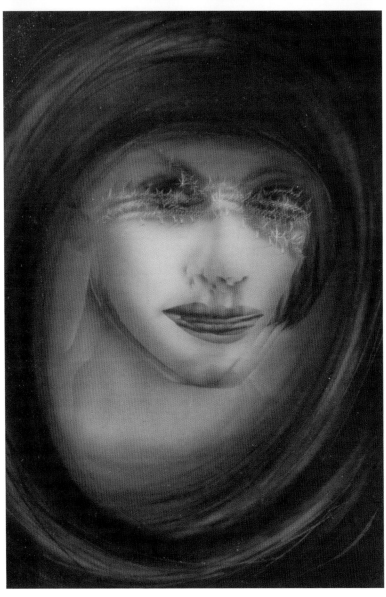

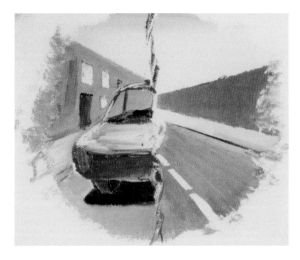

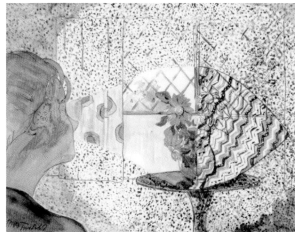

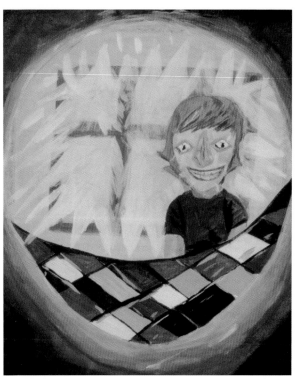

The circle is the field of vision, which is a tunnel becoming progressively smaller as the migraine progresses, until it is just a pinpoint of light. The "diamonds" along the bottom are the flashing, very bright colored lights that come and go during a migraine. The white and black lines represent the flashes. These "diamonds" can occur anywhere, even in the circle of the tunnel. The white light coming through the window is sharp and pointed because it is too bright and hurts the eyes, like slivers of glass or icicles piercing them.

In figure 195, painted by a professional artist, the visual field is concentrically contracted by black-and-white checkerboard patterns. He writes:

The picture is of an attic kitchen, two chairs and a table, with a window behind. The picture was an attempt to depict the full-blown effect of the visual disturbance during that phase of the attack. Obviously I don't see "op art style" patterns as such, but the disturbance is sharp-edged in detail (though constantly flickering) and there is a strong positive to negative interchange. The shimmering can start anywhere, but always expands clock-

▲ **Figures 192, 193, and 194**

Migraine Art collection.

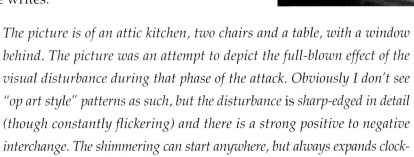

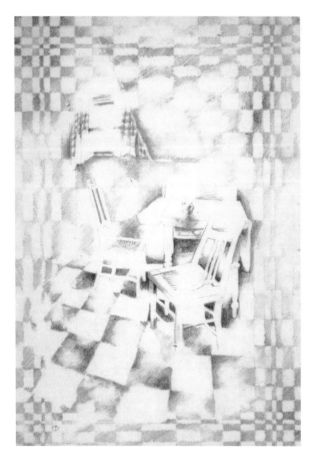

▲ Figure 195

Migraine Art collection.

wise. It appears predominantly on the edges of vision, but it is not as discrete as a tunnel; it is more like a frame. And while my vision remains in color, the actual disturbance does seem to be predominantly monochrome, with sharper definition from light to dark than what I am actually looking at. This is very disorienting; the world outside is colored, and in my head it's light and (monochrome) dark, those patterns seemingly taking on the color of the things that they are disrupting. In addition to the areas of shimmer, there are shifting blanks of what appear to be light at exactly the predominant pitch of the light outside. These blanks usually precede the full-blown attack, often by some hours or by as much as a day. I can't rely on them as signals, however, as often they seem to be the whole attack in themselves, at least as far as visual disturbance is concerned. I can have several of these a week (I think of them as petit *migraine) while I only suffer* grand *migraine about once a month, or after a specific trigger, which is usually release of tension, and occasionally bright lights.*

Figure 89 combines a self-portrait of the artist surrounded by barbed wire attached to wooden stakes as a symbol of the ongoing migraine attack, along with a representation of her visual experiences during the attack. The visual disturbances and other symptoms are described by the artist in text at the bottom of her picture: "Light that dazzles—flecks of bright colors—wavy lines—gray shapes moving upwards—view constricted by moving circles—extra sharp hearing—rolling, thundering noise—endless movement." Both the picture and the artist's description indicate a concentric contraction of the visual field by the moving circles. The "rolling, thundering noise" refers to a sensation of noise (tinnitus) heard as an accompanying symptom of the migraine attack, which is a symptom typical of basilar migraines. It is interesting to compare the artist's text, which

is a sober-minded record of the experience, with her description provided sixteen years later in response to the follow-up. The original experiences of her migraine attack appear to have transformed into a meaningful mystical experience, which relates to the idea of migraines being the basis of mystical visions, as discussed earlier in chapter 1. The now eighty-three-year-old artist writes:

Looking out of the entrance from a cave, a lump of rock guarding the view to the distant seascape and setting sun, with just a glimpse of land—an enormous feeling of movement from rocks, and plants, and stones, and restless sea rushing onshore, curious bird shapes with swordlike beaks guarding the exit and making tremendous noise and moving always in circles, nothing seems quiet or still and the circular shape of the cave entrance seems to move inwards until the setting sun almost vanishes and all is misty and distant and dreamlike. Having not seen this picture for so long, it still seems to have a feeling of endless movement and energy. Even the so-called rock can move.

Concentrically contracted "tunnel vision" visual fields are described as a migraine aura symptom by a few authors. Berbez reports the case of a migraine patient who experienced a gradual contracting of his visual field until the area visible was only large enough to see the face of his clock.[44] As the field of vision contracted further, the edge of the clock and all its numbers disappeared, finally ending in pinhole vision where only the center of the clock was visible. One of Gowers's patients "experienced a premonition which consisted of a concentric contraction of the field of vision, which became restricted to a small spot in the middle of the normal field."[222] Barolin published an illustration of a migraine sufferer's concentrically contracted field of vision.[35] Other authors have briefly mentioned tunnel vision without further details.[66,174,314,436,522,529,553] In the medical literature of the nineteenth century, tunnel vision was frequently dismissed as a symptom of hysteria, and Galezowski,[203] Charcot,[92] Babinski,[31] Fink,[171] and Krafft-Ebing[336] all report tunnel vision in migraine patients and assume the origin was hysterical. Contracted visual fields were finally recognized as neurological symptoms in the studies of the effects of gunshot brain

injuries during the First World War.[273] Hysterical and neurological tunnel vision can be differentiated medically:[617] The main characteristic of contracted visual fields caused by neurological issues, as opposed to hysterical tunnel vision, is that the visual field widens with increasing distance, which is easily tested. This widening with distance is clearly illustrated in one Migraine Art picture (see fig. 193), with the artist on the left side and "the vision I would have if I looked out of a window on a migraine day." Teuber et al. record a jagged outline of the contracted visual fields of patients with gunshot wounds to the brain,[613] in contrast to the smooth contours of tunnel vision in hysterical patients, and they claim this is another way to distinguish between the two. However, this criterion does not apply to the contracted visual fields of migraine sufferers, which are most often depicted with smooth contours in the Migraine Art pictures.

As previously noted, most medical textbook diagrams do not account for where brain dysfunctions happen that result in ring scotomas and concentrically contracted visual fields. Holmes,[272] Spalding,[595,596] and Teuber et al.[613] say that central spots on the visual field, certain ring-shaped and arc-shaped scotomas, and concentrically contracted visual fields can be explained by the projection of concentric zones of the visual field: Most peripheral zones of the visual field are assumed to be processed in the most forward part of the brain's visual processing area, called the brain's calcarine fissure; the center of the visual field is processed toward the rear, in the area called the occipital pole. The concentric zones of the visual field explain the development of a central scotoma progressively expanding toward the edges (see fig. 226), a central scotoma followed by a ring scotoma (see fig. 181), a ring scotoma (see fig. 187), contracted visual fields (see figs. 188–195), the development of contracted visual fields starting in one part of the visual field and progressing clockwise along a concentric zone (see fig. 195), and contracted visual fields progressing from the edges toward the center (see fig. 89).

Other Forms of Visual Loss

Two pictures by the same female artist illustrate a form of visual loss that can be described as a loss of vision in half the visual field with a diagonal

border splitting the visual field into two parts. In figure 180 the artist has depicted the upper part as totally obscured. In figure 196 two wavelike shapes appear in the upper part of the field with loss of vision, and there is a large negative central spot on the field of vision (scotoma). As mentioned in the 1984 film *The Art of Migraine,* this distribution of visual loss has not been recorded before as a symptom of migraines or any other neuro-

▲ **Figure 196**
Migraine Art collection.

logical disorder. The features of this form of visual loss are not compatible with the current medical concepts of how the visual pathways work. It is important to record such unexpected features of visual field defects because they present problems that future studies must deal with.

Perceptual Completion

The perceptual completion phenomenon happens when the part of the visual field with visual loss appears complete or filled in. It is a basic illustration of the well-established fact that visual perception involves past experience and expectations complementing and enriching visual signals so that we can see meaningful objects and scenes.[230,541] Perceptual completion has been recorded happening in physiological blind spots as well as different types of spots on the visual field (scotomas). Loss of vision in the same side of each visual field (homonymous hemianopias) shows the best evidence of perceptual completion.[196,197,208,520,579,633] Most commonly it involves simple symmetrical geometric figures, such as lines and crosses, but complex images have also been documented.[634] Recent studies show that perceptual completion occurs in the central visual system by interpolating visual information from the borders of the spot on the visual field. Stimulation from the adjacent pattern allows the completed image to be seen.[209,524]

A model of how the perceptual completion phenomenon works is provided by the normal process of filling in the retina's blind spot, also called

Mariotte's spot. The blind spot is not normally seen: When looking at a large evenly colored surface, there is no hole in the image that corresponds to the retina's blind spot; when looking at a printed page the blind spot also appears filled in.

Perceptual completion in migraine sufferers has rarely been documented in the medical literature. The Swiss ophthalmologist Dufour, who gave an account of his own visual migraine aura experiences[148] in a letter published in Hubert Airy's seminal study[7] on zigzagged visual hallucinations during migraines (teichopsia), was the first author to record perceptual completion, similar to what happens for the blind spot, in a spot on the visual field during a migraine. "During the first moments of this transient impairment," writes Dufour, "the central lacuna [blank spot] isn't a dark lacuna, it is rather a lacuna of nonvision, and a sufferer with whom I recently talked about it, himself a physician, thought that he could realize, at the boundary of said lacuna, similar phenomena on angular or crossed figures as one observes on [the retina's blind spot]."[148] As an example of perception across the retina's blind spot, Dufour notes that "when a known figure like a cross has its center in [the blind] spot, while the branches pass on all sides beyond the boundaries of the spot, the sensation of the branches is sufficient to reproduce for us the entire cross,"[148] as is shown in experiments by Volkmann[628] and by Wittich.[657] Keller, who was aware of Dufour's paper,[148] also clearly describes perceptual completion in spots on the visual field during migraines: "The sufferer completes the area of visual loss of the smaller scotomas in his perception, as we do it physiologically with our blind spot."[306]

Lashley conducted more detailed study of perceptual completion in spots on the visual field during migraines.[352] His seminal 1941 paper was cited extensively in chapter 1. One part of the paper was his personal observations of the "completion of figure" in spots on the visual field without scintillations during a migraine. He wrote:

A negative scotoma may completely escape observation, even when it is just off the macula [the part of the retina responsible for central vision], unless it obscures some object to which attention is directed. Talking with a friend, I glanced just to the right of his face, whereon his head disappeared. His

shoulders and necktie were still visible, but the vertical stripes in the wall-paper behind him seemed to extend right down to the necktie. Quick mapping revealed an area of total blindness covering about thirty degrees, just off the macula. It was quite impossible to see this as a blank area when projected on the striped wall or other uniformly patterned surface, although any intervening object failed to be seen.

On another occasion, with complete hemianopia [loss of vision in half the visual field], including the macula, it was possible to divide a complex object on any line of fixation. A human face was sharply divided by fixating the tip of the nose, so that half, including one nostril only, was visible. At the same time it was impossible so to fixate a circular object so that only half was seen. Fixating a chalk mark on the middle of a billiard ball failed to make any part of the ball invisible, although the ball was considerably larger than the readily divided nose.

These observations are of interest as showing that filling in the blind spot and the completion of figures in scotomatous areas are not the result of habits of disregarding blind areas or of identifying part figures. The phenomena appear immediately with new blind areas. They must, then, represent some intrinsic organizing function of the [brain's] cortex. The figures completed are reduplicated patterns or very simple symmetric figures.[352]

Lashley describes only two examples of perceptual completion that stood out in his experience because he had the opportunity for careful observation.[352] Some further examples of Lashley's experience were related in an article by Teuber, who writes:

In recording and plotting these episodic disturbances within his own visual field, Lashley noted completion effects for checkerboard and wallpaper patterns whose repetitive lines seemed "filled-in" across the acute functional gaps in his field. Similarly, he related experiences such as the following: While he was traveling by car on a straight Florida highway, a migraine attack set in, with a small paracentral scotoma [spot near the center of the visual field] developing in such a way that appropriate shifting of gaze would make a pursuing highway patrol car disappear, while the road itself, as well as the rest of the landscape, remained subjectively continuous.[612]

In a footnote, Teuber adds some further information on one of the examples of perceptual completion described in Lashley's paper:

In discussing these and similar completion effects recently in front of a former colleague of Lashley's, Dr. Edward Dempsey, the latter recalled an episode in the Harvard Faculty Club when Lashley suddenly exclaimed, "Dempsey, I have just beheaded you"; and, "but I can still see the wallpaper pattern behind you."[612]

The story of Lashley "beheading" his colleague Dempsey by means of a spot on the visual field during a migraine brings to mind the Queen of Hearts in Lewis Carroll's first Alice novel, with her repeated shouts, "Off with his head!" and "Off with her head!" According to the Gryphon, "It's all her fancy, that: They never executes nobody, you know."[88] If the visual phenomenon illustrated in the frontispiece of Carroll's family magazine *Mischmasch* (see fig. 13), where parts of a head and body appear to be scraped away on the right side, was inspired by Carroll's personal experience of a spot on his visual field (scotoma) during a migraine (see "The Migraine Experiences of Lewis Carroll" in chapter 1), it probably would not have escaped Carroll's notice that a shift of his gaze would have made the head completely disappear, allowing him to play the private game of "beheading" other people, similar to his Queen of Hearts. Klee suggests an episode in Carroll's second Alice book, *Through the Looking Glass*, is also similar to the description of a negative spot on her visual field that moved when her eyes moved and showed perceptual completion:[315] Alice noticed a peculiar difficulty when looking directly at the objects on sale in a grocery shop. "The shop seemed to be full of all manner of curious things—but the oddest part of it all was that, whenever she looked hard at any shelf, to make out exactly what it had on it, that particular shelf was always quite empty, though the others round it were crowded as full as they could hold."[89]

Three other reports from the medical literature on perceptual completion in spots on the visual field during migraines merit consideration. Ekbom confirms Lashley's observation "that a negative scotoma like the blind spot is 'filled out' by the background.... When I look at a yellow

wallpaper, the scotoma seems to be yellow too and there is no spot on the wall. But when I look at the picture on the wall the scotoma takes away part of it."[157] Grüsser reports that "a spatially periodic stripe pattern 'fills in' the migraine scotoma."[235] In an account of his personal migraine experiences, West writes:

> *For example: I am not aware that I am failing to see something which is there, in the zone of blindness, I may not detect the zone at all, partly because (oh, neural bag of tricks!) it's been filled by another bit of the brain. If, say, one happens to look at a TV screen, it may disappear in whole or in part, only to be replaced by the wall behind it, while the stand it squats on remains visible throughout. Such vicarious self-help by the brain evokes some of the transferences of function which brain-damaged people have achieved and suggests cerebral versatilities as yet unexplained. Surely, though, memory does some of this filling-in, even on the strength of only a few seconds' acquaintance with the furniture of a particular room.*[639]

The Migraine Art collection includes three illustrations of perceptual completion in spots on the visual field. In the upper half of figure 197, created by a thirty-one-year-old female sufferer with a history of migraines with typical auras, the artist depicts an experience while looking at her mother, a part of whose face is replaced by the corner of a picture hanging on the wall behind her. Turning toward her sister, a wall calendar is similarly replacing her face. This curious experience, "as if I could look behind the heads of my mother and sister," was due to perceptual completion immediately filling in the images adjacent to the spot in the left upper quadrant of the artist's vision. The visual disturbance lasted for twenty minutes and was followed by numbness on both sides of her tongue and lips and numbness on the left side of her face and left arm, which disappeared after thirty minutes. There was no accompanying headache, nausea, or vomiting.

Figure 54 is another example of perceptual completion occurring across the area of a negative spot (scotoma) on

▼ **Figure 197**

Migraine Art collection.

the visual field. The fourteen-year-old artist depicts a situation in a chemistry class at school. On the right side, parts of the teacher's face, neck, and shoulder are missing, with the residual contour forming the shape of an arc. The writing in the top right corner of the blackboard behind the teacher is reduced to scribble. These white scribble patterns also fill the area where the teacher's body has been "scraped away." Altogether the area of white scribble is a large oval, representing the not uncommon shape of a spot on the visual field during a migraine.

Figure 192 represents an example of perceptual completion across half of the field of vision. The picture illustrates a driver's concentrically restricted view as he travels along a road a short distance behind another car. The remaining field of vision inside the "tunnel" is split vertically by a series of colored lines. In his right visual field, the side of the car in front is completely missing, and a row of houses shows a considerable lack of detail. In the area where the right half of the car is lost, the white lines on the road, as well as its texture and color, appear "filled in," echoing Lashley's experience while driving on a Florida highway[612] mentioned above.

Perceptual completion in circumscribed scotomas or half-field visual defects during migraines, which was only documented a few times in the medical literature, is supported by the evidence from three Migraine Art pictures. According to the reports of migraine sufferers, perceptual completion in spots on the visual field appears immediately after the onset of visual loss caused by the focused brain disturbance of migraine auras; that means it represents some "intrinsic organizing function of the [brain's] cortex."[352] It may last as long as the migraine aura, usually several minutes.[352] In the medical literature and the Migraine Art collection, perceptual completion occurs in a variety of configurations, including solid colored areas[157] and simple geometric figures like broken lines on the road (see fig. 192), vertical wallpaper stripes[352] or other stripe patterns,[235] angles and crosses,[148] circular objects,[352] and also complex images such as a road and landscape in the surrounding environment,[612] a piece of furniture,[639] a picture and a calendar hanging on a wall (see fig. 197), and lines of handwritten scribble on a blackboard (see fig. 54). The completed complex images are of objects or scenes in the person's environment at the time of

the visual disturbance: They are familiar from past experience, even if that experience is "only a few seconds' acquaintance with the furniture of a particular room."[639] Perceptual completion in migraines thus appears to confirm Poppelreuter's original idea that the phenomenon is "imaginative completion,"[520] with its emphasis on the importance of past experience and expectation.

Visual Hallucinations

Visual hallucinations, defined as sensory experiences without an external stimulus, can occur in a variety of situations, including while falling asleep and waking up, which are called "hypnagogic hallucinations" and "hypnopompic hallucinations," and in medical conditions such as sensory deprivation, intoxication, and eye, nerve, and psychiatric diseases. Psychiatric disorders are just one of many reasons for hallucinations. The visual hallucinations of the migraine aura are perhaps the best demonstration of the well-established fact that hallucinations can happen in sane people. Contrary to popular belief, hallucinations do not imply insanity, as was suggested by the sixteen-year-old artist who used the title *Migraine Madness* for his picture of a scintillating scotoma (see fig. 56) and by another sufferer who depicted two men in white coats ready to take her away to an asylum (see fig. 110).

In the following sections on the various types of visual hallucinations illustrated in Migraine Art, an analysis of the kinds of shapes, colors, movements, and other characteristics is followed by a discussion of how visual hallucinations occur.

Shapes Seen in Hallucinations

The terms *teichopsia*[7] and *fortification spectrum*[217] both mean the typical migraine aura zigzags that look like the plan of a fortified town (see "Migraine Experiences in Medical Illustrations" in chapter 1), and both terms refer to the "form dimension"[583] or shape of visual hallucinations. However, a review of case reports in the medical literature shows that the

visual hallucinations of migraine auras may take a variety of other forms, as summarized in table 7.4 in appendix B. Sacks was the first author to clearly recognize that migraine aura hallucinations may be made up of all the typical shapes of visual hallucinations[556] described by Klüver[322] and other authors[583] in drug-induced imagery. This provided a frame of reference for understanding the mechanisms of how visual hallucinations occur (see "How Hallucinations Occur" below).

In this section the visual hallucinations depicted in a total of 397 Migraine Art pictures are classified according to shapes seen, using the classification system of Siegel and Jarvik for evaluating drug-induced imagery[583] (see table 7.5 in appendix B). This classification allows more detailed description of visual hallucinations than in the traditional categorization of visual hallucinations as "unformed or formed" and "elementary or complex." The nine categories of shapes along with examples that illustrate them are described by Siegel and Jarvik:[583]

> *Random:* blobs, amorphous shapes, blurry patterns, watery patterns with no definite design, etc.; any form that cannot be classified in the other categories.
>
> *Line:* herringbone patterns, zigzags, polygons, all angular figures without curves or rounded corners, crosses, etc.
>
> *Curve:* circles, ellipses, parabolas, hyperbolas, sine wave patterns, fingerprint whorls, spheres, balls, scribbling, etc.
>
> *Web:* spiderwebs, nets, unsymmetrical lattices and filigrees, veins, etc.
>
> *Lattice:* lattices, gratings, grids, screens, fretwork, checkerboards, honeycombs, etc.
>
> *Tunnel:* tunnels, funnels, alleys, cones, vessels, pits, corridors, etc.
>
> *Spiral:* spirals, pinwheels, springs, etc.
>
> *Kaleidoscope:* kaleidoscopes, geometric circles (mandalas), symmetrical snowflakes, lacework, mosaics, symmetrical flowerlike patterns, etc.
>
> *Complex:* any recognizable image such as faces, people, landscapes, panoramic vistas, animals, inanimate objects, cartoons, etc.

Multiple shape categories were assigned to a picture if: (1) the patterns comprised a single basic shape with features of more than one kind of

shape; (2) it comprised multiple basic shapes of different kinds of shapes; (3) basic shapes of one kind of shape (for example, zigzags) were repeated or combined into a pattern of another "second order" shape (for example, a spiral).

RANDOM SHAPES

Random shapes in visual hallucinations of migraine origin have been described as unformed flashes of light (photopsia), bubbles, clouds, dashes, dots, fibers, flakes, mist, points, specks, splotches, spots, and water patterns (for sources in the medical literature see table 7.4 in appendix B).

The visual hallucinations in Migraine Art can be classified as representing random shapes in 115 pictures. The female nude in figure 198 experiences unformed flashes of light. In figure 199 various random forms appear to fill the sufferer's entire visual field. The random shape hallucinations illustrated in figure 200, with prominent watery patterns, are described by the artist:

The picture I produced shows how a migraine "grows" from the very first symptoms of flashing lights like speckles and water patterns that run down in the front of the eye like a fast-flowing stream. During these initial minutes (usually about twenty to thirty minutes) nothing seems real, it is like

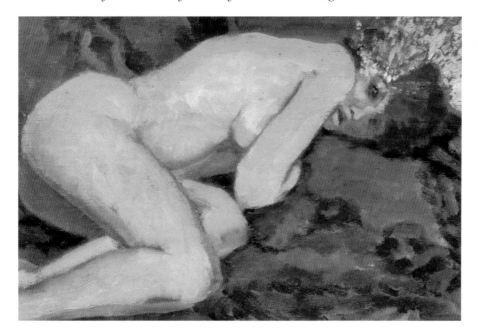

◀ Figure 198
Migraine Art collection.

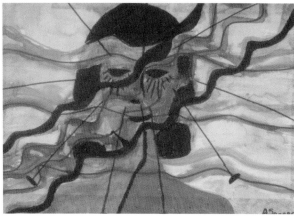

▲ **Figures 199 and 200**

being in another world, and it is impossible to do any normal things such as write or read. Shutting the eyes doesn't completely help because the water visions are still there. It is not always both sides that are affected; sometimes only or mostly one side. After the initial stages go, I am left with a sick headache and a feeling of being completely drained of all energy. The feelings I was trying to explain in my picture were of a strange pattern of events during a migraine attack, which are weird and frightening because you do not feel in control of your body or its actions.

LINE SHAPES

Zigzags and stars are the most frequently described migraine hallucinations in the line category, but there are also reports of a variety of other linear shapes, including single or multiple lines, crosses, angles, herringbone patterns, crenellations, triangles, squares, rectangles, trapezoids, hexagons, and other polygons (for sources in the medical literature see table 7.4 in appendix B).

Line shapes are seen in 311 Migraine Art pictures (see table 7.6 in appendix B), confirming that it is the most commonly encountered shape in migraine hallucinations. The various line shapes encountered are discussed in the following paragraphs.

Zigzags

The term *zigzag* is used in several of the earliest reports of visual hallucinations during migraines. The first mention[299] is probably in a work from the German philosopher Immanuel Kant,[505,506] who noted in 1798 that he once saw, with his eyes closed, "a bright white figure as though drawn with phosphorus on a page, similar to the last quarter of the moon as

it is illustrated on the calendar, but with a margin zigzagged on the convex side."[384] The word is also used by Parry,[454] Piorry,[470] Ruete,[551] George Biddell Airy,[6] Hubert Airy,[7] Mauthner,[399] Dianoux,[134] Reuss,[534] Vignolo,[627] and Gowers.[217] Several authors compare the zigzags of migraine hallucinations to the *fortifications* built for the defense of a town (see "Migraine Experiences in Medical Illustrations" in chapter 1). This word was first used in the migraine literature by Fothergill, who recorded a personal attack of "sick headache" in 1778 that "begins with a singular kind of glimmering in the sight; objects swiftly changing their apparent position, surrounded with luminous angles, like those of a fortification."[187] The same expression is also used by Herschel,[258] Airy,[7] Latham,[353] Liveing,[380] Reuss,[534] Féré,[165] and Gowers.[217] Gowers derived the term *fortification spectrum*, emphasizing that the "spectra of migraine present as their most important feature the zigzag or angled character, which is well known ... as the 'fortification spectrum.'"[217] For a review of the history of the term *fortification spectrum* in the medical literature, see Plant.[473]

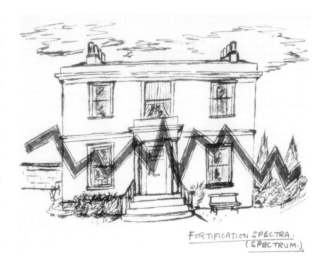

FORTIFICATION SPECTRA.
(SPECTRUM.)

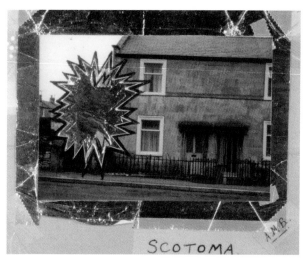

SCOTOMA

▲ **Figures 201 and 202**

Migraine Art collection.

Zigzags appear in 256 Migraine Art pictures, the most frequently encountered form of visual hallucinations in migraines. In 212 pictures, these spectra have a length of more than three zigzag segments, so they can be further classed by "second order" shapes resulting from the repetition and combination of the zigzags (see table 7.7 in appendix B). In fifty-five pictures the zigzags are almost arranged in a line, confirming Gowers's observation that the zigzag or "angled line of light is seldom straight in its direction"[217] (see fig. 201). In fifty-five pictures they form sharp-pointed stars corresponding to Gowers's description of angled or star-shaped

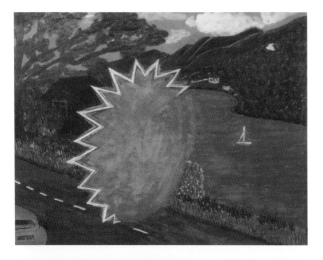

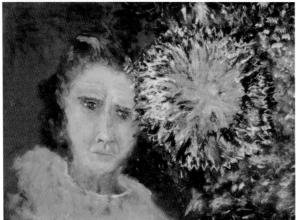

spheres[217] (see fig. 202). Most frequently the zigzags are "in its curved form,"[217] as seen in 139 pieces of Migraine Art (see fig. 203). They form a circle in four pictures (see fig. 204) and segments of a circle in eighteen pictures, including ninety-degree arcs (see fig. 205), 180-degree arcs (see fig. 206), and nearly complete circles (see fig. 207). Figure 205, by a professional medical artist, depicts the arched zigzags as a sort of angled crown above the eye, while the sufferer's head shows "just how I felt, with no flesh and every nerve on my skull singing." Gratings formed by parallel zigzags appear in five pictures, either in one temporal visual field (see fig. 172), half the visual field (see fig. 193), or in the sufferer's entire visual field (see fig. 208). About figure 208 the artist writes, "Suddenly the vision becomes disturbed with blocked areas and flashing zigzag lines, to one side to start with and then filling the entire field of vision." Finally, spirals are seen as second-order shapes of zigzags in three pictures (see fig. 209), as recorded previously by Morgenthaler[421] and Donahue.[137]

Visual hallucinations of shapes other than zigzags can occur on the inner and outer edges and in the area enclosed by the zigzags (fortification spectra). Probably the first report about the margins of a spectrum is from Herschel, who observes "patches of a kind of colored checker work in some of the corners of the fortification forms."[259] Airy describes and illustrates triangles and grating-like patterns at the inner edge of his zigzags, where "the space immediately within the margin is seen to be partly broken up into wedges and angular figures of faint light and shade"[7] (see fig. 21). At the inner margins of a progressive spectrum, Gowers reports a weblike pattern of "crossing lines," "a faint reticulation of luminous

▲ **Figures 203, 204, and 205**

Migraine Art collection.

lines," forming "a complex interlacement"[217] like a defensive line of spikes on top of a wall (see fig. 23). Similarly, Lashley illustrates simple angles, herringbone patterns, gratings, and concentric angular figures at the inner margins of his spots on the visual field (see figs. 26 and 27). He notes that he had "the impression, without adequate data to confirm it, that the size and shape of the fortification figures are constant for each radius of the visual field. That is, the pattern is finer and less complicated in the upper quadrants,"

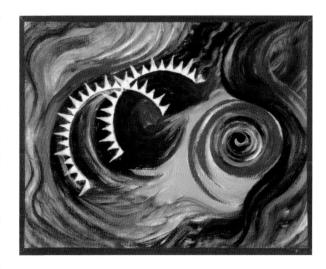

and the "coarser and more complicated figures are generally in the lower part of the field.... If true, this suggests that the pattern is a function of the anatomic substratum, rather than of the nature of the propagated disturbance."[352] According to Miles the visual patterns seen during his personal attacks of scintillating spots on the visual field "confirm the observation that the fortification figures are stronger and coarser in the lower fourth of the positive scotoma than above,"[406] although this is not confirmed in the illustration he supplied (see fig. 28). In two other illustra-

tions by Richards[536] and by Kaufman and Solomon,[302] representing herringbone patterns and gratings at the inner edge (see fig. 29) and outer edge (see fig. 30) of a sparkling spot on the visual field (scintillating scotoma), no difference in the complexity is seen between the patterns in the upper and lower visual fields.

The Migraine Art collection includes nine pictures that illustrate visual hallucinations other than zigzags in the inner edge, the outer edge, or both margins of the zigzag fortification spectra. In figure 210, titled *Mum's Got a Migraine*, a mother who is looking at her two daughters experiences the onset of a migraine attack with a series of four concentric arc-shaped fortification

▲ **Figures 206, 207, and 208**

Migraine Art collection.

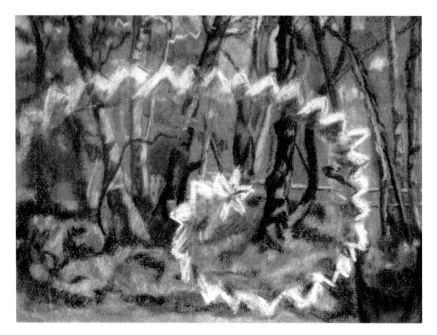

spectra with two concentric triangles in each angle of their inner margins. In figure 211 the outer margin of a yellow arc-shaped fortification spectrum is bounded by two similarly colored concentric rows of triangles. According to the artist, her attack began with:

an arc of flashing, dancing zigzag and triangular lights above and toward the outside of the eye [with] some colors emerging after an initial start of black-and-white flashing. As the visual disturbances got worse, the arc increased in size, and it was sometimes impossible to see. The blue and red patterns in the bottom right corner depict the visual disturbances getting worse. The frightening visual disturbances are followed by a solid heavy pain as if there was a heavy brick inside the head.

▲ **Figures 209 and 210**

Migraine Art collection.

▶ **Figure 211**

Migraine Art collection.

In figure 212 both the inner and outer margins of a curved fortification spectrum are bordered by multicolored triangles. In figures 103 and 213 gratings are depicted at the inner margins of zigzag spectra, while in figure 214 they are seen at the spectrum's outer margin. Three pictures (see figs. 183, 184, and 185) by a professional artist illustrate varieties of zigzag

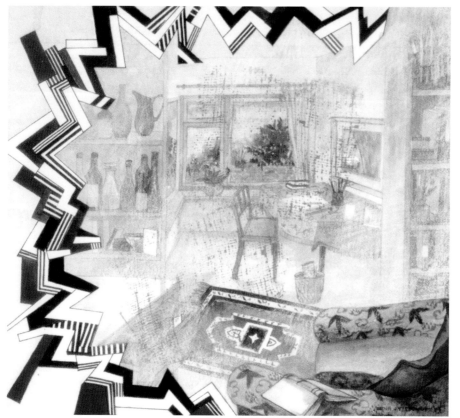

▲ **Figures 212 and 213**

Migraine Art collection.

◀ **Figure 214**

Migraine Art collection.

▼ **Figure 215**

Migraine Art collection.

▶ **Figure 216**

Migraine Art collection.

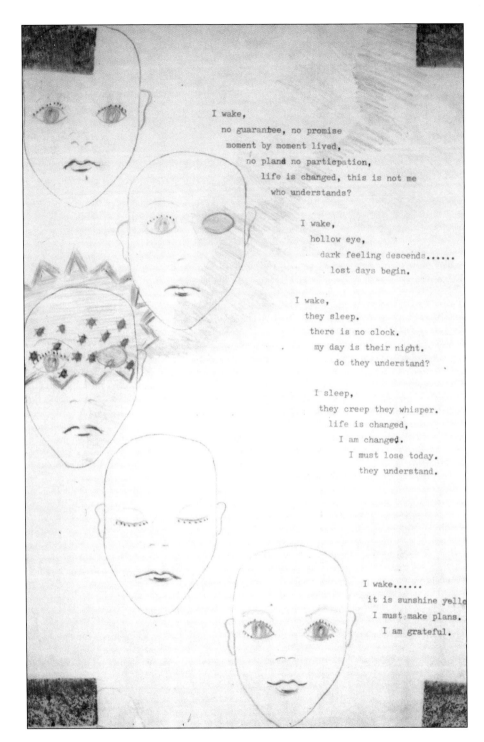

fortification spectra bordered by gratings at the inner margins, and gratings, grids, and checkerboard patterns at the outer margins. Judging from these Migraine Art pictures, Lashley's idea that the complexity of the zigzags is different in the upper and lower parts of the visual field cannot be substantiated.[352]

Visual hallucinations of various forms in the area enclosed by the zigzags have rarely been described in medical literature. This phenomenon is noted by Herschel, who observed "fortification forms" with "a carpet-work pattern over the rest of the [internal] visual area" or "checker work ... filling in" the area enclosed by the spectrum.[259] Charcot published an illustration of a fortification spectrum that enclosed a grating formed by parallel lines[92] (see fig. 37). Bäumler reports a personal migraine aura experience with a regular chessboard pattern inside the area of zigzags, lasting for about eight to ten minutes.[32] Johnson depicts his personal image of cross-hatching filling the area enclosed by a fortification spectrum[293] (see fig. 38). Similarly, Alvarez notes that "on one occasion a brown luminous grating filled the space within the bowed zigzag line. This grating remained bright for thirty minutes after my vision had cleared."[12]

The Migraine Art collection includes seven similar images with multiple random blobs (see fig. 215), multiple stars (see fig. 216), a grid composed of dots (see fig. 217), a grid formed by the arrangement of tiny squares in rows and columns (see fig. 218), lattices (see figs. 214 and 219), and a complex scenic image (see fig. 220) appearing in the area of oval or curved zigzag shape. One of the artists (see fig. 217) comments:

The first symptom to develop takes the form of a flickering blind spot in my direct line of vision. This gradually grows into a jagged arc enclosing a checkered vibrating blur, as depicted in the drawing. This symptom lasts about twenty minutes before subsiding, then gives way to a numbness that develops down the right edge of my tongue and spreads to my right cheek, into my right arm, and then to my hand; I lose all sense of touch in my fingers. This deadness in my arm and hand gradually subsides after twenty minutes and feeling is restored. As this stage recedes the acute headache begins above my left eye, settling in my left temporal region. The headache

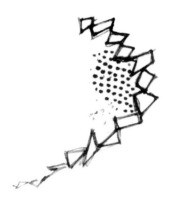

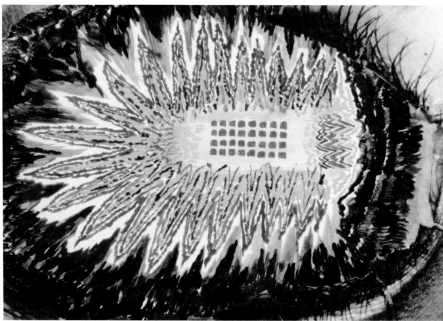

▲ **Figure 217**

Migraine Art collection.

▶ **Figure 218**

Migraine Art collection.

is so violent that I need to retire to a darkened room (if available) and lie down with my eyes and head covered with a cold wet cloth. I feel intensely nauseous and occasionally need to be sick; the retching aggravates the headache so much that I often scream with the intensity of the pain. I am drained of all color, can take no food, but need to constantly sip water because of the extreme dryness of my throat. The attack usually subsides after eight or nine hours, often quite suddenly, leaving me very exhausted. The after-effects of the headache remain as a faint pulsating chronic pain for perhaps two or three days. I feel as though my right temple has been severely bruised. I have occasionally suffered two attacks in a day (and once three) and have even developed an attack in the middle of one I was already suffering, experiencing all three symptoms mentioned above at the same time.

Another artist describes her experience (see fig. 218):

The full migraine experience is first a small localized area of loss of vision, for example prices in a shop window look like ".90" instead of "£9.90," or looking down a child's throat I couldn't see the tonsils and tried shaking the torch as I thought it had momentarily gone off. Then occurs an all-over pattern of zigzags or cross-hatchings, followed by a pattern like the one in

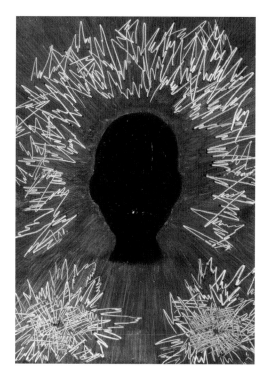

▲ **Figures 219 and 220**

Migraine Art collection.

the picture, but with many variations in color, size of the central area, and size of the surrounding zigzags. All the colors are very bright and shimmer; no normal colors are so bright and luminous and shimmering and multiple. The image starts in the center, quite small, and grows quickly to fill most of the visual field. It is still present when I shut my eyelids. The whole thing is moving and changing and shimmering. I can't read while it is there. It used to go completely and is sometimes followed by a headache, which is especially pronounced in one side of my nose and face.

Migraine zigzag hallucinations, or fortification spectra, vary considerably in different people and sometimes even in the same person during different attacks. This variability and some of the terms used to describe it in medical literature is impressively documented in figure 221. The female sufferer's face is replaced by a machine[477] called the "migraine computer," "supplied by Nature's Rotten Tricks Co.," which is "programmed in! (unwillingly)," resulting in her cry, "Woe is me!" The migraine computer's screen displays the image of an expanding spectrum, reminiscent of one of the illustrations in Hubert Airy's work[7] (see fig. 21). The five levels of the

▲ **Figure 221**

Migraine Art collection.

▼ **Figure 222**

Migraine Art collection.

machine's activity are labeled "scintillating scotomas," "rainbow fortification," "mobile stellate," "pericentral," and "expanding angular." All but the first of these is taken from Gowers's Bowman Lecture on "Subjective Visual Sensations"[217] (see "Migraine Experiences in Medical Illustrations" in chapter 1).

In his 1895 Bowman Lecture, Gowers presented an extensive classification system for migraine fortification spectra, which he slightly modified in his 1904 collection of essays titled *Subjective Sensations of Sight and Sound, Abiotrophy, and Other Lectures*. Table 7.8 in appendix B is a comparison of the terms used in each version of the Bowman Lecture. In 1895 Gowers emphasized that his system was provisional, confirmed by the changes he made nine years later. He wrote, "To reduce to any instructive order the various forms which the angled spectra assume, I have found to be impossible. All I can do is to group them into what seem the chief classes into which they may be provisionally arranged for the convenience of the study, and to point out the manner in which the leading elements are presented by each." Gowers's classifications have remained the gold standard for fortification spectra. It is cited in most books on migraines, but strangely enough no research appears to have been conducted into replicating his results. Of the types of fortification spectra listed in table 7.8 in appendix B, only the "angled sphere" and "expanding," "pericentral," and "arched" zigzags can be identified in the Migraine Art collection.

The Angled or Stellate Sphere (Gowers)

The angled or star-shaped (stellate) sphere, which may occur as a mobile or fixed zigzag, is described by Gowers as "a nearly round spectrum composed of a series of projecting angles, plain or colored.... It is met with in three associations: (1) as an object that moves to and fro; (2) as an isolated initial spectrum before some

other; and (3) as a terminal spectrum, thrown off, as it were, by that which has developed before."[217]

The characteristic star shape of Gowers's angled or stellate sphere appears in fifty-five Migraine Art pictures. In figure 222, yellow stars almost fill three quarters of the sufferer's visual field. She writes:

It seems to come on all of a sudden, and I seem to see lots of bright lights like stars going around in circles, almost like wheels going around and around. My left arm feels as if it is not there [aschematia]. There is also a feeling of nausea that lasts for some time and then gradually fades away, leaving me with a headache that can last for days and with a washed-out feeling.

▲ **Figure 223**
Migraine Art collection.

▼ **Figure 224**
Migraine Art collection.

In figure 223 stars and zigzags appear in the sufferer's entire visual field. The artist describes the sequence of visual symptoms during her recurring attacks:

An attack always started with visual disturbances: I didn't seem to be able to focus properly, things became fuzzy and hazy; for instance if I was adding up a column of figures, the figures seemed to move about [autokinesis, the visual illusion of seeing movement of a stationary object]. I would start to see small stars flickering about and gradually I would see a zigzag arc of moving light. As soon as one arc moved across, another would appear, gradually increasing in speed, until I would see nothing but these arcs of moving zigzag lights, even with my eyes closed. This would last for about half an hour and then gradually decreasing, leaving me feeling very sick and a very bad headache would commence, lasting for the rest of the day. The attacks were always unexpected; I would be out walking or just sitting in the house. I have never discovered what started them, but I always disliked very bright lights or dazzling sun.

▶ **Figure 225**

Migraine Art collection.

▼ **Figure 226**

Migraine Art collection.

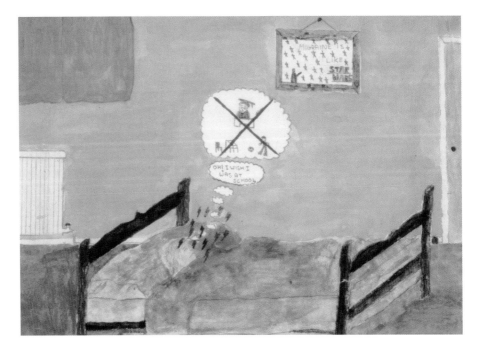

In three Migraine Art pictures featuring star-shaped visual hallucinations, there is the suggestion that the experiences have been created by imaginary humanlike entities. This recalls a remark by Airy, who likened the visual sensations of the zigzags to a "strange intruder,"[7] and is similar to the external attributions so common in the Migraine Art pictures of the various types of abnormal bodily awareness (see chapter 6). In figure 155,

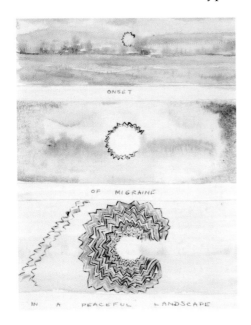

representing the migraine sufferer's experience of "seeing stars when my eyes are closed," four star shapes have smiling human faces, complete with eyes, noses, and mouths. A similar effect is seen in figure 224, where two frowning stars are causing pain by beating a drum inside the sufferer's head, reflecting the connection between visual auras and headaches. Figure 225 shows an eleven-year-old migraine sufferer lying in bed beneath a picture proclaiming "Migraine is like *Star Wars*." As a further reference to the 1977 George Lucas film, the bottom left corner of the picture shows a black-clad Darth Vader–like figure controlling a legion of stars being sent to attack the migraine sufferer.

The Expanding Spectrum (Gowers)

According to Gowers, "The most frequent form of migraine spectrum, that which is commonly regarded as the typical one, is an angled sphere which expands into an irregular oval, and, breaking, may enlarge into a curve.... Its boundary outline retains the angled form, and this extends and increases in the size of its angles, most toward the periphery."[217] The last feature mentioned provides an important clue for the understanding of how this particular type of migraine visual hallucination happens in the brain (see "How Hallucinations Occur" below).

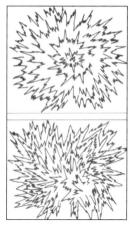

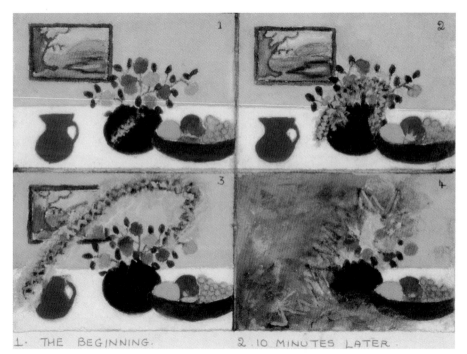

1. THE BEGINNING. 2. 10 MINUTES LATER.

Figure 227
Migraine Art collection.

Figure 228
Migraine Art collection.

Figure 229
Migraine Art collection.

Features of the expanding zigzags can be seen in thirty-four Migraine Art pictures. In four of them the expanding movements of the zigzag spectra are clearly shown in a series of illustrations of the sequence of the visual disturbance (see figs. 56, 226, 227, and 228). In eleven other pictures, successive stages of expanding spectra are depicted within a single illustration, and in nineteen pictures the artists provide a still image of a particular stage of an expanding spectrum.

The Concentric or Pericentral Spectrum (Gowers)

Gowers based his concept of concentric zigzags or "pericentral" fortification spectra, which implies interaction between the zigzag hallucinations and perceived images of the external world, on a unique observation:

> *A spectrum around an object which occupies the fixing point is occasionally seen. A good illustration of this is presented in one of Beck's drawings, which is, I do not doubt, in this point quite trustworthy. A zigzag colored spectrum suddenly surrounded a plate on the dinner-table before him. The quaint description he gives of it is this: "I remember well the phenomena appearing on the plate when I sat down to dinner with two friends. As I looked curious and nervous, Mrs. B– said, 'Why do you not carve?' On taking my eyes off the plate I said to them, 'The zigzag rainbow colors are gone out of the window.' This was the first time my wife and friends believed I saw something very extraordinary." One drawing shows the colored angled spectrum surrounding the edge of the plate, and another the same circular spectrum in a pane of the window at which he looked up. Concentric with the plate as first seen, it maintained the same form when he raised his eyes to the window, and then disappeared. The fact is more important than may at first sight appear, because the spectrum was evidently determined by the actual stimulation of the visual centers.*[217]

In Beck's case, the pericentral spectrum appeared "as a circular zigzag, surrounding a round object looked at,"[218] corresponding to the contours of the object surrounded by the zigzags, in this case a plate. In figure 179 the artist has depicted her experience of seeing "everything surrounded in bright zigzags," which is also illustrated as concentric zigzags around a circular object. However, another Migraine Art picture demonstrates that the circular shape is not a necessary characteristic of the concentric zigzag, but only an incidental feature that depends on the shape of the object. Figure 170 illustrates a pericentral spectrum consisting of a series of zigzags following the contours of a piece of paper. In comparison with the two previous observations, these zigzags are separate rather than continuous. The "migraine computer" picture (see fig. 221) also has a reference to a "pericentral" spectrum.

The Arched Spectrum (Gowers)

Gowers records that a "spectrum in the form of an arch, in the mid position, above the center, was also a frequent experience of Beck, and may be regarded as a segment of a pericentral spectrum"[217] (see fig. 24). Similar observations are provided by Féré, who describes zigzags in the form of a half circle or half corona,[166] and by Antonelli, who records angles like on a wheel with sprockets.[20] Although Gowers's definitions of an arched spectrum (a zigzag in the form of an arch) and a pericentral spectrum (a zigzag around an object in central vision) refer to different features, he considered the arched spectrum to be one kind of pericentral spectrum. This idea was suggested by the observation that, in Beck's case, the pericentral spectrum was circular. The confusion of the two terms stems from the incidental fact that it was a plate rather than a noncircular object that was surrounded by zigzags in Beck's experience of a pericentral spectrum. However, Gowers's concepts of arched and pericentral zigzags must not be confused by folding one category into the other.

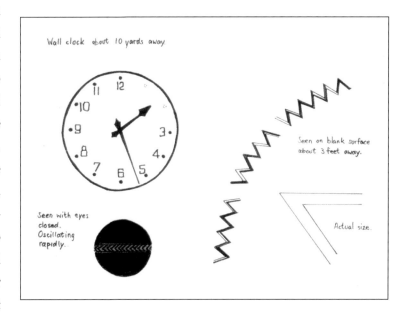

▲ **Figure 230**

Migraine Art collection.

The Migraine Art collection includes eighteen examples of arched spectra similar to those illustrated and described by Gowers. In figure 229 an approximately semicircular arched spectrum appears to emerge from the sufferer's eye. According to the artist, "They are like rainbows coming out of my pupil. If it weren't for the headache they herald, I would quite enjoy them."

Herringbone Patterns

An arrangement of multiple angles into a row results in a line shape reminiscent of herringbones, which are reported as a visual migraine aura by

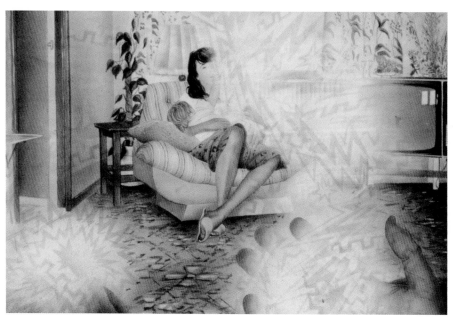

▲ **Figures 231 and 232**

▼ **Figure 233**

Migraine Art collection.

Speed[597] and by Fisher.[173] Such herringbone patterns, formed by rows of more than three angles, are represented in two Migraine Art pictures. Figure 230 illustrates a regular herringbone pattern, "seen with eyes closed" and "oscillating rapidly." Figure 231 depicts herringbone patterns with rows of multiple lines and crenellation patterns. The black contours of the shapes appear hardly visible against the black background.

Crenellations

Crenellations appear in five pieces of Migraine Art. Two pictures, featuring crenellations in a linear form (see fig. 7) and a circular form (see

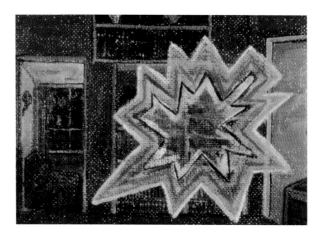

fig. 8), were shown in chapter 1 for their similarity to a recurring pattern in the visions of Hildegard of Bingen. A third picture has multiple parallel black crenellations (see fig. 231). In the fourth example (see fig. 232) the male sufferer, whose outstretched hand is visible in the lower right corner of the picture, experiences multiple red- and green-tinged crenellations in various orientations, together with zigzags and star shapes in the same colors.

The view of Plant that crenellations, as seen in the visions of Hildegard of Bingen, were "never reported in migraines"[473] is contradicted not only by Elliot[158] but also by the Migraine Art.

An interesting combination of crenellations and zigzag patterns is seen in the fortification spectrum in figure 233, composed of multiple parallel shapes featuring multiple zigzags together with a single crenellation. The artist comments, "This is how a tiny spot in the center of vision expands into a jagged, bright-edged blur that covers the whole field of vision. The room is indicative of everyday life, and the open doorway the hope of escape from migraines some day."

Triangles, Squares, Rectangles, and Other Polygons

Visual hallucinations of polygon shapes are depicted in sixty-two Migraine Art pictures, including triangles (twenty-nine pictures), squares (twenty-eight pictures), rectangles (fifteen pictures), and other polygons (twenty pictures). In a series of six pictures, figure 234 represents the development of a spot on the visual field (scintillating scotoma) bordered by angular figures of mostly triangular shapes. Figure 235 illustrates two crescents

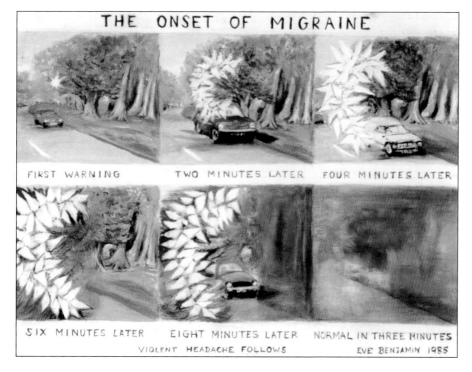

◀ **Figure 234**

Migraine Art collection.

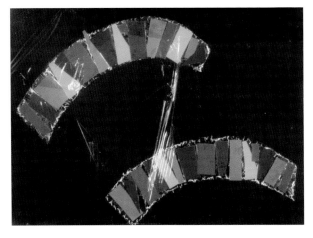

▲ Figure 235

Migraine Art collection.

▼ Figure 236

Migraine Art collection.

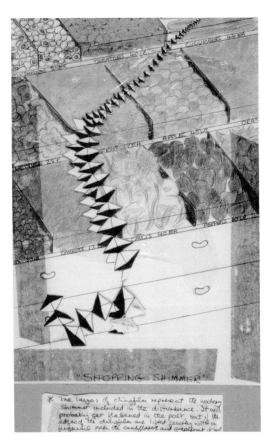

composed of multicolored triangles, rectangles, trapezoids, and polygons, seen by the migraine sufferer against the blackness of her closed eyes. The artist writes:

Invariably an attack is signaled by a few minutes of impaired vision. They enter down left, either one or two crescents (sometimes joined in an irregular oval), shimmering, vibrating, and transparent, with irregular colored shapes. These move slowly upwards and across the darkness of my closed eyes and eventually—perhaps in five or ten minutes—vanish top right. The visual symptoms are followed by headache and nausea almost immediately. Over the years the pain and discomfort have gradually decreased, but the visual disturbances have certainly been with me, more or less unchanged, for thirty years or so. They occur spasmodically now, perhaps one every two months or so, though more frequently in times of stress.

Polyhedrons

In figure 236, a three-dimensional collage titled *Shopping Shimmer*, the artist has represented a regular arrangement of polyhedrons forming the border of a scintillating spot on the visual field that is visualized by "layers of cling film [plastic food wrap]" denoting "the watery shimmer included in the disturbance. If the edges of the cling film are lifted gently with a fingernail over the cauliflowers and grapefruit, it will give a better resemblance to what I actually see." There is a clear increase in the size of the polyhedrons from top to bottom. Unfortunately, since the artist's point of fixation is not indicated in the picture, it can only be speculated whether or not this increase in size occurs with increasing distance

from the fixation point, a typical feature of
the zigzags of fortification spectra (see "How
Hallucinations Occur" below).

*Arrangement of Basic Shapes into
Second-Order Line Shapes*

In eleven Migraine Art pictures, line shapes
appear in an arrangement of basic shapes into
rows, described as a feature of geometric hal-
lucinations by Ahlenstiel and Kaufmann.[5]
Similar observations were reported by a
patient of Riley et al., who experienced "a row ... of spinning crosses in
the blind area";[539] by one of Wiley's patients, who described "rows of ver-
tical scintillating white lines";[646] and by a patient of Liu et al., a nine-year-
old girl with a history of migraines with auras who saw "lines of ants."[379]
In eleven Migraine Art pictures, rows are formed by dots, lines, angles,
angular "roof" shapes, triangles, stars, or ellipses.

▲ **Figure 237**
Migraine Art collection.

CURVE SHAPES

In 1898 Hilbert reported visual hallucinations of curve shapes as "atypical
scintillating scotomas" in two migraine sufferers.[263] One patient saw blue
moving circles on a black background filling out the center of her visual
field, and the other repeatedly experienced multicolored whirling rings
against a brown background in her entire visual field except for a small
region at the edge. His observations are confirmed by numerous other
authors who report visual migraine auras consisting of single or concen-
tric circles, rings, wheels, balls, sine waves, and other wavy lines (for
sources in the medical literature see table 7.4 in appendix B).

Panayiotopoulos compares the visual hallucinations of fifty migraine
patients with twenty patients with epileptic seizures.[451] He found that
visual migraine auras were rarely described as circular lights; the black-
and-white linear patterns of zigzags were dominant. Hallucinations dur-
ing epileptic seizures were predominantly multicolored with circular or
spherical patterns. The author's conclusion, however, that the shapes of

the hallucinations "may be a useful clinical guide in the differential diagnosis of migraine and epilepsy," is called into question by reports of curve shapes in migraine patients' visual hallucinations and by numerous Migraine Art pictures that are indistinguishable from illustrations of visual epileptic hallucinations presented by Panayiotopoulos.[451,452]

Visual hallucinations featuring various curve shapes are encountered in 273 Migraine Art pictures, the main features of which are summarized in table 7.9 in appendix B. About half of the pictures represent Gowers's "curved form" of typical fortification spectra—zigzags displaying a second-order curve shape[217] (see "Line Shapes" above), and the other half illustrate varieties of Hilbert's spots on the visual field ("atypical scintillating scotomas"), examples of which are shown in the following paragraphs.[263]

▲ **Figure 238**
Migraine Art collection.

Circles

Circles are illustrated in seventy-five Migraine Art pictures. While addressing an envelope, a student sees black-and-white circles in a spot near the center of the visual field (a paracentral scotoma) that "translocate" or move with eye movements (see fig. 237). The artist writes:

The picture is an attempt to show the visual disturbance at the very beginning of a migraine attack. The black-and-white spotted area is a vague grayish twinkling blurred patch seen slightly off-center in the field of vision. In real life, it is not possible to look directly at the blurred patch, because it is always slightly to one side of the side you are looking at. It gets in the way wherever you look. The blurred patch appearance usually lasts five to ten minutes before it is replaced by flickering zigzag lines in one corner of the visual field, and later by showers of stars over the whole of the field. The visual disturbance usually lasts a total of twenty to thirty minutes and is usually followed by a headache and sometimes nausea.

Of the seventy-five Migraine Art pieces featuring circles, they appear as *concentric circles* in twenty-six pictures. In a series of images arranged

from right to left, figure 238 represents a visual aura starting with a black circle, followed by a black circle surrounded by a purple ring, and terminating in an explosion of multicolored concentric circles. The artist writes:

> *The painting depicts the sequence of images I used to have when resting, night or day, with a very painful and debilitating attack. A small black dot would appear on the right side of my vision (eyes closed) and with a pulsing beat become larger and larger until it would burst (as in a firework) in the left of the whole visual field, culminating in a crescendo of rainbow colors, surrounded by a wonderful bluey-purple color. The purple outside the black begins only as the black dots enlarge. The whole taking about one minute's duration, then the sequence would start again. This could last as long as one to two hours until sleep came.*

▲ **Figure 239**
Migraine Art collection.

▼ **Figures 240 and 241**
Migraine Art collection.

Arcs

Segments of a circle—*arcs*—are depicted in thirty-one Migraine Art pictures (see figs. 205, 206, and 207).

Spheres

Spheres can be seen in nine Migraine Art pictures. In two of them, by the same artist, the visual aura consists of various Kandinsky-like abstract geometric shapes, including a bright zigzag, a large brown circle, a checkered sphere, and a striped arc that appears alone in one picture (see fig. 239) and duplicated in the other (see fig. 240). Four Migraine Art pictures illustrate luminous spheres, described by one artist as "yellow sunbursts . . . when eyes are closed" (see fig. 110).

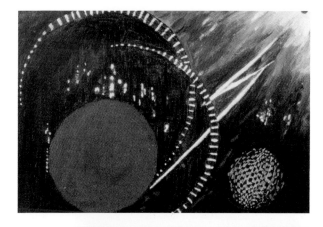

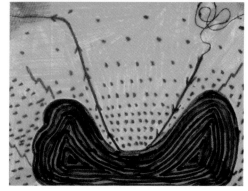

Ellipses and Hyperbolas

Three Migraine Art pictures illustrate visual aura hallucinations in the form of *ellipses*. There is also a single example of a *hyperbola*-shaped visual hallucination.

Sine Waves

Sine waves are depicted in sixteen pieces of Migraine Art. Three of them show multiple parallel sine waves producing regular grating-like patterns (see "Lattice Shapes" below).

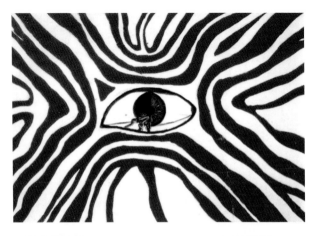

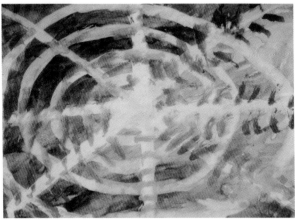

▲ **Figures 242 and 243**

Migraine Art collection.

Fingerprint Whorls

The Migraine Art collection includes two examples of visual hallucinations featuring a curve shape that can be likened to fingerprint whorls. A violet kidney shape at the bottom of figure 241 is patterned with black fingerprint whorls. Figure 242 combines various visual symptoms experienced by the artist. Half of the sufferer's eye is obscured, suggesting loss of vision in half the visual field (hemianopia) with hallucinations in the defective field. The red fingerprint whorls, which surround the eye in a polelike symmetrical orientation, represent another visual aura symptom.

Arrangement of Basic Shapes into Second-Order Curve Shapes

According to Gowers, the zigzags of fortification spectra are typically arranged "in its curved form,"[217] as can be seen in 139 Migraine Art pictures. Basic shapes can be combined into circles or arcs, as illustrated by Gowers's "arched spectrum"[217] and in a patient of Riley et al. who saw a "half circle of spinning crosses."[539] The Migraine Art collection includes thirty-one pictures with

circles or arcs produced from the arrangement of basic shapes, including zigzags (twenty-two pictures), lines (three pictures), angles (two pictures), crenellations (one picture), triangles (one picture), nucleated circles (one picture), sine waves (one picture), and other curved shapes (two pictures).

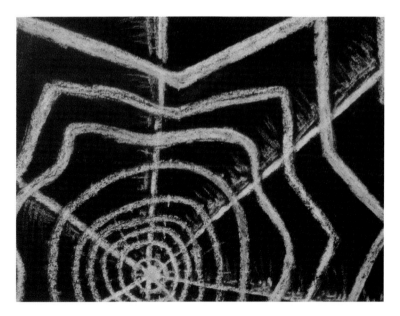

WEB SHAPES

Visual hallucinations of web shapes are documented in case reports from the medical literature (see table 7.4 in appendix B). Gowers describes a "a faint reticulation of luminous lines" forming "a complex interlacement" like a defensive line of spikes on top of a wall[217] as a feature of a particular type of zigzag effect seen by one of his patients (see fig. 23). A migraine sufferer in the study by Ulrich compared the light sensations of the visual aura with "spiderwebs."[620] Speed records "dancing and moving cobwebs"[597] as visual migraine aura experiences. Sacks describes a personal visual aura with visual loss in half his field of vision (hemianopia) with a "most delicate filigree pattern . . . more delicate and transparent than the finest spiderweb"[555] in the part of the field with visual loss.

▲ **Figures 244 and 245**

Migraine Art collection.

The Migraine Art collection includes eight examples of visual hallucinations of web shapes, presented in the following paragraphs.

Spiderwebs

Four pictures with spiderwebs as a metaphor of the migraine attack have been excluded from consideration in this context (see "The Impact of Acute Migraine Attacks on Daily Life" in chapter 4). However, the typical spiderweb formations illustrated in figures 243 and 244 and a similar pattern depicted in figure 245 over the migraine victim's eye are assumed to represent visual aura experiences.

▶ **Figure 246**

Migraine Art collection.

▼ **Figure 247**

Migraine Art collection.

Asymmetrical Lattices

The migraine sufferer's eye can also be seen in figure 246, titled *The Progression,* where a luminous arc increases in size, followed by complete substitution with a large star. The arc shape is made up of intersecting lines, and it encloses an asymmetrical lattice of similarly interlacing lines.

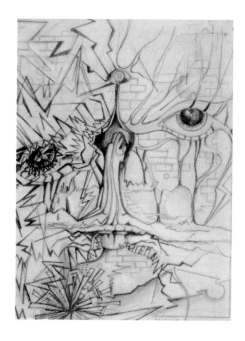

Veins

The visual aura illustrated in figure 247 includes a number of veinlike shapes, as in the top right corner of the picture. The artist writes, "A small cluster of lights would start and build to much of the result you see in my artwork. The visual effects

▲ **Figures 248 and 249**

Migraine Art collection.

lasted about twelve minutes, followed by a heightened sense of vision and awareness usually accompanied by an intense headache." In figure 248 similar veinlike shapes along with other hallucinated forms are superimposed on the artist's mirror image.

Nets

In figure 249 netlike shapes are superimposed on the right side of the mirror image of a female sufferer, some of them following the contours of her face, which is framed by curve and spiral shapes. A number of needles indicate the sufferer's pain on one side of her head. Figure 250 is the mirror image of another female sufferer who sees a delicate net partially

▶ **Figure 250**

Migraine Art collection.

▼ **Figure 251**

Migraine Art collection.

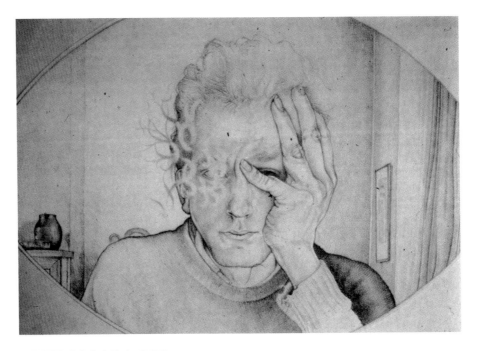

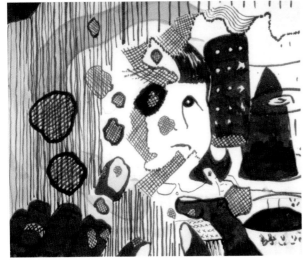

obscuring half of her field of vision. Her posture suggests that she is feeling pain on the side opposite the visual disturbance.

LATTICE SHAPES

Gratings and checkerboard patterns in the margins or in the area enclosed by fortification spectra have rarely been described (see "Line Shapes" above). Alvarez records visual hallucinations with a scintillating spot on the visual field followed by "a grid of bright spots that enlarged to circles, and later changed to fine luminous lines."[12] Only a few reports of lattice shapes unrelated to zigzags have been noted. A migraine patient of Pick's saw a grating formed from parallel sine waves in one half of the visual field[465] (see fig. 34). Shackle describes his own visual migraine aura with "an image consisting of black-and-white cross-hatching,"[581] and Sacks reports images like "moiré patterns."[554] Klien reports a recurring visual migraine aura lasting fifteen to thirty minutes that took the form of a meshwork of equally

sized hexagonal units in the entire visual field of both eyes,[317] an observation that did not escape the notice of Klüver in his study on how hallucinations happen.[322] According to Klien's patient, the meshwork was not projected on white surfaces but seemed to float some distance in front of her and moved when she moved her eyes; it was frequently followed by a headache. She also noted that the scale of the meshwork's units were different in each attack. Similarly, Heyck reports two migraine patients who saw restlessly moving hexagonal honeycomb patterns;[260] a migraine patient of Horowitz's had "the visual sensation of looking at six-sided honeycomb figures that could create 'an endless wallpaper effect'";[275] Sacks confirms that migraine sufferers may experience visual hallucinations like "honeycombs";[554] and he also describes a personal visual aura in the half of his visual field with loss of vision as regular patterns of hexagonal honeycomb cells, "a lattice of exquisite geometric beauty, composed, I could now see, entirely of hexagons and covering the whole half field like gossamer lacework."[555]

Visual hallucinations of lattice shapes are illustrated in forty-six Migraine Art pictures (see table 7.10 in appendix B), representative examples of which are described below.

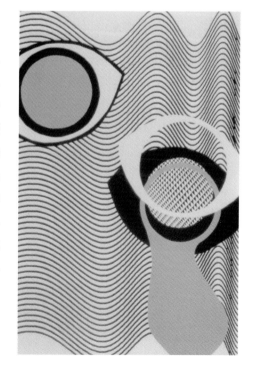

▼ Figure 252

Migraine Art collection.

Lattices

Lattices feature in fifteen Migraine Art pictures. In figures 214 and 219 they are seen inside the area of fortification spectra. In four pictures, lattices are depicted over the sufferers' eyes. In figure 251 the artist's perception of her hands and her daughter's face is obscured by lattice and mesh shapes together with gratings formed from parallel lines or sine waves. According to the artist, "The mesh spots are when I would focus on a small item, then it would be replaced by these mesh shapes," suggesting that they appear in the center of vision and move when the eyes move (translocation). "The hands are my own, which would feel numb, cold, and tingly. The halo wave going over the top of the picture was to illustrate the smell

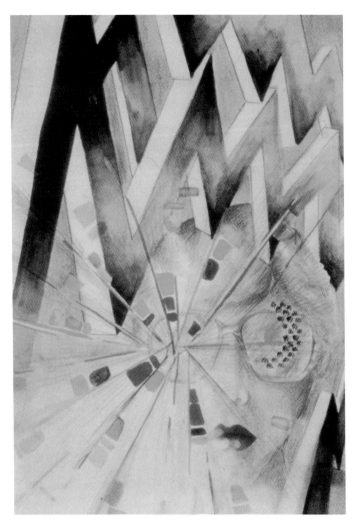

and horrid taste," implying that she also had smell and taste hallucinations.

Gratings

Gratings are seen in twenty-one pieces of Migraine Art. Gratings produced by equally spaced parallel lines appear in eight pictures, in six of them occurring on the margins of fortification spectra. Gratings formed by equally spaced zigzags are seen in five pictures. Three pictures illustrate gratings from equally spaced parallel sine waves (see fig. 252).

Grids

In nine Migraine Art pictures, grids are formed by regular arrangement in rows and columns of a single basic shape—dots, triangles, squares, rectangles, or overlapping circular shapes with central spots like fish scales. The grid depicted in figure 142 is described

▲ **Figure 253**
Migraine Art collection.

by the artist as "repetitive patterning of triangles" that happened repeatedly during severe migraine attacks "when I shut my eyes and pressed my eyeballs with my fingers. This I did during intense headaches. Pressing my eyes caused the intense visual patterns depicted to reverberate, totally dominating my vision."

Checkerboards

Checkerboards are encountered in fifteen Migraine Art pictures. Black-and-white checkerboard patterns are depicted in twelve pictures (see fig. 253), two of them appearing on the margins of fortification spectra (see figs. 183 and 185). Multicolored checkerboards without regular color pat-

◀ **Figure 254**

Migraine Art collection.

terns are illustrated in two pictures (see figs. 194 and 254). In figure 254, according to the thirteen-year-old artist, "the bright light and loss of certain areas of the image I was seeing were the most usual visual experience. The colored squares and white lights indicate this area." The

▶ **Figure 255**
Migraine Art collection.

▼ **Figure 256**
Migraine Art collection.

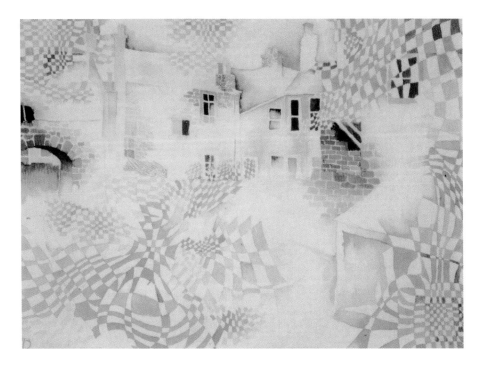

multicolored checkerboard depicted inside the sufferer's eye in figure 245 is made up of diamond shapes rather than squares.

Three pictures, by a professional artist, illustrate checkerboard patterns with squares of different sizes, sometimes spatially distorted, in either black-and-white or monochrome. The artist's account of the "op art style" patterns in figure 195 was discussed above in "Loss of Vision in Specific Parts the Visual Field." In figure 255, similar patterns are seen while "looking across some backyards." Figure 256 "was started live":

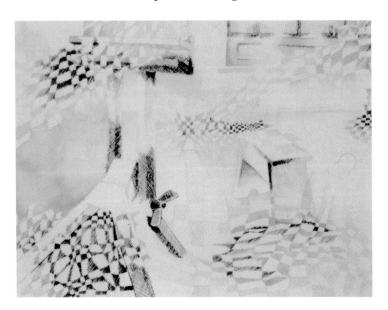

I was in the studio when the attack commenced, so I turned to the window and tried to paint what I saw, as all the materials were on hand. Left-center of the picture is the bottom half of a radial easel, with a little of the painting I was doing when the attack started. Beyond

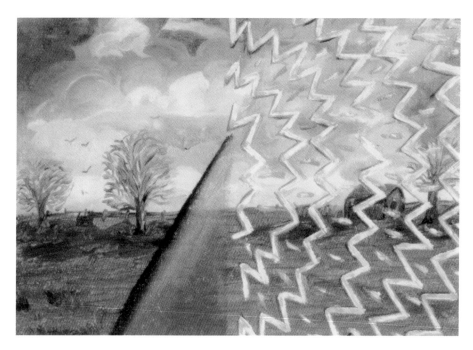

*that, top center-right, is the bottom of a Georgian sash window, and below
that in the middle distance of the picture is a bench.*

TUNNEL SHAPES

Visual hallucinations of tunnel shapes are seen in forty-six Migraine Art
pictures. A tunnel is created by concentrically constricted visual fields or
ring-shaped spots on the visual field (ring scotomas) in sixteen pictures
(see "Loss of Vision in Specific Parts of the Visual Field" above) and by
concentric circles in twenty-six pictures (see "Curve Shapes" above). One
picture (see fig. 187), titled *Tunnel Vision* by the artist, displays the features
of both a ring scotoma and concentric circles. Five other pictures illustrate
cones as other examples of the tunnel shape hallucination (see fig. 257).

SPIRAL SHAPES

Visual hallucinations of spiral shapes, such as spirals, pinwheels, or a
wheel with spikes projecting from the rim, are reported by several authors
as migraine aura symptoms (for sources in the medical literature see table
7.4 in appendix B). Berger gives an account of a personal experience with
spiral forms vibrating vertically and horizontally,[45] and a migraine patient

▶ **Figure 259**

Migraine Art collection.

▼ **Figure 260**

Migraine Art collection.

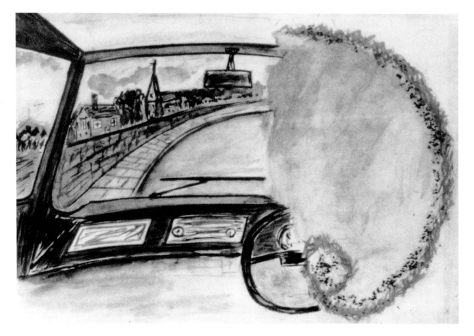

of Wilson's "saw the spiral begin by its outer coil and contract inward to its core,"[654] showing that spiral shape hallucinations can be associated with some form of perceived movement.

Spiral shape hallucinations are represented in thirty-two Migraine Art pictures, a number of which are presented in more detail below.

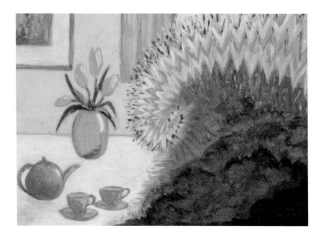

Spirals

In three pictures, spirals are seen together with other visual hallucinations in visual fields where half the field has loss of vision (hemianopia), and in five pictures they are shown in the sufferers' entire visual field. In ten Migraine Art pictures, spirals are depicted over or near the sufferer's eyes, in three of them also surrounding their heads (see fig. 258).

Arrangement of Basic Shapes into Second-Order Spiral Shapes

In five pictures, spirals are formed by red dots (see fig. 110), by random brown and orange shapes at the margins of a scintillating spot on the visual field (see fig. 259), and by the zigzags of fortification spectra (see figs.

117, 209, and 260). Similar observations are reported by Morgenthaler[421] and by Donahue, who described "spiraling" scintillating spots on the visual field (scotomas).[137]

Spiral Hallucinations in Vision and the Sense of Touch

In figure 117 a visual spiral hallucination is accompanied by a spiral hallucination of the sense of touch (a "haptic" hallucination) in

▲ **Figure 261**

Migraine Art collection.

the sufferer's legs, which seem to be greatly enlarged (see "Perception of the Body as Abnormally Large or Abnormally Small" in chapter 6). Serko experienced a similar feeling during mescaline intoxication:[580] "Sometimes the haptic spiral of a leg blended with a luminous spiral that had been rotating in the visual field. 'One has the sensation of somatic [bodily] and optic unity.'"[322]

KALEIDOSCOPE SHAPES

The few reports of visual hallucinations of kaleidoscope shapes (see table 7.4 in appendix B) demonstrate that verbal descriptions of these patterns permit only a poor understanding of what the migraine sufferer actually sees during this migraine aura experience. A symmetrical flower pattern, described as "a green maple leaf–like shape"[655] in the center of the visual field, was recurrently seen by a migraine patient of Winselmann's, but the symptom was diagnosed by the author as hysteria.[655] A patient of Ormond's described a "phenomenon seen only with my eyes closed—a crimson area with an ever-moving pattern like a kaleidoscope," the effect being "of fluid in motion with the patterns in black lines" accompanied by a "headache of neuralgic character all through the attack."[444] A patient of Riley's noted, "Multicolored objects which appear as in a kaleidoscope may float or fly through the affected visual field."[537] Sacks records visual hallucinations "reminiscent of mosaics" or "Turkish carpets."[554] The artist studied by Atkinson and Appenzeller described her aura: "I saw designs, patterns, and objects fly by in my mind at a pace that I normally could

never think these things up."[28] Fisher records "octagonal kaleidoscopic geometric figures fitted together in ten colors" and "mosaics" as visual phenomena during migraines.[173] Arnaud et al. mention "kaleidoscopic images," "decorative pictures," and "diagrams" as visual hallucinations occurring in migraines without providing further details.[25]

Visual hallucinations of kaleidoscope shapes are depicted in fifteen Migraine Art pictures, the various forms of which are described below.

▶ **Figure 262**

Migraine Art collection.

▼ **Figure 263**

Migraine Art collection.

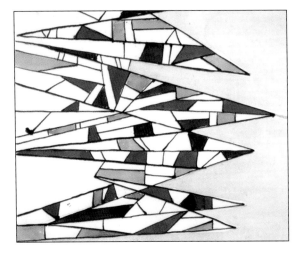

Kaleidoscopes

Figure 261 depicts a kaleidoscopic pattern centered around the image of the sufferer's eye, indicating that "the lights flash from the center outwards." Figure 262 illustrates a number of geometric circles in kaleidoscope form. The artist writes, "I felt separate from the real world, and when I closed my eyes I could see flashes of color and light.... I became almost mesmerized by what I was seeing behind my eyelids."

Mosaics

Nine Migraine Art pictures show mosaics, composed of various line shapes (three pictures), line and curve shapes (five pictures), and line, curve, spiral, and lattice shapes (one picture). The mosaic in figure 263 was experienced by the artist as "flashing lights" accompanied by "piercing headaches." Figures 264 and 265 are two pictures of mosaics from a female sufferer who explains her experience:

> *It was an irregular shape composed of five- and six-sided units, which were largest in the center of the shape and smaller at the edges. Clusters of units were revolving and each individual unit was revolving; it was all swirling and moving all the time. In the middle, the units tended to be blue and orange, those around them were red and green, but there was no very clear demarcation into zones. Colors were intense and brilliant like stained glass windows full of light. In the center of each unit was a brilliant white "eye." After about fifteen minutes, the intensity of the colors thinned and faded. The edges would disappear first. One or two blobs of color might remain centrally for longer; then it would all fade.*

Symmetrical Flower and Animal Shapes

Two pictures illustrate visual hallucinations reminiscent of symmetrical flowerlike patterns (see figs. 266 and 267) and a third shows a

▲ **Figures 264 and 265**
Migraine Art collection.

◀ **Figure 266**
Migraine Art collection.

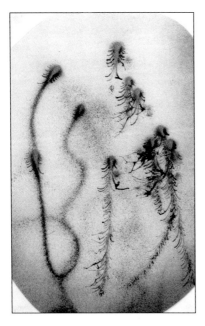 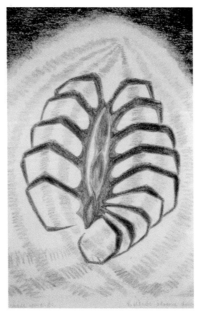

▲ **Figures 267 and 268**

Migraine Art collection.

symmetrical insect-like pattern (see fig. 268). The artist comments:

There were vertical shimmering arcs with a purplish-blue image imposed. The darker image was in constant movement, the right side dominant. At first the curves of it were rounded, but it became more angular and riblike. The ribs on the right swept downward in a curve toward me, while the ribs on the left swept upwards, receding. When both reached the climax point of that movement, there was a tiny jerk; then the movement began again. After some time, the image would fade, leaving an impression of the descending movement on its own and some of the background shimmer. The shimmer would be the last to fade away. The pattern was accompanied by a headache.

COMPLEX IMAGERY

Visual hallucinations of complex imagery are encountered in eight Migraine Art pictures. They are presented here in the context of the various complex visual hallucinations described in the migraine literature (for sources in medical literature see table 7.4 in appendix B).

Complex Hallucinations of Human Figures, Animals, Plants, Inanimate Objects, and Scenes

Since the seminal 1887 report of S. Weir Mitchell on "Neuralgic headaches with apparitions of unusual character,"[414] numerous authors have contributed to the accumulating evidence that complex visual hallucinations can occur, though more rarely, as migraine aura symptoms as well as in epilepsy, drug intoxication, and psychosis. However, this idea has been

controversial and much debated, and the evidence in published case reports was frequently rejected by attributing the complex hallucinations to epilepsy, hysteria, or psychosis rather than to migraines, or by talking about overlapping syndromes such as migraine-epilepsy or dysphrenic migraines.[221,408,415] Möbius assumed hysteria to be the most likely explanation of the complex visions reported by migraine sufferers.[415] Gowers summarized the medical differences between migraines and epilepsy and made the influential statement that in migraines "we never meet with the elaborate psychovisual sensation—a face, a figure, a scene, or the like, which are not rare in epilepsy,"[221] an opinion still held by some eminent neurologists and expressed in current textbooks. Evaluating the evidence for complex visual hallucinations as part of migraine auras, it is true that some of the migraine patients also had seizures, convulsions, or typical signs of hysteria. But it has to be noted that epileptic fits can be part of some forms of migraine[51] or can be triggered by a migraine aura,[433] and that hysteria can be a secondary reaction in patients suffering from neurological diseases,[395] which include migraines.[356,604] Our opinion is that complex visual hallucinations can occur as genuine migraine aura symptoms, as seen in the medical evidence (see table 7.4 in appendix B) and also by findings in the Migraine Art collection.

In the cases in the medical literature, migraine sufferers described the content of their complex hallucinations as human or humanlike forms, animals, or animal-like creatures, plants, inanimate objects, and sometimes complete scenes. Complex hallucinations of *human and humanlike figures* included visions of both male and female adults; children; miniatures of people, discussed below in the section on Lilliputian hallucinations; and large groups of people, described as "a procession of white-robed veiled figures" by one of Mitchell's patients,[414] as "three men in conical hats and cloaks" by a patient of Wakefield's,[629] and as "a crowd of [more than] one hundred people, some dressed in white" by a patient of Andermann's.[14] The hallucinated human figures represented either familiar individuals, like a near relative,[412] or unfamiliar people.[128] Visions of dead people, humanlike ghosts, phantoms, witches, and religious figures were frequently reported, as discussed below in the section on paranormal hallucinations.

Among complex hallucinations of *human body parts* in migraine sufferers, heads and faces with beautiful, ugly, or grimacing features were reported most often. A patient of Mitchell's saw "a crescent of silver on the wall, and suspended from it numerous heads in profile."[414] Other body parts that appeared in complex visual hallucinations included "a strange hand,"[642] "a human hand" covering the patient's field of vision,[213] "legs everywhere,"[381] and "skeletons."[409] Seeing *one's own body* (autoscopy) was described in migraines as a complex visual hallucination in out-of-body states and in the phenomenon of seeing one's own double at a distance (see "Out-of-body Experiences, Seeing One's Own Body, and Duplicate Body Parts" in chapter 6).

Complex visual hallucinations of *animals* included "a huge red spider, which melted into a series of red rectangles revolving in swift motion,"[414] "lines of ants,"[379] a red and squirmy "piranha fish,"[201] snakes,[36,457] "mice, serpents, birds,"[466] chickens,[409] "a large black and very hairy dog,"[414] "small, silent, white dogs,"[394] "dogs and cats,"[411] "a cat,"[642] "a head of a pig,"[28] and two cases with visions of a horse.[394,411] Complex visual hallucinations of *animal-like creatures,* described as "monsters," are recorded by Mingazzini in a forty-three-year-old female migraine sufferer[411] and by Camfield et al. in a nine-year-old boy with basilar migraines who "had with the headache hallucinations of monsters that he could draw convincingly during and after the attack."[87] Similarly, during his attacks a patient of Klee's saw, especially when it was dark, "white 'living creatures' which did not move and whose outlines were not entirely distinct. He was not really afraid of them, and there was no clouding of consciousness or disorientation."[312]

Two examples of *plants* appearing as complex visual hallucinations are recorded in a patient of Mitchell's who saw "a trellis of silver covered with vines and flowers of brilliant tints"[414] and in a patient reported by Manford and Andermann who "described a tree"[394] during the course of migraine attack.

Only rarely encountered are complex hallucinations of *inanimate objects,* including staircases,[409] pagodas and statues,[337,338] a streetcar,[35] "moving black veils" and "scintillating picket fences,"[597] "hallucinatory musical

instruments" that the sufferer tried to pick up from the floor,[312] "a faucet made of a swan's head," "part of a sink" and "half a shoe,"[28] which correspond to the halved images in the visual hallucinations sometimes reported by patients with permanent loss of vision in the same side of both visual fields (homonymous hemianopia).[371] The migraine sufferer reported by Atkinson and Appenzeller also once saw "a fly's eye made of millions of light-blue Mickey Mouses,"[28] which corresponds to another characteristic of complex visual hallucinations in the part of the visual field where vision is lost in half of the field: the appearance of multiple identical copies of an object in the form of a pattern.[328] Such identical replications were also experienced by a migraine sufferer of Donahue's, who reported seeing a "thousand silver forks dancing up and down."[137]

Complex hallucinations of entire *scenes* were experienced by a personal friend of Wilson's, who saw "a large room with three tall arched windows and a figure clad in white (its back toward him) seated or standing at a long bare table; for years this was the unvarying aura."[654] In a patient of Cogan's with a history of migraines, the headache attacks were associated with "striking hallucinations consisting of people, animals, and pastoral scenes. They were vividly colored and when present lasted fifteen minutes or longer. Their severity varied with the intensity of the headaches."[97] Similar scenic hallucinations are described by Lindner et al. in a patient with a history of migraines but not seizures who saw, during a period of nine days, "moving streets and landscapes" and a variety of other complex visual hallucinations accompanied by a headache on one side.[372] Measurements of electrical activity in the brain, called "electroencephalography" or EEG, made during these visual symptoms revealed epileptic discharges in the rear of the brain, which have been described in some cases as an EEG feature of migraines with auras.[433] Fisher describes the case of a migraine sufferer with loss of vision in the same side of both visual fields (homonymous hemianopia) that persisted after a severe migraine attack. She experienced a variety of vivid hallucinations of scenery in the area of the visual field with loss of vision, sometimes with two sets of hallucinations running at the same time in two rectangular areas, like two built-in personal television screens.[175]

Unfortunately, the medical literature includes scant information about the characteristics of complex visual hallucinations other than their content. Mingazzini emphasizes that recurring complex visual hallucinations are a typical feature of dysphrenic migraines,[411] which corresponds to a general criterion of migraine auras: that there are two or more similar spells.[173] In some cases, complex visual hallucinations were reported to fill only half of the migraine sufferer's visual field.[35,167,539,629,642] These are similar to well-known complex visual hallucinations in the part of the visual field where vision is lost in neurological patients with permanent loss of vision in the same side of both visual fields (homonymous hemianopia).[328] In a unique case described by Pick, complex visual hallucinations were distributed over the area of visual loss in a migraine sufferer with loss of vision in the outer half of both visual fields (heteronymous bitemporal hemianopia).[466] Another characteristic of complex visual hallucinations in migraine patients is that they occurred both in black-and-white and in color. They were either motionless[312] or, more frequently, showed various forms of movement, which Mingazzini emphasizes as a characteristic feature.[411] In three cases of complex visual hallucinations restricted to half of the field of vision, the hallucinations moved from the edges to the center of the visual field, corresponding to the same phenomenon observed in neurological patients with permanent loss of vision in half of the visual field[328] and in Fisher's patient mentioned in the previous paragraph.[175] A migraine patient of Féré's saw animals coming from the right and disappearing in the middle of his field of vision;[167] a patient of Barolin's saw a streetcar approaching from the left side;[35] and in a patient of Wakefield's the attack was "ushered in by 'seeing' three men in conical hats and cloaks in the left field of vision moving slowly across to the right."[629] In a peculiar form of complex visual imagery described by Forbes[185] and Saul[559] as "dream scintillations," the sufferer consciously experiences a flow of complex visual hallucinations in a dreamlike manner. According to Saul these episodes "last about twenty minutes and consist of dreamlike images which occur in addition to the usual stream of consciousness, do not interfere with it, and are characterized by elusiveness—their content evading apprehension."[559] A history of recurring headaches and accompanying

gastrointestinal and other disturbances were reported to be part of the experience, so it is safe to assume that these "dream scintillations" represent a migraine aura symptom.

The four Migraine Art pictures featuring the complex visual hallucination of seeing one's own body (autoscopy), mixed with geometric hallucinations like random and line shapes, were described in detail in "Out-of-Body Experiences, Seeing One's Own Body, and Duplicate Body Parts" in chapter 6 (see figs. 119–122). Another picture, figure 220, shows a female migraine sufferer hospitalized during a severe migraine attack and a nurse presenting a vomit bowl to the patient. Inside the area of the spot on her vision (scotoma), bordered by a zigzag spectrum, the artist sees the image of two horses behind a gate, superimposed by a sprinkling of yellow dots, which indicates a combination of a complex scenic hallucination and simple random shape hallucinations.

Hallucinations of Words, Letters, and Numbers

Symbols such as words, letters, and numbers are another type of complex visual hallucination during migraines, and in all reported cases these hallucinations occur along with other complex visual hallucinations. A patient of Hoeflmayr's saw words written in the air;[267] a patient of Schob's had hallucinations of letters, words, and numbers;[566] and a patient reported by Fuller et al. "saw writing on the wall and when asked what it said found he was too far from it. He then walked up to the wall and was able to read it out clearly."[201] In the case of a migraine sufferer with a persisting loss of vision in the same side of both visual fields (homonymous hemianopia) that began during a severe attack, Ormond records hallucinations of "numeral figures" and "half words in handwriting characters,"[444] another example of the hallucinated half pictures occasionally reported by patients with permanent loss of vision in the same side of both visual fields. The Migraine Art collection includes no illustrations of complex visual hallucinations of words, letters, or numbers, emphasizing their rarity.

These reports of complex hallucinations of letters must not be confused with descriptions of scintillating scotomas or spots on the visual field, the sickle and zigzag shapes that have been compared to the letters C and Z by

a patient of Krafft-Ebing's,[336] among others. Brunton remarks that some visions described in Dante's *Divine Comedy*, written between 1307 and 1321, "have a striking similarity in form to the ... zigzags seen in sick headaches," suggesting that "Dante himself appears to have seen something of this kind, for in his *Paradiso*, Canto XVIII, lines 70–72, he says, 'So, within the lights the saintly creatures flying, sang, and made now D, now I, now L, figured in the air.'"[75]

Lilliputian and Brobdingnagian Hallucinations

In 1909 the French psychiatrist Leroy described a peculiar type of miniature hallucination that occurs during intoxication and in a variety of neurological and psychiatric diseases.[367] He called them "Lilliputian hallucinations," named after the inhabitants of Lilliput in Jonathan Swift's 1727 novel *Gulliver's Travels*.[606] In a typical case, brightly colored and clearly individual little people are seen to form parades or engage in complicated lifelike antics. Hallucinations of conversations and choruses in Lilliputian voices as well as a sort of Lilliputian music are sometimes heard. The accompanying emotional state is usually characterized by joy and charm and only rarely by terror and fear. Few reports exist of Lilliputian hallucinations in migraines. In the unique observation of a patient of John K. Mitchell's, the image of a tiny dwarf gradually transformed into a giant gladiator, striking the patient on the head.[412] This hallucination of giants has been called a Brobdingnagian hallucination,[614] again referring to *Gulliver's Travels*. In another migraine sufferer hospitalized for a severe migraine, Klee records that "during his attacks he had on one occasion seen twenty-cm [eight-inch] high, grayish-colored Red Indians crowding round in the room in which he lay.... He was not afraid of them as they did not seem to have anything to do with him."[312] Siri Hustvedt describes her single experience of premigraine Lilliputian hallucinations:

> *I was lying in bed reading a book by Italo Svevo, and for some reason looked down, and there they were: a small pink man and his pink ox, perhaps six or seven inches high. They were perfectly made creatures, and except for their color, they looked very* real. *They didn't speak to me, but they walked around, and I watched them with fascination and a kind of amiable tender-*

ness. They stayed for some minutes and then disappeared. I have often wished they would return, but they never have.... It wasn't until after my duo had vanished that I understood I had seen a miniature version of two legendary oversized characters from my childhood in Minnesota: Paul Bunyan and his blue ox, Babe. The giant man and his huge animal that I had read about in stories had shrunk dramatically and turned pink. It was then that I asked myself about the content *of the hallucination. What did it mean that my aura took that form rather than something else? Are these visions purely nonsensical? What memory traces are activated during these experiences?*[281]

In two observations, migraine sufferers reported miniature hallucinations of inanimate objects rather than people or animals. A patient of Mingazzini's had "visions of small, indefinite, equal-sized objects,"[409] and a patient of Schob's once "saw around the lamp, for a quarter of an hour, a real dance of small, approximately fifteen-cm [six-inch] high figures, like children's toys; they were in very rapid movement and disappeared immediately when the lamp was switched off."[566]

Figure 269 depicts the view of a ten-year-old girl facing a dressing-table mirror, with multicolored dots and stars together with profiles of two miniature female faces distributed over her entire visual field. The miniature faces are Lilliputian hallucinations.

◀ **Figure 269**

Migraine Art collection.

Figure 100, by a seventy-two-year-old female artist with a history of basilar migraines,[494] shows a similar combination of random dots and complex Lilliputian hallucinations. Every two or three months from her early thirties she experienced hallucinations of tiny "black beetles with faces," occurring at the peak of her severe migraine attacks and lasting for about two to five minutes. Starting with two or three identical images of these beetles, they would increase in number and were often arranged in a regular line. Continuously moving, they would run across the carpet, up the wall, and over the ceiling. Closing her eyes would make them disappear immediately.

Hallucinations in Dream Imagery

Airy notes that the typical zigzags of fortification spectra may begin during sleep, incorporated into the imagery of a dream and carried over into the waking state.[7] He writes, "Sometimes the attack has been nocturnal, mingling with a dream, from which I wake and find the spectacle in full fervor." Similarly, a migraine patient of Gutheil's experienced scintillations at the end of a dream from which she awoke with a headache,[237] and a sufferer reported by Podoll et al. had recurring dreams featuring pulsing colored "sea anemone" patterns that ended in migraine headaches.[504] Féré reports both simple and complex visual hallucinations recurring as part of the imagery of "precursory dreams" before a migraine attack.[168] In Féré's first patient, recurring attacks of visual migraines with scintillating spots in the right half of the visual field were regularly preceded by the same terrifying dream with images on the right side that were compared to a thunderstorm, a volcanic eruption, and a fire, without any noise or smell. This patient probably suffered from migraines caused by the brain deterioration of syphilis, which subsequently led to mental deterioration, epileptic fits, and death. Féré's second case was a sixteen-year-old girl who repeatedly dreamed of a white phantom and frequently had a full-blown migraine attack with an aura the following day. Her dream was described: "It is a white-clad woman whose face she can only see through a veil, but who seems to be of marvelous beauty to her; she constantly appears on the right side and takes to diverse manifestations which, however, always

recall some religious scenes, and disappears all of a sudden." Curschmann clearly states that such dreams have to be considered a manifestation of the visual migraine aura.[117] Lippman characterizes migraine precursory dreams by the following features: "1. Recurrence. 2. They usually occur in brilliant colors.... 3. They appear at *specific* times in the life-span of the patients. 4. They are characterized by certain emotional *tones* which usually carry over, some-

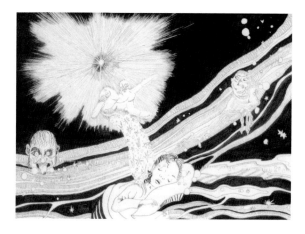

▲ **Figure 270**

Migraine Art collection.

times for hours, into the waking state. 5. In some cases the dream is so vivid that it persists as a hallucination after the patient is wide awake."[376] Lippman emphasizes nightmares in migraines, also mentioned in a number of other reports in both early and recent medical literature.[49,131,139,179, 236,238,334,380,415,417,504,527,534,537,556,667] In contrast to the anecdotal quality of most of these reports, Levitan,[368] Beyme,[50] and Heather-Greener et al.[251] systematically studied the content of migraine precursory dreams, confirming that the majority of these dreams are characterized by negative emotions. Sacks saw the halved figure of his mother in a dream from which he awoke with a visual migraine aura with loss of vision in half his visual field—in his dream she "seemed *bisected* in an extraordinary way"; she "stopped in the middle" and "had no left half."[555] Once again this resembles the halved pictures sometimes experienced by patients with permanent loss of vision in the same side of both visual fields (homonymous hemianopia). The precursory dreams of migraine sufferers have also been reported to include body image disturbances such as the sensation of the body being abnormally large or small,[391] the feeling of a presence,[373] sinking and flying sensations,[417] and falling sensations of floating gently down a "long dark funnel with corrugated sides."[376]

The Migraine Art collection includes a single picture illustrating a precursory dream with visual hallucinations of both simple and complex shapes. Figure 270 shows the sleeping sufferer experiencing the common star shapes of the migraine aura together with the image of an outstretched arm as well as two grotesque figures that form the scenario of

her nightmare. For two Migraine Art pictures that represent body image disturbances experienced while dreaming, see figures 124 and 125.

Paranormal Hallucinations

Visual hallucinations of complex shapes also include various forms of so-called paranormal hallucinations,[274] which merit consideration even though the Migraine Art collection has no examples. As summarized in table 7.4 in appendix B, the complex hallucinations reported as visual migraine aura symptoms also include images of dead people, ghosts, phantoms, witches, and religious figures such as God, Jesus Christ, the Virgin Mary, angels, saints, and the devil (for more on hallucinations of a religious nature, see "The Visions of Hildegard of Bingen" in chapter 1).

In 1887, S. Weir Mitchell reported four peculiar cases of migraine headaches with "apparitions of unusual character," including one female migraine sufferer who repeatedly saw the figure of her sister, who had been dead for several years, followed by a severe headache. "Until this sequence occurred several times, she laid the headache to the ghost, and not the ghost to the headache, as she learned to do after the phenomena had been many times repeated."[414] Mitchell summarized his findings:

> *In the cases I shall describe, the ordinary subjective images of zigzag lines or rotating wheels were replaced by more definite shapes, so as sometimes to induce the belief for a time, on the part of the patient, that a ghost has been seen.... Our present state of knowledge, or want of knowledge, makes comment difficult as regards these cases. Why should the zigzag lines or the Catherine wheel [a wheel with spikes projecting from the rim] be so common, and how shall we explain why in rare cases the storehouse of memory sets free for visual projection strange figures long unremembered? ... Finally, one is tempted to ask if some ghost stories may not arise out of these rare examples of headaches preceded by hallucinations.*

Similar experiences have also been recorded in more modern times, as in Lippman's report of a migraine patient who recurrently had "ghastly experiences" just after waking from a nightmare:

Night after night I awoke from a nightmare. I would awake with a startled awareness, "that something is after me." It was. Right there, at the opposite corner of my bed stood a tall shapeless apparition, shrouded in white, staring at me forebodingly. I would lie motionless. My heart racing, shivering from fright and coldness. . . . Then slowly "it" would commence, to me, the agonizing march toward my bed. Heart-splintering step after heart-splintering step. The urge to cry out was excruciating, but the vocal cord as well as every other muscle in my body was paralyzed from fear. But when "it" finally reached my bed, and I was resigned to my fate, "it" suddenly diffused in the air. Then "it" gradually reformed itself and assumed "its" previous position, at the opposite corner of my bed, for a repeat performance. And so it went, 'til the first rays of gray would dissipate the complete darkness in the room. The days following those ghastly experiences were spent half in living down the horror which lingered on for hours.[376]

Klee reports the case of a migraine patient who was hospitalized because of her severe migraine attacks. He writes, "During several of her severe attacks she has had the experience that she saw, and probably also spoke to, her deceased adoptive mother, and during one attack she saw and talked with her deceased biological mother who lay 'as if she were alive' in a hospital bed (as she had done on the last occasion that the patient had seen her, many years previously)."[312] Similarly, in a survey of abnormal perceptual experiences in forty-six new female referrals to a migraine clinic, Morrison encountered two patients who reported "seeing someone they knew once after death."[422]

In 1902 Brunton suggested that the visions of fairies, then so commonly reported, represented the outcome of migraine hallucinations, at least in some cases:

To some the idea may seem far-fetched, but I am inclined to believe that the fairies which many people declared that they saw were nothing more than the colored zigzags of migraines modified by imagination. . . . It is quite extraordinary to notice in the stories of fairies how often the "seer" was struck blind of one or other eye, and after this his power of seeing fairies disappeared. . . . It is noticeable that visions of the fairies, or little green folk,

are very generally accompanied by jingling of bells, and this I regard as stimulation of the nerve centers for hearing coincidently with that of the visual centers.[78]

While Brunton suggested a sort of misinterpretation of the simple hallucinations seen in migraine spots on the visual field (scintillating scotomas), complex Lilliputian hallucinations, which were not recognized as a distinct symptom before Leroy's 1909 paper, are another possible way to account for seeing fairies. Brunton relates the following observation, which perfectly matches the features of Lilliputian hallucinations:

> *When I was a small child, my aunt's maid told me that she had seen fairies when she was a little girl living in Earlston [Scotland], the home of Thomas the Rhymer [more commonly known as the popular poet Thomas of Ercildoune], and the center of fairyland. She was standing one morning at the door of her house, when she saw a troop of small people dressed in green coming up the street. She called to her father and mother to look at them, but neither of them could see anything.*[78]

Victorian fairy paintings include many images of such Lilliputian figures, who most often appear in large numbers, for example in Sir Joseph Noel Paton's 1849 oil painting *The Quarrel of Oberon and Titania*.[397] The painting had among its admirers Lewis Carroll, who counted no less than 165 fairies in it.[227]

The observations of Mitchell and Brunton opened a path to a rational interpretation of the apparently paranormal phenomena of apparitions,[619] as was clearly recognized by Mercier,[405] who notes:

> *[Brunton] had shown, not, perhaps, in every case satisfactorily, that there was a possible explanation, according to the known laws of physical nature, of those occurrences which seemed to us occult, mysterious, and inexplicable. That was a service which he thought science could not overestimate. There would always remain and always must remain, a region in which we must fail to explain, and in which we must fail to bring phenomena under known laws, i.e. laws of uniform sequence. But so long as we were in this world our task was to reduce that region as much as possible.*[405]

Unfortunately, the work of Mitchell and Brunton did not stimulate further research, so no firm generalizations can be drawn from the evidence available—but migraines must certainly be taken into consideration in any future scientific study of supernatural visions with natural causes.[398]

Colors Seen in Hallucinations

In the earliest accounts of the typical migraine zigzag hallucinations, it was recorded that they can include all the colors of the visible spectrum.[6,7,217] Schilder writes, "The variety of colors in the fortification spectrum in migraines should be particularly noted."[564] The frequency of seeing color in these migraine zigzags varies, as does the intensity of the color, which may be faint or strong; the duration during the visual aura, which may be temporary or last for the entire experience; and its location, which may be in the center or, more frequently, at the edges of the spot on the visual field (scotoma) bordered by the zigzags.[217] According to Alvarez the rainbow colors are usually seen "on the inner side of the zigzag line."[12] Baumgartner studied the visual symptoms of eighty-seven migraine patients and found that "color phenomena within the zigzag lines of the fortification spectra ... were frequent but irregular."[39] The shapes of migraine visual hallucinations other than zigzags are also frequently described in the literature as occurring in color; there are colored spots of light, silver streaks and stars, a golden rhomboidal figure, a colored diamond, a brown luminous grating, a green "maple leaf–like" shape, and multicolored kaleidoscopic patterns (for sources in the medical literature see table 7.4 in appendix B).

In contrast to the emphasis on color in the medical literature, Panayiotopoulos claims that migraine hallucinations are predominantly black-and-white and that colors, which may be seen in the course of a migraine aura, have to be considered "as part of the scintillating scotoma [spot on the visual field] and teichopsias [zigzag shapes] and not as the predominant feature of the migrainous visual hallucinations."[451] He even suggests that the absence or presence of color can be used to distinguish between visual hallucinations of migraine origin and epileptic origin. This notion

is clearly contradicted not only by the medical literature but also by pictures from the Migraine Art collection.

In this section the visual hallucinations seen in the Migraine Art collection are classified according to color, again using the classifications of Siegel and Jarvik,[583] which include the following nine categories: black, violet, blue, green, yellow, orange, red, brown, and white. Each of the colors used in the pictures is scored in the category nearest to the color on the spectrum, for example: Purple is categorized as violet, gold counts as yellow, maroon is red, tan is brown, silver is white, and blue-green is blue and green. The results are summarized in table 7.11 in appendix B. The colors of the visual hallucinations cover the entire visible spectrum, so Panayiotopoulos's notion that migraine visual hallucinations are predominantly black-and-white cannot be substantiated.[451] The possible objection that the artists' use of colors might reflect artistic license rather than their actual occurrence in visual hallucinations is countered by analyzing the realism in the artworks illustrating visual disturbances (see table 7.1 in appendix B). One artist explicitly stated that "when I painted the picture I knew which colors I needed" to give a true depiction of the phenomena experienced (see fig. 261), and another artist remarked that "I have still the variety of colored pens I bought to convey the visual disturbances I had" (see fig. 181), showing the artists' intention to represent their experiences realistically. Color is emphasized in other artists' descriptions of their visual hallucinations as "some colored thing," "the rainbow's spectrum," "neon hula hoops," "neon waterfalls," and "a brightly colored neon sign effect." A female artist compares her hallucinations of random shapes to "showers of gold lights" (see fig. 154). Another female artist relates that both she and her mother, who also suffered from migraines, called "the jagged silver lights" of expanding fortification spectra "aluminum snakes." The grid pattern in figure 218 was experienced with many variations in color: "No normal colors are so bright and luminous and shimmering and multiple." The mosaic patterns seen by another artist appeared in colors that were "intense and brilliant like stained glass windows full of light" (see figs. 264 and 265).

The psychologist Katz distinguishes between "surface colors," which are bound to the surface of a definite object, and "plane colors," which

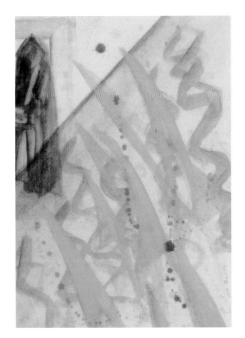 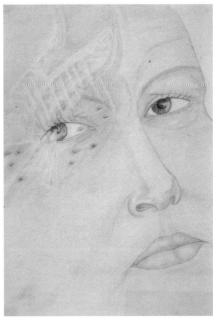

◀ **Figures 271 and 272**

Migraine Art collection.

appear as disembodied colors without any specific orientation in space and no suggestion of being associated with a solid object.[300] Plane colors may be transparent, so that objects can be seen behind them, the color existing in space between the object and the artist. Pick was the first to note that visual hallucinations in migraines may take the appearance of plane colors.[468] A fifty-two-year-old male patient with recurring headaches who had a single experience with a visual aura with a typical zigzag fortification spectrum also reported that on a different occasion he had seen, at a constant distance of about four paces in front of him, two transparent yellow stripes that moved when his eyes moved when he tried to approach them and that disappeared after about fifteen minutes. In a later study, Pick remarks that the colored mists occasionally described by patients with visual migraines also have the character of plane colors.[469] Plane colors as visual migraine aura symptoms are clearly documented in Migraine Art. The bluish watery patterns in figure 271 are transparent plane colors, behind which can be seen a dressing gown hanging on a hook. The migraine sufferer depicted in figure 272 sees faint rainbowlike colors that appear to float in space in front of her eye.

The migraine literature includes a number of reports of colors occur-

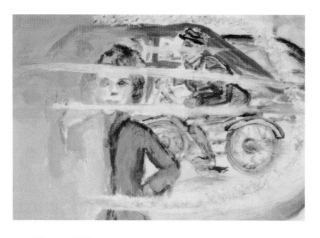

Figure 273

Migraine Art collection.

ring as visual migraine aura symptoms where the color is the main feature of the experience. In these cases it may be more appropriate to discuss "hallucinations of color" rather than "the colors of hallucinations." Colored spots in random shapes on the visual field have frequently been described. A sensation of color in the entire visual field or half the visual field is called *chromatopsia*. More specifically the sensation of red is called erythropsia, yellow is xanthopsia, green is chloropsia, blue is cyanopsia, and violet is ianthopsia. A few reports exist of chromatopsia occurring during a visual migraine aura. These include cases involving red,[195,521,655] yellow,[597] green,[262,521] and blue.[91] The rarity of sensing color in the visual field is confirmed by the fact that only one Migraine Art picture (see fig. 273) illustrates yellow in half the visual field together with hallucinations of line and curve shapes in the entire visual field.

Movements Seen in Hallucinations

Listing's term *scintillating scotoma* refers to the sparkling movements of visual hallucinations on the edges of scotomas—spots on the visual field—during migraines.[378] In Airy's account of teichopsia, or zigzag hallucinations, he notes that "three orders of motion, (1) gradual outward spread of the whole, (2) slow rolling of parts, (3) rapid tremor of the margin, are especially characteristic of this affection."[7] Gowers describes the gradual outward spreading movement as a major feature of the most common form of fortification spectra, the expanding sphere.[217] The presence of motion was already recognized as a characteristic feature of the visual hallucinations of migraines in the earliest medical reports.

A more comprehensive classification of the movements seen in migraine hallucinations comes from Siegel and Jarvik and includes eight categories:[583]

Aimless: any movement without apparent direction, "things floating around," etc.

Vertical: up or down

Horizontal: right or left

Oblique: any linear motion at an angle other than vertical or horizontal

Explosive: motion away from the center, outward from the center, etc.

Concentric: motion toward the center

Rotational: circular motion, clockwise or counterclockwise

Pulsating: flickering, pulsating, throbbing, twinkling, etc.

In many reports of visual hallucinations in the migraine literature it is simply stated that there was some type of movement, or the type of movement was only vaguely described as boiling,[7] floating or flying,[537] shooting,[158] dancing,[597] waving,[312] or compared to a "madly whirling maelstrom of light."[271] All of these may be classified as *aimless* movements. Descriptions of *vertical* movements included shimmering halos apparently falling down and approaching the sufferer,[465] snowflakes falling to the ground,[620] a "falling light curtain,"[137] "specks falling like a curtain,"[654] colored rings drizzling from the top to the bottom,[260] and "a thousand silver forks dancing up and down."[137] *Horizontal* movements were described by a patient of Peatfield and Rose's who repeatedly saw "bright flashes passing across the visual fields to the left."[457] Complex visual hallucinations in migraine sufferers with transient loss of vision in half the visual field (hemianopia) were reported to move horizontally from the periphery to the center of the visual field (see "Complex Imagery" above). Gowers records *oblique* movements of a mobile angled sphere,[217] and Russell et al. record a visual aura with zigzag lines moving "diagonally across the visual field."[553] The typical gradual outward spreading movements of fortification spectra can be classified as *explosive* movements. A visual migraine aura recorded by West was described as "star shells exploding silently above a distant warfront an inch behind my eyes."[639] As an unusual feature of scintillating spots on the visual field, Dianoux describes a *concentric* movement of zigzag lines from the periphery toward the center of the visual field,[134] also seen by other authors.[48,295,386,553,671] A concentric movement was also experienced by a patient of Wilson's who saw a spiral "begin by its outer coil and contract inward to its core."[654] *Rotational* movements are described by Vignolo as

▶ **Figure 274**

Migraine Art collection.

"bright rotating flames,"[627] by Elliot as "revolving colored haloes" and "bright circles usually revolving,"[158] and by Peatfield as "a colored rotating diamond."[456] *Pulsating* movements were described as scintillations, vibrations, tremor, flame-like flickering, or "twinkling … similar to moonlight on freshly fallen snow."[271] The pulsation rate of typical scintillating scotomas (spots on the visual field) is estimated by most authors to range between five and twelve cycles per second (Hz): Estimates include 5 Hz,[7] 9 Hz,[84] 10 Hz,[352] and 8–12 Hz.[293,406] Hare estimates it at 10–15 Hz to begin with, later falling to 3–4 Hz.[243] However, due to the difficulty of judging the speed subjectively, all these estimates have to be considered speculations. In fact, Crotogino et al. show that when measured with an objective task, the perceived scintillation rate of the visual migraine aura was found to be around 18 Hz,[116] somewhat higher than previous observations.

References to movements are encountered in just twenty Migraine Art pictures, which reflects the difficulty of showing movements in a still picture. The fifteen Migraine Art pictures that show successive stages of expanding spectra in a series of illustrations or within a single illustration are examples of explosive movements (see "Line Shapes" above). Figure 274 shows a scintillating spot on the visual field that displays first explosive and then concentric movements. In another picture the vertical up and

down movements of "shooting lights" are indicated by arrows. In three Migraine Art pictures, vertical and pulsating movements are described in text within the artwork, referring to "gray shapes moving upwards," "oscillating," and "pulsating" movements.

Other Characteristics of Hallucinations

Four general characteristics of the visual hallucinations of migraine auras, described in the literature and illustrated in pieces of Migraine Art, are discussed in this section: their duration, "translocation" or movement with eye movements, persistence after closing the eyes, and different types of location in space.

DURATION OF VISUAL HALLUCINATIONS

The visual hallucinations occurring as symptoms of migraine auras typically last from a few minutes to an hour,[658] and a duration of ten to thirty minutes is reported most frequently.[7,12,217,243,352] However, in more recent years, Queiroz et al. suggest that in unusual cases, visual auras may "last only a few seconds."[522] A visual aura that lasts from one hour to seven days is called a "prolonged aura." If the visual aura lasts for over one week, and a neuroradiological examination shows no evidence of a stroke, it represents a rare but well-documented complication of migraines called "persistent aura without infarction."[239,379,387] The persistent aura may last for weeks, months, or years.[284] These symptoms are characteristic of a type of migraine that was first described by the American neurologist David C. Haas in 1982 in two cases that he called "prolonged migraine aura status."[239] It was not until thirteen years later that Grant T. Liu et al. reported the first large group of ten cases with this condition in a paper titled "Persistent Positive Visual Phenomena in Migraine."[379] Their patients' "complaints were similar in their simplicity and involvement of the entire visual field, and usually consisted of diffuse small particles such as TV static, snow, lines of ants, dots, and rain."[379] Only recently have Internet forums for those suffering from persistent "visual snow or static" attracted researchers' interest in this rare migraine complication.

In three Migraine Art pictures, the visual hallucinations are stated to have lasted three minutes (see fig. 234), forty minutes (see fig. 228), and sixty minutes (see fig. 274), which agrees with the medical literature. The visual hallucinations experienced by migraine sufferers last long enough that they can observe them with considerable accuracy, as reflected in the Migraine Art pictures presented in this book.

In medical terms, visual hallucinations that last minutes rather than seconds are a way to discriminate between a migraine and an epileptic aura, as was first recognized by Gowers, who writes, "The epileptic aura occupies a few seconds; the premonition of a migraine is almost always many minutes, often twenty, in its deliberate course."[221]

TRANSLOCATION WITH EYE MOVEMENTS

A common characteristic of most visual hallucinations in migraine auras (perhaps with the exception of some complex visual hallucinations) is that eye movements result in corresponding movements of the hallucinated images: The visual hallucinations demonstrate "translocation" related to eye movements. These movements of the hallucinations resulting from eye movements are different from genuine movements of the visual hallucinations, described above in the section on "Movements Seen in Hallucinations." It is interesting to note that the feature of translocation appears to be described in Lewis Carroll's *Through the Looking Glass* when Alice looks around at the shelves in a grocery shop. "'Things flow about so here!' she said at last in a plaintive tone, after she had spent a minute or so in vainly pursuing a large bright thing, that looked sometimes like a doll and sometimes like a work-box, and was always in the shelf next above the one she was looking at."[89] In the medical literature, migraine spots on the visual field (scintillating scotomas) moving with eye movements are recorded as an effect of both voluntary[3,12] and involuntary eye movements.[297] Alvarez vividly describes the movement of the zigzag line when he moved his eyes. "What has puzzled me is the fact that when I and some of my patients experience a scotoma we can throw the zigzag figure to the left or right or up and down by appropriate movements of the eyes."[12] Translocation is clearly illustrated in one Migraine Art picture: Figure 189

depicts a silvery shimmering fortification spectrum superimposed on a page of text that poses the question, "How can you read when the page looks like this? The center of the circle is the point looked at, and when your glance moves, so do the zigzags." Movement with eye movements is not only characteristic of the migraine scintillating spot on the visual field, but also visual hallucinations in patients with lesions of the brain's central visual pathways,[327] and visual hallucinations caused by electrical stimulation of the rear section of the brain.[75] This contradicts a common misunderstanding that translocation with eye movements proves the hallucinations are within the eye itself.[12]

PERSISTENCE AFTER CLOSING THE EYES

The visual hallucinations of the migraine aura can be seen with the eyes open or closed: They persist after the eyes are closed. This characteristic seems to apply to most migraine visual hallucinations and has frequently been described in the literature since the early report from Airy.[7] In 101 Migraine Art pictures, visual hallucinations are shown superimposed on the surrounding external world, so it can be inferred that the hallucinations are being experienced with open eyes. Of the 204 pictures illustrating both visual hallucinations and the migraine sufferers' eyes either alone or with other parts of the body, the eyes are open in 177 pictures and closed in twenty-seven pictures. In four Migraine Art pictures, visual hallucinations experienced with closed eyes are shown by the sufferer's head, eye and eyebrow, hand, or full body in black, representing the experience that when the eyes are closed, no visual information about the body is available.

▲ Figure 275

Migraine Art collection.

The feature of persistence of visual hallucinations after the eyes are closed is clearly described in the report of the female migraine sufferer in figure 275, who writes:

> *Just looking at my picture conjures up for me all signs and symptoms of a migraine attack. The first time I ever had the experience of a migraine, I*

thought that I was going blind. I was reading at the time and noticed that I couldn't see part of the page through my left eye—why? Because very slowly, at first, jagged silver lights were creeping up the left side of my eye and eventually covering all the eye. Then it seemed to be the turn of the right eye. Even if I closed my eyes, the lights were still very much in evidence. Sometime later a pain began somewhere at the base of my skull and radiated over the top of my head to the front. It felt as if my head was in a vise getting tighter and tighter, and I wanted all *light to go away—the jagged, shining, silver lights* and *the daylight outside. Even covering my face with my hands did little to alleviate the situation. It was all-encompassing in its severity, but as it began to fade away, I found myself asking,* Why? Was it something I'd done to bring it on? Was it something I'd eaten or drunk? Why now? Would it happen again? *Yes, it would.*

As a postscript, the artist adds:

I think what I wanted to express most in my picture was the feeling of being "taken over" by something totally in the control of the situation, other than myself. A feeling of having to "go with the flow," as it were, until it had run its course—the utter blackness of despair amid the jagged, shining, silver lights and its viselike grip until everything else seemed to take on the appearance of jaggedness and unreality.

It is known that in some cases, visual hallucinations are only experienced with closed eyes. This is illustrated in figure 230, which shows a pattern "seen with eyes closed" and "oscillating rapidly." Visual migraine aura symptoms that only appear when the eyes are closed are described by Sacks, who records that "some patients may observe, on closing the eyes, a form of visual tumult or delirium, in which latticed, faceted, and tessellated motifs predominate—images reminiscent of mosaics, honeycombs, Turkish carpets, etc., or moiré patterns. These figments and simple images tend to be brilliantly luminous, colored, highly unstable, and prone to sudden kaleidoscopic transformations."[554] It may be noted, however, that all shape, color, and movement aspects as well as the action patterns mentioned by Sacks[554] may also occur in visual hallucinations

seen with open eyes, as shown in numerous examples in the section "Shapes Seen in Hallucinations" above.

LOCATION IN SPACE

Migraine visual hallucinations have different types of perceived location in space relative to the images of external objects. In the most common type they are experienced as projected, like images from a slide projector, onto the surface of real objects.[2] This is illustrated in figure 230, which depicts a zigzag fortification spectrum which is "seen on a blank surface about three feet away." In four Migraine Art pictures, scintillating scotomas (spots on the visual field) are seen projected onto the page of a book, a leaflet, and a newspaper. Depending on the viewing distance, the visual hallucination appears smaller when projected on nearby objects and larger on distant objects, a relationship known as "Emmert's effect," first described by Emmert as a feature of afterimages.[160]

In another type of perceived location, the images of the visual hallucinations can be floating at a certain distance and position in the visual field (see fig. 276). They can appear as transparent or opaque images between the sufferer and objects in the external world (see figs. 178, 251, and 253). This feature is clearly described in an account by Parry, who notes:

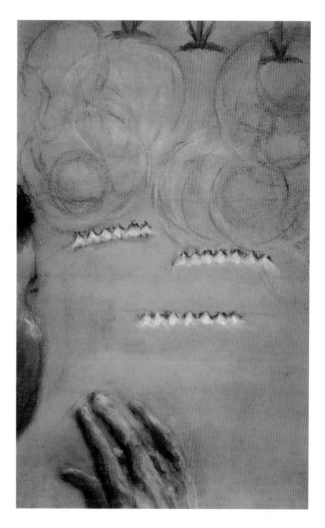

▲ **Figure 276**

Migraine Art collection.

> *When I looked at any particular object, it seemed as if something brown, and more or less opaque, was interposed between my eyes and it, so that I saw it indistinctly, or sometimes not at all.... After it had continued a few movements, the upper or lower edge appeared bounded by an edging of light*

and 278**

Migraine Art collection.

*of a zigzag shape, and coruscating [sparkling]
nearly at right angles to its length.*[454]

A rare type of location of the imagery of
visual hallucinations is shown in figure 277,
where the artist has depicted a nighttime
migraine with "bright flashing, whirling
lights that surrounded me during the onset
of attacks," the arc-shaped colored visual hal-
lucinations extending beyond her visual field
and surrounding her completely. This type
of projection into space, not previously de-
scribed in migraines but known to occur in
drug-induced visual imagery,[322,583] can be
called a panoramic hallucination, as its appar-
ent location is a 360-degree panorama. It
achieves "an entire view of any … situation,
as it appears to an observer turning quite
around."[34] Panoramic hallucinations provide
phenomenal evidence for the notion that the
"mind's eye" has a 360-degree visual field,
as suggested by psychological experiments
by Attneave and Farrar on the representation
of physical space.[29]

In yet another type of perceived location
in space, the imagery of migraine visual hal-
lucinations fits in with the contours of real
objects, like zigzags surrounding a plate,[217]
miniature hallucinations of toylike objects
dancing around a real lamp,[566] and Lilliput-
ian hallucinations of "Red Indians crawling
round in the room."[312] Gowers describes this
phenomenon for the zigzag hallucinations of the concentric or pericentral
spectra,[217] which are illustrated in Figs. 170 and 179. Three other pieces of
Migraine Art demonstrate that the same phenomenon can also be encoun-

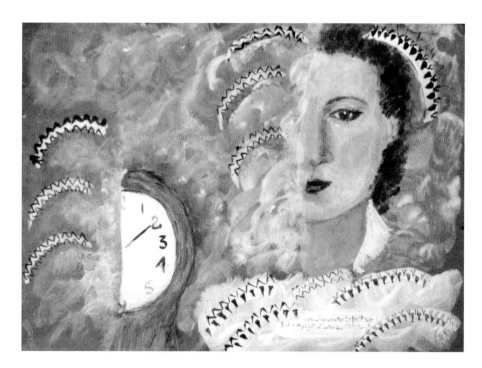

tered for visual hallucinations of other shapes. Figure 278 depicts multiple arcs around a plant pot. Figure 279 shows a "black-and-white squiggle" composed of tiny triangles and angles forming a quarter of a circle, which smoothly follows the contours of the sufferer's face in a mirror. Figure 249 illustrates another sufferer's mirror image framed by a variety of visual hallucinations of line, curve, web, and spiral shapes. Similar interactions between hallucinated and perceived images have also been described as features of the visual illusions in palinopsia and the corona phenomenon, both described in "Visual Illusions" below.

How Hallucinations Occur

*The mechanisms of geometric hallucinations imply
that the properties of visual hallucinations correspond
to physical processes in the brain.*

The idea that the properties of hallucinations correspond to the properties of the brain regions where they are produced can be traced back to the German psychiatrist Kahlbaum,[298] who thought hallucinations were perceptions of real processes in the brain. This idea suggests that there is a

relationship between psychological conscious experience and the structure and function of the brain's neurons. This has also been called "isomorphism" in Gestalt psychology. The concept was first outlined by Wertheimer[638] and elaborated by Köhler, who writes, "Any actual consciousness is in every case not only blindly coupled to its corresponding psychophysical processes, but is akin to it in essential structural properties"[325] (cited in Koffka[331]).

Many features of the most commonly encountered form of migraine hallucination, the zigzags of fortification spectra or expanding spectra, can be explained by brain mechanisms based on this isomorphism. In his seminal study on fortification spectra, Airy regarded the visual disturbance "as a veritable photograph of a morbid process going on in the brain,"[7] suggesting the structural properties of the visual hallucination are like the underlying malfunctioning brain process. Similarly Gowers was guided by the principle of isomorphism when he speculated that "the process that precedes the headache of a migraine is very mysterious, whether it is referred to the eye [visual auras] or the arm [aura affecting the sense of touch]; there is a process of intense activity which seems to spread like the ripples in a pond into which a stone is thrown."[221] Lashley thought that the underlying malfunctioning brain process was a spread of excitation followed by inactivity over the brain's primary visual cortex. He calculated the speed of this spread to be about three millimeters (an eighth of an inch) per minute, if the speed of the spread is constant, based on the distance from the part of the brain's primary visual cortex that is farthest back to the part farthest forward being sixty-seven millimeters (2^3/4 inches), and that an aura lasts about twenty minutes[352] (see "Migraine Experiences in Medical Illustrations" in chapter 1).

This spreading depression of activity in the brain's cerebral cortex was first described by Leão in experiments on cats.[359] Leão found that after electrical, mechanical, or chemical stimulation of an area of the cortex, there was a local reduction in spontaneous electrical activity. This reduction slowly spread with a constant speed in all directions "like the ripples in a pond into which a stone is thrown."[221] The speed of the spreading depression is about two to six millimeters (0.08 to 0.24 inches) per minute, and following it there is a slow recovery of local activity within five to ten

minutes. Grafstein found that at the leading edge of the spreading depression, neurons are thrown into violent activity for a period of several seconds.[224] Milner connected Lashley's observations to Leão's spreading depression and the hyperactivity of neurons at the leading edge of this process.[407] The duration of migraine spots on the visual field (scintillating scotomas) corresponds to the duration of Leão's spreading depression. The zigzag hallucinations and spots on the visual field are similar to the behavior of the neurons—excitation followed by inactivity—during the spreading depression. These two ideas led Milner to propose that migraine scintillating spots on the visual field could be the equivalent of a spreading depression at the beginning of a migraine.[407] This idea was subsequently supported by many authors.[355]

The mechanism of spreading depression over the brain's primary visual cortex also explains why the zigzags of fortification spectra increase in size and why the expanding spectra expand with accelerating speed as they pass from the center to the periphery of the visual field. This is described by Airy, who notes that in fortification spectra the "enlargement is slow at first, and gradually quickens,"[7] and by Gowers, who reports that the angled form of expanding spectra "extends and increases in the size of its angles, most towards the periphery."[217] Lashley was the first to say:

> *The increase in size of the scotoma [spot on the visual field] as it passes toward the peripheral areas does not necessarily mean that the disturbance starts from a point and spreads to larger areas. Apparent size in the visual field is not related to the size of the excited region of the [brain's] striate cortex, since the cortical field of the macula [a small part of the retina responsible for sharp central vision] is probably as large as that of all the remaining retina.*[352]

The expansion of zigzag migraine hallucinations as they move toward the edge of vision is related to the fact that the projection area of the brain's primary visual cortex diminishes for more peripheral locations. So a region of the visual field toward the edge accounts for less area in the brain than a similarly sized region in the center of vision. This progressively smaller representation in the brain can be described by the change

in the "cortical magnification factor," defined as the linear size of the brain's cortex in millimeters that corresponds to one degree of the field of vision at various angular distances from the center of vision. In a study by Daniel and Whitteridge on how the visual field is represented in the brains of monkeys, it was found that the magnification factor falls off smoothly from the center of vision to the periphery.[124] This was confirmed by estimates of the human magnification factor.[101,135,141,548,549] As Richards first clearly pointed out:

A constant propagation rate of excitation would indeed cause the larger arcs to grow faster, because the peripheral part of the visual field is represented by a diminishing amount of cerebral cortex: since there is progressively less cortex per degree of visual field as one moves from the field's central region to its outer margin, a wave moving at a constant rate across the cortex will appear to move faster as it moves toward the peripheral field.[536]

Grüsser documented his personal visual migraine auras by drawing the perimeter of his visual disturbances every one or two minutes during the attacks, and he was able to predict the observed "particle" size of the zigzags at different distances from the center of vision with a mathematical equation using this cortical magnification factor and assuming the brain process moved at a constant speed.[235] Similar mathematical models of migraine zigzag hallucinations are described by Schwartz,[575] Reggia and Montgomery,[531] and Dahlem et al.,[120,121,122] who programmed a "migraine computer" (see fig. 221) to produce visual patterns greatly similar to visual migraine auras.[531]

The relationship between the rate of spread of zigzag fortification spectra and distance from the center of the visual field also holds true for spectra moving from the periphery toward the center of the visual field, an unusual variant of the visual migraine aura described by Dianoux[134] and other authors.[48,295,386,553,671] Lord records:

The rate of spread of scintillating zigzags was greatest in the periphery whether attacks began there or centrally. Indeed, when teichopsia [zigzag fortification spectra] began peripherally and moved centrally, the rate of

spread slowed dramatically the nearer the distur-
bance approached the center of vision. These find-
ings also favor the orderly spreading disturbance
with symptoms dependent on the underlying func-
tional organization of the local cortex, reflecting the
relatively greater representation of macular [central]
vision.[386]

Richards took the principle of isomorphism (that
migraine visual auras correspond to physical pro-
cesses in the brain) a step further when he pro-
posed that the zigzags of migraine hallucinations
could reflect how neurons are organized in the
human brain's primary visual cortex.[536] He proposed that the neurons are
arranged in the form of a horizontal lattice or honeycomb. According to
Richards a honeycomb pattern emerges when a number of zigzag arcs
seen successively during the visual migraine aura are plotted together
with approximately radial lines added, although these lines are never seen
in the aura (see fig. 280). According to Richards the "honeycomb and the
tendency for the inner angle between lines to approximate sixty degrees are
suggestive of hexagonal organization"[536] in the architecture of the brain's
primary visual cortex. Considering a hypothetical wave front of electrical
activity advancing across the cortex, Richards speculates how this electri-
cal activity could result in the perception of the zigzag shapes seen at the
boundary of a fortification spectrum.

Grüsser's elaborate model of how mechanisms in the brain's primary
visual cortex lead to migraine scintillating spots on the visual field, "in
which the main components are an increase in extracellular potassium
concentration, a decrease in extracellular calcium concentration, and the
constant speed diffusion of the ions along the extracellular space of the
stripe of Gennari within the primary visual cortex,"[235] also implies the
principle of isomorphism between the properties of the zigzag hallucina-
tions and the properties of the underlying brain process. To answer the
question "Why zigzag patterns?"[235] Grüsser replies that the "peculiar

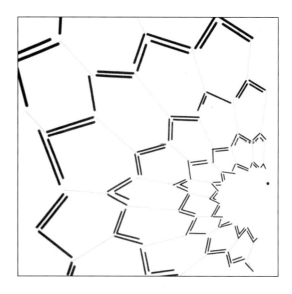

▲ **Figure 280**

Hypothetical honey-
comb pattern con-
structed by Richards[536]
from zigzagged arcs
of fortification spectra.

shape of the migraine [images] may be explained by the well-established functional microstructure of the area V1 hypercolumns,"[235] which are the column-shaped organizational structures in the brain's primary visual cortex, first found in the experiments of Hubel and Wiesel.[278] Grüsser's original publication includes further details of this work.

It is worth noting that Kölmel suggested a similar explanation using the principle of isomorphism to account for geometric hallucinations of other shapes besides zigzags.[327] In a group of ninety-six patients with defects in one visual field from various causes, usually vascular lesions in the brain, fourteen experienced colored patterns, often in the form of pyramids or tetrahedrons, in the part of the visual field with loss of vision. According to Kölmel the geometric structure of these colored patterns "must reflect the neuronal organization of the visual cortex,"[327] and he suggested that "this functional unit is organized on the basis of pyramids and tetrahedrons."[327] It should be noted, however, that this type of explanation cannot be convincingly applied to all shapes of geometric hallucinations, since neurons organized into webs, tunnels, spirals, or kaleidoscopes do not reflect the established facts of brain anatomy.

There is another argument that can be put forward to counter the idea that a spreading depression in the brain's primary visual cortex also accounts for migraine visual hallucinations of geometric shapes other than zigzags. With the possible exception of a single Migraine Art picture depicting polyhedrons at the border of a scintillating spot on the visual field (see fig. 236), none of the numerous illustrations of visual hallucinations with geometric shapes other than zigzags corresponds to the described geometry underlying the shapes,[474] as shown by the absence of increasing size with increasing distance from the center of the visual field. Just the opposite, one artist represented a visual migraine aura with a mosaic composed of five- and six-sided units "which were largest in the center . . . and smaller at the edges" of the visual field (see figs. 264 and 265). So whichever brain structures are responsible for generating these migraine hallucinations of geometric shapes other than zigzags, they would not be expected to show the same variation in cortical magnification.

*The mechanisms of geometric hallucinations imply
that the activation of cerebral structures creates geometric shapes.*

The idea that geometric visual hallucinations could result from the activation of brain structures that create geometric shapes can be traced back to the astronomer Sir John F.W. Herschel, who suggested such a mechanism could account for a variety of different kinds of visual imagery.[258] In a lecture delivered to the Philosophical and Literary Society in Leeds, England, in 1858, Herschel described a class of hallucinations with an "involuntary production of visual impressions, into which geometric regularity of form enters as the leading character."[258] He described his personal experiences with episodes of typical migraine fortification spectra—"very much in general aspect like the drawing of a fortification, with salient and reentering angles, bastions, and ravelins"—and spontaneous visual hallucinations, probably also of migraine origin, with rectangular, latticed, and carpet patterns and a variety of circular shapes.[258] Herschel speculated:

> *Now, the question at once presents itself—What* are *these geometrical spectra? and how, and in what department of the bodily or mental economy do they originate? They are evidently not dreams. The mind is not dormant, but active and conscious of the direction of its thoughts; while these things obtrude themselves on notice, and, by calling attention to them,* direct *the train of thought into a channel it would not have taken of itself. . . . It may be said that the activity of the mind, which in ordinary vision is excited by the stimulus of impressions transmitted along the optic nerve, may in certain circumstances take the initiative, and propagate along the nerve a stimulus, which, being conveyed to the retina, may produce on it an impression analogous to that which it receives from light, only feebler, and which, once produced, propagates by a reflex action the sensation of visible form to the sensorium [the part of the brain that interprets stimuli]. Still, even granting that such reflex action is possible, and the retina is so impressed, the question remains—Where does the pattern itself or* its prototype in the intellect *originate? certainly not in any action* consciously *exerted by the mind, for both the particular pattern to be formed and the time of its appearance are not merely beyond our will and control, but beyond our knowledge.*

If it be true that the conception of a regular geometrical pattern implies the exercise of thought and intelligence, it would almost seem that in such cases as those above adduced we have evidence of a thought, *an intelligence, within our own organization distinct from that of our own personality. Perhaps it may be suggested that there is a kaleidoscopic power in the sensorium to form regular patterns by the symmetrical combination of casual elements, and most assuredly wonders may be worked in this way. But the question still recurs in another form: "How is it that we are utterly unconscious of the possession of such a power; utterly unable to exert it; and only aware of its being exerted at times, and in a manner we have absolutely no part in except as spectators of the exhibition of its results?"*[258]

Herschel explained geometric visual hallucinations as conscious experiences resulting from the involuntary and unconscious activation of prototypes of geometric shapes. Herschel's reflections on the "kaleidoscopic power" of the mind were decades ahead of the late-nineteenth-century neurological and psychiatric discourses about the multilayered structure of the mind[290] and the unconscious,[191] and it was not until Jung's concept of the collective unconscious[296] that geometric shapes were reconsidered as stemming from the unconscious activity of the mind. It wasn't until the late 1950s, however, that advances in medical study of the visual system allowed the problems raised by Herschel's questions to be tackled with new methods and concepts.

In 1959 the neurophysiologists Hubel and Wiesel demonstrated that neurons in the primary visual cortex of a cat's brain respond very selectively to particular features of the images shown to the animal, such as the orientation and length of lines.[277] It became common to speak of "feature detectors" in the visual part of the brain, which were presumably specialized to detect a single feature, sometimes called the trigger feature. It was realized later that neurons at all levels of the visual system do not respond in a strict all-or-nothing fashion to one specific stimulus, but rather give graded responses as a stimulus varies in any number of ways. It was then suggested that visual neurons seem more like multidimensional filters rather than feature detectors. For the visual system to extract a spe-

cific piece of information about a feature, such as line orientation and length, shape, color, and movement, would require a comparison of the outputs of many cells. This is called "distributed representation" or "population coding" for features.[127]

The concept of "feature extraction" in the visual system was proposed by Richards as an interpretation of how the visual hallucinations of migraine auras happen. He suggested that the lines of the zigzag fortification spectra could represent the activity of "line detectors":

Considering the recent direct evidence obtained by the neurophysiologists from single cells in the visual cortex of the cat and monkey brain, it is of interest to compare their description of feature detectors with some of the properties of the fortification figures. For example, David H. Hubel and T.N. Wiesel have shown that one kind of feature extraction conducted by the visual cortex in their experimental animals is the detection of lines of a particular length and orientation. The fortification figure suggests that the human visual system performs a similar type of analysis. The expanding boundary of cortical disturbance is actually a set of discrete lines in visual space.[536]

Richards also discussed whether the zigzags of fortification spectra could represent the activity of "corner detectors,"[536] but this was dismissed because most of the lines "form not precise corners but rather parts of a disjointed T, with one line extending beyond its neighbor. Moreover, only a small fraction of the lines are actually jointed at their end points, and the gaps separating the end points seem to be located at random."[536]

According to Richards, the "visual displays that arise during visual migraines can take several forms, but only the classical type experienced by the Airys and reported in their papers ... is sufficiently clear and well-documented to provide reliable evidence on feature extraction in the human visual system."[536] A review of the migraine literature (see table 7.4 in appendix B) and an analysis of the Migraine Art collection, however, clearly show the existence of visual hallucinations taking several other geometric shapes, including line, curve, web, lattice, tunnel, spiral, and kaleidoscope shapes (see "Shapes Seen in Hallucinations" above). These geometric hallucinations

may be evidence of the human visual system's geometric "feature extraction"—it analyzes and processes incoming information about the visual world in terms of the geometric shapes. The geometrizing illusion[5] or mosaic illusion,[554] in which the image of the world appears to be fractured into mosaic pieces of the same shape, is another phenomenon that points to geometric feature extraction in the human visual system (see "The Mosaic Illusion" below). Some of the shapes of visual hallucinations and of the mosaic illusion are similar to the shapes that Biederman called "geons" (for "geometric ions")[52] that he believed are used to organize objects into parts in the preprocessing subsystem of the brain's visual object perception system.[333] Anderson and Rizzo suggest that this kind of dysfunctional activation of fragments of visual features caused geometric visual hallucinations after damage to the rear part of the brain.[15] It must be noted, however, that web, lattice, tunnel, spiral, and kaleidoscope "detectors" or "filters" have not yet been demonstrated in experiments. Gowers writes:

> *Activity of the cerebral centers that is independent of their common exciting causes … presents indications of the character … of their function that can be obtained from no other source. Foremost in interest and also in importance are the sensations of sight which occur without stimulation of the retina…. It cannot be doubted that, by the study of these subjective symptoms, much will ultimately be learned regarding the function and mode of action of the cerebral visual centers. Whatever the drawbacks to observation through the consciousness of another person, knowledge can be gained in no other way of the action of the higher centers of the brain, and the time must come when physiological knowledge, which can be gained only through the effects of disease and the disturbance of functional derangement, will receive more attention.*[218]

The idea of geometric feature extraction in the brain's visual system by geometric shape "detectors" or "filters" explains why the shapes of visual hallucinations are universal. This includes not only visual migraine auras but identical hallucinations in other situations: images seen before falling asleep (hypnagogic images), hallucinations induced by sensory deprivation, drug-induced imagery, and hallucinations in other neurological and

psychiatric diseases. The idea of universal hallucinatory shapes was first established by Klüver in his study of mescaline-induced hallucinations. In 1942 Klüver summarized his findings:

> The author's analysis of the hallucinatory phenomena appearing chiefly during the first stages of mescaline intoxication yielded the following form constants [universal shapes]: (a) grating, lattice, fretwork, filigree, honeycomb, or chessboard; (b) cobweb; (c) tunnel, funnel, alley, cone, or vessel; (d) spiral. Many phenomena are, on close examination, nothing but modifications and transformations of these basic forms. The tendency toward "geometrization," as expressed in these form constants, is also apparent in the following two ways: (a) the forms are frequently repeated, combined, or elaborated into ornamental designs and mosaics of various kinds; (b) the elements constituting these forms, such as the squares in the chessboard design, often have boundaries consisting of geometric forms.... The fact that certain geometric forms and designs constantly recur has led us to assume certain hallucinatory form constants. Although further analysis may reveal additional form constants, it seems certain that the number of basic forms is limited.[320]

If the geometric hallucinations of migraine auras are conscious experiences resulting from the malfunctioning activation of geometric shape "detectors" or "filters" in the brain's visual system, the question emerges as to what mechanism accomplishes the activation. Cogan distinguished visual hallucinations representing "irritative" phenomena, due to local discharges as in epilepsy, from hallucinations as "release" phenomena, due to a loss of normal visual input by sensory deprivation or by damage to the neurons that carry the information.[97] Hallucinations of the irritation type are typically brief, intermittent, show the same patterns, and are associated with other discharges in the sensory or motor systems, while hallucinations of the release type are relatively continuous for many minutes or hours, are more variable in their patterns, and are not characteristically associated with other sensory or motor discharges. Epileptic hallucinations and those produced by electrical or magnetic stimulation of the back of the head are typical examples of irritative hallucinations.

The hallucinations occurring in blindness, called "Charles Bonnet syndrome,"[573] and in visual fields with loss of vision in half the field (hemianopia)[327,328] are examples of release hallucinations. In migraines, both the irritative and release type of visual hallucinations are assumed to exist. The zigzag borders of fortification spectra or expanding spectra, only briefly visible at successive locations on the visual field, represent the irritative type because of the temporary discharges at the leading edge of the spreading depression over the brain's primary visual cortex. The other forms of geometric visual hallucinations described, which may be experienced in the entire visual field for a few minutes to an hour, are presumed to result from release activity in other parts of the brain, probably in the visual association cortex, by removing their usual sensory input due to spreading depression in less central brain regions. Since a spreading depression involves a wave of brief excitation followed by longer-lasting inactivity, geometric visual hallucinations experienced continuously for many minutes in the entire visual field cannot be explained by a spreading depression of activity in the brain structures responsible for hallucinations, but only by a release mechanism: a spreading depression in other parts of the brain having an impact ("disinhibition") on these regions.

Mechanisms of Complex Visual Hallucinations

Cogan's distinction between visual hallucinations from irritative or release phenomena can also be applied to complex visual hallucinations.[97] Penfield and Perot found that complex visual hallucinations could be generated by stimulating the posterior temporal part of the brain near the occipital cortex.[460] This suggests that complex visual hallucinations in epilepsy are probably due to a direct irritative process acting on centers in the brain's visual association cortex, while complex visual hallucinations in migraines probably result from abnormal release in the visual association cortex.[394]

Complex visual hallucinations in migraines have the same human and animal shapes (see "Complex Imagery" above) as in other conditions, such as hypnagogic hallucinations just before sleep, Charles Bonnet syndrome[573] in blind people, and a variety of neurological and psychiatric diseases.[394]

This universal content of complex visual hallucinations may correspond with how much of the brain's cerebral cortex is occupied by processing human and animal shapes as opposed to other visual objects.[350] From an evolutionary perspective, such disproportionate space in the brain for these privileged objects reflects their extreme importance in human social life (for human shapes and faces) and survival in nature (for animals).

Visual Illusions

A variety of visual illusions, defined as visual experiences resulting from the transformation of an external stimulus, have been reported as migraine aura symptoms. Some of these reports were the first descriptions of such illusions in the medical literature, showing that the study of migraines can significantly contribute to knowledge of these rare symptoms.[48,409] This is confirmed by the large number of visual illusions found in a total of forty-six pictures from the Migraine Art collection, some of which have not been previously described in migraines (see table 7.12 in appendix B).

Visual illusions are rare and appear suddenly, which has prevented systematic investigation of them. With a few exceptions, how they occur is unknown. Visual illusions in patients with disorders in a specific part of their brains indicate that the main brain regions involved are the occipital lobe and the neighboring parietal and temporal lobes, with the right side of the brain possibly playing a greater role.[211] Visual illusions are not specific to the disorders that cause them, which include intoxication, eye diseases, and neurological and psychiatric diseases. In healthy people, visual illusions can be induced by sensory deprivation.[257] Some visual illusions have also been reported to occur spontaneously in healthy people, but a diagnosis of a migraine aura without a headache should be carefully considered in these cases.

Dysmetropsia

Dysmetropsia has been described as a group of visual illusions involving changes in the apparent size or distance of objects.[653] It comprises macrop-

▶ **Figure 281**

Migraine Art collection.

sia, where objects get larger; micropsia, where they get smaller; pelopsia, where objects appear nearer; and teleopsia or porropsia (a synonym used mostly in German[255]), where they appear farther away; and combinations of these illusions. If these changes occur gradually rather than abruptly, they have also been called "zoom vision."[554] Cyclical alternation of objects becoming larger and smaller has been described by Klee and Willanger as a pulsating phenomenon.[314] Another term, dysmegalopsia, is the visual illusion where the two halves of an object appear to be of different sizes.[233]

Some of these visual illusions are illustrated in four pieces of Migraine Art. Figure 137 includes a notation of "visual magnification" (macropsia). The artist writes, "Objects are larger than life with great detail, accompanied by pain at the top of my skull." Figure 281 illustrates the effect of single letters or digits getting larger while reading. In figure 282 the sufferer has her hands on her forehead and is seated facing a mirror, in which she sees a diminished image of herself and other objects. The plant pot on the window sill also appears diminished (micropsia). Figure 283 shows two views of the same tree, the one on the left showing its natural size and the other greatly reduced in size. It also appears to be much farther away from the viewer, as if seen through the wrong end of a telescope, suggesting a

combination of the object getting smaller (micropsia) and appearing farther away (teleopsia).

These visual illusions can apply to the total environment, to single or multiple objects or persons, or to the image of one's own body in a mirror. All these forms have been documented as migraine aura symptoms. According to one sufferer, "the room appeared large,"[54] while others said that "everything goes small."[99] There are many case reports of objects or persons as unusually small or distant, and large or near.[22,36,54,99,114,117,128,137,201,221,240,270,312–314,374,379,411,446,522, 527,581,582,615,653,661] Wood reported the unique case of a twenty-four-year-old woman becoming aware of "her hands and objects in her neighborhood growing in size, until, to use her own words, 'they were terribly large.'"[661] Seeing the mirror image of one's own body getting small has not been described in the medical literature, but it is clearly documented in one Migraine Art picture (see fig. 282).

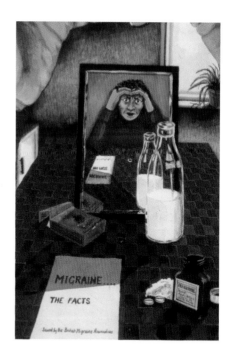

▲ **Figure 282**

Migraine Art collection.

Few authors have estimated how frequently these size and distance illusions (dysmetropsia) occur as a migraine aura symptom. In a group of fifty adult patients with severe migraines, objects getting larger were encountered in six cases, and objects getting smaller were seen in three cases.[312] In another group two hundred adults, Ardila and Sanchez found two examples of both the illusion of objects getting larger and objects getting smaller.[22] Of the one hundred migraine patients studied by Queiroz et al., two described objects getting larger or smaller, and objects appearing farther away.[522] Congdon and Forsythe studied a series of three hundred children with migraines, five of whom reported that "everything goes small"[99] (micropsia). The impression from this medical literature, that these size and distance illusions are a rare symptom of migraines, is questioned by the results of a recent study by Abe et al.[1] Using a questionnaire the authors examined the prevalence of macropsia and micropsia as well as distortions of time perception in 3,223 Japanese high school students aged thirteen to eighteen. They found that about nine percent of the students reported one or more types of visual illusion within the past six months. The prevalence

▶ **Figure 283**

Migraine Art collection.

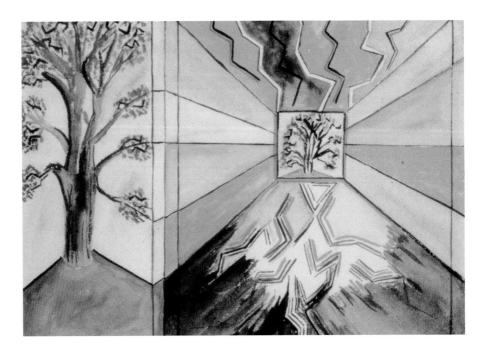

of migraines was more than three times higher in students with occasional visual illusions than in those without them, and experiencing more than one type of illusion was found to be associated with migraines. It could be that these occasional visual illusions are much more prevalent in adolescents than is commonly assumed in the literature, and that a considerable number of them appear to be due to migraines.

Tilted Vision, Inverted Vision, and Other Forms of Rotation

Tilted vision is an illusion where the entire field of vision or objects fixed on appear to be rotated by less than ninety degrees. Vision at right angles is turned ninety degrees, and inverted vision is turned 180 degrees.[242,318,467,645] In most cases these rotations are experienced in the frontal plane, and more rarely in the sagittal plane or the horizontal plane (described below).

The Migraine Art collection includes two illustrations of the rotation of objects in the frontal plane. The background wall in figure 117, seen in duplicate, is rotated by twenty-five degrees (tilted vision). Two varieties of rotation illusion are illustrated in figure 284, which is two pages of an

FOR ONLY YOURS

as introduction to

LANGUAGE

Its purpose – to begin least – was clear and concu all four multimillionaires' n was to be *theirs*, rather than istered on their behalf. It wa tion from the control of " suits", as John Lennon ca irksome powers at NEMS Songs and EMI. It w run people of less than and waistcoat out stiff colla or middle as capable of t or b to organisation. Apple was to triumphant annexation by living apotheosis of all the po' riches which youth had ge It was to be free and easy an handed; above all, in that p Sixties word, it was to be 'fu

new divisions, and their >pointed directors and man- uickly spilled over from the 10p into a suite of offices in : Street, a quarter of a mile lere was established Apple with Jane Asher's brother, A & R man, and Apple Pub- in by Derek Taylor, their atic Press officer. Also at prStreet, Neil Aspinall strove per his long-lapser hcy lessons in creating ar 1 filing system despit in four years, the B, ies een them accum ed not : documentary the an ess conferenc d on the nny Carson s during a

special trip to New York, Paul explained the revolut also philanthropic motiv would guide the Beatles' Paul said that Apple' "a controlled weirdness . . Western Communism."

Finch and Josje Leeger, who ollowed Simon and Marijke Holland, they had formed them- – group of olal lairvoyant aptness – The Fool. 1roughout that summer and in, The Fool enjoyed the Royal

Posthuma and Marijke beautiful people' from Holland. amy-eyed, lissom boy and girl, ad drifted out of the LSD sum- ad into the Beatles' innermost , simply for being so beauti- softly spoken and so richly

who announced the newes sion: an Apple Foundatic Arts. "We want to help p without doing it like a cl always had to go to the b our knees and touch our and say, 'Please can we d

▲ **Figure 284**

Migraine Art collection.

open book that include headings, text, and a photograph that have been arranged by the artist to form a collage. An example of tilted vision is seen in the first column of the left page, where half a line of text is tilted at an angle of about forty degrees, with the center of rotation in the middle of the line. An example of inverted vision is seen in the second column of the right page. The artist cut out a line of text and replaced it upside down. This is clearly seen in the original piece of Migraine Art but is not easily detected in this reproduction.

The illusion of rotation in the *frontal plane*, as shown in these two Migraine Art pictures, has been described in the literature as a rare visual migraine aura symptom manifesting as *tilted vision*,[37,84,114,137,522,527,545,645,654] *vision at right angles*,[318,645] and *inverted vision*.[240,527,538,645] Some migraine patients reported that "the entire environment tilts,"[527] but more commonly the illusion applies to isolated objects described as "tilted."[654]

Butler records the case of a twenty-eight-year-old migraine patient who, during one of her attacks, experienced vertigo, nausea, and tilted vision so that "the whole field of vision turns to an angle and remains inclined for about half a minute."[84] A patient of Wilder's with a history of migraines since the age of five experienced repeated attacks that included vertigo, the tendency to fall backwards, and an apparent right-angled tilting of the environment that lasted for half a minute and was followed by a headache of about two hours' duration.[645] Vision at right angles is also recorded by Klopp in a thirty-eight-year-old patient who, for three or four years, experienced recurring attacks of migraine headaches and isolated episodes of one or two seconds' duration when the entire visual field was tilted to the left at a right angle.[318] Inverted vision is recorded as an aura symptom in two cases of juvenile migraines. Riley mentions a child who complained that "people appeared upside down" during a migraine attack,[538] and Hachinski et al. published the drawing of a girl who on one occasion "saw a picture as being upside down and her mother walking upside down" before the headache began.[240] In both of these cases inverted vision applied to the objects of fixation, but in other cases migraine patients reported that the entire "scene turns upside down."[527]

Tilted vision with an illusion of rotation in the *sagittal plane,* so that the whole environment or an object seems to be tilted toward the subject,[242] was described as a migraine aura symptom by one of Klee's patients, who "reported that a cupboard, at which she looked, might seem to lean toward her."[312] Inverted vision may also occur as an illusion with an apparent rotation in the sagittal plane, so that the object or the whole environment seems to be inverted top to bottom without reversal of right and left,[318] but this phenomenon has not yet been observed as a migraine aura symptom.

A rotation of the total environment by 180 degrees in the *horizontal plane,* a disorder of spatial orientation with right-to-left as well as front-to-back reversal,[467,644,660] was recorded as a migraine aura by a patient of Nielsen and Ingham's.[435] During her attacks the twenty-four-year-old sufferer experienced "a loss of sense of direction" lasting about twenty minutes. "She does not know north, south, east, or west, the building in which she

happens to be seems turned wrong, and the doors seem to open from the wrong direction."

Visual Allesthesia

Visual allesthesia, from the Greek *allache* meaning "elsewhere" and *aisthesis* meaning "perception," is an illusion where visual images of a real object, person, or scene are displaced from one half of the visual field to another in both eyes.[48,256]

The Migraine Art collection includes a single example of this illusion. In the collage of the photograph in figure 284, the artist suggests that visual images are displaced from the correct visual field into the opposite one. This can best be seen in parts of the round window, moved from the lower right to the upper left quadrant.

Visual allesthesia was first reported as a personal experience by Beyer, who just before the onset of a migraine headache had the illusion that objects in the right lower quadrant of his field of vision would appear moved diagonally into the left upper quadrant.[48] Beyer's self-observation is summarized by Critchley:

> Dr. Beyer, a victim of chronic migraines, was strolling in the streets of his home town in Germany, when he was astonished to see a bright blue rectangular shape outlined against the gray sky, above and to his left. A moment later he was startled to discern a little dog, also above and to the left. He stopped in his tracks, looked around, and then realized that what he had seen was a real dog on the pavement to the right of him, and that the blue object was in reality a [mailbox] of the German [post office]. An hour or so later came the typical crashing headache of his migraine. Professor Pötzl used the expression "the migrainous fata morgana" [mirage] in reference to this particular case.[112]

Critchley and Ferguson mention visual allesthesia in a review of migraine visual aura symptoms, but do not relate any clinical details of personally observed cases.[114] Argenta and Ranzato provide a detailed case report of visual allesthesia as an aura heralding a migraine attack.[23]

Gloning et al. report this illusion in a patient with migraine attacks due to the presence of a small malformation in an artery in the right side of his brain.[211] The patient suffered from recurring attacks on one side of his head with spots on the left half of his visual field (scintillating scotomas). During a severe attack he experienced objects from the left half of his visual field moving to the right. After the attack a left-sided visual-field defect in both eyes was found. In this interesting case, visual allesthesia occurred because of a localized dysfunction in the right parietooccipital region of his brain.

Visual allesthesia can occur along with the illusion of palinopsia, or visual perseveration in time (see the next section). Critchley remarks that Beyer's seminal description of visual allesthesia during a migraine attack "does not make it clear whether objects were simply dislocated from one visual field into the other, or whether the true object perseverated like a hallucination, long after it should have acted as a stimulus."[106]

Visual Perseveration

The term *visual perseveration* includes a number of visual illusions characterized by either abnormal persistence in time or the abnormal spatial spread of visual perceptions.[106] Visual perseveration in time or palinopsia is the illusion of persistence or recurrence of visual images after the object is no longer visible.[106] Based on the time interval between seeing the original target and the appearance of the perseverated image, it is possible to differentiate three forms: "immediate palinopsia," "true palinopsia," and "hallucinatory palinopsia."[329] Bender et al. remark that "palinopsia may be considered a form of optical illusion, a visual hallucination, or a cross between the two."[42] In both the immediate and delayed forms of the illusion, the persistent images are often "parts of a whole,"[42] such as an eye without the whole face, a toe without the foot, or a small clock without the objects adjacent to it. They often become incorporated appropriately into the visual scene being perceived, for example a patient who was looking for a taxi suddenly saw illuminated taxi signs on every passing car.[362] This interaction between perseverated and perceived images

is characterized by Pötzl as "categorical incorporation."[518] These two fea-
tures of perseverated images imply that there is a distinct "visual logic"
that underlies visual perception and which is revealed by these illusions.

All three forms of visual perseveration in time have been reported as
migraine aura symptoms, although none is represented in the Migraine
Art collection. Immediate palinopsia is described as the experience of pro-
longed afterimages during migraine attacks.[12,24,70,166,314,379,463] Alvarez
reports that at a musical recital, "I was distressed by a brilliant afterim-
age of the piano which I got if I looked at it for more than a few seconds,"
and on another occasion, "I got such brilliant afterimages of my television
screen that I could not watch the picture."[12] Three patients in the study
by Klee and Willanger reported positive afterimages where "particularly
light-colored objects . . . appeared to remain in front of the eyes after they
had moved their gaze. The color of the image remained unchanged as long
as the afterimage persisted."[314] True palinopsia, characterized by a time
of several minutes to somewhat more than an hour between seeing an
object and its later perception,[329] was reported as a migraine aura symp-
tom by Kölmel,[326] Ardila and Sanchez,[22] and Robert et al.[540] Robert et al.
studied a sixty-year-old female migraine sufferer who once saw a vase of
flowers in several locations in the room, and on another occasion saw a
mustache on the faces of all the males visiting her, illustrating Pötzl's "cat-
egorical incorporation" discussed above. Hallucinatory palinopsia, char-
acterized by a long period of days to weeks between seeing an object and
perceiving it as an illusion, was described by a migraine patient of Lind-
ner et al. who experienced "landscapes seen several weeks before" and
the "image of Garfield seen on a sticker two days before the first attack."[372]

The illusion of visual spread has been described as a "visual persever-
ation in space," where the area of an object perceived extends beyond its
borders and spreads into neighboring areas.[106] A quote from Critchley's
original case report illustrates the features of this rare illusion:

> If she looked at anyone wearing a striped or checkered garment, the pat-
> tern would seem to extend over the person's face. The pattern of cretonne
> curtains would often seem to extend along the adjacent wall. When she

▲ Figure 285

Migraine Art collection.

came to the hospital by the taxi, the iron railings enclosing the garden of Queen Square appeared to extend across the road, and the taxi seemed to charge through this barrier.[106]

In another case recorded by Critchley a migraine sufferer experienced visual perseveration as a migraine aura, first as the illusion of visual spread and then as true palinopsia:

A migrainous patient of mine would experience before her eyes flashes like lightning. Sometimes when at home she would notice yellow blobs all around her. Eventually she realized that these were, in fact, an extension of the yellow checkered tiles on the floor of her kitchen. These visual phenomena would accompany her as she went from room to room. Thirty minutes later, a severe headache would develop accompanied by nausea. Here the visual perseveration was an aura ... and the checkered flooring acted as a provocative factor, first of the perseveration and then of the attack of migraine.[112]

The Migraine Art collection includes a single picture with evidence of the illusion of visual spread. In figure 285 the pattern of the upper part of a long-sleeved dress extends beyond its actual limits and spreads onto the background, leaving unaffected all visible parts of the woman's body. As judged from the typical gesture of the hand held against the head, the woman can be identified as the migraine artist herself, so her picture represents a visual illusion experienced while looking in a mirror.

Double Vision

Diplopia, or double vision, can occur in migraines because of temporary paralysis of the eye muscles[594] or because of dysfunction in the brain; in this case the double image persists when only one eye is open (monocular diplopia).[523]

Double vision is illustrated in eleven pieces of Migraine Art. Figure 137 includes a note of "double vision." In figure 286 both of the patient's eyes are open with the word "pain" in the center of both pupils. All the letters are doubled and shifted to the side, partially overlapping. In figure 287 a female figure on a TV screen appears duplicated with some overlap, the overlapping real and double images shown with equal clarity. In these two pictures the double images do not allow differentiation between double vision because of temporary paralysis of the eye muscles and one-eyed double vision originating in the brain.

In the following pictures the features of double vision correspond to monocular diplopia originating in the brain. In figure 288 double vision occurs next to a large central spot on the visual field (scotoma) on the left side of the picture. Here the false images of kitchen utensils are completely separate and much less distinct than the real images. Similar "ghost images" can be seen in figure 289, where the contours of a nose, mouth, and eyes are doubled and shifted to the side with some overlap. The false images of the irises, which are depicted in a paler color, are seen at the side of a

▲ **Figures 286, 287 and 288**

Migraine Art collection.

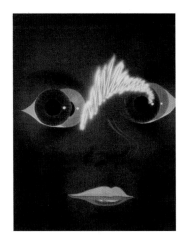

▲ Figures 289 and 290

Migraine Art collection.

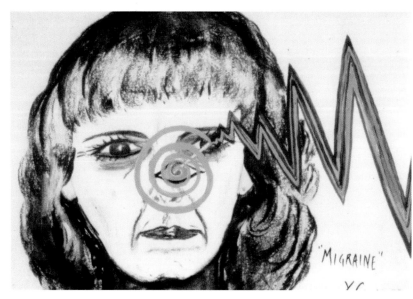

large fortification spectrum. In figure 290, doubling of a single eye is shown, with the false image next to a large fortification spectrum and a spiral hallucination. Figure 291 illustrates the artist's "impression of the visual disturbance that comes at the onset of a migraine attack." The contours of a single eye are doubled and shifted upward, overlapping the real eye, with the false image considerably less distinct than the contours of the real image. The false image of the eye is somewhat larger than its true image, representing a combination of double vision and visual magnification (macropsia). "The kidney shapes" on the other side of the face "used to float out from the eye in brilliant colors, almost luminous in intensity." In figure 252 duplication of the contours of one eye shifted upward with some overlap occurs against a stylized background of regular sine wave patterns. In all four of these pictures, duplication occurs in parts of a whole—the eyes and not the complete face. A picture combining features of double vision and seeing multiple images of the same object (polyopia) is shown in figure 294 in the next section, and two other pictures, displaying double vision of an eye (see fig. 322) and a man's neck and tie (see fig. 323) along with the mosaic illusion, are discussed below in "The Mosaic Illusion."

Many writers have mentioned diplopia as a migraine aura symptom, but the number of actual cases reported has been small. Gowers was the

first to note double vision as a rare symptom of migraines,[216] apparently referring to double vision because of temporary paralysis of the eye muscles, which can occur in basilar migraines[51] and in the rare syndrome of ophthalmoplegic migraine.[193] Babinski[31] and Möbius[415] each report monocular diplopia in migraine patients, but dismiss the symptoms as hysteria. Various forms of monocular diplopia have been recorded as migraine aura symptoms. Hoff and Schilder observed monocular diplopia with a clearly contoured true image and an indistinct false image in a patient with recurring headaches most likely due to migraines, although the authors did not make a diagnosis.[269] Butler gives a detailed description of this illusion in migraines, emphasizing the origin of the disturbance in the brain. In Butler's cases the double images were shifted either vertically or horizontally and persisted no matter which eye was closed.[84] According to the observations of Klee, who reported double vision in twelve of fifty patients with severe migraines, there was usually partial overlap of the two images, although sometimes they were completely separate. Several of Klee's patients noticed that the diplopia was monocular, and that the relative position of the two images did not change when the direction of gaze was changed,[312] which is another characteristic feature of monocular diplopia. In one patient studied by Klee, double vision occurred combined with the illusion of visual magnification (macropsia): "During fixation a tap may appear double and also apparently increase in size."[312] This phenomenon is confirmed by one Migraine Art picture (see fig. 291). Drake reports a migraine patient with recurring episodes of monocular diplopia that lasted up to thirty minutes and occasionally came with initial or subsequent blurring of vision in both eyes.[140] Kosmorsky describes monocular diplopia within the area of a fortification spectrum:

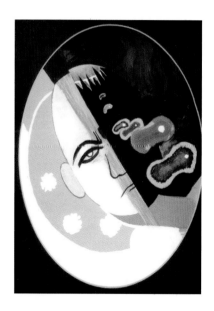

▲ **Figure 291**

Migraine Art collection.

> *Recently, during an episode of acephalgic migraine, I experienced an unusual visual phenomenon. I noted the onset of my typical hemianopic scintillating scotoma [spot on half the visual field] in the paracentral area [near the center of the visual field] on my left homonymous field [in the same half of*

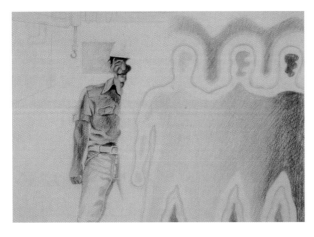

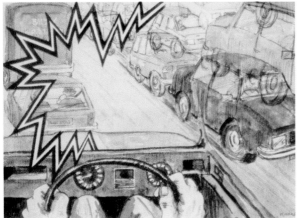

Figures 292 and 293

Migraine Art collection.

each visual field in each eye]. This scotoma gradually enlarged over a period of five minutes. I began to notice that within the area of these zigzag scintillations, images were doubled. Even more interestingly, when I covered either eye, the images remained doubled within the scintillating scotoma. The doubling of images did not change during monocular [one-eyed] or binocular viewing.[332]

Monocular diplopia can be restricted to a part of a whole object, for example the eyes rather than the whole head.[269] This rarely described feature of one-eyed double vision originating in the brain is illustrated in five Migraine Art pictures, all of which show duplication of one or both eyes in a human face (see figs. 252, 289–291, and 322). The duplication of the eyes in these cases of double vision can probably be related to their status as the most prominent objects that attract attention when looking at a human face.[664] This doubling of parts of a whole has also been described in perseverated images (see "Visual Perseveration" above).

Polyopia

Polyopia, seeing multiple images of the same object, is a visual illusion originating in the brain that persists no matter which eye is closed.[409,410] A hallucinatory kind of polyopia, which persists when both eyes are closed, has also been described.[76]

Various forms of polyopia are represented in a total of eight Migraine Art pictures. Four of them illustrate the type of illusion described by Hoff and Pötzl as *polyopia like sun images,* a term used to emphasize the simi-

larity of the phenomenon to the dazzling sensation of staring at the setting sun.[268] In figure 292 the migraine artist, who is experiencing a right-sided loss of vision, looks directly at a worker in a factory. Multiple images of the worker's shape arise at the border between the sufferer's intact visual field and the field of vision with visual loss, and the images extend sideways to the periphery. Multiple colored lines surround the multiple images of the worker's shape, similar to a corona. The artist experienced this type of visual disturbance only once, when he was forty years old. He writes:

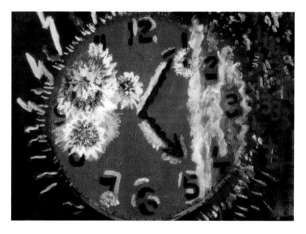

▲ **Figure 294**

Migraine Art collection.

> *I was walking across a factory floor when, to my astonishment, I could see only the left-hand side of the workman walking toward me, and generally I could see only the left-hand side of everything I looked at, even the floor. On the right-hand side were vague, flickering, auralike shapes in rainbow colors. There was no headache, no distress whatsoever. Instead I felt a wonderful, blissful calm. I was enjoying this experience and felt no fear or anxiety. I sat down in the factory canteen, and after twenty minutes my vision returned to normal.*

In figure 191, multiple images of a woman's face, arranged horizontally and evenly, are depicted in a tunnel bordered by spirals. In figure 293 a driver experiences a large fortification spectrum. Multiple images of cars on the opposite side of the road are seen arranged vertically and evenly. The secondary images are less distinct and have fading colors. Figure 294 depicts the face of a clock with a variety of simple visual hallucinations superimposed. Double images or multiple images of the hands and individual digits occur mainly on the right side of the artist's field of vision, apparently moving toward the periphery both horizontally and vertically.

One Migraine Art picture illustrates a second type of seeing multiple images that has been called *polyopic porropsia* by Pötzl.[516] In such cases the multiple images appear to become more and more distant, similar to the

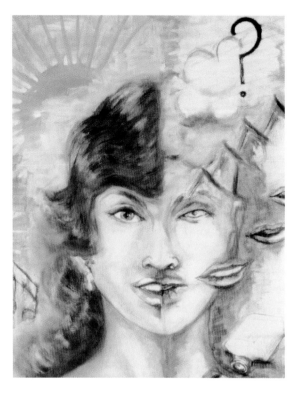

▲ **Figure 295**

Migraine Art collection.

shrinking in the illusion of teleopsia (see "Dysmetropsia" above). In figure 295 the right half of the mirror image shows some visual loss and also color blindness. Multiple images of the mouth arise in the center of the visual field, diminishing in size as they become more distant.

A variant of a third type of seeing multiple images, which has been called *concentrically arranged polyopia*,[210] is shown in three Migraine Art pictures. A semicircular arrangement of multiple images can be seen in figure 296. Here the artist, seen at the bottom of the picture, experiences multiple images of herself reflected in a dressing-table mirror together with star-shaped visual hallucinations and fortification spectra spread throughout her visual field. A similar view of this scene is shown in another picture by the same artist (see fig. 297). In figure 57, drawn by an eight-year-old girl, multiple images of a clock, with all the duplicates set at 2 p.m., are arranged in the form of an arc. As noted above, there is an illusional and a hallucinatory form of seeing multiple images, with the hallucinatory form persisting when the eyes are closed. In the girl's depiction of herself she is lying on a sofa with her eyes covered by her hands.

Polyopia was first described by Mingazzini in a patient with a prolonged attack of dysphrenic migraine.[409] This patient experienced four or five identical images of a person standing in front of him, in a horizontal row to the left. In a case from Curschmann, headache attacks were repeatedly accompanied by double or triple images appearing horizontally.[117] A patient of Hoff and Schilder's also experienced monocular diplopia and polyopia.[269] Klee and Willanger report a migraine patient who experienced quadruple vision of another person when either she or that person was moving.[314] In her right field of vision, one migraine patient of Podoll's experienced multiple images of a desk shifted vertically and overlapping considerably. The multiple images "appeared to be stored

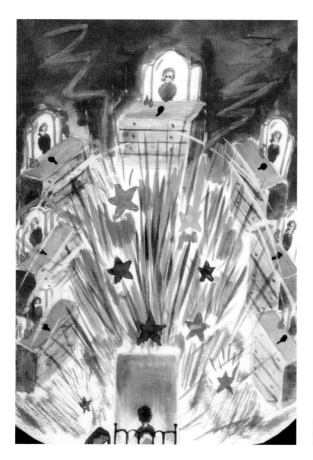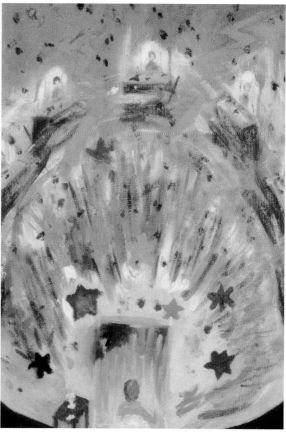

one upon the other" (unpublished observation). While all these reports of seeing multiple images as visual migraine auras can be classified as polyopia like sun images, the Migraine Art collection also includes examples where the multiple images seem to recede and shrink (polyopic porropsia) and concentrically arranged polyopia, which have not been described previously in the migraine literature. Two Migraine Art pictures illustrate that polyopia can be restricted to parts of a whole (see figs. 294 and 295), a feature also found in palinopsia and in monocular diplopia, discussed in the two previous sections. Seeing multiple images is often connected to visual loss and simple hallucinations, which is confirmed by these Migraine Art illustrations. If polyopia occurs together with loss of vision in half the visual field (hemianopia), the multiple images progress from the center to the periphery of the field with loss of vision (see figs. 292 and 295), opposite to the direction that complex visual hallucinations

▲ **Figures 296 and 297**

Migraine Art collection.

move in the field with loss of vision when there are multiple copies of an object (see "Complex Imagery" above).

Medical analysis suggests that monocular diplopia and polyopia are variants of the same condition or dysfunction in the brain. Critchley considers both these forms of illusion to be varieties of visual perseveration in space, where the sufferer continues to see an object in an interrupted way rather than in a continuous way (visual spread).[106] In four case reports in the literature, monocular diplopia and polyopia have been experienced at different times by the same migraine patient.[117,269,312,409] This is also seen in a migraine artist who submitted a drawing featuring double vision while watching TV (see fig. 287) and another picture of seeing multiple images while driving a car (see fig. 293). In the visual migraine aura depicted by another artist in figure 294, double vision and seeing multiple images are experienced simultaneously. The medical literature and Migraine Art imply a close relationship between these two types of visual illusion.

Corona Phenomenon

Klee and Willanger introduced the term *corona phenomenon* for the visual illusion of an extra edge around an object.[314] This illusion is also described by other authors, who liken it to a halo, border, or shiny ring closely following the contours or surrounding either the horizontal or vertical side of an object. Heron et al., who observed the illusion of an extra edge surrounding objects after prolonged sensory deprivation, suggest that it may be related to disturbances of seeing visual contrast,[257] but how this illusion happens has yet to be uncovered.

The Migraine Art collection includes six illustrations of a typical[493] corona phenomenon. The corona can appear with a single contour or two extra contours, surrounding parts or all the contours of an object in black, white, or color. There is no consistent relationship between the color of the corona and the color of the object. The teacher portrayed in figure 116 experiences "scintillating, seething blobs of color" in her entire visual field together with the illusion that "the blue exercise book is rimmed

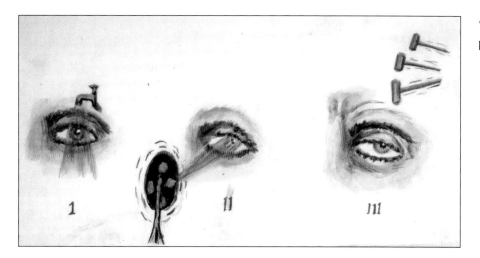

with luminous orange and a fringe of paler light." Figure 298 shows a corona in a sequence of three stages, the first characterized by blurred vision, as if looking through a stream of tap water; the second with a corona surrounding a tree; and the third with pain depicted by three mallets beating on the migraine sufferer's forehead. Figure 299 depicts a still life in which all the objects are bordered by a similarly tinged corona. Figure 300 shows a corona surrounding part of the contours of a man, a woman, and a dove, together with a similar extra edge around a central spot on the visual field (positive scotoma). The artist writes:

This migraine typically started with disturbed vision—a bright "sparkling" that developed into a glowing dark mass [a positive scotoma], nearly always palette shaped, like the retained image one gets after staring at a bright

Figure 299
Migraine Art collection.

light. This always blots out whatever one focuses on. The dark shape still had remnants of the sparkle around it and a similar sparkling "halo" was also seen on things near the center of focus. As the dark shape fades it leaves the area focused on not there [a negative scotoma]. Unless you have experienced this it is difficult to appreciate how one can have an empty area of focus. This all gives me plenty of time to take medication as the headache

▲ **Figure 300**

Migraine Art collection.

▼ **Figure 301**

Migraine Art collection.

starts with the return of normal vision about half an hour to one hour after the beginning of the visual attack.

The corona depicted in figure 301, close to a number of positive spots on the visual field, follows parts of the contours of a vase containing three tulips. In figure 302 the artist experiences a right-sided loss of vision in the visual field (hemianopia) together with the illusion of a complete corona around three birds feeding on a table and a partial corona around three birds in flight.

Five other Migraine Art pictures represent unusual variants[493] of the corona illusion. Figures 312 and 321 in the next section show multiple concentric halos around the mirror image of the migraine sufferer's head together with the visual illusion of distorted contours (metamorphopsia) of the face in the first image and mosaic illusion in the second. In figure 292 the multiple images of the shape of a worker are surrounded by multiple colored extra contours. Figure 303 shows a female artist's view of a man in a stylized landscape. All parts of the man's body, which are seen in the left half of the artist's field of vision, are surrounded by either a single extra contour (the inner side of his leg) or multiple waves and zigzags (the side of his body). This record of the artist's visual aura combines a corona and Gowers's pericentral spectrum,[217] described above in the section titled "Line Shapes." In figure 120, by the same artist, the vision of the sufferer's own body is surrounded by a similar unusual corona. These unusual corona variants demonstrate that in addition to extra contours seen around perceived images, they can also be seen around illusory images and both simple and complex hallucinated images, such as positive spots on the visual field (scotomas) and the sight of one's own body (autoscopy).

The first report of a corona phenomenon as a migraine aura symptom was from Ruete, who records that objects seen in the

area of a zigzag spot on the visual field were seen "as if surrounded by a halo."[551] Similarly, Gowers describes a migraine patient who saw objects surrounded by an iridescent fringe during his attacks,[216] which prompted Möbius to recommend an examination for glaucoma,[415] which has a similar fringe in spectral colors around objects. However, Speed also observed "halo vision" as a migraine aura symptom where glaucoma had been ruled out.[597] Greenacre describes a "halo of the vision" appearing as "a white or red shining light displaced to the head, as the figure of the Madonna," which she thought was a visual phenomenon that "may have some relation to the scintillating scotoma [spot on the visual field] and headache of migraine."[228] The visual symptoms experienced by a thirty-seven-year-old woman suffering from migraines with auras also included seeing halos around objects.[270] It was not until Klee's study, which recorded the illusion in eight out of fifty hospitalized patients,[312] that the corona phenomenon was recognized as a common aura symptom of migraines. Queiroz et al. found corona phenomena in two of one hundred adult migraine sufferers with visual auras.[522] An unusual variant of the illusion is reported by Wilson, who records a combination of a corona phenomenon with objects getting farther away and smaller (teleopsia

and micropsia) in one of his patients. This patient observed that objects "suddenly appear to be surrounded by a series of clear concentric rings, inside which is a black ring; all the rings eventually become black and

▲ **Figures 302 and 303**

Migraine Art collection.

▲ Figure 304

Esoteric concept of the aura of the human body.

seem to be rolling round and round. Whenever these rings appear, external objects seem to recede at once to a great distance and to become very small."[653] Combinations of the corona phenomenon with other visual illusions, as well as other unusual variants that have not been previously described, are depicted in five Migraine Art pictures, a testimony to the wide range of variation, which appears to be larger than previously assumed.

There is a remarkable similarity between the visual illusion of a corona around a human body (see fig. 300), described by one artist as "auralike shapes in rainbow colors" (see fig. 292), and the supposedly paranormal phenomenon of "aura vision" (see fig. 304), described by psychic and parapsychological researchers as a vaporous light or emanation surrounding a person's head, shoulders, hands, or body, assumed to represent that person's spirituality and visible only to sensitive people like a clairvoyant.[357,449] Both Ruete[551] and Greenacre[228] explicitly likened this visual illusion to the religious vision of the halo of a saint or the Virgin Mary. The similarity is even more striking considering the unusual variants of the corona phenomenon illustrated in figures 120 and 303. Aura vision may represent, at least in some cases, a visual aura symptom of migraines. This idea is further supported by the pictures of aura vision in the literature of the esoteric doctrine called theosophy. Theosophists have published numerous illustrations of auras characterized by various forms and colors and maintain that such auras are indicative of different emotional states, for example love (see fig. 305) and fear (see fig. 306), from Leadbeater's work titled *Man Visible and Man Invisible*.[358] It is obvious that the zigzags in these pictures, superimposed on the image of the human body in the theosophist's aura vision, are identical to the most common visual hallucination in migraines, the zigzags of fortification

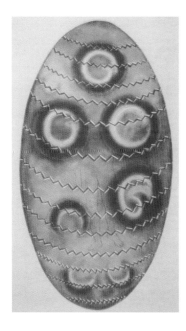

◀ **Figures 305 and 306**

Theosophical illustration of the human aura representing love and fear.[358]

▼ **Figure 307**

Migraine Art collection.

spectra. Together with the previously discussed out-of-body phenomena (see "Out-of-Body Experiences" in chapter 6) and paranormal hallucinations (see "Complex Imagery" above), aura vision can be considered another form of purely subjective experience where the migraine aura, in Mercier's words, is "a possible explanation, according to the known laws of physical nature, of those occurrences which seemed to us occult, mysterious, and inexplicable."[405]

Distorted Shapes and Outlines

Metamorphopsia has sometimes been used as a general term for all visual illusions,[104] but here the term is confined to mean perceptual distortions of the contour or shape of objects or people.[390,651]

The Migraine Art collection includes eleven examples of metamorphopsia. Figure 137 includes a reference to "distorted shapes." Figure 307 illustrates distorted shapes of a cathedral and a skyscraper with the illusion that the buildings are split. In the same picture the whirl of simple geometric spirals and arcs at the center of a representation of the migraine sufferer's

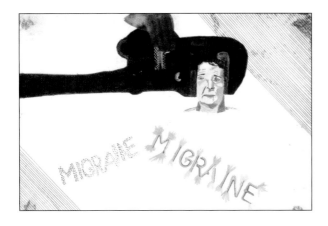

△ Figure 308

Migraine Art collection.

eye appears to force the adjacent lines of text into similar wave shapes. Figure 308 is another example of a perceptual distortion of the word *migraine* with displacement and fusion of letters. In figure 309 the linear contours of the street lights are distorted, as if they were bent along the contours of geometric hallucinations with arcs, circles, herringbone patterns, and lattices. Figure 215 illustrates distorted shapes and outlines, together with an overall sprinkling of dots, in the area enclosed by a zigzag fortification spectrum. The lines of all the visible objects are wavy. Figure 310 shows a window with wavy lines and planes, resulting in distortion of the panes of glass. Flame-like shapes and large fortification spectra can be seen in the surroundings, and the artist depicts a distorted view of two human eyes, one shifted considerably lower than the other. This is an example of generalized metamorphopsia, which includes both objects and human forms.

In the remaining five pictures, distorted shapes and outlines are restricted to the human face. Two Migraine Art illustrations show the eyes

▶ Figure 309

Migraine Art collection.

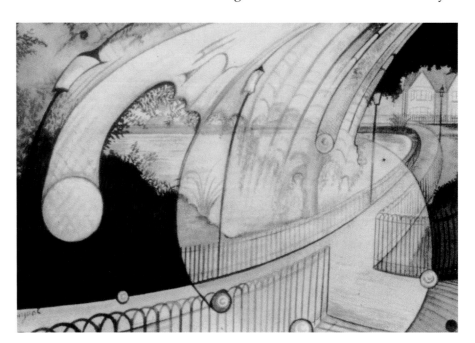

displaced. In figure 248 the artist depicts his
distorted view while looking at his "mirror
image." One of his eyes is slightly tilted and
considerably lower. Figure 322 in the next sec-
tion displays the mosaic illusion as the main
feature of the artist's visual disturbance, and
both eyes are tilted symmetrically. In the mir-
ror image in figure 311, the artist experiences
a left spot near the center of the visual field
(paracentral scotoma) in which his face
appears transformed into a skull with his eye

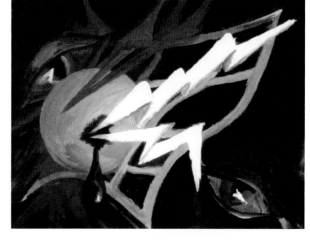

replaced by a star surrounded by convoluted wave patterns.
Another example of this transformation can be seen in the mir-
ror image of the patient's face in figure 312. On the lower left
side, the eye is enlarged and surrounded by concentric wavy
lines. In the opposite half of the visual field there is no evidence
of distorted shapes and outlines, but a large spot on the visual
field obliterates the cheek and chin. In figure 313 the pain-racked
sufferer views her severely distorted mirror image. In her left
field of vision, sprinkled with black dots, most of her head is
gray, except for the mouth. The left eye has been replaced by
the contours of a red spiral. On the right the upper half of the
eye socket is surrounded by concentric lines, and the eye
appears to have left its socket to float in front of her head.

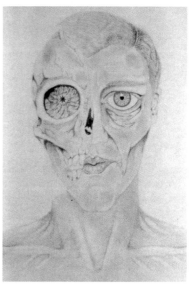

▲ **Figures 310
and 311**

Migraine Art collection.

Summarizing the features of distorted shapes and outlines encountered
in the eleven Migraine Art pictures, four pictures illustrate object meta-
morphopsia (see figs. 137, 215, 308, and 309), one picture represents gen-
eralized metamorphopsia of both objects and human shapes (see fig. 310),
and five display facial metamorphopsia (see figs. 248, 311–313, and 322).
The types of distortion include four cases with wavy contours of objects (see
figs. 215, 307, 309, and 310), one case with wavy planes (see fig. 310), three
with displacement of parts of the face (see figs. 248, 310, and 322), and two
with other deformations of objects (see figs. 307 and 308). In three pictures
illustrating facial metamorphopsia, the distortion is characterized by

▲ Figures 312 and 313

Migraine Art collection.

"category-specific transformations" of parts of the face or the whole face into different images in the same category, for example a skull replacing the face or rows of teeth replacing the lips (see figs. 311, 312, and 313).

Distorted shapes and outlines may apply to objects (object metamorphopsia), to both objects and human shapes (generalized metamorphopsia), or selectively to faces (facial metamorphopsia). Different types of object distortion have been reported in migraine patients. Waviness in the contours of objects is recorded by Latham,[353] Riley,[537] Heyck,[260] Speed,[597] and Barolin and Gloning.[37] While looking sideways at a window, Latham's patient noticed "that one of the panes of glass appeared as though warped and waved ... as I moved my eyes, the other panes of glass presented the same appearance."[353] Waviness of planes was described in a case of Klee and Willanger's. According to this patient:

> *Surfaces apparently bend up towards her; for example a tabletop can resemble a landscape with hills, the tops of which stand about two to three centimeters [about an inch] above the level of the table. When she walks in the street she occasionally lifts her feet high to avoid similar elevations in the surface, and not until she has passed does she realize that the street is flat.*[314]

Hachinski et al. report a patient with juvenile migraines who described one episode "when desks in the classroom appeared to undulate."[240] Displacement of parts of an object was recorded in the previously mentioned patient of Klee and Willanger's, who sometimes experienced a "displacement of the edges of larger objects at which she gazes, for example the edge of a table."[314] The previously mentioned case of a schoolgirl with recurring migraine attacks experienced that "the numbers on a wall clock were irregularly spaced."[240] A small number of authors report other distortions of objects as visual migraine aura symptoms: Round objects appeared angular, wider, and darker to a patient of Hoeflmayr's,[267] and one of Barolin and Gloning's patients experienced distorted angles.[37] In generalized metamorphopsia, which involves a distorted perception of both objects and human shapes, the same types of distortions of objects can occur in human figures and faces. A patient with juvenile migraines recorded by Bille found that "people and objects appeared deformed, like the reflections in mirrors seen in carnivals,"[54] and one of Klee and Willanger's patients "experienced distortion of things at which she looked, for example people's faces."[314]

Facial metamorphopsia is a form of visual disturbance not adequately described in the medical literature. Bodamer makes a distinction between facial metamorphopsia, where sufferers have the ability to recognize faces, and prosopagnosia, where there is an inability to recognize familiar faces despite undistorted vision (an early report of prosopagnosia[351] can be found in Lewis Carroll's portrait of Humpty Dumpty in *Through the Looking Glass*[89]). As an example, one of Bodamer's patients with a lesion in his brain's left occipital region experienced sudden epileptic episodes where facial shapes and outlines were distorted, so that "all faces, according to the patient, were peculiarly contorted and the features displaced; for example the ward nurse's nose was deviated to the side by several degrees, one eyebrow was higher than the other, the mouth lay at a diagonal, the hair was disheveled like a wig askew.... Even his own face, viewed in a mirror, made no exception."[64] Unfortunately, the distinction between facial metamorphopsia and prosopagnosia was confused by later authors, who considered facial metamorphopsia to be a subtype of prosopagnosia, "a

metamorphopsic form of agnosia for faces, in which the impairment in recognition is determined primarily by perceptual distortions which are, however, restricted to faces."[253] Only recently has facial metamorphopsia,[252] also called prosopometamorphopsia,[107] been reconsidered as a distinct symptom differing from both generalized metamorphopsia and prosopagnosia.[154,427]

Few authors report facial metamorphopsia as a migraine aura symptom. Curschmann presents the earliest and most detailed report.[117] One of his patients repeatedly saw people's faces as indistinct and blurred, the left side appearing more shadowy, darker, and red, and with the faces sometimes showing deformation and mutilation of the nose or ear. The patient also experienced complex visual hallucinations of grotesque grimacing faces with the same mutilations. She remembered seeing a syphilis patient with a mutilated nose and ear shortly before the start of her visual disturbances, suggesting that her visual illusions and hallucinations were probably due to the illusion of perseveration in time (palinopsia).[117] Mingazzini notes that patients with dysphrenic migraines may complain that other patients or medical personnel appear misshapen.[411] Hécaen and Angelargues report sudden perceptual distortion restricted to faces in three patients with migraines.[253] Unfortunately no further clinical details are available. One of Barolin's patients recorded that customers he spoke to appeared to have very small shrunken heads, like lemons.[36] Golden reports a patient with juvenile migraines who said, "Daddy looked like someone else, like an evil person, and although I knew it was really him and I was hallucinating, I was scared,"[213] illustrating that the perceptual distortions of facial metamorphopsia nevertheless allow an accurate recognition of familiar faces. Fuller et al. report a patient with dysphrenic migraines who "complained that his wife and brother-in-law were changing before his eyes … that they each had only one eye."[201]

Five pictures in the Migraine Art collection provide evidence of facial metamorphopsia as a visual disturbance on one or both sides of the visual field of each eye, which suggests that this migraine aura symptom is probably underreported in the medical literature. In two pictures the distortion of the face is a displacement of the eyes (see figs. 248 and 322).

This is similar to the report of Bodamer's patient who said that while looking at the face of another person, one eyebrow appeared to be higher than the other.[64] In two pictures with one-sided facial metamorphopsia (see figs. 311 and 312) and one picture with facial metamorphopsia on both sides (see fig. 313), "category-specific transformations" of the face are the prominent feature. These transformations involve changing parts of the face or the whole face into a completely different image that is still within the category of human faces. Similar transformations have been described in the literature as characteristic of facial metamorphopsia. For example, a patient of Pichler's with an injury to his brain's right parietooccipital region said that "heads were flattened on the left side, with graying hair on that side, as if overgrown by a fungus";[464] a patient reported by Nass et al. with an artery malformation in the right parietal lobe of his brain frequently had the experience that people's faces "looked older";[427] and a patient of Young et al. with a tumor in the right parietal lobe of his brain said that one day all his visitors had beards sprouting from their faces, and on another day they were all balding.[665] On another occasion this patient said that other people's "eyes left the skull and rotated in front of their heads,"[665] which is similar to the transformation illustrated in one Migraine Art picture (see fig. 313). Mooney et al. report the case of a commercial artist with a brain tumor who was able to paint his visual experience of one-sided distortion of facial shapes and outlines while looking at his doctor, when "the eye became a ghastly staring hole, the cheekbone a cavity; he had teeth on the upper lip, and often had two ears"[420] (see fig. 314). The same transformation of lips into teeth is encountered in two Migraine Art pictures (see figs. 311 and 312).

The phenomenon of category-specific transformation, as observed in facial metamorphopsia, is similar to the phenomenon of "categorical incorporation" described by Pötzl as a feature of perseverated images in palinopsia[518] and described above in "Visual Perseveration." Both phenomena imply that there is a distinct "visual logic" underlying the brain's visual perception system. Distortions of facial shapes and outlines (facial metamorphopsia) and perseverated images (palinopsia) are also similar in that both these visual disturbances combine features of a visual illusion and a

▶ **Figure 314**

Facial metamorphopsia depicted by an artist with a brain tumor.[420]

visual hallucination. The case of one of Curschmann's migraine patients[117] mentioned above is a good illustration of the similarities between facial metamorphopsia and palinopsia.

The Illusion of Splitting

The illusion of splitting is the visual illusion that an object or a person appears fractured, with the parts displaced or separated from each other.[252] Images can be split along the vertical axis, together with loss of vision in the outer half of each visual field (bitemporal hemianopia), caused by a disturbance in the chiasm part of the brain where the optic nerves cross.[176,310,426] For splitting occurring along other axes, however, the mechanisms are not known.

This illusion is represented in six Migraine Art pictures.[489] Figure 315 illustrates a dining room with the table set for a meal. Splitting occurs along multiple linear and arclike fracture lines that pass through the ceiling, walls, window frame, floor covering, and other objects like the light fixture, the dining table, place settings, and chairs. These fracture lines are bordered by fortification spectra and areas with some loss of color perception. The artist writes:

When the visual disturbance first begins, there is a bright zigzag pattern that jumps with the movements of my eye. As my eyes travel around the room, different areas are lit up by the zigzag and appear fractured from the rest of the room, so that the overall impression of the room is a jumble of detached areas. While all this is happening, I am becoming aware of an increasing revolving Catherine wheel [a wheel with spikes projecting from the rim] just to the right of my head and nearly out of sight. A feeling of nausea is experienced together with the onset of visual disturbance and the sensation that the right half of my head is missing [aschematia]. There is a vague headache in the left side.

▲ **Figure 315**

Migraine Art collection.

In figure 316 the artist's mirror image is distorted by curvelike white lines that result in the displacement of the frames of his eyeglasses. According to the artist, his visual disturbance with "brilliant pulsating zigzags … always started with fractured vision in the upper part of my sight."

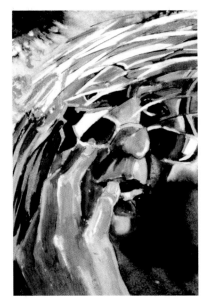 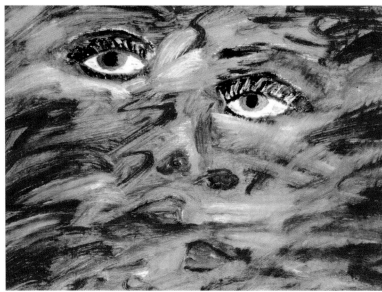

▲ **Figures 316 and 317**

Migraine Art collection.

Figure 317 shows splitting of the mirror image of the artist's face, with the two halves shifted along the vertical axis. The artist writes:

The picture is meant to show what I see, but the eyes are how I feel. . . . The onset of an attack is always marked by zigzag lines that are very fluorescent. During an attack things seem distorted, people's faces seem to be split, and they are also blurred. The time it lasts is varied, but mostly about twenty minutes. Once I have burped, the lights and distortion disappear, and I then have a headache and feel sick.

In three other Migraine Art pieces, splitting is depicted together with other visual illusions, including tilted vision, inverted vision, and displacement of images from one part of the visual field to another (allesthesia) (see fig. 284), double vision (see fig. 287), and distorted shapes and outlines (see fig. 307).

The features of the illusion of splitting in the Migraine Art pictures can be summarized as follows: The image of an object (four pictures) or a person (two pictures) appears fractured into two parts (three pictures) or more (three pictures). The fracture lines are most often linear (five pictures), with horizontal orientation (one picture), vertical orientation (two pictures), or some other orientation (three pictures). Less frequently the fracture lines

have a curved form (two pictures). The split parts are shifted in all the pictures, and in two pictures they are also separated from each other.

The illusion of splitting has only rarely been described as a visual migraine aura symptom. Wilson describes distorted vision with objects appearing "broken."[654] Rose and Gawel published a picture titled *Fragmentation of the Visual Image* (see fig. 318) that illustrates examples of splitting along horizontal and other axes with a sideways shift of the parts, as seen in the tree trunks.[547] An adolescent girl with recurring episodes of unconsciousness, probably due to basilar migraines, once experienced "split vision," followed by a severe headache and vomiting.[169] Queiroz et al. mention "fractured vision" as a visual migraine aura symptom.[522] In an account of his personal migraine attacks, Creditor notes that spots on the visual field (scintillating scotomas) were frequently preceded by a "visual distortion in which the halves of peoples' faces were vertically displaced in the midline in such a way that one eye appeared to be a centimeter or two [less than an inch] lower than the other."[102] A person's image splitting along a vertical axis with the parts shifted was also experienced by one of Bruyn's patients, who, some hours before her attack, "saw people as longitudinally cut into two (right and left) halves but subsequently

◀ Figure 318

The illusion of splitting illustrated as visual migraine aura by Rose and Gawel.[547]

joined after the left half had been [shifted] over a distance of about six inches [fifteen centimeters], so that the left half of the face was opposite to the right half of the neck, the left half of the neck opposite to the right half of the chest."[79]

Since only a limited number of case reports of the illusion of splitting exist in migraine patients and in patients with other neurological disorders, few attempts have been made to describe this illusion comprehensively. The most thorough study previously available was published by Hécaen and Albert, who record that the "illusion of splitting of an object into two parts may occur along a horizontal or vertical axis and may be accompanied by separation of the parts, such that they do not touch."[252] The Migraine Art pictures expand on this description. In the illusion of splitting, an object or a person appears to be split into two or more parts along one or more fracture lines of varying shape. The shape of the fracture line may be linear (with a horizontal, vertical, or other orientation) or curved. The illusion of splitting may be accompanied by a shift of the split parts along the fracture line, or by separation, which can occur with all forms of fracture lines. The illusion of splitting is strongly connected to simple visual hallucinations of varying shapes. In some cases these visual hallucinations seem to act as the fracture lines of the splitting.

The illusion of splitting is different than the fragmentation of visual images[321] and from the geometrizing illusion[5] or mosaic illusion.[554] Fragmentation was first described for vividly recalled images,[321] but the same features can be present in visual illusions and hallucinations.[323] Fragments of objects may be seen that seem to be without any connection, organization, or meaning.[323] The outlines of these isolated fragments may be similar to those of the split parts in the illusion of splitting, although often they are more irregularly shaped. In contrast to fragmentation, in the illusion of splitting all split parts or fragments remain visible, though they are shifted and separated. Rose and Gawel use the term "fragmentation of the visual image"[547] for the illusion of splitting as a migraine aura symptom[547] (see fig. 318), but this term is not recommended. The geometrizing illusion[5] or mosaic illusion[554] is the fragmentation of the visual image into multiple geometric patterns of varying shapes, interlaced like a mosaic.

The shapes of the mosaic pieces can be similar to those seen in fragmentation, and the bordering lines of the mosaic pieces can be similar to those in the illusion of splitting. Unlike fragmentation, in the mosaic illusion the whole image of an object remains recognizable, produced by assembling the multiple fragments. In contrast to the illusion of splitting, the mosaic illusion results in much more complex fragmentation of the visual image, governed by the tendency for the fragments to be geometric.

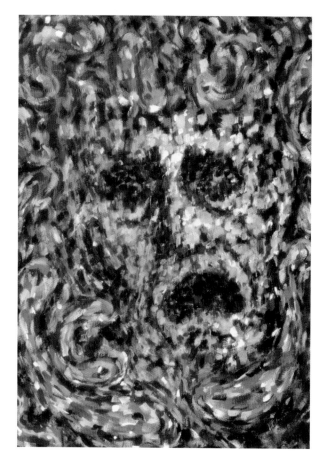

▼ **Figure 319**

Migraine Art collection.

The Mosaic Illusion

Geometrizing illusion[5] or mosaic illusion[554] is the fragmentation of the visual image into multiple pieces of varying shapes, interlaced like a mosaic.

This illusion is encountered in six Migraine Art pictures, in all of them affecting the entire visual field.[492] According to Siegel and Jarvik's system of classification,[583] the "jigsaw pieces" in the mosaic illusion can be assigned to these shapes: random (one picture), line (five pictures), curve (five pictures), and lattice (two pictures). In figure 319 the mirror image of the artist's face, which is composed of amorphous blobs, squares, and curved shapes, appears as a pointillist painting. In figure 320 a portrait of the artist and the background is fragmented, especially on the right side, with a predominance of large angular forms together with a few arcs and gratings, resulting in an effect like a cubist painting. The same shapes except for lattices are seen in the self-portrait of another artist, but patterns of fragmentation are more refined (not shown; see fig. 6 of the paper by Wilkinson and Robinson[650]). In figure 321 the fragments of the artist's mirror image are blended in a complex mosaic with great variation in shapes, including angular figures, curves, waves, circles, gratings,

and brickwork patterns. The head and neck are surrounded by multiple colored corona-like contours. The visual impact of the painting is similar to an early Picasso. In figure 322 an acrylic plastic plate covers the artist's self-portrait, mimicking the reflections of light in a mirror. The mirror image is composed of concentric waves around both eyes and multiple symmetrical arcs in the forehead region, reminiscent of art nouveau. Both eyes are considerably tilted in a symmetrical arrangement. On the right side an extra eye can be seen, indicating double vision (monocular diplopia). In figure 323 the image is composed of disjointed triangles, rectangles, and polygons. The duplication that occurs in the neck and tie, and the multiplication in the mouth, eyes, and other facial features, contribute to the considerable distortion of the image, particularly of the face.

The mosaic illusion was first described as a migraine aura symptom by Sacks when he reported the case of a forty-five-year-old man who repeatedly "observed that portions of the visual image, in particular faces, may appear 'cut up,' distorted and disjointed, being composed of sharp-edged fragments."[554] Sacks defines mosaic illusion as "fracture of the visual image into irregular, crystalline, polygonal facets, dovetailed together as in a mosaic."[554] According to the size and shape of the pieces, the mosaic illusion is described as the visual world appearing like a pointillist painting, a classical mosaic, or a cubist work of art. Sacks depicts these different styles as different stages of the illusion (see fig. 324). In the earlier stages of mosaic illusion the visual image can still be recognized, but it may end in "a peculiar form of visual agnosia" (inability to recognize objects).[554]

In his 1984 book titled *A Leg to Stand On*, Sacks describes a personal visual migraine aura experience with geometric hallucinations of first web, then lattice shapes, and subsequent mosaic illusion in the half-field of vision with visual loss. He wrote:

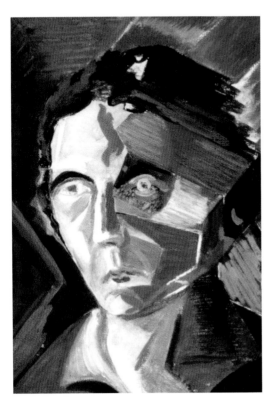

▼ **Figure 320**

Migraine Art collection.

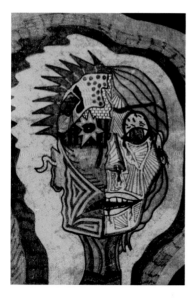 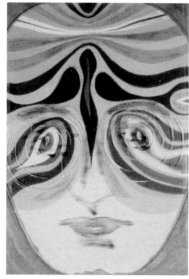 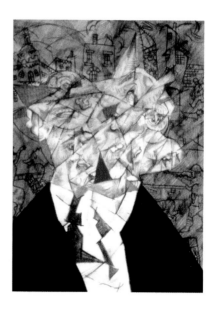

▲ **Figures 321, 322, and 323**

Migraine Art collection.

And now—yes—something was happening in the blind half of my scotoma [spot on the visual field]. A most delicate filigree pattern had appeared while I mused, more delicate and transparent than the finest spiderweb, and with a sort of faint, quivering, trembling, boiling motion. It became clearer, brighter, a lattice of exquisite geometric beauty, composed, I could now see, entirely of hexagons, and covering the whole half-field like gossamer lacework. The missing half of the room now grew visible, but remained entirely contained within the lacework, so that it appeared itself latticed in structure— a mosaic of hexagonal pieces, perfectly dovetailed and juxtaposed with each other. There was no sense of space, of solidity or extension, no sense of objects except as facets geometrically apposed, no sense of space and no sense of motion or time.

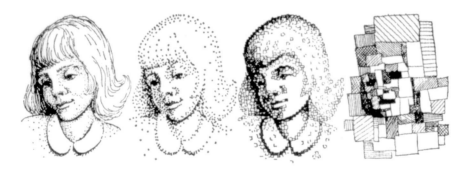

◀ **Figure 324**

Mosaic illusion illustrated as visual migraine aura by Sacks.[554]

After Sacks's publications, many other authors described mosaic illusion as a visual migraine aura, but except for papers by Fisher[174] and Liu et al.[379] there is a striking absence of case reports. In a case of Fisher's, "A woman aged forty-five, after carrying out aerobic exercises, developed blurred vision followed first by the appearance of looking through shattered glass, then a streaming of horizontal bright lines from left to right, and finally a visual display resembling a jigsaw puzzle with pieces coming and going, producing a changing pattern of vision and nonvision."[174] According to a case reported by Liu et al., "A twenty-year-old woman had a fifteen-year history of headaches … preceded by a twenty-minute visual prodrome [aura symptom] where objects became 'fragmented' and 'cubed.'"[379]

The Migraine Art illustrations of the mosaic illusion show that the shapes of the mosaic pieces involve a wide range of shapes, which are identical to the typical shapes observed in geometric visual hallucinations.[320] This expands on Sacks's description of the mosaic illusion, which emphasizes only "sharp-edged fragments," as curve shape fragments can also occur (see fig. 322). The shapes encountered in the mosaic illusion and in geometric visual hallucinations, previously discussed as Ahlenstiel and Kaufmann's notion of geometrizing illusion,[5] suggest that there are related underlying processes for both types of visual disturbance. Sacks's report of geometric visual hallucinations followed by the mosaic illusion during a visual migraine aura[555] also points to related causes of these visual disturbances. It seems that faulty operation of the brain's visual system as it extracts geometric features with geometric shape "detectors" or "filters"—the faulty activation of which may be the cause of geometric hallucinations (see "How Hallucinations Occur" above)—is responsible for the tendency of the mosaic illusion to become geometric.

The Impact of Visual Disturbances on Daily Life

Most migraine sufferers consider the impact of visual disturbances on their daily lives to be considerably less than that of the headaches (see

"The Impact of Acute Migraine Attacks on Daily Life" in chapter 4), since their duration is much shorter than a full-blown attack and may even occur without pain. Nevertheless, there are some daily activities where visual disturbances may be hazardous, if not troublesome. The effects of visual migraine auras on *reading* have been well-documented: They include letters or text obscured by loss of vision in half the visual field (hemianopia), spots on the visual field (scotomas), or visual hallucinations; blurring of letters;[36] difficulty recognizing words due to eye fatigue and dimmed vision (asthenopic dyslexia);[314,539] reading impairment from illusions such as autokinesis, where letters dance and lines of text move;[128,181,312,463] and dysmegalopsia, in which "columns of type on a page or half of a word would differ in size."[539] *Driving* can be dangerous because of visual loss as well as the fact that the ability to judge distances may be impaired during a visual migraine aura.[12,54] Hay suggests that visual disturbances could be responsible for a number of fatal car accidents of previously unknown cause.[249] The risks of driving while experiencing a visual migraine aura are impressively documented by anecdotal observations, such as one from Alvarez, who reports:

> *Once, when I had a scotoma [spot on the field of vision] as I was driving my car along a narrow country road, I must have had a left hemianopia [loss of vision in half the visual field] because suddenly I discovered a car a few yards away, bearing down on me. I had not seen it as it approached. It is curious that just before this happened I was not conscious of this decided defect in the left half of my field of vision. Several of my patients, after having had a similar experience while driving, decided that always, when they got a scotoma, they would stop a while and wait for the return of their vision.*[12]

The impact of visual disturbances on *reading* is represented in seventeen Migraine Art pictures. Reading can be impaired by various forms of visual loss, such as a spot on the visual field with vanishing and reappearance of letters or parts of letters (asthenopic scotoma) (see fig. 170), blurred vision (see fig. 164), tunnel vision (see figs. 188 and 189), and negative spots on the visual field (see fig. 165). Other pictures illustrate the effects on reading of scintillating spots on the visual field (see figs. 169 and 181) and zigzag

fortification spectra (see figs. 47, 63, and 189). The effect of visual illusions on reading is shown in three Migraine Art pieces, one of them depicting single letters appearing abnormally large (macropsia) (see fig. 281), another with tilted and inverted vision of lines of text (see fig. 284), and the third illustrating shift and fusion of letters (see fig. 308). The question of one artist, "How can you read when the page looks like this?" (see fig. 189), is appropriate for this entire group of sufferers.

Nine Migraine Art pictures illustrate the effects that visual disturbances have on *driving*. In one painting a bus driver is forced by his visual aura to wait at the nearest bus stop for the return of his vision. In one picture a cross next to the image of a car indicates that the migraine sufferer is "unable to drive" because of her visual aura with "blurred vision" and "jagged colored lights, like a stained glass window in church." Similarly, a question mark superimposed on the car in another picture represents "the effect of a migraine while driving, making a 'stop and wait' necessary." In figure 203 the driver's view of the road is obscured by a zigzag fortification spectrum. He writes, "If driving in bright weather, the first visual effect is usually the disappearance of part of the car in front. The whole picture can only be seen by 'scanning.' It becomes necessary to stop very soon." In two pictures, one titled *The Onset of Migraine* (see fig. 234) and the other *Attack Imminent!!* (see fig. 259), the drivers' views of the approaching traffic are similarly obscured by scintillating scotomas. In figure 192 the driver's visual disturbance with tunnel vision, loss of vision in half the visual field (hemianopia), and perceptual completion results in the car in front of him partially disappearing, the missing parts being "replaced" by the road and its markings. Even worse, the driver's view depicted in figure 190 is constricted by tunnel vision with the area within the tunnel almost completely obscured, justifying the artist's remark, "How can you drive when the road looks like this?" In figure 293 the driver's view is affected by a fortification spectrum on the left side and multiple images (polyopia) on the right side, resulting in the images of the approaching cars multiplying.

Five Migraine Art pictures illustrate the impact of visual disturbances on *work, family life,* and *leisure activities.* In figure 96 a seamstress, experi-

◀ **Figure 325**
Migraine Art collection.

encing a visual aura with zigzag fortification spectra, expresses embarrassment at her inability to continue working. In figure 292 the artist "could see only the left side of the workman" walking toward him, so he was obliged to sit for twenty minutes "in the factory canteen" until his vision returned to normal. In figure 178 the mother's ability to watch over her children playing on monkey bars in the park is impaired. Figure 208 shows another mother "on holiday," experiencing a visual aura that renders her incapable of "watching the children at play." Figure 325 depicts the impact of a visual aura with fortification spectra on the performance of a lawn bowler.

Acoustic Disturbances

In contrast to visual disturbances, which are frequently encountered, acoustic symptoms rarely occur as migraine auras. Acoustic disturbances may be categorized according to the same types of phenomena described for visual disturbances. The symptoms of visual loss have counterparts in decreased or complete loss of hearing, known to be one of the typical symptoms of basilar migraines. The sense that ambient sounds are fluctuating in intensity, as if emanating from a radio while the volume control is being turned up and down, is a migraine aura symptom called oscillocusis.[471,641] In contrast to the many forms of visual hallucination, acoustic hallucinations of migraine origin usually appear as the simple form of tinnitus, again a symptom of basilar migraines. Gans gives a vivid description of the varieties of tinnitus, ranging from "buzzing and wheezing in the ear, to the sound of running water, or other sounds imitating the humming noise heard in seashells, or ringing of bells."[205] Although the term *tinnitus* has a clear definition that is, according to Gowers, "at least a testimony to the frequency and reality of the suffering that is caused,"[219] it does not allow for more detailed description of the wide variety of these simple acoustic hallucinations. There are also a few reports of complex acoustic hallucinations, like hearing voices or music, most of them in patients with transient psychotic states during a dysphrenic migraine.[167,179,312,335,337,411,417,566] However, the symptom of hearing voices very briefly has also been recorded during less dramatic migraine attacks.[138,381] Based on a study of thirteen children, Schreier suggests a possible association between hearing voices, migraines, and a variety of emotional or anxiety disorders in nonpsychotic children. The voices

accompanied the migraine attacks in only two of the sufferers, and both of these children also heard voices at other times.[572] The visual illusion of perseverating images (palinopsia) has its acoustic counterpart in palinacousis,[291] which has only been found in a few migraine sufferers. A migraine patient of Bonhoeffer's had recurring attacks ending in the sensation of her own voice reechoing in a peculiarly strange way.[68] Bille reported a fifteen-year-old boy who found that "every sound had an echo," which lasted for about thirty minutes before a severe migraine attack.[54] An adult migraine sufferer reported by Barolin and Gloning complained that all voices sounded as if they were in an echo chamber.[37] One of Sacks's patients found that the faintest sounds were followed by a protracted echoing or reverberation for some seconds after they had stopped.[554] Another visual illusion, the slow or fast motion illusion, also called "the rushes,"[138] has an acoustic counterpart too. Klee and Willanger studied a migraine sufferer who reported that "speech sounded as if played on a tape recorder that ran too slowly, and there were also jerky changes in the rate of speech."[314] Golden reports a twelve-year-old patient experiencing "episodes during which he suddenly felt as if everyone was talking too fast."[213] For one of the patients of Dooley et al., "misperception of increased speed was primarily associated with her own voice and that of others," and yet another patient "spoke slowly, as if to compensate for his perception that his speech was more rapid than usual."[138] In all but one of the cited cases, the slow or fast motion illusion was experienced both acoustically and visually.

Acoustic symptoms are illustrated in two Migraine Art pictures. In figure 89 the female sufferer experiences a "rolling, thunderous noise" as part of her attack. During the migraine aura illustrated in figure 315, the artist heard "a crackling sound that I have depicted as water splashing on the floor. This is because, when I heard it for the first time, I actually thought it was raining heavily and water was splashing from the ceiling. I could as easily have described it as crackling electricity. I do not actually see this water. It is an interpretation of the sound." Both artists exemplify the difficulty of verbalizing simple acoustic hallucinations experienced as tinnitus.

Language Disturbances

Language disturbances occurring as transient migraine aura symptoms include all major syndromes that involve the loss of the ability to use words (aphasia), including global aphasia, Broca's aphasia (in which speech is nonfluent and labored), Wernicke's aphasia (in which the content of speech is jumbled and full of jargon), and amnesic aphasia (the loss of the ability to name objects).[37] Dreifuss reports detailed observations of a multilingual poet who lost the ability to use words and who sometimes only spoke the language of his childhood during a migraine attack. He could read a text in his second language only by simultaneously translating it into his first language.[142] Rare syndromes of word loss that have also been described in migraines include the inability to comprehend speech, called "pure word deafness,"[443,465,566] loss of the ability to write (agraphia),[162] loss of the ability to read (alexia) with loss of the ability to write (dysgraphia),[453] and loss of the ability to read without the loss of writing.[53,180,303,354]

It is worth noting that language disturbances are also included in a variety of signs and symptoms described in Lewis Carroll's second Alice book, *Through the Looking Glass.* In one episode, Alice experiences the word-finding difficulties that are the main feature of amnesic aphasia, the loss of the ability to name objects. When she reaches the wood, she remarks, "'Well, at any rate it's a great comfort … after being so hot, to get into the—into the—into *what*?' She went on, rather surprised at not being able to think of the word. 'I mean to get under the—under the—under *this*, you know!,' putting her hands on the trunk of a tree."[89] Trying to recall her own name, she experienced a typical "tip-of-the-tongue" phenomenon so that "all she could say, after a great deal of puzzling, was 'L, I *know* it

begins with L!,'"[89] which referred to the last name of Alice Liddell, to whom Carroll first told the stories of Alice's adventures. In the same book the White King was puzzled by a loss of the ability to write, in which his pencil "writes all manner of things that I don't intend."[89] Finally, as has already been noted by Livesley[381] and Klee,[315] Carroll's famous nonsense poem "Jabberwocky" mimics the fluent jargon characteristic of Wernicke's aphasia, as clearly evidenced by the poem's opening stanza:

'Twas brillig, and the slithy toves
Did gyre and gimble in the wabe:
All mimsy were the borogoves,
And the mome raths outgrabe.[89]

In Alice's comment on the poem, she referred to a kind of language comprehension disturbance that is another major feature of Wernicke's aphasia: "'It seems very pretty,' she said when she had finished it, 'but it's *rather* hard to understand!' (You see she didn't like to confess, even to herself, that she couldn't make it out at all.) 'Somehow it seems to fill my head with ideas—only I don't exactly know what they are!'"[89]

Language disturbances involving the loss of the ability to use words are depicted in two Migraine Art pictures. In figure 116, the teacher, standing before her class, realized that her students were laughing at her because she was "speaking complete rubbish." This is illustrated by the fluent jargon being uttered, a sign of Wernicke's aphasia. Figure 59 shows another sufferer in the throes of a migraine attack. An apparently meaningless cluster of letters approaching his ear represents the loss of language comprehension in the same syndrome.

The language disturbance of aphasia, losing the ability to use words, must not be confused with speech disorders like dysarthria, which involves poor articulation rather than a dysfunction in the content of speech, and which can occur as a characteristic symptom of basilar migraines. Poor articulation rather than the loss of the ability to use words is suggested by two artists who wrote within their artworks, "temporary speech impediment" and "speech slurred."

Migraines and Art

"Did Picasso suffer from migraines?"[156] asks designer Arthur O. Eger, struck by the phenomenal similarities between migraine visual hallucinations and Picasso's geometric forms, and between the mosaic illusion and the features of Picasso's cubist style of painting. The data available did not allow Eger to answer his question. However, he suggested that medical conditions such as migraines, epilepsy, low blood sugar in diabetics, and the use of hallucinogenic drugs—all of which can be associated with visual disturbances and other hallucinatory experiences—could have acted as sources of artistic inspiration for Picasso and other men and women in the history of art. The idea that Picasso might have suffered from migraines receives further support from the fact that not only cubism but also another of the more peculiar features of his style—the illusory vertical splitting which can be seen in some of his unique paintings of female faces—echoes a visual migraine aura symptom, the illusion of splitting.[170] Picasso's biography fails to mention him suffering from migraines, but we agree with Ferrari and Haan that "this could easily have been overlooked if he only suffered from migraines with auras."[170]

Lisle reports that Georgia O'Keeffe, renowned for her sensual paintings of giant flowers, visualized the images of some of her abstract paintings during migraine attacks.[377] Fuller and Gale present convincing evidence that Giorgio de Chirico, founder of the presurrealist style of metaphysical art, suffered from migraines and used visual migraine aura hallucinations as models for some of the more striking details of his drawings and paintings.[199] It can even be speculated that visual illusions of distorted shapes and outlines (metamorphopsia) inspired his unique treatment of

space and perspective.[429,430,431,432,484,507,512] There is also evidence that the composer, writer, and painter Alberto Savinio, brother of Giorgio de Chirico, included the zigzags of fortification spectra and other geometric imagery of migraine origin in several of his paintings.[507,508,509] The British artists Sarah Raphael[480,481] and Debbie Ayles,[30,511] the Italian artist Dario Arcidiacono,[483] and the American painter Linda Anderson[479,567] participated in interviews focusing on their migraine experiences as sources of artistic inspiration. Atkinson and Appenzeller describe a professional artist who used her complex visual hallucinations as inspiration for some of her artworks: "I have always had what I would call visions.... Most of them I draw.... Believe me, I never tell my gallery owners."[28] With the exception of a thesis by Cadenhead,[86] studies are sadly lacking of other painters or sculptors for whom migraines could be relevant to artistic creativity.

In art therapist Karen A. Cadenhead's thesis, titled *The Art of Migraine: An Exploration of the Alchemy of Migraine Headaches on the Art and Lives of Artists/Migraineurs*, she writes, "There is an absence of studies in the field of migraine research that look at this syndrome from the viewpoint of the artist. It is an extremely rich avenue of exploration, one which may provide greater understanding of migraines as well as the creative process as it may relate to headaches."[86] Cadenhead premised her study "on the belief that the artist can transform the experience of his suffering ... into art forms that 'speak' to a universal audience. This transmutation is metaphorically viewed as an alchemy; painful migraine experience is converted into a work of art."[86] A study of ten migraine sufferers involved in visual and written arts confirmed "the hypothesis that the artist transforms his suffering into an art form providing relief and meaning." Among other findings, Cadenhead found: (1) "The state of consciousness during creating and migraines is similar"; (2) "Images come to subjects during their headaches"; (3) "Art images common to migraines are the zigzag shape, radiating lines, and an emphasis on the eyes"; and (4) "Creating art can prevent or cut down on the number of headaches a subject has."[86]

In this chapter we present the work of four contemporary professional artists who participated in the Migraine Art competitions. Our objective is to assess whether the idea that migraine experiences are a source of

artistic inspiration in painters and sculptors can be verified with scientific evidence.[496] The artists gave their informed consent to participate in an interview exploring the relationships between migraines and art. In contrast to the subjects examined in Cadenhead's thesis,[86] all four artists exclusively support themselves through their art.

Romey T. Brough

Romey T. Brough, daughter of the renowned British radio and music hall ventriloquist Peter Brough, was born in 1944. She is best-known for her exciting and vibrant floral paintings. After completing her training at the Harrow School of Art, she traveled to Italy, where she studied first in Positano and then at the Rome Academy. Since 1964 she has exhibited continuously both in the United Kingdom and the United States. In 1977 an example of her work was placed in the Tate Gallery Archives in London, along with her biography. In addition to her painting, she has lectured and given demonstrations in Japan, Australia, and the Americas.

Brough's entry to the third Migraine Art competition in 1985 was a self-portrait during a migraine attack. It was a "one-off," so it was no surprise to hear the artist admit, "To be honest, I had forgotten the drawing totally—it was very interesting to see it again." She had not represented migraine experiences in her artworks before or since, except for the three pictures produced to illustrate this chapter. Since the age of thirteen she has suffered from migraine auras without headaches. The episodes recurred about four or five times a year, lasted twenty to sixty minutes, and featured the visual illusions of objects getting smaller (micropsia) and appearing farther away (teleopsia). "I had the experience of the room I'm in, including the people, shrinking away from me to become very small, as though seen through the wrong end of a telescope. That was quite interesting, once I knew that it wasn't threatening. You just have to go with the flow and wait for it to go away. However, that stopped when I was about twenty-five; I haven't had it for ages." Since the age of twenty she has suffered from attacks of migraines without auras, which occur one to three times a year. She gets a pulsating headache on both sides that is of moderate to severe intensity and is aggravated by routine physical

activity, along with hypersensitivity to light, noise, and touch, never last-ing longer than twenty-four hours. According to the artist, "During the headache you feel like your head is going to explode." At the age of forty-nine, during an episode of a migraine aura without a headache, she once observed a ring-shaped spot on the visual field (scotoma) starting in the left upper quadrant and progressing clockwise in a concentric zone at a constant rate (see fig. 326). "I had the experience of a beautiful prism of light starting in one quarter of my vision and gradually spreading to form a circle. I could see through the center of the circle to the real world, but I didn't trust my ability to walk or stand, so I sat and watched this vision. It was absolutely magical. The colors were radiating from the central hole. It lasted about three quarters of an hour. There was no pain afterwards and no panic." At the age of fifty-five, during a single episode of a migraine aura without a headache, "Funny things happened with colors. . . . Objects in the entire visual field appeared in yellow, orange, and red," like the greenish patterned floor (see fig. 327) turned orange and red (see fig. 328). These abnormal color sensations lasted about half a minute.

Summarizing her migraine experiences, from a medical point of view, Brough fulfills the criteria for both migraines without auras and migraine auras without headaches, but fortunately such attacks occurred only rarely.

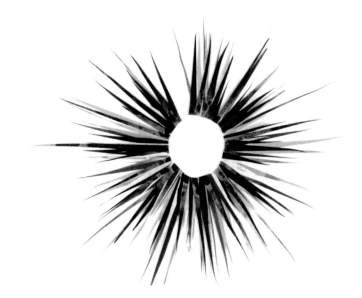

▶ **Figure 326**

Ring scotoma.

Until she reached her late forties she had only experienced a single type of visual migraine aura. When asked if these migraine experiences had any impact on her work, she responded:

> *Not really, but I never thought about this before. When you become aware that your reality can be distorted by your eyes, maybe it makes you want to pin down the reality on paper. But I was already obsessed by drawing and painting by the time I reached six or seven, and I'm still not happy unless I'm drawing or painting every day. I felt like this even before the onset of migraines. No, I don't think that migraines had an influence on my art. Quite to the contrary, I would say that my visual awareness as an artist has, in recent years, helped me to come to terms with the aforementioned visual disturbances. Appreciating the beauty of these visual experiences helped me to keep calm rather than panic.*

◀ **Figure 327**

Normal vision of greenish patterned floor.

▲ **Figure 328**

Color perception disorder whereby greenish patterned floor turned orange and red.

Roger Heaton

Roger Heaton, born in 1942, has a studio in rural Lincolnshire, England, that attracts both national and international clients. Having specialized in animal paintings, mostly commissioned, his pet portraits are now in great demand. After completing his education first at Nottingham College and then at the Hornsey College of Art and Design in London, he worked as a graphic designer from 1964 to 1979, and since that time he has concentrated on his work as a full-time artist and illustrator and organizer of art courses. In 1981 he won first prize in the first Migraine Art competition, and in 1985 one of his works was selected for the Royal Academy Summer Exhibition. As a celebration of the millennium, the artist undertook decorating his village church with one hundred angels, basing the work on famous paintings from the history of art.

The artist inherited the condition from his mother and has suffered from migraines with typical auras since the age of thirteen, with attacks happening from two to six times a year to three or four times a week.

> *I would start feeling sick, as though I had an upset stomach, sometimes resulting in vomiting. Then I sometimes got pins and needles, usually affecting my left hand and lasting about ten minutes. Then I would get the "dazzle" for about twenty to thirty minutes. Before the dazzle had finished I would get the headache, which would then last all day and would be excruciating, as though someone was squashing my head. I would also be very sensitive to light during these blinding headaches.*

Occasionally the artist experienced a visual illusion rapidly alternating between normal vision and objects appearing nearer (pelopsia), similar to the pulsating phenomenon described by Klee and Willanger:[314]

> *I would get a feeling of looking at something, say the far end of the table, and then all of a sudden it would be right in front of my eyes, and then very suddenly back to its original position, and this would go faster and faster, and then I would be violently sick. Once I'd been sick, this pulsing sensation would have gone but would have brought a severe headache as its aftermath.*

Since the age of eighteen his type of migraine has changed. Now its only manifestation is a migraine aura without a headache, always featuring the dazzle beginning with a colored circular central spot on the visual field (scotoma) increasing in size and then, with the return of central vision, followed by a ring-shaped spot on the visual field that breaks up and expands in the typical way of a fortification spectrum.

Medically speaking, Heaton fulfills the criteria for migraines with auras. At times the attacks occurred quite frequently, but he experienced only two kinds of visual migraine aura symptoms. Asked if migraines had any impact on his work, he responded:

No, not at all. I have always drawn and painted, and when I was sixteen or seventeen and it was time to make a career decision, I decided to become a professional artist. At that time I'd had migraines with the dazzle for some years, but I don't think that it prompted me to go into painting. To me it was an inconvenience rather than an inspiration. What I do—whether it's animals, landscapes, or portraits—they're all naturalistic, so all the shapes I'm using in my pictures are in the subject and not derived from any pattern occurring in the dazzle. I did go through a phase of abstract painting when I was at art college, but certainly it bore no relationship to the dazzle effect. At that time, there were very rounded shapes in my abstract paintings rather than the angular patterns seen in the dazzle. So there doesn't seem to be any influence of migraines on my professional art at all.

The only connection I can see between migraines and my art is being able to appreciate the forms, colors, and movements in the dazzle effect, but that's about all. If I hadn't been trained in art, I wouldn't have been able to sort out patterns that make up this dazzle. To the average person without art training, it's just like the dazzle you see when looking at a lightbulb. But because I'm an artist, dealing with images, I can analyze the colors in the dazzle and, to a certain extent, the actual shapes.

Before submitting entries to three successive Migraine Art competitions, it never occurred to me that people could be interested in visual distortions experienced by migraine sufferers. I remember being in college

and trying to draw the dazzle effect. However, at that time I couldn't really find a way of looking at the dazzle. The main difficulty was in concentrating on what was happening at the edges of my vision. It was almost as though I couldn't get my eyes far enough round to actually focus on it.

The artist here refers to difficulties resulting from decreased sensitivity of shape and color perception in the periphery of his visual fields, in contrast to sensitivity to movement, which is increased. Since spots on the visual field (scintillating scotomas) are characterized by translocation or movement with eye movements, a dazzle in the periphery of the fields of vision cannot actually be focused on, but can only be observed by focusing attention toward the periphery. Heaton explained:

It was only when I first decided to enter the Migraine Art competition that I really made an effort to study the dazzle, and with a bit of practice I was able to represent it. My first picture of the dazzle was started when I was painting a landscape. At the time the dazzle began, I was trying to decide when I should start concentrating on its features. In the beginning I wasn't able to see what I was looking at, because of the blue circle in the center of my vision, so it was pointless trying to draw. It was only when the circle on the edge of my vision opened out that patterns emerged that I concentrated on. Then I was able to look through the dazzle and mark the area on the sketch where the dazzle obscured the landscape. I had to wait for another attack to study its forms and colors.

Producing the Migraine Art pictures actually enabled me to come to terms with migraines. In analyzing the shapes, structure, and colors within the glittering ring, I learned to look upon each attack as just another visual experience rather than something incapacitating.

J.J. Ignatius Brennan

J.J. Ignatius Brennan, an Irishman born in the United Kingdom in 1949, is an artist with an international reputation who is best-known for his drawings and sculptures in the tradition of the surrealist movement.[93,94,159,488,497,567] Brennan's art education began at the Colchester

School of Art in Essex, England; he then went to Bristol Polytechnic and completed his studies at the Slade School of University College London. From 1973 Brennan worked as a lecturer, but he left teaching in 1990 to concentrate full-time on his own work. Since 1980 he has continuously exhibited in the United Kingdom and abroad, and his artworks can be found in collections in the United Kingdom, the United States, Hungary, and Japan. Among other awards, he won first prize in the fourth Migraine Art competition in 1987, and five years later won second prize in a competition titled "Migraine Images."[19,600]

Brennan was certainly qualified to participate in these competitions, having been a migraine sufferer, like his younger brother and sister, since the age of eleven when he first experienced episodes of visual loss, which were quite frightening at times, with zigzag clouds obscuring parts or all of his field of vision. These visual disturbances were often followed by slight nausea and numbness of the face or limbs on both sides. It was not until the age of eighteen that he really became aware that his headache attacks severely limited his ability to work. These acute headache attacks, with pain on one side and a pulsating quality, would manifest approximately once a week, last up to a day, and occur with nausea and hypersensitivity to light and sound. The migraine attacks often had a variety of the aura symptoms of basilar migraines, including poor speech articulation (dysarthria), difficulty controlling voluntary movements (ataxia), tingling (paresthesia) on both sides of the body, and numbness around the mouth and nose and all four limbs, with the left hand and foot usually most affected. Most common were visual auras with loss of vision in the entire visual field, central spots on the visual field (scotomas), or concentrically contracted visual fields, the latter occurring with the most severe migraine attacks. During these visual auras, which lasted several minutes, hallucinations with cloudy shapes, zigzags, triangles, and sometimes also round shapes appeared to move across his whole field of vision. Tunnel vision was often accompanied by the mosaic illusion in the area that retained vision, with perceived images breaking into pieces. During episodes of metamorphopsia, objects or faces were often seen as deformed, unsymmetrical, and with parts of the image shifted. For example, when viewing

a face, the artist would sometimes get the impression that the eyes were tilted, and one would move off and enlarge while the other would seemingly move away from the face instead of being aligned. On some occasions Brennan experienced objects apparently seeming bigger and changing proportions relative to other things, and polyopia like sun images, which manifested as multiple images arranged in horizontal or angled rows. Rarely, the artist lost three-dimensional vision so that "everything appeared flattened." Body image disturbances experienced by the artist included episodes with the face or hands feeling abnormally large, the feeling of having multiple hands, and the feeling that the upper and lower arms were missing. It was not until the artist's late thirties that the frequency of his migraine attacks, but not the intensity and variability, began to decline, now recurring every four to eight weeks.

According to Brennan, he was interested in art when he was a boy, and his decision to make a career as a professional artist was firmly established at age eighteen when he began his formal art education. He explained:

> I started with pictures of my migraine experiences, unconsciously rather than deliberately, when I was at art school. I used to do a lot of drawing of landscapes at that time and I often found I would be drawing clouds not just in the sky but everywhere, which was, I think, a reference to the voids experienced during visual loss. I also used serrated zigzag shapes in my drawings, symbolizing the experience of a whole being broken up, of not being able to put the pieces together, but I don't think that I was then aware of their origin in my visual migraine experiences. I didn't want to acknowledge this. I wouldn't have seen it as a legitimate means to do good art, but later I realized I was wrong. It's like a reference, like a support, which I'm privileged to have access to. Clouds, zigzags, and other imagery are part of my own personal visual vocabulary, but they have certainly come out of migraine experiences, I'm absolutely sure. I don't tend to do that deliberately, but when it suits a particular subject, for example to represent a feeling or an emotion, I make use of some of these images in different ways, or in combination with others, depending on the subject.

In 1987, when the artist participated in the fourth Migraine Art competition, he clearly realized the impact of migraine experiences on his art, as expressed during an interview following the exhibition "The Art of Migraine," organized by the Headache Research Foundation at Faulkner Hospital in Boston (see "History of the Four Migraine Art Competitions" in chapter 2). An article by journalist David Stipp includes the following report:

> *Many migraine victims don't want to talk or even think about their illness. [Mr.] Brennan, a London artist and teacher who won this year's £300 first prize, says he kept his appearance short at the awards ceremony. "I didn't want to look too hard at the paintings," says Mr. Brennan, who has suffered migraine attacks every few weeks for the past thirty years. "It was too many migraines in too small an area."*
>
> *When Mr. Brennan heard about the contest, his first reaction was to put the idea right out of his mind. "Migraines have totally bad associations for me," he says, including prolonged nausea, excruciating headaches, and numbing paralysis of his arms and legs. "I don't like thinking about them."*
>
> *But he did like thinking about the prizes. So with encouragement from his wife, he drew a picture representing himself having an attack.... "I wanted to get it over with," he says, "so I worked very quickly."*
>
> *Like other migraine artists, Mr. Brennan found depicting the disorder therapeutic to some extent. And he began to realize that images suggested by migraines had subconsciously crept into many of his past pictures. Now he is steeling himself to enter the next contest.*
>
> *Meanwhile, Mr. Brennan, who also sculpts, has spent part of his prize money on a new router to help shape his latest works. "This is the first real advantage I've ever got out of my migraines," he says. "It has made up for a few attacks."[600]*

The use of migraine experiences as a source of artistic inspiration can be demonstrated in a large number of Brennan's artworks beyond his prizewinning portrayals of his migraine attacks, as seen in three drawings and two sculptures produced by the artist in 1993. He said:

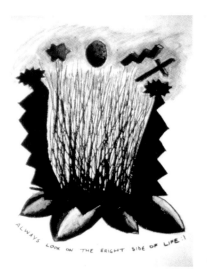 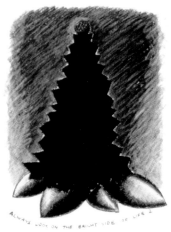 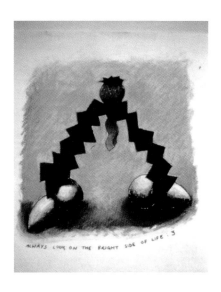

▲ **Figure 329**

J.J. Ignatius Brennan, *Always Look on the Bright Side of Life: 1*, 1993.

▲ **Figure 330**

J.J. Ignatius Brennan, *Always Look on the Bright Side of Life: 2*, 1993.

▲ **Figure 331**

J.J. Ignatius Brennan, *Always Look on the Bright Side of Life: 3*, 1993.

These three pictures, titled Always Look on the Bright Side of Life, *were done after a good friend had died. I've cited the Monty Python song as the title because my friend, who was in fact a part-time comedian, stipulated that it be sung at his funeral. I've used the black scotoma zigzag image in all of them because it symbolizes something unknown and disturbing to do with the loss of vision during migraine. In* No. 1 *[see fig. 329], I've pulled apart the darkness in the hope of finding something else— and things emerge, with life. The star and zigzag shapes are also derived from migraine visual disturbances. The cross denotes religion and suffering.* No. 2 *[see fig. 330] is probably out of sequence and should really be the first. Artistic temperament and logic don't necessarily go hand in hand. Again, I've used the dark zigzag shape to signify something unknown, unseen, unfocusable. It's a somber image that reflects my feelings at the time with only the ball or fruit shape on the top giving hope. The overall image is a bit like a migraine Christmas tree.* No. 3 *[see fig. 331] starts to get a little bit clearer. It's possible that it reflects the stage in a migraine when my vision gets better, but I don't make decisions that coldly when I work. The yellow is a hopeful color. In all three drawings I've used the enlarged, heavy, feet-like shapes, which give a rather useless, stuck, immobile feeling, referring to the experience of insecurity of gait during my migraine attacks.* The Sculpture You Want Is Underneath *[see fig. 332] is a more playful work. Again, I've used the black zigzag as a device to*

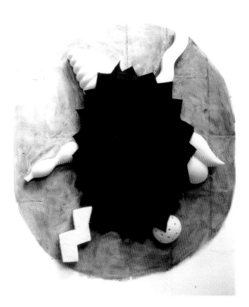 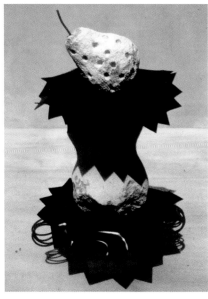

◀ **Figure 332**

J.J. Ignatius Brennan, *The Sculpture You Want Is Underneath*, 1993.

◀ **Figure 333**

J.J. Ignatius Brennan, *Neo-Roman Offering*, 1993.

encourage viewers to imagine what might be there and how the shapes could combine. In Neo-Roman Offering *[see fig. 333], the zigzag shapes literally separate the stone shapes but also serve to combine them into a coherent image. Overall, as regards my migraine attacks, I've tried to make a positive thing out of something essentially negative and annoying. This applies to all the works, both drawings and sculptures.*

The life and work of J.J. Ignatius Brennan clearly document the significance of migraine experiences as a factor in artistic creativity, which is confirmed by the artist's own words. The influence of migraine on Brennan's art took place subconsciously to begin with, but participation in the Migraine Art competition made the artist realize it in its entire scope. It is not intended to suggest that all examples of the artist's work are illustrations of his migraine experiences, which is only true for his prizewinning Migraine Art pictures, but evidently his experiences of basilar migraines have enriched his visual language,[93],[94] representing one of the major sources of inspiration for his artworks.

Edmund Blood

The late Edmund Blood (1946–2002) was a professional freelance artist whose talents encompassed comic strips, detective stories, and CD covers.

His original artwork has been used to illustrate books and various promotional items. Successive stages of his education between 1963 and 1970 included the Hartlepool College of Art, Saint Martin's School of Art, and the Camberwell College of Art in London. From 1971 his abilities as a professional painter were demonstrated by a series of one-man exhibitions in northwestern England. He also participated in various group exhibitions in Cumbria and at the Mall Galleries in London. In 1986 he won the Rexel Award at the Royal Institute of Painters in Watercolors in London. Following a period of teaching, he decided to concentrate on his work from 1996 onward.

From the age of eight, Edmund Blood, like his mother and several of her relatives, suffered from migraine attacks every one or two months with a "drill-like" headache on both sides, nausea and vomiting, hypersensitivity to light and sound, and an increase in intensity following routine physical activities. Aura symptoms of basilar migraines included a variety of visual symptoms on both sides of twenty to twenty-five minutes duration, described in more detail below, as well as poor speech articulation (dysarthria), decreased hearing "as if sounds were becoming more and more distant," and double vision. In 1986 a severe basilar migraine attack was complicated by spots on the visual field (scotomas) on both sides of the visual field that did not fully recover, and he was diagnosed with a migraine infarction, permanent tissue damage caused by a lack of blood flow. His attacks of migraines with typical auras, which occurred only rarely, featured tingling on one side or weakness involving one hand, unclassifiable speech difficulties, and definite loss of the ability to use words (aphasia). During one migraine attack, while engaged in a conversation with some friends, the multilingual artist realized that he had lost his ability to express himself in Spanish, a language in which he had been fluent for fifteen years, while he was still able to speak French, which he had spoken for thirty-five years. His ability to converse in Spanish returned after about twenty minutes.

On being asked if migraines had any impact on his professional work, he replied:

I don't think that migraines had any part in my decision to become a visual artist. I have to say that when I was an art student I was fairly conventional. I already had the same obsession with subject matter: I've always been obsessed with buildings and places, but the way I drew was much more influenced by pictures I had seen, by various artists, and my work was quite imitative. I was a fairly late developer, and it was not until my late twenties that I started to develop my own language properly.

Before my participation in three successive Migraine Art competitions, I had only once tried to illustrate the visual effects of my migraine attacks to show people what it is like. At the age of seventeen I had an attack one morning, when we were doing a painting exercise in college, and so I tried to represent the actual visual disturbance in my painting, breaking up the still life into blocks of colors. In the end, however, it didn't look very different from anybody else's, since most of my fellow students were consciously treating the still life in a sort of cubist style of painting.

It was only over the last fifteen or so years, after my participation in the Migraine Art competitions, that migraines have begun to play a conscious part in the way that I do things. The curious thing is that as a representational artist, I have actually used some of the disturbing visual effects of migraines as a positive factor in a great deal of my original work. I have frequently been complimented on my judgment of pictorial space and my restraint, when I was, in a way, only presenting a "frozen" image from the beginning or the end of a migraine attack, when my perception seems briefly disturbingly clear in detail.

At the very beginning of my visual migraine aura, even before the blanking comes and the flickering of those op art style patterns begins, there is a general sense of nonrightness about things, which is the easiest symptom of the attack to miss. When it's starting to go, it's difficult to see; it's starting to look confused, you feel disrupted, at which point you know it's going to become a migraine. What you see appears too rich to look at, details are much enhanced, and it's the very intensity of things that is so disturbing. When you try to focus on something, all you see is the mass of details; it's almost as if this is too much information to process. Everything is so sharp and clear but so detailed that you've lost the focus of the thing overall and

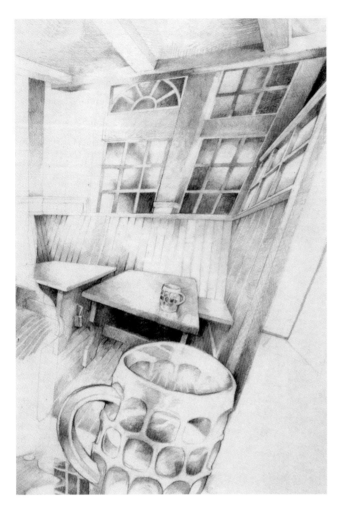

▲ Figure 334
Edmund Blood, *Pub Interior*, 1981/1982.

you cannot distinguish space. Normally what you would get the biggest sense of in vision is the solidness of objects and the space, but at the beginning of a migraine what becomes much stronger are all the lights and darks and contrasts between the little details, which overpower the structure of the image.

Such vivid enhancement of detail has not previously been recorded as a visual migraine aura symptom, but this symptom is known to occur as a perceptual disturbance in mescaline intoxication.[320] Blood continued:

In some of my works, I've tried to destroy the "overall effect" of vision and to convey this abnormal awareness of details. So what I did was to make the picture so complex that somebody looking at it has the same difficulty forming the image as I would have looking at it with a migraine. And I did that very deliberately to make it an uncomfortable drawing to look at, so that people would have to step back and read it rather than take it in one. I know that it has worked, because people do come up and say, "I love that drawing, but it's so difficult to look at," which is exactly what I was after.

An example of this vivid enhancement of detail is shown in figure 334, *Pub Interior,* drawn by the artist in about 1981 or 1982. According to Blood:

It was just a study, but as far as it went in describing how uncomfortable it is to sit with a migraine coming on, I was very satisfied with this picture. You are sitting in a pub in London, feeling disoriented and not quite connected; basically you are waiting to reconnect with all these places, for them all to move back into space. If you've got it, you just sit and wait, and

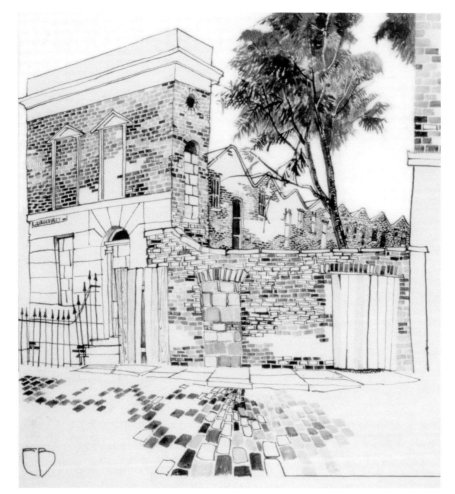

�q **Figure 335**
Edmund Blood,
Clerkenwell Street,
1981/1982.

you know that if you wait long enough it will all come back, and everything will fall into place, and everything will belong where it is; but right there it doesn't. That's the sort of genuine general sense of disruption of space you have at the very beginning of a migraine when all details of things are so clear and so intense. You know that it's space, but it feels just like a mass of details, and all you are left with is a succession of familiar shapes, broken up, which over a very brief period of time make up the whole picture. This drawing was just playing around with how difficult it was to see the positives and the negatives, the light coming through, the light reflecting on near and far objects, and the spaces between objects.

In many pictures I did since my late twenties, I always liked filling bits with pattern and leaving bits blank. There was a comment by someone

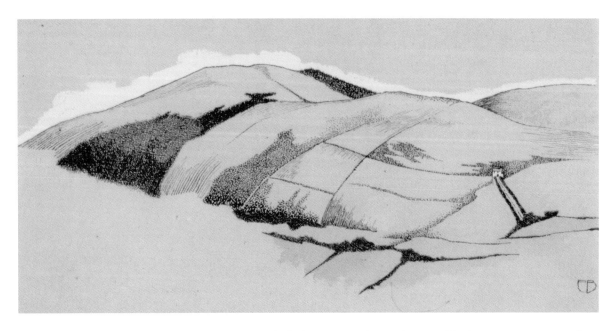

▲ **Figure 336**

Edmund Blood, *Cobra Castle*, 1987.

years ago who said, "Oh, you are always leaving blanks in your pictures." I've always put that down to the fact that if I didn't have anything to say about a bit, I wouldn't put it in: I had a perfectly sound intellectual reason for it. Where you have nothing to say, you just leave blanks. Now, whether that is a subconscious reaction to the blanking syndrome experienced in migraines, I don't know. Maybe it is: Looking back on my work, it seems that you can see it. But it wasn't consciously. I would have had another explanation for it.

Figure 335, *Clerkenwell Street*, dated 1981 or 1982, provides an example of this use of blanks in the artist's work. He explained:

I actually drew that on-site in a street in London. The detail is so clear and so intense that you cannot distinguish space, because the sheer clarity of everything is so confusing. But you also note that there are bits not clear; you are aware that there are bits missing and that things are blanking out, which absolutely identifies what's going on. Those particular "op art style" patterns, which I used to represent the bricks of the walls, I used as the nearest thing I could get to make a shimmer, although in migraines those patterns are not far away and they can equally well be formed by squares, hexagons, diamonds, or other angular crystalline pieces of the op art style.

There is another feature that is characteristic in many pictures I did since my late twenties. I always liked to intensify contrasts in my paintings and drawings. In artistic terms, you wouldn't normally flip from light to dark, which I have actually found useful as a positive thing in my work. Most of my colleagues don't make use of contrasts in that particular way, and they say, "I love the way you do those contrasts; that's very you." What I don't know, and what I am probably not qualified to say, is how much the fact that I do this is dependent on the fact that for all my life I've had migraines, so that I'm used to this battle between contrasts. Reversing out the light and the dark is exactly what happens with those little angular crystalline pieces in the actual visual disturbance. The contrasts between them are as strong as anything that you see in what you are observing. Those patterns will cut across and disrupt anything that you see, breaking up the real image into a sort of mosaic, not just superimposing but rippling through the objects; you feel as if it's in there with the things.

The artist describes here a sequential occurrence of geometric hallucinations of lattice shapes and the mosaic illusion, similar to the observations reported by Sacks.[555]

An example of such intensified contrasts appears in figure 336, *Cobra Castle,* drawn by the artist in 1987. He commented:

In this drawing of a landscape, all you are left with are a few little bits; it's fairly minimal. There are few darks and lights, some of which help describe what you see and some of which don't. Some of the darks and lights could change quite radically: You could reverse the shadings in these fields, and it actually would work just as well in terms of a drawing.

The life and work of Edmund Blood convincingly document the significance of visual migraine experiences as a major factor of his artistic creativity. The artist's own account shows that the visual effects of migraines subconsciously influenced his work as a professional artist, which came to his conscious awareness only in his mid thirties when he first participated in the Migraine Art competitions. Several of the more striking features of the artist's own visual language, which he had developed since

his late twenties, can be related to various kinds of bilateral visual symptoms of basilar migraines that the artist was well acquainted with from the time he was eight years old: the vivid enhancement of visual detail, blanks in the visual field caused by scotomas, "op art style" geometric patterns, and the mosaic illusion.

Conclusions

Generalizing the medical histories of the four artists discussed in this chapter, it seems that for migraines to act as major sources of artistic inspiration, important prerequisites are: early onset in childhood; severe migraines, especially in terms of how often they strike; and the intensity and variability of the visual aura symptoms. This is illustrated by the medical and professional biographies of J.J. Ignatius Brennan and Edmund Blood. It also has to be noticed that both artists fulfill the criteria for basilar migraines. Without these prerequisites, migraines are unlikely to have an impact on the artist's professional work, as shown in the histories of Romey T. Brough and Roger Heaton. As a consequence for the study of artists' biographies, more attention should be paid to the presence of migraines than has previously been devoted to this seemingly irrelevant medical detail. Eger suggests that visual migraine experiences have provided inspiration for people not only in modern times but in ancient times as well.[156] Such an imitation of nature was the earliest cradle of representational art for our ancestors in the first part of the Stone Age: The ornamental designs in their cave and rock drawings of animals and human beings are an imitation of visual patterns like those seen in migraines, rather than an imagined invention.

As an insight from our interviews and correspondence with the professional artists in this chapter and with a considerably larger number of migraine patients and artists who remain anonymous, we want to emphasize that migraines obviously mean tormented suffering, but they *can* mean an inspirational experience, and thereby paradoxically an enrichment of the lives of those afflicted with the condition, appealing to their curiosity, intellect, and sense of beauty.[478] A similar view is expressed by West in his essay titled "The Migraine Headache as Heuristic Tool":

I smile at my pseudostatus and devote a blink of thanks to whatever power gives me trips I never wanted. . . . No hallucinogens needed, says my private sign: Migraine itself has taken me far afield, sent me on a galactic and chromatic wild-goose chase whose backhanded bonus has been spectral analogies beyond price, sometimes even beyond words. . . . I complain about it, but in the end rate it a plus.[639]

In closing, art critic John Ruskin defined fine art as when the hand, the head, and the heart of human beings go together.[552] Migraine Art thus qualifies as fine art. It contributes to the understanding of human experience and spirituality. Peter Wilson's hope in 1980 that Migraine Art may have a social impact in that it "alerts just a few hundred more people into a more realistic understanding of what migraine really means"[652] has clearly been fulfilled by the work of the numerous women and men without whose efforts this book would not exist.

First Migraine Art Competition Entry Form (1980)

National Art Competition sponsored by the British Migraine Association and Messrs. W.B. Pharmaceuticals Limited

First Prize (Adults)	£250
Second Prize	£150
Third Prize	£100

CHILDREN'S SECTION AGED 5 TO 10 YEARS

First Prize	£50
Second Prize	£25
Third Prize	£10

Plus six Consolation Prizes of Premium Bonds

CHILDREN'S SECTION AGED 11 TO 16 YEARS

First Prize	£75
Second Prize	£50
Third Prize	£25

Competitors are asked to draw or paint their *own* impressions of any of the six forms of visual disturbance which herald a classical migraine attack OR to depict the effect migraine has on their lives. The six forms

of visual disturbance are described in the August 1980 issue of the *Migraine Newsletter.*

The illustration should be no larger than 12″ by 9″ [30 by 23 centimeters] on any material and in any medium from crayon or charcoal to oils or watercolours.

The entries will be judged by a panel of hospital consultants, art critics, and representatives of the British Migraine Association and WB Pharmaceuticals Ltd.

The competition begins in August 1980 and closes on the 1st June 1981. All competitors will be notified of the results in August 1981.

British Migraine Association National Art Competition 1980 Conditions of Entry

1. The competition is open to all residents of the British Isles and it is intended that publicity in connection with the competition will draw attention to the more dramatic aspects of migraine which separate the condition from the more common forms of headache.

2. The decisions of the judges' panel must be accepted as final. The organisers regret that no correspondence can be entered into.

3. Winning entries will become the property of the British Migraine Association.

4. The organisers cannot accept responsibility for lost or damaged entries. Competitors are advised to send their entries by recorded delivery.

5. Competitors other than prize winners wishing to have their entries returned are requested to enclose £1.00 postal order or cheque to cover postage and packing.

6. No entries received after the 1st June 1981 can be considered for the competition.

Second Migraine Art Competition Entry Form (1982)

Second National Migraine Art Competition

(Sponsored by the British Migraine Association and WB Pharmaceuticals Limited)

PRIZES

Adult Section

First Prize	£300
Second Prize	£250
Third Prize	£150
Two Consolation Prizes	£20

Children Section (11–16 YEARS)

First Prize	£100
Second Prize	£75
Third Prize	£50
Two Consolation Prizes	£20

Competitors are invited to draw, paint, or illustrate

 a) their *own* impressions of any form of visual disturbance which heralds a classical migraine attack

 b) the pain associated with a migraine attack

 c) depict the effect migraine has on their lives.

Entries, which should be no larger than 12″ by 9″ [30 by 23 centimeters], may be on any material and in any medium from crayon or charcoal to oils or watercolours.

The entries will be judged by a panel of hospital consultants, an artist, and representatives of the British Migraine Association and WB Pharmaceuticals Limited.

The competition begins in August 1982 and closes on 1st March 1983. All competitors will be notified of the results in April 1983.

Conditions of Entry

1. The competition is open to all migraine sufferers.
2. The decision of the judging panel must be accepted as final. The organisers regret that they are unable to enter into any corresponding regarding the winning entries.
3. Winning entries will become the property of the organisers.
4. Entries other than prize winners may be retained by organisers for exhibition purposes.
5. Competitors other than prize winners wishing to have their entries returned are requested to enclose £1.00 postal order or cheque (payable to the British Migraine Association) to cover postage and packing.
6. Competitors are advised to send their entries (protected by cardboard) by Recorded Delivery.

 Entries should be posted to the British Migraine Association, 178a High Road, Byfleet, Weybridge, Surrey, KT14 7ED.

 Envelopes should be clearly marked "Competition Entry."
7. The organisers cannot accept responsibility for lost or damaged entries.
8. Entries received after 1st March 1983 will not be considered for the competition.

Appendix B

Table 1.1
Shapes of the recurring patterns in the thirty-five miniatures
in *Scivias*, depicting the visions of Hildegard of Bingen

Shape	Number of miniatures
Groups of points, stars, or flaming eyes (miniatures 2, 3, 4, 9, 10, 12, 13, 15, 17, 19, 20, 25, 27, 29, 34, 35)	16
Concentric circles or parts of circles (miniatures 3, 7, 9, 10, 11, 12, 19, 21, 23, 31, 33, 34, 35)	13
Crenellations (miniatures 3, 7, 21, 22, 26, 27, 29, 30, 32)	9

Table 2.1
Responses to the four Migraine Art competitions

Competition	Open for entries	Approximate number of entries
First competition	August 1980–June 1, 1981	300
Second competition	August 1982– June 1, 1983	300
Third competition	December 1984–July 1, 1985	180
Fourth competition	February 1987–October 1, 1987	120
Total of all four		900

Table 2.2
Multiple entries to the four Migraine Art competitions

Number of entries	Number of artists
1	392
2	48
3	13
4	3
5	1
6	0
7	0
8	0
9	2

Table 2.3
Results of the postal follow-up inquiry

Postal follow-up inquiry	Number of artists
Inquiries sent	433
Responses received	136
Artists deceased	5
No response	292

Table 3.1
Shapes of visual hallucinations illustrated in the thirty-two
Migraine Art pictures by child artists

Shape[a]	Number of pictures
Random	7
Line	27
Curve	17
Web	1
Lattice	4
Tunnel	0
Spiral	4
Kaleidoscope	2
Complex	1

[a]More than one shape can appear in the same picture, so the numbers in the table do not add up to the total number of pictures.

Table 4.1
Sidedness of migraine headaches illustrated in 173 Migraine Art pictures

Graphic feature[a]	Headache on one side	Headache on both sides
Hand(s) against the head	44	35
The color red	11	7
Arrows	4	3
Man-made objects, instruments, and weapons	36	48
Miscellaneous	5	3

[a]More than one feature can appear in the same picture, so the numbers in the table do not add up to the total number of pictures.

Table 4.2
Dietary triggers of migraine attacks illustrated in thirty-three Migraine Art pictures

Trigger[a]	Number of pictures
Red wine	5
Other alcoholic beverages	10
Chocolate	12
Cakes and confectionery	7
Ice cream	4
Cheese	13
Milk and other dairy products	6
Eggs	3
Meat	5
Citrus fruits	10
Other fruits	9
Onions	5
Garlic	3
Other vegetables	4
Other foods	5

[a]More than one trigger can appear in the same picture, so the numbers in the table do not add up to the total number of pictures.

Table 4.3

Visual triggers of migraine attacks illustrated
in forty-nine Migraine Art pictures

Trigger[a]	Number of pictures
Direct sunlight	26
Sunlight reflected off water	6
Bright electric lights	21
Disco lights	3
TV screens	10
Cinema screens	1

[a]More than one trigger can appear in the same picture, so the numbers in the table do not add up to the total number of pictures.

Table 4.4

Acoustic triggers of migraine attacks illustrated in twenty-two
Migraine Art pictures

Trigger[a]	Number of pictures
Loud human voice	4
Music	11
Radio or telephone	6
Miscellaneous noise	8

[a]More than one trigger can appear in the same picture, so the numbers in the table do not add up to the total number of pictures.

Table 6.1
Distribution of abnormal body-size perception illustrated
in eighteen Migraine Art pictures

Affected body parts	Body parts perceived as abnormally large (macrosomatognosia)	Body parts perceived as abnormally small (microsomatognosia)
Any body part	17	3
Whole body	1	2
Half of the body	0	0
Parts of the body	16	1
Head area	10	0
Head	5	0
Eyes	2	0
Tongue	1	0
Mouth and teeth	1	0
Teeth	1	0
Neck	4	0
Upper extremities	6	0
Arms and hands	2	0
Hands	2	1
Hands and nails	2	0
Lower extremities	1	0
Legs and feet	1	0
Torso	0	0

Table 6.2
Medical case reports of out-of-body experiences
and related phenomena in migraine patients

No.	Author	Gender	Age	Family history
1.	Oppenheim (1898)	—	—	—
2.	Lippman (1953), case 1	female	37	positive
3.	Lippman (1953), case 2	female	48	positive
4.	Lippman (1953), case 3	female	55	—
5.	Lippman (1953), case 4	female	44	positive
6.	Lippman (1953), case 5	male	31	positive
7.	Lippman (1953), case 6	female	36	—
8.	Lippman (1953), case 7	female	33	positive
9.	Lippman (1953), case 8	male	49	positive
10.	Todd (1955), case 4	female	17	positive
11.	Lukianowicz (1967), case 12	male	34	—
12.	Lukianowicz (1967), case 20	female	21	—
13.	Hachinski et al. (1973), case 10	female	18	—
14.	Livesley (1973), case 2	female	—	—
15.	Podoll and Robinson (1999), case 1	female	66	positive
16.	Podoll and Robinson (1999), case 2	female	50	positive
17.	Podoll and Robinson (1999), case 3	male	18	positive

Table 6.3
Body image disturbances illustrated in thirty-eight Migraine Art pictures
(classified according to Lukianowicz[389])

Type of body-image disturbance	Number of pictures
Disturbances of the body image affecting its shape	17
Zoophilic metamorphosis (perception of the body as an animal)	0
Sexual metamorphosis (perception of the body with the opposite gender)	0
Reincarnation and transcarnation	0
Autoscopy (seeing one's own body from outside)	5
Loss of shape of the body image	7
Duplication of the body or its parts	6
Splitting of the body image	3
Additional body parts	0
Disturbances of the body image affecting its size	18
Increased size of the whole body	1
Increased size of certain body parts	16
Decreased size of the whole body	2
Decreased size of body parts	1
Disturbances of the body image affecting its mass	3
Increase in body mass	1
Decrease in body mass	2
Disturbances of the body image affecting its position in space	5
Levitation	2
Falling	0
Floating	1
Sinking	2

Table 6.4

Features of pain-related bodily awareness illustrated
in 133 Migraine Art pictures

Type of bodily awareness (cenesthesia)	Located on one side	Located on the surface of the body	Located inside the body	Fractured skull
Limited (circumscript) pain sensation	47	68	50	14
Sensation of pressure	9	28	20	18
Sensation of pulling	2	4	0	0
Sensation of movement	6	6	6	1
Sensation of constriction and strangulation	0	2	0	0

Table 6.5

External attributions of pain-related bodily awareness illustrated
in 133 Migraine Art pictures

Type of bodily awareness (cenesthesia)	Natural forces	Man-made objects	Animals	Animal-like entities	Humans	Human-like entities	Other external entities
Limited (circumscript) pain sensation	5	75	6	1	8	12	3
Sensation of pressure	12	28	1	1	4	3	0
Sensation of pulling	0	3	0	0	0	0	0
Sensation of movement	0	0	5	2	0	2	3
Sensation of constriction and strangulation	0	1	0	1	0	0	0

Table 7.1
Visual disturbances illustrated in 426 Migraine Art pictures

Visual disturbance	Subjective representations	Objective representations	Artistic representations	All pictures
All visual disturbances	132	75	219	426
Loss of vision	123	75	216	414
Visual hallucinations	115	75	207	397
Visual illusions	23	5	18	46

Table 7.2
Signs and symptoms of migraines with auras associated with visual disturbances illustrated in 426 Migraine Art pictures

Signs and symptoms associated with visual disturbances	Subjective representations	Objective representations	Artistic representations	All pictures
Headache[a]	6[b]	13	104	123
Nausea and vomiting	0	2	29	31
Hypersensitivity to light (photophobia)	0	0	13	13
Hypersensitivity to sound (phonophobia)	0	0	6	6
Sense of touch (somatosensory) and motor symptoms	0	0	4	4
Body-image disturbances	2[c]	0	22	24
Acoustic disturbances	0	0	2	2
Language disturbances	0	0	2	2
Poor speech articulation (dysarthria)	0	0	1	1

[a]Headache includes both illustrations of the pain of an acute migraine attack and representations of pain-related bodily awareness (cenesthesia).

[b]Presence of headache is inferred from holding hands against the head, as seen in the artists' mirror images.

[c]Representations of seeing one's own body from outside (autoscopy).

Table 7.3
Features and locations of visual loss illustrated in 414 Migraine Art pictures

Visual disturbance	Subjective rep.	Objective rep.	Artistic rep.	All pictures
FEATURE				
Blurred vision	0	1	4	5
Spot on the visual field with complete loss of vision (absolute scotoma)	123	75	213	414
Spot on the visual field with partial loss of vision (relative scotoma)	10	0	2	12
Spot on the visual field in which vision is absent (negative scotoma)	17	5	16	38
Spot on the visual field in which vision is enriched (positive scotoma)	118	75	212	405
Spot on the visual field with vision fatigue (asthenopic scotoma)	1	0	14	5
LOCATION IN THE VISUAL FIELDS				
Loss of vision in one eye	0	1	3	4
Loss of vision in the outer or inner half of each visual field (heteronymous hemianopia)	1	0	1	2
Loss of vision in the same half of each visual field (homonymous hemianopia)	11	6	13	30
Loss of vision in the same quarter of each visual field (homonymous quadrantanopia)	0	0	1	1
Loss of vision in the upper or lower half of the visual field (altitudinal hemianopia)	0	0	4	4
Complete loss of vision (cortical blindness)	45	0	3	48
Spots in the center of both visual fields (bilateral central scotoma)	0	0	3	3
Ring scotoma	3	0	4	7
Tunnel vision	6	1	3	10

Table 7.4

References in medical literature to the shapes of visual hallucinations
reported as migraine aura symptoms

Shape of visual hallucination	References in the endnotes
RANDOM	
Flashes of light	39, 99, 137, 578, 654
Bubbles	80, 639
Clouds	306, 534, 620
Dashes	539
Dots	240, 312, 522, 539
Fibers	620
Flakes	80, 620
Mist	137
Points	178
Specks	654
Splotches	10
Spots	80, 99, 312, 374, 463, 522, 527, 534, 678
Water patterns	639
LINE	
Zigzags	3, 6, 7, 24, 31, 71, 80, 165, 187, 217, 235, 240, 243, 258, 280, 293, 299, 343, 358, 380, 399, 402, 437, 454, 470, 515, 534, 536, 542, 551, 553, 590, 591, 603, 627, 635, 646
Stars	37, 99, 158, 179, 240, 312, 400, 416, 527, 534, 539, 620, 654
Lines	312, 463, 565
Crosses	539
Angles	35, 527
Herringbone patterns	173, 597
Crenellations	158, 587
Triangles	173, 174, 302, 312, 457, 582, 639
Squares	240, 457
Rectangles	37, 73, 414, 457, 582
Trapezoids	302
Hexagons	312
Other polygons	84, 302, 582

Shape of visual hallucination	References in the endnotes
CURVE	
Curves	6, 7, 31, 217, 302, 312, 372, 378, 380, 551, 582, 603
Circles	20, 32, 99, 158, 173, 240, 263, 369, 414, 435, 457, 527, 578, 620, 667
Concentric circles	37, 128, 239, 240, 434
Rings	32, 173, 260, 263, 265, 435, 539, 654, 667
Wheels	20, 400, 620
Balls	20, 168, 411, 534
Sine waves	37, 295
Other wavy lines	302, 312, 582, 639
WEBS	
Line of defensive spikes	217
Spiderwebs	620
Cobwebs	597
Filigree patterns	555
LATTICE	
Cross-hatching	293, 581
Moiré patterns	554
Lattices	556
Gratings	7, 12, 92, 302, 352, 465, 536
Grids	12, 536
Checkerboards	32, 259
Honeycombs	260, 275, 317, 554, 555
TUNNEL	
Tunnels	32, 35, 44, 66, 174, 222, 314, 436, 522, 529, 553
SPIRAL	
Spirals	37, 45, 137, 379, 421, 654
Pinwheels	173, 239
Wheels with spiked rims	221, 414, 639, 654

Shape of visual hallucination	References in the endnotes
KALEIDOSCOPE	
Kaleidoscopes	25, 173, 444, 537
Carpetwork patterns	259
Turkish carpets	554
Mosaics	173, 554
Symmetrical flowerlike pictures	655
Decorative pictures	25
Designs	28
Diagrams	25
COMPLEX	
One's own body	27, 79, 110, 240, 375, 616
Human figures	14, 28, 83, 97, 128, 267, 312, 372, 385, 409, 411, 414, 422, 466, 566, 629, 667
Parts of the human body	44, 213, 267, 381, 409, 414, 417, 444, 642
Animals	28, 36, 201, 379, 394, 409, 411, 412, 414, 457, 466, 642
Plants	394, 414
Inanimate objects	28, 35, 137, 173, 312, 337, 372, 409, 538, 539, 597
Words, letters, numbers	201, 267, 444, 566
Cartoons	28, 372
Scenes	97, 372, 409, 654
Lilliputian hallucinations	281, 312, 409, 412, 566
Paranormal hallucinations	
Dead people	179, 312, 409, 411, 414, 422, 661
Ghosts or phantoms	376, 411, 417
Fairies	78
Religious figures	337, 411, 526

Table 7.5
Shapes of visual hallucinations illustrated in 397 Migraine Art pictures

Shape	Subjective representations	Objective representations	Artistic representations	All pictures
All shapes	115	75	207	397
Random	39	25	51	115
Line	88	57	166	311
Curve	89	46	138	278
Web	4	1	3	8
Lattice	18	11	17	46
Tunnel	11	1	9	21
Spiral	12	5	15	32
Kaleidoscope	10	1	4	15
Complex	3	0	5	8

Table 7.6
Visual hallucinations of line shapes illustrated in 311 Migraine Art pictures

Pattern of visual hallucinations	Subjective representations	Objective representations	Artistic representations	All pictures
All patterns of line shapes	88	57	166	311
Zigzags	66	51	139	256
Stars	10	9	36	55
Crenellations	4	0	1	5
Herringbone patterns	1	0	1	2
Polygons	2610	26	62	
Triangles	10	1	18	29
Squares	13	6	9	28
Rectangles	9	2	4	15
Other polygons	12	2	6	20
Polyhedrons	1	0	0	1
Angles, crosses, and other angular figures	38	11	61	110

Table 7.7

Second-order shapes (with length greater than three segments)
of zigzag spectra illustrated in 212 Migraine Art pictures

Visual disturbance	Subjective representations	Objective representations	Artistic representations	All pictures
All second-order zigzag shapes	58	42	112	212
LINE	20	22	59	101
Straight lines	11	14	30	55
Stars	10	9	36	55
CURVE	43	27	69	139
Circles	1	1	2	4
Arcs	7	3	8	18
Curves	35	23	59	117
LATTICE				
Gratings	2	3	0	5
SPIRAL				
Spirals	2	0	1	3

Table 7.8

Comparison of Gowers's 1895 and 1904 classifications of fortification spectra[a]

Gowers 1895 classification[217]	Gowers 1904 classification[220]
	Unilateral spectra:
Expanding spectra	expanding angled spectra
Progressive spectra	progressive spectra
Lateral spectra	radial spectra:
Angled or stellate spheres, mobile or fixed	mobile stellate spectra
Secondary limiting spectra	Central spectra:
Concentric or pericentral spectra:	pericentral spectra:
arched spectrum (a variety of pericentral spectrum)	arched spectrum (a segment of a pericentral spectrum)

[a]Terms in the same row are illustrated by identical clinical observations in Gowers's publications. Hierarchical relationships between the terms in different rows are indicated by indentation.

Table 7.9
Visual hallucinations of curve shapes illustrated in 273 Migraine Art pictures

Pattern of visual hallucinations	Subjective rep.	Objective rep.	Artistic rep.	All pictures
All curve shape patterns	89	46	138	273
All curve shape patterns formed by zigzags	43	27	69	139
Circles	28	11	36	75
Concentric circles	8	4	14	26
Circles formed by zigzags	1	1	2	4
Arcs	14	4	13	31
Arcs formed by zigzags	7	3	8	18
Spheres	3	0	6	9
Ellipses	3	0	0	3
Sine waves	3	1	12	16
Fingerprint whorls	1	1	0	2
Other curve shapes	70	34	98	202
Curves formed by zigzags	35	23	59	117

Table 7.10
Visual hallucinations of lattice shapes illustrated in forty-six Migraine Art pictures

Pattern of visual hallucinations	Subjective rep.	Objective rep.	Artistic rep.	All pictures
All lattice shape patterns	18	11	17	46
Lattices	7	4	4	15
Gratings	9	3	9	21
Grids	2	2	5	9
Checkerboards	9	2	4	15

Table 7.11
Colors of visual hallucinations illustrated in 397 Migraine Art pictures

Color	Subjective rep.	Objective rep.	Artistic rep.	All pictures
All colors	115	75	207	397
Black-and-white only	25	7	54	86
Colored	90	68	153	311
Black	61	24	103	188
Purple	28	16	46	90
Blue	50	37	74	161
Green	40	29	60	129
Yellow	56	47	105	208
Orange	30	21	43	94
Red	51	46	102	199
Brown	18	16	31	65
White	77	36	106	219

Table 7.12
Visual illusions illustrated in forty-six Migraine Art pictures

Type of visual illusion	Subjective rep.	Objective rep.	Artistic rep.	All pictures
Distortion of size or distance (dysmetropsia)	2	0	2	4
Objects appear larger (macropsia)	1	0	1	2
Objects appear smaller (micropsia)	1	0	1	2
Objects appear nearer (pelopsia)	0	0	0	0
Objects appear farther (teleopsia)	0	0	1	1
Tilted vision	1	0	1	2
Inverted vision	1	0	0	1
Images are displaced from one part of the visual field to another (visual allesthesia)	1	0	0	1
Visual perseveration in time or space	1	0	0	1
Images persist or recur over time (palinopsia)	0	0	0	0
Objects extend beyond their real borders (visual spread)	1	0	0	1
Double vision (diplopia)	4	2	5	11
Multiple images of an object (polyopia)	3	2	3	8
Corona phenomenon	4	0	2	6
Distorted shapes and outlines (metamorphopsia)	5	1	5	11
Illusion of splitting	2	1	3	6
Mosaic illusion	5	0	1	6

1. Abe, K.; Oda, N.; Araki, R.; Igata, M. 1989. Macropsia, micropsia, and episodic illusions in Japanese adolescents. *J Am Acad Child Adolesc Psychiat* 28:493–496.

2. Ahlenstiel, H. 1954. Über niedere, schwenkbar-projektive Halluzinationen. Leipzig: *Psychiat Neurol Med Psychol* 6:294–299.

3. Ahlenstiel, H. 1958. Der Zackenbogen des Flimmerskotoms. *Arch Psychiat Z ges Neurol* 196:577–579.

4. Ahlenstiel, H. 1962. *Vision und Traum. Betrachtungen über die Darstellungsformen in Trugbildern.* Stuttgart: Enke.

5. Ahlenstiel, H.; Kaufmann, R. 1953. Geometrisches Gestalten in optischen Halluzinationen. *Arch Psychiat Z ges Neurol* 190:503–529.

6. Airy, G.B. 1865. The Astronomer Royal on hemiopsy. London, Edinburgh, and Dublin: *Philos Mag J Sci* 30:19–21.

7. Airy, H. 1870. On a distinct form of transient hemiopsia. *Philos Trans Roy Soc Lond* 160:247–264.

8. Alvarado, C.S. 1980. The physical detection of the astral body: An historical perspective. *Theta* 8, no. 2.4–7.

9. Alvarez, W.C. 1945. Was there sick headache in 3000 BC? *Gastroenterol* 5:524.

10. Alvarez, W.C. 1958. Aberrant types of migraine seen in later life. *Geriatrics* 13:647–652.

11. Alvarez, W.C. 1959. The many causes of migraine in middle-aged and elderly women. *Geriatrics* 14:433–442.

12. Alvarez, W.C. 1960. The migrainous scotoma as studied in 618 persons. *Am J Ophthalmol* 40:489–504.

13. Alvarez, W.C. 1963. Notes on the history of migraine. *Headache* 2:209–213.

14. Andermann, F. 1987. Clinical features of migraine-epilepsy syndromes. In Andermann, F.; Lugaresi, E., eds. *Migraine and Epilepsy.* Boston: Butterworths, 3–30.

15. Anderson, S.W.; Rizzo, M. 1994. Hallucinations following occipital lobe damage: The pathological activation of visual representations. *J Clin Exp Neuropsychol* 16:651–663.

16. Anonymous. 1895. Report of Council. *Trans Ophthalmol Soc UK* 15:255–257.

17. Anonymous. 1896. Report of Council. *Trans Ophthalmol Soc UK* 16:364–368.

18. Anonymous. 1896. Subjective Gesichtsempfindungen. *Klin Mbl Augenheilk* 34:141.

19. Anonymous. 1992. Artists capture impact of a migraine attack. *Gen Pract Weekly* 42:400.

20. Antonelli, A. 1892. L'amblyopie transitoire. Paris: *Arch Neurol* 24:203–231, 423–448.

21. Appleton, R.; Farrell, K.; Buncic, J.R.; Hill, A. 1988. Amaurosis fugax in teenagers: A migraine variant. *Am J Dis Child* 142:331–333.

22. Ardila, A.; Sanchez, E. 1988. Neuropsychologic symptoms in the migraine syndrome. *Cephalalgia* 8:67–70.

23. Argenta, G.; Ranzato, F.P. 1968. Allestesia ottica quale fenomeno prodromico di un attacco emicranico. *Riv Neurol* 38:440–444.

24. Aring, C.D. 1972. The migrainous scintillating scotoma. *JAMA* 220:519–522.

25. Arnaud, J.-L.; Rose, F.C.; Diamond, S.; Arnaud, P. 1986. Visual hallucinations and migraine. *Funct Neurol* 1:473–479.

26. Arnold, O.H.; Hoff, H. 1953. Körperschema-

störungen bei LSD 25. *Wien Z Nervenheilk* 6:259–274.

27. Ask-Upmark, E. 1963. *Bedside Medicine: Selected Topics.* Stockholm: Almquist & Wiksell.

28. Atkinson, R.A.; Appenzeller, O. 1978. Deer woman. *Headache* 17:229–232.

29. Attneave, F.; Farrar, P. 1977. The visual world behind the head. *Am J Psychol* 90:549–563.

30. Ayles, D.; Nicola, U.; Podoll, K. 2004. Cosa si prova ad avere un'emicrania: 'Mig Installation', un'opera multimodale di Debbie Ayles. *Confinia Cephalalgica* 13:109-118.

31. Babinski, J. 1890. De la migraine ophthalmique hystérique. Paris: *Arch Neurol* 20:305–335.

32. Bäumler, C. 1925. Über das sogenannte Flimmerskotom. *Dtsch Z Nervenheilk* 83:1–46.

33. Baillet, L. 1911. Les miniatures du *Scivias* de Sainte Hildegarde conservé à la bibliothèque de Wiesbaden. Paris: *Monuments et Mémoires publiés par l'Académie des Inscriptions et Belles Lettres de la Fondation Eugène Piot* 19:49–149.

34. Barker, R. 1796. Specification of the panorama. In London: *The Repertory of Arts and Manufactures* 4:165–167. Reprinted in Buddemeier, H. 1970. *Panorama—Diorama—Photographie: Entstehung und Wirkung neuer Medien im 19 Jahrhundert.* Munich: Fink, 163–164.

35. Barolin, G.S. 1963. Atypische Migränen: Klinik—Differentialdiagnose—EEG. Vienna: *Klin Wschr* 75:293–301.

36. Barolin, G.S. 1972. Psychology and neuropsychology in migraine. *Res Clin Stud Headache* 3:126–153.

37. Barolin, G.S.; Gloning, K. 1969. Neuropsychologische Störungen bei Migräne. Vienna: *Z Nervenheilk* 27:306–320.

38. Basbaum, A.I. 1988. Unlocking the secrets of pain—the science. In Bernstein, E., ed. 1988. *Medical and Health Annual.* Chicago: Encyclopaedia Britannica, 84–103.

39. Baumgartner, G. 1977. Neuronal mechanisms of the migrainous visual aura. In Rose, F.C., ed. *Physiological Aspects of Clinical Neurology.* Oxford: Blackwell, 111–121.

40. Bechterev, V.M. 1926. Partial cortical and subcortical paralyses of psycho-reflective functions. *Obozr Psikh* 31:31–41.

41. Bender, M.B.; Teuber, H.-L. 1946. Ring scotoma and tubular fields: Their significance in cases of head injury. Chicago: *Arch Neurol Psychiat* 56:300–326.

42. Bender, M.B.; Feldman, M.; Sobin, A.J. 1968. Palinopsia. *Brain* 91:321–338.

43. Benton, A.; Sivan, A.B. 1993. Disturbances of the body schema. In Heilman, K.M.; Valenstein, E., eds. *Clinical Neuropsychology 3rd ed.* New York and Oxford: Oxford Univ. Press, 123–140.

44. Berbez, P. 1889. Les migraines. *Gaz Hebd Méd Chir* 26:19–20, 34–36, 50–52.

45. Berger, H. 1929. Selbstbeschreibung eines Falles von Hemicrania ophthalmica. *Med Welt* 3:1439–1440.

46. Bèttica-Giovannini, R. 1979. La preghiera di Blaise Pascal per il buon uso delle malattie. Turin: *Ann Osp Maria Vittoria* 22:420–425.

47. Bexton, W.H.; Heron, W.; Scott, T.H. 1954. Effects of decreased variation in the sensory environment. *Can J Psychol* 8:70–76.

48. Beyer, E. 1895. Über Verlagerungen im Gesichtsfeld bei Flimmerskotom. *Neurol Zbl* 14:10–15.

49. Beyme, F. 1986. Psychotherapie nächtlicher Migräne unter Einsatz von kreativem Träumen nach Garfield. Roche, Switzerland: *Hexagon* 14:1–7.

50. Beyme, F. 1993. Revalidierung des "Dream Hostility Counts" nach Saul und Sheppard mittels einer Zeitserie aus 24 Träumen, von denen sieben in einer Aufwachmigräne ausmündeten. *Schweiz Arch Neurol Psychiat* 144:561–573.

51. Bickerstaff, E.R. 1961. Basilar artery migraine. *Lancet* 1:15–17.

52. Biederman, I. 1987. Recognition-by-components: A theory of human image understanding. *Psychol Rev* 94:115–147.

53. Bigley, G.K.; Sharp, F.R. 1983. Reversible alexia without agraphia due to migraine. *Arch Neurol* 40:114–115.

54. Bille, B. 1962. Migraine in school children. A study of the incidence and short-term prognosis, and a clinical, psychological and encephalographic comparison between children with migraine and matched controls. *Acta Paediat* 51, suppl. 136:1–151.

55. Binet-Sanglé, C. 1899. La maladie de Blaise Pascal. *Ann Méd Psychol* 57:177–199.

56. Black, D. 1975. *Ekstasy: Out-of-the-Body Experiences*. Indianapolis and New York: Bobbs-Merrill.

57. Black, W.G. 1883. Folk-medicine: A chapter in the history of culture. *Publications of the Folk-Lore Society, no. 12*. London: Folklore Society.

58. Blackmore, S. 1982. *Beyond the Body: An Investigation of Out-of-the-body Experiences*. London: Heinemann.

59. Blackmore, S. 1984. A postal survey of OBEs and other experiences. *J Soc Psych Res* 52:225–244.

60. Blackmore, S. 1986. Out-of-body experiences in schizophrenia: A questionnaire survey. *J Nerv Ment Dis* 174:615–619.

61. Blanke, O.; Landis, T.; Spinelli, L.; Seeck, M. 2004. Out-of-body experience and autoscopy of neurological origin. *Brain* 127:243-258.

62. Blau, J.N. 1998. Somesthetic aura: The experience of "Alice in Wonderland." *Lancet* 352:582.

63. Blomfield, R. 1938. *Sebastien le Prestre de Vauban 1633–1707*. London: Methuen.

64. Bodamer, J. 1947. Die Prosop-Agnosie (Die Agnosie des Physiognomieerkennens). *Arch Psychiat Z ges Neurol* 179:6–53.

65. Bodensteiner, J.B. 1990. Visual symptoms in childhood migraine. *J Child Neurol* 5:190.

66. Boles, D.B. 1993. Visual field effects of classical migraine. *Brain Cogn* 21:181–191.

67. Bollig, G.; Undall, E.; Mørland, T.; Podoll, K. 2005. Migrene og kunst. *Tidsskr Nor Lægeforen* 125:777-778.

68. Bonhoeffer, K. 1940. Dauerausfallserscheinungen bei Migräne. *Dtsch Med Wschr* 32:521–523.

69. Bonnier, P. 1905. L'aschématie. *Rev Neurol* 13:605–609.

70. Bowen, S.F. Jr 1969. Migraine associated with retinal entoptic phenomena. *JAMA* 207:764–765.

71. Bowerman, L.S. 1989. Transient visual field loss secondary to migraine. *J Am Optom Assoc* 60:912–917.

72. Brackmann, H. 1897. Migräne und Psychose. *Allg Z Psychiat* 53:554–561.

73. Brewster, D. 1842. *Letters on Natural Magic, 5th ed.* London: Murray and Tegg.

74. Brewster, D. 1865. On hemiopsy, or half-vision. London, Edinburgh, and Dublin: *Philos Magaz J Sci* 29:503–507. Reprinted in *Trans Roy Soc Edinburgh 1867* 24:15–18.

75. Brindley, G.S.; Lewin, W.S. 1968. The sensations produced by electrical stimulation of the visual cortex. *J Physiol* 196:479–493.

76. Brown, J.W. 1985. Hallucinations: Imagery and the microstructure of perception. In Frederiks, J.A.M., ed. *Handbook of Clinical Neurology, Vol. 45: Clinical Neuropsychology*. Amsterdam: Elsevier, 351–372.

77. Brunschvicg, L., ed. 1905. *Original des Pensées de Pascal. Fac-simile du manuscrit 9202 (Fonds français) de la Bibliothèque Nationale. Texte imprimé en regard et notes par Léon Brunschvicg.* Paris: Hachette.

78. Brunton, L. 1902. Hallucinations and allied mental phenomena. *J Ment Sci* 48:226–261.

79. Bruyn, G.W. 1986. Migraine equivalents. In Rose, F.C., ed. *Handbook of Clinical Neurology, Vol. 48: Headache*. Amsterdam: Elsevier, 155–171.

80. Bücking, H.; Baumgartner, G. 1974. Klinik und Pathophysiologie der initialen neurologischen Symptome bei fokalen Migränen (Migraine ophthalmique, Migraine accompagnée). *Arch Psychiat Nervenkr* 219:37–52.

81. Bull, O. 1895. *Perimetrie*. Bonn: Cohen, 115.

82. Burke, E.C.; Peters, G.A. 1956. Migraine in childhood: A preliminary report. *AMA Am J Dis Child* 92:330–336.

83. Butler, T.H. 1933. Scotomata in migrainous subjects. *Br J Opthalmol* 17:83–87.

84. Butler, T.H. 1941. Uncommon symptoms of migraine. *Trans Ophthalmol Soc UK* 61:205–221.

85. Buytendijk, F.J.J. 1957. Das Menschliche der menschlichen Bewegung. *Nervenarzt* 28:1–7.

86. Cadenhead, K.A. 1985. *The Art of Migraine: An Exploration of the Alchemy of Migraine Headaches on the Art and Lives of Artists/Migraineurs.* Thesis. Boston: Boston Univ. School of Education.

87. Camfield, P.R.; Metrakos, K.; Andermann, F. 1978. Basilar migraine, seizures, and severe epileptiform EEG abnormalities: A relatively benign syndrome in adolescents. *Neurology* 28:584–588.

88. Carroll, L. 1865. *Alice's Adventures in Wonderland.* London: Chadwick and Sons.

89. Carroll, L. 1871. *Through the Looking Glass.* London: Chadwick and Sons.

90. Carroll, L. 1971. *The Rectory Umbrella and Mischmasch.* New York: Dover.

91. Chalupecky, H. 1901. Ueber Farbensehen oder Chromatopsie. *Wien Klin Rundsch* 15:509–512, 531–533, 547–549, 567–570.

92. Charcot, J.M. 1888. *Leçons du Mardi à la Salpêtrière: Policlinique 1887–1888, Tome I: Policlinique du Mardi 22 Novembre 1887 et du 10 Janvier 1888.* Paris: Babé.

93. Chatterjee, A. 2004. The neuropsychology of visual artistic production. *Neuropsychologia* 42:1568-1583.

94. Chatterjee, A. 2006. The neuropsychology of visual art: conferring capacity. *Int Rev Neurobiol* 74:39-49.

95. Chermann, J.F. 1999. Syndrome d'Alice aux pays des merveilles. *Rev Prat Méd Gen* 13:1115.

96. Cho, A.A.; Clark, J.B.; Rupert, A.H. 1995. Visually triggered migraine headaches affect spatial orientation and balance in a helicopter pilot. *Aviat Space Environ Med* 66:353–358.

97. Cogan, D.G. 1973. Visual hallucinations as release phenomena. *Graefes Arch klin exp Ophthal* 188:139–150.

98. Comfort, A. 1982. Out-of-body experiences and migraine. *Am J Psychiat* 139:1379–1380.

99. Congdon, P.J.; Forsythe W.I. 1979. Migraine in childhood: A study of 300 children. *Develop Med Child Neurol* 21:209–216.

100. Corbett, J.J. 1983. Neuro-ophthalmic complications of migraine and cluster headaches. *Neurol Clin* 1:973–995.

101. Cowey, A.; Rolls, E.T. 1974. Human cortical magnification factor and its relation to visual acuity. *Exp Brain Res* 21:447–454.

102. Creditor, M.C. 1982. Me and migraine. *N Engl J Med* 307:1029–1032.

103. Critchley, M. 1949. *Sir William Gowers 1845–1915: A Biographical Appreciation.* London: Heinemann.

104. Critchley, M. 1949–1950. Metamorphopsia of central origin. *Trans Ophthalmol Soc UK* 69:111–121.

105. Critchley, M. 1950. The body-image in neurology. *Lancet* 258:335–341.

106. Critchley, M. 1951. Types of visual perseveration: "paliopsia" and "illusory visual spread." *Brain* 74:267–299.

107. Critchley, M. 1953. *The Parietal Lobes.* New York: Hafner.

108. Critchley, M. 1956. The idea of a presence. *Acta Psychiat et Neurol Scand* 30:155–168.

109. Critchley, M. 1965. Disorders of corporeal awareness in parietal disease. In Wapner, S.; Werner, H., eds. *The Body Percept.* New York: Random House, 68–81.

110. Critchley, M. 1967. Migraine: From Cappadocia to Queen Square. In Smith, R., ed. *Background to Migraine: First Migraine Symposium 8–9 November 1966.* London: Heinemann, 28–38.

111. Critchley, M. 1979. Corporeal awareness: Body-image; body-scheme. In Critchley, M. *The Divine Banquet of the Brain and Other Essays.* New York: Raven, 92–105.

112. Critchley, M. 1986. Aurae and prodromes in migraine. In Critchley, M. *The Citadel of the Senses and Other Essays.* New York: Raven, 199–204.

113. Critchley, M. 1988. Unlocking the secrets of pain—the psychology. In Bernstein, E., ed. *1988 Medical and Health Annual.* Chicago: Encyclopaedia Britannica, 104–119.

114. Critchley, M.; Ferguson, F.R. 1933. Migraine. *Lancet* 1:123–126, 182–187.

115. Crookal, R. 1972. *Casebook of Astral Projection.*

Secaucus, N.J.: University Books.

116. Crotogino, J.; Feindel, A.; Wilkinson, F. 2001. Perceived scintillation rate of migraine aura. *Headache* 41:40–48.

117. Curschmann, H. 1916. Über einige seltene Formen der Migräne. *Dtsch Z Nervenheilk* 54:184–205.

118. Cummings, J.L.; Gittinger Jr., J.W. 1981. Central dazzle: A thalamic syndrome? *Arch Neurol* 38:372–374.

119. Cutting, J. 1989. Body image disorders: Comparison between unilateral hemisphere damage and schizophrenia. *Behav Neurol* 2:201–210.

120. Dahlem, M.A.; Chronicle, E.P. 2004. A computational perspective on migraine aura. *Prog Neurobiol* 74:351–361.

121. Dahlem, M.A.; Müller, S.C. 2003. Migraine aura dynamics after reverse retinotopic mapping of weak excitation waves in the primary visual cortex. *Biol Cybern* 88:419–424.

122. Dahlem, M.A.; Engelmann, R.; Löwel, S.; Müller, S.C. 2000. Does the migraine aura reflect cortical organization? *Eur J Neurosci* 12:767–770.

123. Damas Mora, J.M.R.; Jenner, F.A.; Eacott, S.E. 1980. On heautoscopy or the phenomenon of the double: Case presentation and review of the literature. *Br J Med Psychol* 53:75–83.

124. Daniel, P.M.; Whitteridge, D. 1961. The representation of the visual field on the cerebral cortex in monkeys. *J Physiol* 159:203–221.

125. Debney, L.M. 1984. Visual stimuli as migraine trigger factors. In Rose, F.C., ed. *Progress in Migraine Research 2.* London: Pitman, 30–54.

126. Denes, F. 1989. Disorders of body awareness and body knowledge. In Boller, F.; Grafman, J., eds. *Handbook of Neuropsychology, Vol. 2.* Amsterdam: Elsevier, 207–228.

127. Desimone, R.; Ungerleider, L.G. 1989. Neural mechanisms of visual processing in monkeys. In Boller, F.; Grafman, J., eds. *Handbook of Neuropsychology, Vol. 2.* Amsterdam: Elsevier, 267–299.

128. Determann. 1896. Casuistischer Beitrag zur Kenntniss der Migräne. *Dtsch Med Wschr* 22:152–154, 171–172.

129. Devinsky, O.; Feldmann, E.; Burrowes, K.; Bromfield, E. 1989. Autoscopic phenomena with seizures. *Arch Neurol* 46:1080–1088.

130. Dewhurst, K.; Beard, A.W. 1970. Sudden religious conversions in temporal lobe epilepsy. *Br J Psychiat* 117:497–507.

131. Dexter, J.D.; Riley, T.L. 1975. Studies in nocturnal migraine. *Headache* 15:51–62.

132. Diamond, S. 1999. Art and migraine. *Headache Quart* 10:285.

133. Diamond, S.; Prager, J.; Gandhi, S. 1986. Hallucinations and migraine. In Amery, W.K.; Wauquier, A., eds. *The Prelude to the Migraine Attack.* London: Baillière Tindall, 99–111.

134. Dianoux, E. 1875. *Du scotome scintillant ou amaurose partielle temporaire.* Paris: Delahaye.

135. Dobelle, W.H.; Turkel, J.H.; Henderson, D.C.; Evans, J.R. 1979. Mapping the representation of the visual field by electrical stimulation of human visual cortex. *Am J Ophthalmol* 88:727–735.

136. Domitrz, I. 2007. Migraine with visual aura: visual aura pictured by the patient. *Neurol Neurochir Pol* 41:184–187.

137. Donahue, H.C. 1950. Migraine and its ocular manifestations. *Arch Ophthalmol* 43:96–141.

138. Dooley, J.; Gordon, K.; Camfield, P. 1990. "The rushes": A migraine variant with hallucinations of time. *Clin Pediatrics* 29:536–538.

139. Doust, J.W.L. 1951. Studies in the physiology of awareness: The incidence and content of dream patterns and their relationship to anoxia. *J Ment Sci* 97:801–811.

140. Drake Jr., M.E. 1983. Migraine as an organic cause of monocular diplopia. *Psychosomatics* 24:1024–1027.

141. Drasdo, N. 1977. The neural representation of visual space. *Nature* 266:554–556.

142. Dreifuss, F.E. 1961. Observations on aphasia in a polyglot poet. *Acta Psychiat et Neurol Scand* 36:91–97.

143. Drummond, P.D. 1986. A quantitative assessment of photophobia in migraine and tension

headache. *Headache* 26:465–469.

144. Drummond, P.D. 1997. Photophobia and autonomic responses to facial pain in migraine. *Brain* 120:1857–1864.

145. Drummond, P.D.; Woodhouse, A. 1993. Painful stimulation of the forehead increases photophobia in migraine sufferers. *Cephalalgia* 13:321–324.

146. Du Bois-Reymond, E. 1860. Zur Kenntniss der Hemikrania. *Arch Anat Physiol Wiss Med* 4:461–468.

147. Dubuffet, J. 1991. Art brut: Vorzüge gegenüber der kulturellen Kunst. In Dubuffet, J. *Die Malerei in der Falle: Antikulturelle Positionen. Schriften, Vol 1*. Bern and Berlin: Gachnang & Springer.

148. Dufour, M. 1889. Sur la vision nulle dans l'hémiopie. *Rev Méd Suisse Rom* 9:445–451.

149. Duke-Elder, W.S. 1949. *Textbook of Ophthalmology, Vol. 4: The Neurology of Vision, Motor and Optical Anomalies*. London: Henry Kimpton, 3683.

150. Dupré, E.; Camus, P. 1907. Les cénesthopathies. *Encéphale* 2:616–631.

151. Durham, R.H. 1960. "Alice in Wonderland" syndrome. In Durham, R.H. *Encyclopedia of Medical Syndromes*. New York: Paul B. Hoeber, 19.

152. Durville, H. 1914. *Le fantome des vivants: Recherches expérimentales sur le dédoublement du corps de l'homme*. Paris: Librairie du Magnétisme.

153. Eastman, M. 1962. Out-of-the-body experiences. *Proc Soc Psych Res* 53:287–309.

154. Ebata, S.; Ogawa, M.; Tanaka, Y.; Mizuno, Y.; Yoshida, M. 1991. Apparent reduction in the size of one side of the face associated with a small retrosplenial haemorrhage. *J Neurol Neurosurg Psychiat* 54:68–70.

155. Edelson, R.N.; Levy, D.E. 1974. Transient benign unilateral pupillary dilation in young adults. *Arch Neurol* 31:12–14.

156. Eger, A.O. 1995. *Decoratieve Kunst: Over Stijl en Grondvorm van Decoraties en Ornamenten*. De Bilt, Netherlands: Cantecleer.

157. Ekbom, K.-A. 1975. Duration of the scintillating scotoma. *Headache* 14:241–246.

158. Elliot, R.H. 1932. Migraine. *Postgrad Med J* 8:328–336.

159. Emery, A.E.H. 2004. Art and neurology. *Pract Neurol* 4:366–371.

160. Emmert, E. 1881. Grössenverhältnisse der Nachbilder. *Klin Mbl Augenheilk* 19:443–450.

161. Eulenburg, A. 1887. Zur Aetiologie und Therapie der Migräne. *Wien Med Presse* 28:3–8, 54–58.

162. Evers, S.; Homann, B.; Vollmer, J. 1996. Agraphia as the only symptom of migraine aura: a case report. *Cephalalgia* 16:562–563.

163. Federn, P. 1926. Einige Variationen des Ichgefühls. *Int Z Psychoanal* 12:263–274.

164. Fenichel, G.M. 1968. Migraine in childhood: Brief review of this inherited disorder which strikes five per cent of school-age children. *Clin Pediatr* 7:192–194.

165. Féré, C. 1881. Contribution à l'étude de la migraine ophthalmique. *Rev Méd* 1:625–649.

166. Féré, C. 1883. Note sur un cas de migraine ophthalmique à accès répétés et suivis de mort. *Rev Méd* 3:194–201.

167. Féré, C. 1897. Note sur un cas de psychose migraineuse. *Rev Méd* 17:390–395.

168. Féré, C. 1903. Note sur des rêves précurseurs de la migraine ophthalmique. *Rev Méd* 23:127–130.

169. Ferguson, K.S.; Robinson, S.S. 1982. Life-threatening migraine. *Arch Neurol* 39:374–376.

170. Ferrari, M.D.; Haan, J. 2000. Migraine aura, illusory vertical splitting, and Picasso. *Cephalalgia* 20:686.

171. Fink. 1891. *Des rapports de la migraine ophthalmique avec l'hystérie*. Paris: Thèse.

172. Fischer, R. 1971. A cartography of the ecstatic and meditative states. *Science* 174:897–904.

173. Fisher, C.M. 1980. Late-life migraine accompaniments as a cause of unexplained transient ischemic attacks. *Can J Neurol Sci* 7:9–17.

174. Fisher, C.M. 1986. Late-life migraine accompaniments—further experience. *Stroke* 17:1033–1042.

175. Fisher, C.M. 1986. An unusual case of

migraine accompaniments with permanent sequela—a case report. *Headache* 26:266–270.

176. Fisher, N.F.; Jampolsky, A.; Flom, M.C. 1968. Traumatic bitemporal hemianopsia, part II: Binocular cooperation. *Am J Ophthalmol* 65:574–577.

177. Flanagan, S. 1989. *Hildegard of Bingen, 1098–1179: A Visionary Life.* London and New York: Routledge.

178. Flatau, E. 1902. Ueber einen bemerkenswerten Fall von Hemikranie. *Zbl Nervenheilk* 25:746–752.

179. Flatau, E. 1912. *Die Migräne: Monographien aus dem Gesamtgebiete der Neurologie und Psychiatrie, Heft 2.* Berlin: Springer.

180. Fleishman, J.A.; Segall, J.D.; Judge, F.P. 1983. Isolated transient alexia: A migrainous accompaniment. *Arch Neurol* 40:115–116.

181. Foerster, R. 1896. Amaurosis partialis fugax. *Klin Mbl Augenheilk* 7:422–430.

182. Foerster, R. 1871. Lichtsinn bei Krankheiten der Chorioidea und Retina. *Klin Mbl Augenheilk* 9:337–346.

183. Foerster, R. 1877. Beziehungen der Allgemein-Leiden und Organ-Erkrankungen zu Veränderungen und Krankheiten des Sehorgans. In Graefe, A.; Saemisch, T., eds. *Handbuch der gesammten Augenheilkunde, Vol. 7, Part 5.* Leipzig: Engelmann, 59–234.

184. Foerster, O. 1903. Ein Fall von elementarer allgemeiner Somatopsychose. (Afunktion der Somatopsyche.) *Mschr Psychiat Neurol* 14:189–205.

185. Forbes, A. 1949. Dream scintillations. *Psychosom Med* 2:160–162.

186. Foster, J. 1941. Discussion on Butler, uncommon symptoms of migraine. *Trans Ophthalmol Soc UK* 61:219–220.

187. Fothergill, J. 1784. Remarks on that complaint commonly known under the name of sick-headache. *Med Observ Inquir* 6:103–137.

188. Fox, O. 1962. *Astral projection: A Record of Out-of-the-body Experiences.* New York: University Books.

189. Frederiks, J.A.M. 1963. Macrosomatognosia and microsomatognosia. Amsterdam: *Psychiat*

Neurol Neurochir 66:531–536.

190. Frederiks, J.A.M. 1985. Disorders of the body schema. In Frederiks, J.A.M., ed. *Handbook of Clinical Neurology, Vol. 45: Clinical Neuropsychology.* Amsterdam: Elsevier, 373–393.

191. Freud, S. 1900. *Die Traumdeutung.* Leipzig and Vienna: Deuticke.

192. Friedman, A.P. 1972. The headache in history, literature, and legend. *Bull NY Acad Med* 48:661–681.

193. Friedman, A.P.; Harter, D.H.; Merritt, H.H. 1962. Ophthalmoplegic migraine. *Arch Neurol* 7:320–327.

194. Friedman, B. 1971. Migraine—with special reference to scintillating scotoma. *Eye Ear Nose Throat Mon* 50:52–58.

195. Fuchs, E. 1885. Klinische Miscellen. *Arch Augenheilk* 14:385–391; 15:1–11.

196. Fuchs, W. 1920. Untersuchungen über das Sehen der Hemianopiker und Hemiamblyopiker. I. Teil: Verlagerungserscheinungen. *Z Psychol* 84:67–169.

197. Fuchs, W. 1921. Untersuchungen über das Sehen der Hemianopiker und Hemiamblyopiker. II. Teil: Die totalisierende Gestaltauffassung. *Z Psychol* 86:1–143.

198. Führkötter, A.; Carlevaris, A., eds. 1978. *Hildegardis Scivias: Corpus Christianorum Continuatio Mediaevalis, vols. 43 and 43A.* Turnholti, Belgium: Brepols.

199. Fuller, G.N.; Gale, M.V. 1988. Migraine aura as artistic inspiration. *Br Med J* 297:1670–1672.

200. Fuller, G.N.; Guiloff, R.J. 1987. Migrainous olfactory hallucinations. *J Neurol Neurosurg Psychiat* 50:1688–1690.

201. Fuller, G.N.; Marshall, A.; Flint, J.; Lewis, S.; Wise, R.J.S. 1993. Migraine madness: Recurring psychosis after migraine. *J Neurol Neurosurg Psychiat* 56:416–418.

202. Gabbard, G.O.; Twemlow, S.W. 1984. *With the Eyes of the Mind: An Empirical Analysis of Out-of-body States.* New York: Praeger.

203. Galezowski, X. 1878. Étude sur la migraine ophthalmique. *Arch Gén Méd* 141:669–686; 142:37–58.

204. Galezowski, X. 1882. Ophthalmic megrim: An affection of the vasomotor nerves of the retina and retinal center which may end in a thrombosis. *Lancet* 1:176–177.

205. Gans, M. 1943. The interrelationship of sleep and migraine: An attempt of casual therapy. *Acta Med Orient* 2:97–104.

206. Gans, M. 1951. Treating migraine by "sleep-rationing." *J Nerv Ment Dis* 113:405–429.

207. Garcin, R.; Halbron, P. 1934. Contribution à l'étude des migraines accompagnées et en particulier de la physiopathologie des migraines ophtalmiques accompagnées. *Ann Méd* 36:81–114.

208. Gassel, M.M.; Williams, D. 1963. Visual function in patients with homonymous hemianopia, part III: The completion phenomenon; insight and attitude to the defect; and visual functional efficiency. *Brain* 86:229–260.

209. Gerrits, H.J.M.; Timmerman, G.J.M.E.N. 1969. The filling-in process in patients with retinal scotoma. *Vision Res* 9:439–442.

210. Gloning, I.; Gloning, K.; Weingarten, K. 1956. Über okzipitale Polyopie. *Wien Z Nervenheilk* 13:224–235.

211. Gloning, I.; Gloning, K.; Hoff, H. 1968. *Neuropsychological Symptoms and Syndromes in Lesions of the Occipital Lobe and the Adjacent Areas.* Paris: Gauthier-Villars.

212. Göbel, H.; Isler, H.; Hasenfratz, H.-P. 1995. Headache classification and the Bible: Was Saint Paul's thorn in the flesh migraine? *Cephalalgia* 15:180–181.

213. Golden, G.S. 1979. The Alice in Wonderland syndrome in juvenile migraine. *Pediatrics* 63:517–519.

214. Golden, G.S.; French, J.H. 1975. Basilar artery migraine in young children. *Pediatrics* 56:722–726.

215. Goodacre, S. 1972. The illnesses of Lewis Carroll. *Practitioner* 209:230–239.

216. Gowers, W.R. 1888. *A Manual of Diseases of the Nervous System, Vol. 2: Diseases of the Brain and Cranial Nerves; General and Functional Diseases of the Nervous System.* London: Churchill.

217. Gowers, W.R. 1895. Subjective visual sensations. *Trans Ophthalmol Soc UK* 15:1–38.

218. Gowers, W.R. 1895. Subjective visual sensations. *Nature* 52:234–236.

219. Gowers, W.R. 1896. Subjective sensations of sound. *Lancet* 2:1357–1363.

220. Gowers, W.R. 1904. *Subjective Sensations of Sight and Sound, Abiotrophy, and Other Lectures.* Philadelphia: Blakiston.

221. Gowers, W.R. 1906. Clinical lectures on the borderline of epilepsy III—migraine. *Br Med J* 2:1617–1622.

222. Gowers, W.R. 1909. An address on the prodromas of migraine. *Br Med J* 1:1400–1403.

223. Graef, H. 1962. *Mystics of Our Time.* London: Burns and Oates.

224. Grafstein, B. 1956. Mechanism of spreading cortical depression. *J Neurophysiol* 19:154–171.

225. Green, C.E. 1967. Ecsomatic experiences and related phenomena. *J Soc Psych Res* 44:111–130.

226. Green, C.E. 1968. *Out-of-the-body Experiences.* Oxford: Institute of Psychophysical Research.

227. Green, R.L., ed. 1953. *The Diaries of Lewis Carroll.* London: Cassell

228. Greenacre, P. 1947. Vision, headache and the halo: Reactions to stress in the course of superego formation. *Psychoanal Quart* 16:177–194.

229. Greenacre, P. 1955. *Swift and Carroll: A Psychoanalytic Study of Two Lives.* New York: International Univ. Press.

230. Gregory, R.L. 1977. *Eye and Brain: The Psychology of Seeing, 3rd ed.* London: Weidenfeld and Nicolson.

231. Grof, S. 1975. *Realms of the Unconscious: Observations from LSD Research.* New York: Viking.

232. Gross, G.; Huber, G. 1996. Pain in psychotic disorders. *Neurol Psychiat Brain Res* 4:87–92.

233. Gross, G.; Huber, G.; Klosterkötter, J.; Linz, M. 1987. *BSABS: Bonner Skala für die Beurteilung von Basissymptomen [Bonn Scale for the Assessment of Basic Symptoms].* Berlin, Heidelberg, and New York: Springer.

234. Grotjahn, M. 1947. About the symbolization of *Alice's Adventures in Wonderland. Am Imago* 4:32–41.

235. Grüsser, O.-J. 1995. Migraine phosphenes and the retino-cortical magnification factor. *Vision Res* 35:1125–1134.

236. Gutheil, E. 1926. Analyse eines Falles von Migräne. *Fortschr Sexualwiss Psychoanal* 2:194–126.

237. Gutheil, E. 1934. Analysis of a case of migraine. *Psychoanal Rev* 21:272–299.

238. Gutheil, E. 1951. *The Handbook of Dream Analysis.* New York: Liveright.

239. Haas, D.C. 1992. Prolonged migraine aura status. *Ann Neurol* 11:197–199.

240. Hachinski, V.C.; Porchawka, J.; Steele, J.C. 1973. Visual symptoms in the migraine syndrome. *Neurology* 23:570–579.

241. Hall, M. 2000. *Target Migraine.* London: Association of the British Pharmaceutical Industry.

242. Halpern, F. 1930. Kasuistischer Beitrag zur Frage des Verkehrtsehens. *Z ges Neurol Psychiat* 126:246–252.

243. Hare, E.H. 1966. Personal observations on the spectral march of migraine. *J Neurol Sci* 3:259–264.

244. Hart, C.; Bishop, J. 1990. *Translation of Hildegard of Bingen's* Scivias. New York and Mahwah, N.J.: Paulist.

245. Hattemer, M. 1930. Gesichte und Erkrankung der Hildegard von Bingen: Ein pathographischer Versuch. *Hippokrates* 3:125–149.

246. Haviland, W.A. 1996. *Cultural Anthropology, 8th ed.* Fort Worth, Texas: Harcourt Brace.

247. Hay, K.M. 1971. Migraine in general practice. In Cumings, J.N., ed. *Background to Migraine: Fourth Migraine Symposium, 11 September 1970.* London: Heinemann, 25–35.

248. Hay, K.M. 1984. Migraine. *The Physician* 1:579–582.

249. Hay, K.M. 1994. *Breathless to Life: His Autobiography.* Edinburgh, Cambridge, and Durham: Pentland.

250. Head, H.; Holmes, G. 1911. Sensory disturbances from cerebral lesions. *Brain* 34:102–254.

251. Heather-Greener, G.Q.; Comstock, D.; Joyce, R. 1996. An investigation of the manifest dream content associated with migraine headaches: A study of the dreams that precede nocturnal migraines. *Psychother Psychosom* 65:216–221.

252. Hécaen, H.; Albert, M.L. 1978. *Human Neuropsychology.* New York: Wiley.

253. Hécaen, H.; Angelargues, R. 1962. Agnosia for faces (prosopagnosia). *Arch Neurol* 7:92–100.

254. Hécaen, H.; de Ajuriaguerra, J. 1992. *Méconnaissances et hallucinations corporelles.* Paris: Masson.

255. Heilbronner, K. 1904. Über Mikropsie und verwandte Zustände. *Dtsch Z Nervenheilk* 27:414–423.

256. Herrmann, G.; Pötzl, O. 1928. *Die optische Allaesthesie: Studien zur Psychopathologie der Raumbildung. Abhandlungen aus der Neurologie, Psychiatrie, Psychologie und ihren Grenzgebieten, Heft 47.* Berlin: Karger.

257. Heron, W.; Doane, B.K.; Scott, T.H. 1956. Visual disturbances after prolonged perceptual isolation. *Can J Psychol* 10:13–18.

258. Herschel, J.F.W. 1867. *Familiar Lectures on Scientific Subjects.* London: Strahan.

259. Herschel, J.F.W. 1870. Letter to Hubert Airy dated 17 November 1869. In Airy, H., On a distinct form of transient hemiopsia. *Philos Trans Roy Soc Lond* 160:252–253.

260. Heyck, H. 1962. Die neurologischen Begleiterscheinungen der Migräne und das Problem des "angiospastischen Hirninsults." *Nervenarzt* 33:193–203.

261. Heymanowitsch, A.J. 1931. Über atypische Migräne. *Nervenarzt* 4:640–644.

262. Hilbert, R. 1893. Die Chloropie. *Zbl prakt Augenheilk* 17:50–52.

263. Hilbert, R. 1898. Das atypische Flimmerscotom. *Zbl prakt Augenheilk* 22:105–107.

264. Hishikawa, Y. 1976. Sleep paralysis. In Guilleminault, C.; Dement, W.C.; Passouant, P., eds. *Narcolepsy.* New York: Spectrum, 97–124.

265. Hoch, P. 1931. Über seltene Formen der Migräne. *Arch Psychiat Nervenkr* 97:553–568.

266. Hockaday, J.M. 1978. Late outcome of childhood onset migraine and factors

affecting outcome, with particular reference to early and late EEG findings. In Greene, R., ed. *Current Concepts in Migraine Research.* New York: Raven, 41–48.

267. Hoeflmayr, L. 1903. Eine merkwürdige Complication eines Migräneanfalles. *Neurol Zbl* 22:102–109.

268. Hoff, H.; Pötzl, O. 1933. Über cerebral bedingte Polyopie und verwandte Erscheinungen. *Jb Psychiat Neurol* 50:35–56.

269. Hoff, H.; Schilder, P. 1928. Zur Kenntnis der Symptomatologie vestibulärer Erkrankungen. *Dtsch Z Nervenheilk* 103:145–175.

270. Hoffman, J.A. 1984. LSD flashbacks. *Arch Gen Psychiatry* 41:631–632.

271. Hollenhorst, R.W. 1953. Ocular manifestations of migraine: Report of 4 cases of hemianopsia. *Proc Mayo Clin* 28:686–693.

272. Holmes, G. 1918. Disturbances of vision by cerebral lesions. *Br J Ophthalmol* 2:353–384.

273. Holmes, G.; Lister, W.T. 1916. Disturbances of vision from cerebral lesions, with special reference to the cortical representation of the macula. *Brain* 39:34–73.

274. Holt, R.R. 1964. Imagery: The return of the ostracized. *Am Psychologist* 19:254–264.

275. Horowitz, M.J. 1970. *Image Formation and Cognition.* New York: Appleton Century Crofts.

276. Howlett, S. 1989. Migraine—more than just a headache. *MIMS Magazine* 1:77–80.

277. Hubel, D.H.; Wiesel, T.N. 1959. Receptive fields of single neurons in the cat's striate cortex. *J Physiol* 148:574–591.

278. Hubel, D.H.; Wiesel, T.N. 1962. Receptive fields, binocular interaction, and functional architecture in the cat's visual cortex. *J Physiol* 160:106–154.

279. Huber, G. 1957. *Pneumencephalographische und psychopathologische Bilder bei endogenen Psychosen: Monographien aus dem Gesamtgebiete der Neurologie und Psychiatrie, Heft 79.* Berlin, Göttingen, and Heidelberg: Springer.

280. Hupp, S.L.; Kline, L.B.; Corbett, J.J. 1989. Visual disturbances of migraine. *Surv Ophthalmol* 33:221–236.

281. Hustvedt, S. 2008. Lifting, lights, and little people. *New York Times,* 17 February 2008.

282. Ikemura, Y.; Akena, H.; Iida, M.; Doi, K.; Highashitani, N.; Yanagi, Y. 1987. Psychiatry of diencephalon damages: A case report. *Func Neurol* 2:87–91.

283. International Headache Society. 1988. Classification and diagnostic criteria for headache disorders, cranial neuralgias, and facial pain. *Cephalalgia* 8, suppl. 7:1–96.

284. International Headache Society. 2004. The International Classification of Headache Disorders, 2nd edition. *Cephalalgia* 24, suppl. 1:1-160.

285. Irwin, H.J. 1981. Some psychological dimensions of the out-of-body experience. *Parapsychol Rev* 12:1–6.

286. Irwin, H.J. 1983. The association between out-of-body experiences and migraine. *Psi Research* 2 (2):89–96.

287. Irwin, H.J. 1983. Migraine, out-of-body experiences, and lucid dreams. *Lucidity Letter* 2:50–52.

288. Irwin, H.J. 1985. *Flight of Mind.* Metuchen, N.J. and London: Scarecrow.

289. Ives, E.R.; Nielsen, J.M. 1937. Disturbance of body scheme: Delusion of absence of part of body in two cases with autopsy verification of the lesions. *Bull Los Angeles Neurol Soc* 2:120–125.

290. Jackson, J.H. 1880. On a particular variety of epilepsy ("intellectual aura"), one case with symptoms of organic brain disease. *Brain* 11:179–207.

291. Jacobs, L.; Feldman, M.; Diamond, S.P.; Bender, M.B. 1973. Palinacousis: persistent or recurring auditory sensations. *Cortex* 9:275–287.

292. Jasper, H.H.; Rasmussen, A.T. 1956. Studies of clinical and electrical responses to deep temporal stimulation in man with some considerations of functional anatomy. *Res Publ Assoc Res Nerv Ment Dis* 36:316–334.

293. Johnson, G.L. 1936. Subjective visual sensations. *Arch Ophthalmol* 16:1–4.

294. Johnston McNussen, P. 1998. Migraine,

tension-type headache, and cluster headache. In Rosen, E.S.; Thompson, H.S.; Cumming, W.J.K.; Eustace, P., eds. *An Atlas of Neuro-ophthalmology.* London and Philadelphia: Mosby, 22.1–22.13.

295. Jolly, F. 1902. Ueber Flimmerskotom und Migräne. *Berl Klin Wschr* 39:973–976, 1003–1006.

296. Jung, C.G. 1912. *Wandlungen und Symbole der Libido: Beiträge zur Entwicklungsgeschichte des Denkens.* Leipzig and Vienna: Deuticke.

297. Jung, R. 1979. Translokation corticaler Migrainephosphene bei Augenbewegungen und vestibularen Reizen. *Neuropsychologia* 17:173–185.

298. Kahlbaum, K.L. 1886. Die Sinnesdelirien: Ein Beitrag zur klinischen Erweiterung der psychiatrischen Symptomatologie und zur physiologischen Psychologie. *Allg Z Psychiat* 23:1–86.

299. Kant, I. 1798. Von der Macht des Gemüths durch den bloßen Vorsatz seiner krankhaften Gefühle Meister zu seyn. *J prac Arzneykunde Wundarzneykunst* 5:701–751.

300. Katz, D. 1911. Die Erscheinungsweisen der Farben und ihre Beeinflussung durch die individuelle Erfahrung. *Z Psychol Ergänzungsband* 7:1–425.

301. Katz, J.; Melzack, R. 1990. Pain "memories" in phantom limbs: Review and clinical observations. *Pain* 43:319–36.

302. Kaufman, D.M.; Solomon, S. 1992. Migraine visual auras: A medical update for the psychiatrist. *Gen Hosp Psychiat* 14:162–170.

303. Kay, J.; Lesser, R. 1985. The nature of phonological processing in oral reading: Evidence from surface dyslexia. *Quart J Exp Psychol* 37A:39–81.

304. Kayan, A.; Hood, J.D. 1984. Neuro-otological manifestations of migraine. *Brain* 107:1123–1142.

305. Keller, H.L. 1933. *Mittelrheinische Buchmalereien in den Handschriften aus dem Kreise der Hiltgart von Bingen: Inaugural-Dissertation zur Erlangung der Doktorwürde der Hohen philosophischen Fakultät der Universität Frankfurt/Main.* Stuttgart: Ernst Surkamp.

306. Keller, K. 1920. Über die visuellen Erscheinungen der Migräne. *Neurol Zbl* 39:148–157.

307. Kesari, S. 2004. Digital rendition of visual migraines. *Arch Neurol* 61:1464–1465.

308. Kew, J.; Wright, A.; Halligan, P.W. 1998. Somesthetic aura: the experience of "Alice in Wonderland." *Lancet* 351:1934.

309. Kiester, E. 1987. Doctors close in on the mechanisms behind headache. *Smithsonian* Dec. 1987:175–189.

310. Kirkham, T.H. 1972. The ocular symptomatology of pituitary tumors. *Proc R Soc Med* 65:517–518.

311. Klages, W. 1954. Körpermißempfindungen bei Thalamuskranken und bei Schizophrenen. (Eine vergleichend psychopathologische Studie.) *Arch Psychiat Z ges Neurol* 192:130–142.

312. Klee, A. 1968. *A Clinical Study of Migraine with Particular Reference to the Most Severe Cases.* Copenhagen: Munksgaard.

313. Klee, A. 1975. Perceptual disorders in migraine. In Pearce, J., ed. *Modern Topics in Migraine.* London: Heinemann, 45–51.

314. Klee, A.; Willanger, R. 1966. Disturbances of visual perception in migraine. *Acta Neurol Scand* 42:400–414.

315. Klee, J.G. 1991. Neurology in Alice's *Wonderland* and *Through the Looking Glass. Headache Quart* 2:28–31.

316. Klein, R. 1928. Über Halluzinationen der Körpervergrößerung. *Mschr Psychiat Neurol* 67:78–85.

317. Klien, H. 1917. Entoptische Wahrnehmung des retinalen Pigmentepithels im Migräneanfall? *Z ges Neurol Psychiat* 36:323–334.

318. Klopp, H.W. 1951. Über Umgekehrt- und Verkehrtsehen. *Dtsch Z Nervenheilk* 165:231–260.

319. Klosterkötter, J. 1988. *Basissymptome und Endphänomene der Schizophrenie: Eine empirische Untersuchung der psychopathologischen Übergangsreihen zwischen defizitären und produktiven Schizophreniesymptomen. Monographien aus dem Gesamtgebiete der Psychiatrie, Band 52.* Berlin, Heidelberg, and New York: Springer.

320. Klüver, H. 1928. Mescal: The "divine" plant

and its psychological effects. London: Kegan Paul, Trench, Tubner.

321. Klüver, H. 1930. Fragmentary eidetic imagery. *Psychol Rev* 37:441–458.

322. Klüver, H. 1942. Mechanisms of hallucinations. Contributed in honor of Lewis M. Terman. In McNemar, Q.; Merrill, M.A., eds. *Studies in Personality.* New York and London: McGraw-Hill, 175–207.

323. Klüver, H. 1965. Neurobiology of normal and abnormal perception. In Hoch, P.H.; Zubin, J., eds. *Psychopathology of Perception.* New York and London: Grune and Stratton, 1–40.

324. Klüver, H. 1966. *Mescal and Mechanisms of Hallucinations.* Chicago: Univ. of Chicago Press.

325. Köhler, W. 1924. *Die physischen Gestalten in Ruhe und im stationären Zustand: Eine naturphilosophische Untersuchung.* Erlangen, Germany: Verlag der Philosophischen Akademie.

326. Kölmel, H.W. 1982. Visuelle Perseveration. *Nervenarzt* 53:560–571.

327. Kölmel, H.W. 1984. Colored patterns in hemianopic fields. *Brain* 107:155–167.

328. Kölmel, H.W. 1985. Complex visual hallucinations in the hemianopic field. *J Neurol Neurosurg Psychiat* 48:29–38.

329. Kölmel, H.W. 1993. Visual illusions and hallucinations. *Baillière's Clin Neurol* 2:243–264.

330. Koenig, F. 1953. Über die Ophthalmoneurologie der Migräne. Basel: *Ophthalmologica* 125:363–366.

331. Koffka, K. 1955. *Principles of Gestalt Psychology, 4th ed.* London: Routledge & Kegan Paul.

332. Kosmorsky, G. 1987. Unusual visual phenomenon during acephalgic migraine. *Arch Ophthalmol* 105:613.

333. Kosslyn, S.M.; Koenig, O. 1992. *Wet Mind: The New Cognitive Neuroscience.* New York: Macmillan.

334. Kovalevsky, P. 1902. *La migraine et son traitement.* Paris: Vigot Frères.

335. Krafft-Ebing, R. von. 1895. Ueber transitorische Geistesstörung bei Hemicranie. *Wien Klin Rundsch* 9:721–723.

336. Krafft-Ebing, R. von. 1897. Ueber Hemicranie und deren Beziehungen zur Epilepsie und Hysterie. In Krafft-Ebing, R. von. *Arbeiten aus dem Gesammtgebiet der Psychiatrie und Neuropathologie, Heft 1.* Leipzig: Barth, 109–132.

337. Krafft-Ebing, R. von. 1897. Ueber transitorische Geistesstörung bei Hemicranie. In Krafft-Ebing, R. von. *Arbeiten aus dem Gesammtgebiet der Psychiatrie und Neuropathologie, Heft 1.* Leipzig: Barth, 133–158.

338. Krafft-Ebing, R. von. 1902. Ueber Migränepsychosen. *Jb Psychiat Neurol* 21:38–50.

339. Kramer, S.N. 1944. Dilmun, the land of the living. *Bull Am Schools Orient Res* 96:18–28.

340. Krauss, R.H. 1992. *Jenseits von Licht und Schatten: Die Rolle der Photographie bei bestimmten paranormalen Phänomenen—ein historischer Abriß.* Marburg, Germany: Jonas.

341. Krenkel, M. 1873. Das körperliche Leiden des Apostels Paulus. *Zschr wiss Theol* 16:238–244.

342. Kryst, S.; Scherl, E. 1994. A population-based survey of the social and personal impact of headache. *Headache* 34:344–350.

343. Kubena, T.; Kubena, K. 1998. Zrakové vjemy pri oftalmické migréne. *Cesk Slov Oftalmol* 54:105–108.

344. Kunkle, E.C.; Anderson, W.B. 1961. Significance of minor eye signs in headache of migraine type. *Arch Ophthalmol* 65:504–507.

345. Kupfer, M. 1891. *Flimmerskotom und entoptische Erscheinungen.* Inaugural-Dissertation. Erlangen, Germany: Medizinische Fakultät der Friedrich-Alexander-Universität.

346. Kurylyszyn, N.; McGrath, P.J.; Cappelli, M.; Humphreys, P. 1987. Children's drawings: What can they tell us about intensity of pain? *Clin J Pain* 2:155–158.

347. Labarraque, H. 1837. *Essais sur la céphalalgie et la migraine.* Paris: Thèse.

348. Lancaster, N.P. 1954. Body-image disturbances in patients attending a psychiatric outpatient clinic. *Lancet* 1:81–82.

349. Lance, J.W. 1969. *The Mechanism and Manage-*

ment of Headache. London: Butterworths, 96–97.

350. Lance, J.W. 1976. Simple formed hallucinations confined to the area of a specific visual field defect. *Brain* 99:719–734.

351. Larner, A.J. 2004. Lewis Carroll's Humpty Dumpty: An early report of prosopagnosia? *J Neurol Neurosurg Psychiatry* 75:1063.

352. Lashley, K.S. 1941. Patterns of cerebral integration indicated by the scotomas of migraine. *Arch Neurol Psychiat* 46:331–339.

353. Latham, P.W. 1873. *On Nervous or Sick-headache: Its Varieties and Treatment; Two Lectures*. Cambridge: Deighton, Bell.

354. Laurent, B.; Michel, D.; Antoine, J.C.; Montagnon, D. 1984. Migraine basilaire avec alexie sans agraphie: spasme artériel à l'artériographie et effet de la naloxone. *Rev Neurol* 140:663–665.

355. Lauritzen, M. 1994. Pathophysiology of the migraine aura: The spreading depression theory. *Brain* 117:199–210.

356. Lawall, J.S.; Oommen, K.J. 1978. Basilar artery migraine presenting as conversion hysteria. *J Nerv Ment Dis* 166:809–811.

357. Leadbeater, C.W. 1899. *Clairvoyance*. London: Theosophical Publishing Society.

358. Leadbeater, C.W. 1902. *Man Visible and Man Invisible: Examples of Different Types of Men as Seen by Means of Trained Clairvoyance*. London: Theosophical Publishing Society.

359. Leão, A.A.P. 1944. Spreading depression of activity in the cerebral cortex. *J Neurophysiol* 7:359–390.

360. Lebensohn, J.E. 1934. The nature of photophobia. *Arch Ophthalmol* 12:380–390.

361. Lebensohn, J.E. 1941. Wollaston and hemianopsia. *Am J Ophthalmol* 24:1053–1056.

362. Lefèbre, C.; Kölmel, H.W. 1989. Palinopsia as epileptic phenomenon. *Eur Neurol* 29:323–327.

363. Leker, R.R.; Karni, A.; River, Y. 1996. Microsomatognosia: Whole body schema illusion as part of an epileptic aura. *Acta Neurol Scand* 94:383–385.

364. Lélut, F. 1846. *L'amulette de Pascal: Pour servir à l'histoire des hallucinations*. Paris: Baillière.

365. Lennox, W.G.; Lennox, M.A. 1960. *Epilepsy and Related Disorders, Vol. 2*. Boston and Toronto: Little, Brown.

366. Lepie, H.; Minkenberg, G. 1995. *Die Schatzkammer des Aachener Doms*. Aachen, Germany: Domkapitel Aachen.

367. Leroy, R. 1909. Les hallucinations lilliputiennes. *Ann Méd Psychol* 67:278–289.

368. Levitan, H. 1984. Dreams which culminate in migraine headaches. *Psychother Psychosom* 41:161–166.

369. Lewis, DW.; Middlebrook, M.T.; Mehallik, L.; Rauch, T.M.; Deline, C.; Thomas, E.F. 1996. Pediatric headaches: What do the children want? *Headache* 36:224–230.

370. Lhermitte, J. 1939. *L'Image de notre corps*. Paris: Nouvelle Revue Critique.

371. Lhermitte J. 1951. *Les hallucinations: Clinique et psychopathologie*. Paris: Doin.

372. Lindner, A.; Reiners, K.; Toyka, K.V. 1996. Meningeal hyperperfusion visualized by MRI in a patient with visual hallucinations and migraine. *Headache* 36:53–57.

373. Lippman, C.W. 1951. Hallucinations in migraine. *Am J Psychiat* 107:856–858.

374. Lippman, C.W. 1952. Certain hallucinations peculiar to migraine. *J Nerv Ment Dis* 116:346–351.

375. Lippman, C.W. 1953. Hallucinations of physical duality in migraine. *J Nerv Ment Dis* 117:345–350.

376. Lippman, C.W. 1954. Recurrent dreams in migraine: an aid to diagnosis. *J Nerv Ment Dis* 120:273–276.

377. Lisle, L. 1980. *Portrait of an Artist: A Biography of Georgia O'Keeffe*. New York: Seaview.

378. Listing, J.B. 1867. Mittheilung über das sogenannte "sichelförmige Flimmerskotom." In Zehender, W. Referat über Testelin, Notiz über Hemiopie. *Klin Mbl Augenheilk* 5:334–335.

379. Liu, G.T.; Schatz, N.J.; Galetta, S.L.; Volpe, N.J.; Skobieranda, F.; Kosmorsky, G.S. 1995. Persistent positive visual phenomena in migraine. *Neurology* 45:664–668.

380. Liveing, E. 1873. *On Megrim, Sick-headache,*

and Some Allied Disorders: A Contribution to the Pathology of Nerve-storms. London: Churchill.

381. Livesley, B. 1973. The Alice in Wonderland syndrome. *Nurs Times* 69:730–732.

382. Lobowa, L.P. 1938. Vestibuläres Syndrom in der Struktur neuropsychischer Erkrankungen (Referat). *Zbl ges Neurol Psychiat* 88:616–617.

383. Loeser, J.D. 1988. Unlocking the secrets of pain—the treatment: A new era. In Bernstein, E., ed. *1988 Medical and Health Annual.* Chicago: Encyclopaedia Britannica, 120–131.

384. Loewenberg, R.D. 1953. From Immanuel Kant's self-analysis. *Am Imago* 10:307–322.

385. Löwenfeld, L. 1882. Zur Casuistik der transitorischen psychischen Störungen. *Neurol Zbl* 1:268–272.

386. Lord, G.D.A. 1982. A study of premonitory focal neurological symptoms in migraine. In Rose, F.C., ed. *Advances in Migraine Research and Therapy.* New York: Raven, 45–48.

387. Luda, E.; Bo, E.; Sicuro, R.; Comitangelo, R.; Campana, M. 1991. Sustained visual aura: a totally new variation of migraine. *Headache* 31:582–583.

388. Lukianowicz, N. 1958. Autoscopic phenomena. *Arch Neurol Psychiat* 80:199–220.

389. Lukianowicz, N. 1967. "Body image" disturbances in psychiatric disorders. *Br J Psychiat* 113:31–47.

390. Lunn, V. 1948. *Om Legemsbevidstheden: Belyst ved Nogle Forstyrrelser af den Normale Oplevelsesmaade.* Copenhagen: Ejnar Munksgaard.

391. Lunn, V. 1965. On body hallucinations. *Acta Psychiat Scand* 41:387–399.

392. MacGregor, A. 1999. *Managing Migraine in Primary Care.* Oxford: Blackwell Science.

393. Main, A.; Dowson, A.; Gross, M. 1997. Photophobia and phonophobia in migraineurs between attacks. *Headache* 37:492–495.

394. Manford, M.; Andermann, F. 1998. Complex visual hallucinations: Clinical and neurobiological insights. *Brain* 121:1819–1840.

395. Marsden, C.D. 1986. Hysteria—a neurologist's view. *Psychol Med* 16:277–288.

396. Martin, P.R. 1993. *Psychological Management of Chronic Headaches.* New York and London: Guilford.

397. Martineau, J., ed. 1997. *Victorian Fairy Painting.* London: Merrell Holberton.

398. Maudsley, H. 1939. *Natural Causes and Supernatural Seemings.* London: Watts.

399. Mauthner, L. 1872. Zur Casuistik der Amaurose. *Oesterr Z prakt Heilk* 18:169–172, 317–321, 333–336, 347–350, 363–367, 379–383, 411–414, 459–464.

400. Mauthner, L. 1881. *Gehirn und Auge: Separat-Abdruck der Vortraege aus dem Gesammtgebiete der Augen-Heilkunde für Studirende und Aerzte, I Band, Heft VI—VIII.* Wiesbaden, Germany: Bergmann, 508–518.

401. Mayer-Gross, W. 1935. On depersonalization. *Br J Med Psychol* 15:103–126.

402. McCulloch, W.S. 1977. Sketch of the spread of fortification spectra, 1 February 1965. In Baumgartner, G., Neuronal mechanisms of the migrainous visual aura. In Rose, F.C., ed. *Physiological Aspects of Clinical Neurology.* Oxford: Blackwell, 112.

403. Mendel, E. 1906. Die Migräne. *Dtsch Med Wschr* 32:785–788.

404. Menninger-Lerchenthal, E. 1935. *Das Truggebilde der eigenen Gestalt: Abhandlungen aus der Neurologie, Psychiatrie, Psychologie und ihren Grenzgebieten, Heft 74.* Berlin: Karger.

405. Mercier. 1902. Discussion on Brunton, hallucinations, and allied mental phenomena. *J Ment Sci* 48:257.

406. Miles, P.W. 1958. Scintillating scotoma: Clinical and anatomic significance of pattern, size, and movement. *JAMA* 167:1810–1813.

407. Milner, P.M. 1958. Note on a possible correspondence between the scotomas of migraine and spreading depression of Leão. *EEG Clin Neurophysiol* 10:705.

408. Mingazzini, G. 1893. Sui rapporti fra l'emicrania oftalmica e gli stati psicopatici transitorii. *Riv Sper Freniatr Med Leg Alienazioni Ment* 19:216–229.

409. Mingazzini, G. 1897. Fernere klinische

Beobachtungen über geistige Störungen in Folge von Hemicranie. *Mschr Psychiat Neurol* 1:122–155.

410. Mingazzini, G. 1908. Über Symptome infolge von Verletzungen des Occipitallappens durch Geschosse. *Neurol Zbl* 27:1112–1123.

411. Mingazzini, G. 1926. Klinischer Beitrag zum Studium der cephalalgischen und hemikranischen Psychosen. *Z ges Neurol Psychiat* 101:428–451.

412. Mitchell, J.K. 1897. Headache with visual hallucination. *J Nerv Ment Dis* 24:620–625.

413. Mitchell, J.L. 1981. *Out-of-body Experiences: A Handbook.* Jefferson, N.C.: McFarland.

414. Mitchell, S.W. 1887. Neuralgic headaches with apparitions of unusual character. *Am J Med Sci* 94:415–419.

415. Möbius, P. 1894. *Die Migräne.* Vienna: Hölder.

416. Möllendorff. 1867. Ueber Hemikranie. *Arch pathol Anat Physiol klin Med* 41:385–395.

417. Moersch. 1924. Psychic manifestations in migraine. *Am J Psychiat* 3:697–716.

418. Monroe, R.A. 1971. *Journeys Out of the Body.* New York: Doubleday.

419. Montandon, R. 1946. *Le monde invisible et nous: II, Formes matérialisées, médiums— fantomes—ectoplasme—comment ils se manifestent.* Paris and Neuchâtel, Switzerland: Victor Attinger.

420. Mooney, A.J.; Carey, P.; Ryan, M.; Bofin, P. 1965. Parasagittal parietooccipital meningioma. *Am J Ophthalmol* 59:197–205.

421. Morgenthaler, W. 1919. Über Zeichnungen von Gesichtshalluzinationen. *Z ges Neurol Psychiat* 45:19–29.

422. Morrison, D.P. 1990. Abnormal perceptual experiences in migraine. *Cephalalgia* 10:273–277.

423. Muldoon, S.; Carrington, H. 1929. *The Projection of the Astral Body.* London: Rider.

424. Muldoon, S.; Carrington, H. 1951. *The Phenomena of Astral Projection.* London: Rider.

425. Murray, T.J. 1982. The neurology of *Alice in Wonderland. Can J Neurol Sci* 9:453–457.

426. Nachtigäller, H.; Hoyt, W.F. 1970. Störungen des Seheindruckes bei bitemporaler Hemianopsie und Verschiebung der Sehachsen. *Klin Mbl Augenheilk* 156:821–836.

427. Nass, R.; Sinha, S.; Solomon, G. 1985. Epileptic facial metamorphopsia. *Brain Dev* 7:50–52.

428. Navarre, P.-J. 1911. *La maladie de Pascal: Étude médicale et psychologique.* Lyon: Rey.

429. Nicola, U.; Podoll, K. 2001. L'arte emicranica come strumento di studio dell'ispirazione artistica. *Confinia Cephalalgica* 10.137–144.

430. Nicola, U.; Podoll, K. 2002. L'enigma di Giorgio de Chirico. La nascita della pittura metafisica dallo spirito dell'emicrania. *Confinia Cephalalgica* 11:9–24.

431. Nicola, U.; Podoll, K. 2003. *L'aura di Giorgio de Chirico. Arte emicranica e pittura metafisica.* Milan: Mimesis.

432. Nicola, U.; Podoll, K. 2003. Le avventure di Giorgio de Chirico nel paese dell' emicrania. In Porcella, G., ed. *Arte emicrania? Opere e parole tra mal di testa & metafisica.* Rome: Il Cigno, 5–9.

433. Niedermeyer, E. 1992. Migraine-triggered epilepsy. *Clin Electroencephalogr* 24:37–43.

434. Nielsen, J.M. 1930. Migraine equivalent. *Am J Psychiat* 9:637–641.

435. Nielsen, J.M.; Ingham, S.D. 1940. Evidence of focal vascular disturbance in migraine equivalent. *Bull Los Angeles Neurol Soc* 5:113–119.

436. O'Connor, P.S.; Tredici, T.J. 1981. Acephalgic migraine: Fifteen years experience. *Ophthalmology* 88:999–1003.

437. Oestreich, A.E. 1980. Intactness of useful central vision during migraine scotoma. *Headache* 20:217.

438. Olesen, J. 1978. Some clinical features of the acute migraine attack: An analysis of 750 patients. *Headache* 18:268–271.

439. Olesen, J. 1984. The significance of trigger factors in migraine. In Rose, F.C., ed. *Progress in Migraine Research 2.* London: Pitman, 18–29.

440. Onfray, R. 1926. Où l'on voit que Pascal avait des migraines ophtalmiques. *Presse Méd* 34:715–716.

441. Onfray, R. 1926. Les migraines ophtalmiques de Pascal: Pascal sténographe. *Presse Méd* 34:1293–1294.

442. Onfray, R. 1949. *L'abîme de Pascal.* Alençon, France: Alençonnaise.

443. Oppenheim, H. 1898. *Lehrbuch der Nervenkrankheiten für Ärzte und Studirende, 2nd ed.* Berlin: Karger.

444. Ormond, A.W. 1925. Visual hallucinations in sane people. *Br Med J* 2:376–379.

445. Osis, K. 1979. Insiders' views of the OBE: A questionnaire survey. In Roll, W.G., ed. *Research in Parapsychology 1978.* Metuchen, N.J.: Scarecrow, 50–52.

446. Ostenfeld, I. 1967. Et tilfaelde af mikropsi. *Ugeskr Laeger* 129:325–327.

447. Otto, R. 1972–1973. Zu einigen Miniaturen einer Sciviashandschrift des 12 Jahrhunderts. *Mainzer Z* 67/68:128–137.

448. Pässler. 1902. Ueber einige seltenere Fälle von Migräne. *Münch Med Wschr* 49:1087–1090.

449. Palmer, J. 1979. A community mail survey of psychic experiences. *J Am Soc Psych Res* 73:221–251.

450. Palmer, J.; Vassar, C. 1974. ESP and out-of-the body experiences: An exploratory study. *J Am Soc Psych Res* 68:257–280.

451. Panayiotopoulos, C.P. 1994. Elementary visual hallucinations in migraine and epilepsy. *J Neurol Neurosurg Psychiat* 57:1371–1374.

452. Panayiotopoulos, C.P. 1999. Elementary visual hallucinations, blindness, and headache in idiopathic occipital epilepsy: Differentiation from migraine. *J Neurol Neurosurg Psychiatry* 66:536–540.

453. Parker, D.M.; Besson, J.A.; McFadyen, M. 1990. Intermittent alexia. *Cortex* 26:657–660.

454. Parry, C.H. 1825. *Collection from the Unpublished Medical Writings of the Late C.H. Parry, Vol. 1.* London: Underwood.

455. Patterson, S.; Silberstein, S.D. 1993. Sometimes Jello helps: Perceptions of headache etiology, triggers, and treatment in literature. *Headache* 33:76–81.

456. Peatfield, R.C. 1991. Temporal lobe phenomena during the aura phase of migraine attacks. *J Neurol Neurosurg Psychiat* 54:371–372.

457. Peatfield, R.C.; Rose, F.C. 1981. Migrainous visual symptoms in a woman without eyes. *Arch Neurol* 38:466.

458. Penfield, W.; Boldrey, E. 1937. Somatic motor and sensory representation in the cerebral cortex of man as studied by electrical stimulation. *Brain* 60:389–443.

459. Penfield, W.; Jasper, H.H. 1954. *Epilepsy and the Functional Anatomy of the Human Brain.* Boston: Little, Brown.

460. Penfield, W.; Perot, P. 1963. The brain's record of auditory and visual experience. *Brain* 86:595–696.

461. Penfield, W.; Rasmussen, A.T. 1950. *The Cerebral Cortex of Man: A Clinical Study of Localization of Function.* London: Macmillan.

462. Perty, M. 1879. Neue Erfahrungen aus dem Gebiete der mystischen Thatsachen mit Hinsicht auf verwandte ältere. (Bilocation oder Fernwirkung der Lebenden.) *Psychische Studien* 6:294–301, 344–352.

463. Pichler, A. 1912. Das Gesichtsfeld beim Flimmerskotom, sowie andere Beiträge zum klinischen Bilde dieser Krankheit. *Prag Med Wschr* 37:607–613.

464. Pichler, E. 1943. Über Störungen des Raum- und Zeiterlebens bei Verletzungen des Hinterhauptlappens. *Z ges Neurol Psychiat* 173:434–464

465. Pick, A. 1894. Zur Symptomatologie der functionellen Aphasien, nebst Bemerkungen zur Migraine ophthalmique. *Berl Klin Wschr* 31:1060–1063.

466. Pick, A. 1904. The localizing diagnostic significance of so-called hemianopic hallucinations, with remarks on bitemporal scintillating scotomata. *Am J Med Sci* 127:82–92.

467. Pick, A. 1908. Ueber eine besondere Form von Orientierungsstörung und deren Vorkommen bei Geisteskranken. *Dtsch Med Wschr* 34:2014–2017.

468. Pick, A. 1919. Kleine Beiträge zur Lehre von den Halluzinationen. *Neurol Zbl* 38:647–652.

469. Pick, A. 1922. Bemerkungen zur Lehre von den Halluzinationen. *Mschr Psychiat Neurol* 52:65–77.

470. Piorry, P. 1831. Memoire sur une des affections désignées sous le nom de migraine ou hémicranie. *J Univ hebd Méd Chir* 2:5–18.

471. Piovesan, E.J.; Kowacs, P.A.; Werneck, L.C.; Siow, C. 2003. Oscillucusis and sudden deafness in a migraine patient. *Arq Neuropsiquiatr* 61:848–850.

472. Piso, C. 1618. *Selectiorum observationum et consiliorum de praetervisis hactenus morbis affectibusque praeter naturam ab aqua seu serosa colluvie et diluvie artis liber singularis.* Pont-à-Mousson, France: C. Mercator.

473. Plant, G.T. 1896. The fortification spectra of migraine. *Br Med J* 293:1613–1617 [published erratum appears in *Br Med J* 1987, 294:90].

474. Plant, G.T. 1986. A centrally generated colored phosphene. *Clin Vision Sci* 1:161–172.

475. Podoll, K. 1998. Migraine art—the migraine experience from within. *Cephalalgia* 18:376.

476. Podoll, K. 2001. Derek Robinson's audiovisual program *In the Picture—A Personal View of Migraine:* The cradle of the Migraine Art concept. *Neurol Psychiat Brain Res* 9:17–22.

477. Podoll, K. 2005. Subjektive visuelle Sensationen—Halluzinatorische Formkonstanten der Migräneaura als Schnittstelle zwischen Kunst und Neurowissenschaften. In Könches, B.; Weibel, P., eds. *unSICHTBARes. Kunst_Wissenschaft. Algorithmen als Schnittstellen zwischen Kunst und Wissenschaft.* Bern: Benteli, 286–303.

478. Podoll, K. 2006. Migraine art in the Internet: A study of 450 contemporary artists. *Int Rev Neurobiol* 74:89–107.

479. Podoll, K. 2007. Migräneaura, Synästhesie und künstlerische Inspiration. In Clausberg, K.; Weibel, P., eds. *Ausdruck, Ausstrahlung, Aura. Synästhesien der Beseelung im Medienzeitalter.* Bad Honnef, Germany: Hippocampus, 185–196.

480. Podoll, K.; Ayles, D. 2002. Inspired by migraine: Sarah Raphael's 'Strip!' paintings. *J Roy Soc Med* 95:417–419.

481. Podoll, K.; Ayles, D. 2006. Sarah Raphael's migraine with aura as inspiration for the foray of her work into abstraction. *Int Rev Neurobiol* 74:109–118.

482. Podoll, K.; Ebel, H. 1998. Halluzinationen der Körpervergrößerung bei der Migräne. *Fortschr Neurol Psychiat* 66:259–270.

483. Podoll, K.; Nicola, U. 2004. Cefalee emicraniche come fonte di ispirazione in un artista contemporaneo. *Confinia Cephalalgica* 13:11–20.

484. Podoll, K.; Nicola, U. 2007. Die Krankheit des Giorgio de Chirico. Migräne oder Epilepsie? In Bormuth, M.; Podoll, K.; Spitzer, K., eds. *Kunst und Krankheit. Studien zur Pathographie.* Göttingen, Germany: Wallstein, 127–145.

485. Podoll, K.; Robinson, D. 1999. Lewis Carroll's migraine experiences. *Lancet* 353:1366.

486. Podoll, K.; Robinson, D. 1999. Out-of-body experiences and related phenomena in Migraine Art. *Cephalalgia* 19:886–896.

487. Podoll, K.; Robinson, D. 2000. Macrosomatognosia and microsomatognosia in Migraine Art. *Acta Neurol Scand* 101:413–416.

488. Podoll, K.; Robinson, D. 2000. Migraine experiences as artistic inspiration in a contemporary artist. *J Roy Soc Med* 93:263–265.

489. Podoll, K.; Robinson, D. 2000. Illusory splitting as visual aura symptom in migraine. *Cephalalgia* 20:228–232.

490. Podoll, K.; Robinson, D. 2000. Self-report of the syndrome of Alice in Wonderland in migraine. *Neurol Psychiat Brain Res* 8:89–90.

491. Podoll, K.; Robinson, D. 2000. Cenesthetic pain sensations illustrated by an art teacher suffering from basilar migraine. *Neurol Psychiat Brain Res* 8:171–176.

492. Podoll, K.; Robinson, D. 2000. Mosaic illusion as visual aura symptom in migraine. *Neurol Psychiat Brain Res* 8:181–184.

493. Podoll, K.; Robinson, D. 2001. Corona phenomenon as visual aura symptom in migraine. *Cephalalgia* 21:712–717.

494. Podoll, K.; Robinson, D. 2001. Recurrent Lilliputian hallucinations as visual aura

symptom in migraine. *Cephalalgia* 21:990–992.

495. Podoll, K.; Robinson, D. 2001. The idea of a presence as aura symptom in migraine. *Neurol Psychiat Brain Res* 9:71–74.

496. Podoll, K.; Robinson, D. 2001. Visual migraine aura as source of artistic inspiration in professional painters. *Neurol Psychiat Brain Res* 9:81–94.

497. Podoll, K.; Robinson, D. 2001. *Migräne und spirituelle Erfahrung*. Aachen, Germany: Ariadne.

498. Podoll, K.; Robinson, D. 2002. Migraine Art—the migraine experience from within. *Neurol Psychiat Brain Res* 10:29–34.

499. Podoll, K.; Robinson, D. 2002. Auditory-visual synaesthesia in a patient with basilar migraine. *J Neurol* 249:476–477.

500. Podoll, K.; Robinson, D. 2002. Splitting of the body image as somesthetic aura symptom in migraine. *Cephalalgia* 22.

501. Podoll, K.; Robinson, D. 2003. Pictorial representations of macrosomatognosia occurring as migraine aura symptom. *Neurol Psychiat Brain Res* 10:125–128.

502. Podoll, K.; Mühlbauer, V.; Houben, I.; Ebel, H. 1998. Hypnagoge Halluzinationen der Körpervergrößerung und der Körperverkleinerung. *Fortschr Neurol Psychiat* 66:338–344.

503. Podoll, K.; Bollig, G.; Vogtmann, T.; Pothmann, R.; Robinson, D. 1999. Cenesthetic pain sensations illustrated by an artist suffering from migraine with typical aura. *Cephalalgia* 19:598–601.

504. Podoll, K.; Töpper, R.; Robinson, D.; Saß, H. 2000. Wiederkehrende Träume als Aurasymptome der Migräne. *Fortschr Neurol Psychiat* 68:145–149.

505. Podoll, K.; Hoff, P.; Saß, H. 2000. Die Migräne Immanuel Kants. *Fortschr Neurol Psychiat* 68:332–337.

506. Podoll, K.; Hoff, P.; Saß, H. 2001. The migraine of Immanuel Kant. *Neurol Psychiat Brain Res* 9:49–50.

507. Podoll, K.; Robinson, D.; Nicola, U. 2001. The migraine of Giorgio de Chirico—part I:

History of illness. *Neurol Psychiat Brain Res* 9:139–156.

508. Podoll, K.; Robinson, D.; Nicola, U. 2002. Giorgio de Chirico/Alberto Savinio—Die andere Moderne. Die Geburt der metaphysischen Malerei aus dem Geist der Migräne. *Dtsch Ärztebl* 99:A449–450.

509. Podoll, K.; Robinson, D.; Nicola, U. 2002. Retrospektive zu de Chirico und Savinio in München: Bilderwelten, geprägt durch die Migräne. *MMW-Fortschr Med* 144, no. 6:57.

510. Podoll, K.; Ebel, H.; Robinson, D.; Nicola, U. 2002. Sintomi essenziali ed accessori nella sindrome di Alice nel paese delle meraviglie. *Minerva Med* 93:287-293.

511. Podoll, K.; Nicola, U. 2004. Le allucinazioni caleidoscopiche come sintomo visivo dell'aura emicranica. *Confinia Cephalalgica* 12:53-63.

512. Podoll, K.; Robinson, D.; Nicola, U. 2004. The migraine of Giorgio de Chirico—part II: The poetology of revelation. *Neurol Psychiat Brain Res* 12:9-20.

513. Poeck, K. 1965. Über die Orientierung am eigenen Körper. *Akt Fragen Psychiat Neurol* 2:144–167.

514. Poeck, K.; Orgass, B. 1971. The concept of the body schema: A critical review and some experimental results. *Cortex* 7:254–277.

515. Pöppel, E. 1973. Fortification illusion during an attack of ophthalmic migraine. *Naturwissenschaften* 60:554–555.

516. Pötzl, O. 1933. Polyopie und gnostische Störung. Ein Beitrag zur Pathophysiologie der zerebralen Sehstörungen. *Jb Psychiat Neurol* 50:57–77.

517. Pötzl, O. 1943. Über Anfälle vom Thalamustypus. *Z ges Neurol Psychiat* 176:793–800.

518. Pötzl, O. 1954. Über Palinopsie (und deren Beziehung zu Eigenleistungen okzipitaler Rindenfelder). *Wien Z Nervenheilk* 8:161–186.

519. Pons, T.P.; Garraghthy, P.E.; Ommaya, A.K.; Kaas, J.H.; Taub, E.; Mishkin, M. 1991. Massive cortical reorganization after sensory deafferentiation in adult macaques. *Science* 252:1857–1860.

520. Poppelreuter, W. 1917. *Die psychischen Schädi-*

gungen durch Kopfschuß im Kriege 1914/16 mit besonderer Berücksichtigung der pathopsychologischen, pädagogischen, gewerblichen und sozialen Beziehungen, Vol. 1. Die Störungen der niederen und höheren Sehleistungen durch Verletzungen des Okzipitalhirns. Leipzig: Voss.

521. Purtscher, O. 1887. Neue Beiträge zur Frage der Erythropsie. *Arch Augenheilk* 17:260–275.

522. Queiroz, L.P.; Rapoport, A.M.; Weeks, R.E.; Sheftell, F.D.; Siegel, S.E.; Baskin, S.M. 1997. Characteristics of migraine visual aura. *Headache* 37:137–141.

523. Quensel, F. 1927. Ein Fall von rechtsseitiger Hemianopsie mit Alexie und zentral bedingtem monokulärem Doppeltsehen. *Mschr Psychiat Neurol* 65:173–207.

524. Ramachandran, V.S.; Gregory, R.L. 1991. Perceptual filling in of artificially induced scotomas in human vision. *Nature* 350:699–702.

525. Ramachandran, V.S.; Stewart, M.; Rogers-Ramachandran, D.C. 1992. Perceptual correlates of massive cortical reorganization. *NeuroReport* 3:583–586.

526. Ranzow, E. 1920. Über Migränedämmerzustände und periodische Dämmerzustände unklarer Herkunft. *Mschr Psychiat Neurol* 47:98–118.

527. Raskin, N.H.; Appenzeller, O. 1980. Migraine: Clinical aspects. In Smith, L.H., ed. *Major Problems in Internal Medicine* 19:28–83.

528. Raskin, N.H.; Schwartz, R.K. 1980. Ice pick-like pain. *Neurology* 30:203–205.

529. Rau, H.; Vetterli, A. 1978. Über die kopfschmerzfreie Migränevariante. *Arch Psychiat Nervenkr* 225:333–348.

530. Raullet, J. 1883. *De la migraine ophthalmique.* Paris: Thèse.

531. Reggia, J.A.; Montgomery, D. 1996. A computational model of visual hallucinations in migraine. *Comput Biol Med* 26:133–141.

532. Regnard, A. 1898–1899. Génie et folie: Réfutation d'un paradoxe. *Ann Méd Psychol* 56, ser. 8, vol. 7:10–34, 177–195, 353–370; 56, ser. 8, vol. 8:5–25, 204–228; 57, ser. 8, vol. 9:22–42, 379–419.

533. Restak, R.M. 2006. Alice in migraineland. *Headache* 46:306–311.

534. Reuss, A. von. 1876. Kasuistische Beiträge zur Kenntniss des Flimmerskotoms. *Wien Med Presse* 17:7–9, 52–54, 126–128, 188–190, 231–234, 297–298, 366–368, 392–394.

535. Reuss, A. von. 1905. Zur Symptomatologie des Flimmerscotoms nebst einigen Bemerkungen über das Druckphosphen. *Arch Augenheilk* 53:78–94.

536. Richards, W. 1971. The fortification illusions of migraines. *Sci Am* 224:88–96.

537. Riley, H.A. 1932. Migraine. *Bull Neurol Inst NY* 2:429–544.

538. Riley, H.A. 1937. Migraine in children and the mechanism of the attack. *Bull Neurol Inst NY* 6:387–402.

539. Riley, H.A.; Brickner, R.M.; Soltz, S.E. 1935–1936. Unusual types of migraine. *Bull Neurol Inst NY* 4:403–421.

540. Robert, J.; Miró, O.; Pedrol, E.; Cardellach, F. 1995. Palinopsias como manifestación de una migraña acompañada. *Med Clin Barc* 105:76–77.

541. Rock, I. 1983. *The Logic of Perception.* Cambridge, Mass., and London: MIT Press.

542. Rönne, H. 1936. Die Architektur des corticalen Sehzentrums durch Selbstbeobachtung bei Flimmerscotom beleuchtet. Copenhagen: *Acta Ophthalmol* 14:341–347.

543. Rogo, D.S. 1978. Introduction: Autobiographical accounts. In Rogo, D.S., ed. *Mind Beyond the Body: The Mystery of ESP Projection.* New York: Penguin, 231–259.

544. Rolak, L.A. 1991. Literary neurologic syndromes: Alice in Wonderland. *Arch Neurol* 48:649–651.

545. Ropper, A.H. 1983. Illusion of tilting of the visual environment: Report of five cases. *J Clin Neuroophthalmol* 3:147–151.

546. Rose, F.C. 1984. Preface. In Rose, F.C., ed. *Progress in Migraine Research 2.* London: Pitman, ix.

547. Rose, F.C.; Gawel, M. 1979. *Migraine—the Facts.* Oxford: Oxford Univ. Press.

548. Rovamo, J. 1978. Receptive field density of retinal ganglion cells and cortical magnification factor in man. *Med Biol* 56:97–102.

549. Rovamo, J. Virsu, V. 1979. An estimation and application of the human cortical magnification factor. *Exp Brain Res* 37:495–510.

550. Ruete, C.G.T. 1843. *Klinische Beiträge zur Pathologie und Physiologie der Augen und Ohren: Erstes Jahresheft.* Brunswick, Germany: Vieweg, 286.

551. Ruete, C.G.T. 1845. *Lehrbuch der Ophthalmologie für Aerzte und Studirende.* Brunswick, Germany: Vieweg.

552. Ruskin, J. 1857. *The Elements of Drawing; in three letters to beginners.* London: Smith Elder.

553. Russell, M.B.; Iversen, H.K.; Olesen, J. 1994. Improved description of the migraine aura by a diagnostic aura diary. *Cephalalgia* 14:107–117.

554. Sacks, O.W. 1970. *Migraine: The Evolution of a Common Disorder.* Berkeley and Los Angeles: Univ. of Calif. Press.

555. Sacks, O.W. 1984. *A Leg to Stand On.* London: Duckworth.

556. Sacks, O.W. 1992. *Migraine: Revised and Expanded.* Berkeley and Los Angeles: Univ. of Calif. Press.

557. Sackville-West, V. 1943. *The Eagle and the Dove. A Study in Contrasts: Saint Teresa of Avila—Saint Thérèse of Lisieux.* London: Michael Joseph.

558. Saper, J.E. 1988. Portrait of a migraine. In Zeleny, R.O., ed. *The World Book Health & Medical Annual 1989.* Chicago and London: World Book, 10–23.

559. Saul, L.J. 1965. Dream scintillations. *Psychosom Med* 27:286–289.

560. Saurma-Jeltsch, L.E. 1998. *Die Miniaturen im "Liber Scivias" der Hildegard von Bingen.* Wiesbaden, Germany: Reichert.

561. Schilder, P, 1923. *Das Körperschema: Ein Beitrag zur Lehre vom Bewusstsein des eigenen Körpers.* Berlin: Springer.

562. Schilder, P. 1935. *The Image and Appearance of the Human Body.* London: Kegan Paul, Trench, Trubner.

563. Schilder, P. 1938. Psychoanalytic remarks on *Alice in Wonderland* and Lewis Carroll. *J Nerv Ment Dis* 87:159–168.

564. Schilder, P. 1942. *Mind: Perception and Thought in Their Constructive Aspects.* New York: Columbia Univ. Press.

565. Schmidt-Rimpler, H. 1898. Die Erkrankungen des Auges im Zusammenhang mit anderen Krankheiten. In Nothnagel, H., ed. *Specielle Pathologie und Therapie, Vol. 21.* Vienna: Hölder.

566. Schob. 1917. Beitrag zur Kenntnis der schweren Migräneformen (Migräne mit Herdsymptomen und psychischen Störungen). *Z ges Neurol Psychiat* 35:151–174.

567. Schönberger, B. 2008. Die Aura—Wenn Migräne Bilder malt. *Stern Gesund leben* 3:40–43.

568. Schönfeld, H., ed. 1979. *Hildegard von Bingen, Scivias. Die Miniaturen vom Rupertsberg.* Bingen am Rhein, Germany: Pennrich.

569. Schomer, J. 1937. *Die Illustrationen zu den Visionen der hl. Hildegard als künstlerische Neuschöpfung (Das Verhältnis der Illustrationen zueinander und zum Texte).* Inaugural-Dissertation. Bonn: Katholisch-Theologische Fakultät der Rheinischen Friedrich-Wilhelms Universität.

570. Schott, G.D. 2007. Exploring the visual hallucinations of migraine aura: the tacit contribution of illustration. *Brain* 130:1690–1703.

571. Schrader, M.; Führkötter, A. 1956. *Die Echtheit des Schrifttums der heiligen Hildegard von Bingen. Quellenkritische Untersuchungen: Archiv für Kulturgeschichte, Beiheft 6.* Cologne and Graz, Austria: Böhlau-Verlag.

572. Schreier, H.A. 1998. Auditory hallucinations in nonpsychotic children with affective syndromes and migraines: Report of 13 cases. *J Child Neurol* 13:377–382.

573. Schultz, G.; Melzack, R. 1991. The Charles Bonnet syndrome: 'Phantom visual images'. *Perception* 20:809–825.

574. Schuster, P. 1936–1937. Beiträge zur Pathologie des Thalamus opticus, I—IV, Mitteilung. *Arch Psychiat Nervenheilk* 105:358–432, 550–622; 106:13–53, 201–233.

575. Schwartz, E.L. 1980. A quantitative model of

the functional architecture of human striate cortex with application to visual illusion and cortical texture analysis. *Biol Cybern* 37:63–76.

576. Scott, R. 1978. "It hurts red": A preliminary study of children's perception of pain. *Percept Mot Skills* 47:787–791.

577. Seeligmüller, A. 1910. *War Paulus Epileptiker? Erwägungen eines Nervenarztes.* Leipzig: Hinrichs.

578. Selby, G.; Lance, J.W. 1960. Observations on 500 cases of migraine and allied vascular headache. *J Neurol Neurosurg Psychiat* 23:23–32.

579. Sergent, J. 1988. An investigation into perceptual completion in blind areas of the visual field. *Brain* 111:347–373.

580. Serko, A. 1913. Im Mescalinrausch. *Jb Psychiat Neurol* 34:355–366.

581. Shackle, J.W. 1928. A note on night terrors. *Lancet* 214:287–288.

582. Shevell, M.I. 1996. Acephalgic migraines of childhood. *Pediatr Neurol* 14:211–215.

583. Siegel, R.K.; Jarvik, M.E. 1975. Drug-induced hallucinations in animals and man. In Siegel, R.K.; West, L.J., eds. *Hallucinations—Behavior, Experience, and Theory.* New York and London: Wiley, 81–161.

584. Siegrist, A. 1894. *Beiträge zur Kenntniss von Wesen und Sitz der Hemicrania ophthalmica: Mittheilungen aus Kliniken und medicinischen Instituten der Schweiz. I Reihe, Heft 10.* Basel and Leipzig: Carl Sallmann.

585. Sigerist, H.E. 1955. *A History of Medicine, Vol. I: Primitive and Archaic Medicine.* New York: Oxford Univ. Press, 451.

586. Simboli, C.R. 1921. *Disease-spirits and Divine Cures among the Greeks and Romans.* Ph.D. Thesis. New York: Columbia Univ.

587. Singer, C. 1917. *Studies in the History and Method of Science, First Series.* Oxford: Clarendon.

588. Singer, C. 1958. *From Magic to Science: Essays on the Scientific Twilight.* New York: Dover.

589. Sirigu, A.; Grafman, J.; Bressler, K.; Sunderland, T. 1991. Multiple representations contribute to body knowledge processing: Evidence from a case of autotopagnosia. *Brain* 114:629–642.

590. Sittig, O. 1923. Nachweis der temporalen Sichel in einem Migräneskotom. *Med Klin* 19:204–205.

591. Sjöberg, B. 1997. Fenomenet "synstress" avbildat. *Läkartidningen* 94:1970.

592. Smith, R. 1998. Impact of migraine on the family. *Headache* 38:423–426.

593. Snow, P. 1963. The consumer's end. *J Coll Gen Practit* 6, suppl. 4:2–4.

594. Sowka, J. 1996. Neurogenic diplopia: Paralysis of cranial nerves III, IV, and VI. *Optometry Clin* 5:53–76.

595. Spalding, J.M.K. 1952. Wounds of the visual pathway: I. The visual radiation. *J Neurol Neurosurg Psychiat* 15:99–109.

596. Spalding, J.M.K. 1952. Wounds of the visual pathway: II. The striate cortex. *J Neurol Neurosurg Psychiat* 15:169–183.

597. Speed, W.G. 1964. A few interesting neurologic manifestations of migraine. *Headache* 3:128–133.

598. Stafstrom, C.E.; Rostasy, K.; Minster, A. 2002. The usefulness of children's drawings in the diagnosis of headache. *Pediatrics* 109:460–472.

599. Stafstrom, C.E.; Goldenholz, S.R.; Dulli, D.A. 2005. Serial headache drawings by children with migraine: correlation with clinical headache status. *J Child Neurol* 20:809–813.

600. Stipp, D. 1987. If you want to know how migraine feels, just take a look at it: At art show, sufferers give glimpse of awful world; the shock of bagel vision. *The Wall Street Journal* 9 November 1987:1, 20.

601. Stockert, F.G. von 1934. Lokalisation und klinische Differenzierung des Symptoms der Nichtwahrnehmung einer Körperhälfte. *Dtsch Z Nervenheilk* 134:1–13.

602. Störring, G.E. 1938. Zur Psychopathologie des Zwischenhirns (Thalamus und Hypothalamus). *Arch Psychiat Nervenkr* 107:786–847.

603. Strehl, F. 1882. Zur Casuistik des sog: Flimmerskotoms. In Rothmund, A. von; Eversbusch, O., eds. *Mittheilungen aus der kgl.*

Universitäts-Augenklinik zu München. I. Band. Munich and Leipzig: Oldenbourg, 97–126.

604. Sturzenegger, M.H.; Meienberg, O. 1985. Basilar artery migraine: A follow-up study of 82 cases. *Headache* 25:408–415.

605. Swanson, J.W.; Vick, N.A. 1978. Basilar artery migraine. *Neurology* 28:782–786.

606. Swartz, S. 1991. A dose of art for migraine sufferers. *The* [Santa Rosa, Calif.] *Press Democrat.* 8 April 1991:D1, D7.

606. Swift, J. 1727. *Travels into Several Remote Nations of the World by Capt. Lemuel Gulliver* [*Gulliver's Travels*]. London: Benjamin Motte.

607. Szymanski, J.S. 1931. Wandlungen der Seelen-nauffassung im Laufe der Zeiten. *Arch Psychiat Nervenkr* 94:561–718.

608. Tart, C.T. 1971. *On being stoned: A psychological study of marijuana intoxication.* Palo Alto, Calif.: Science and Behavior.

609. Tennyson, A. 1833. *Poems.* London: E. Moxon.

610. Terson, A. 1926. Les migraines ophtalmiques de Pascal: Pascal sténographe. *Presse Méd* 34:1293.

611. Terson, A. 1926. Les migraines ophtalmiques de Pascal: Pascal sténographe. *Chron Méd* 33:268–273.

612. Teuber, H.-L. 1966. Alterations of perception after brain injury. In Eccles, J.C., ed. *Brain and Conscious Experience.* Berlin, Heidelberg, and New York: Springer, 182–216.

613. Teuber, H.-L.; Battersby, W.S.; Bender, M.B. 1960. *Visual Field Defects after Penetrating Missile Wounds of the Brain.* Cambridge, Mass.: Harvard Univ. Press.

614. Thomas, C.J.; Fleming, G.W.T.H. 1934. Lilliputian and Brobdingnagian hallucinations occurring simultaneously in a senile patient. *J Ment Sci* 80:94–102.

615. Todd, J. 1955. The syndrome of Alice in Wonderland. *Can Med Ass J* 73:701–704.

616. Todd, J.; Dewhurst, K. 1955. The double: Its psycho-pathology and psycho-physiology. *J Nerv Ment Dis* 122:47–55.

617. Turner, R.G. 1976. Hysterical blindness. In Rose, F.C., ed. *Medical Ophthalmology.* London:

Chapman and Hall, 224–237.

618. Twemlow, S.W. 1989. Clinical approaches to the out-of-body experience. *J Near Death Stud* 8:29–43.

619. Tyrrell, G.N.M. 1953. *Apparitions.* London: Duckworth.

620. Ulrich, M. 1912. Beiträge zur Aetiologie und zur klinischen Stellung der Migräne. *Mschr Psychiat Neurol* 31 (Ergänzungsheft):134–203.

621. Unruh, A.; McGrath, P.; Cunningham, S.J.; Humphreys, P. 1983. Children's drawings of their pain. *Pain* 17:385–392.

622. Vahlquist, B.; Hackzell, G. 1949. Migraine of early onset: A study of thirty one cases in which the disease first appeared between one and four years of age. *Acta Paediat* 38:622–636.

623. Vugt, P. van. 2004. Migraine and inspiration. C.L. Dodgson's migraine and Lewis Carroll's literary inspiration: A neurolinguistic perspective. *Humanising Language Teaching* 6:3–4.

624. Vater, A.; Heinicke, J.C. 1723. *Dissertatio, qua visus duo vitia rarissima, alterum duplicati, alterum dimidiati physiologice et pathologice considerata exponuntur.* Thesis. Wittenberg, Germany: Wittenberg Univ.

625. Vick, R.M.; Sexton-Radek, K. 1999. Interplay of art making practices and migraine headache pain experience. *Headache Quart* 10:287–291.

626. Vick, R.M.; Sexton-Radek, K. 2005. Art and migraine: Researching the relationship between artmaking and pain experience. *Art Ther J Am Art Ther Assoc* 22:193–204.

627. Vignolo, T. 1880. *Mythus und Wissenschaft: Eine Studie.* Leipzig: Brockhaus, 267.

628. Volkmann, A.W. 1853. Ueber einige Gesichts-phänomene, welche mit dem Vorhandensein eines unempfindlichen Flecks im Auge zusammenhängen. Leipzig: *Berichte über die Verhandlungen der Königlich Sächsischen Gesellschaft der Wissenschaften zu Leipzig—Mathematisch-Physische Classe* 5:27–50.

629. Wakefield, G. 1975. Clinical features. In Pearce, J., ed. *Modern Topics in Migraine.* London: Heinemann, 22–29.

630. Wakeling, E., ed. 1994. *Lewis Carroll's Diaries:*

The Private Journals of Charles Lutwidge Dodgson (Lewis Carroll), Vol. 2. Luton, U.K.: Lewis Carroll Society.

631. Wallace, A. 1893. On migraine. *Lancet* 1:79–81.

632. Ware, J. 1814. On the muscae volitantes of nervous persons. *Med Chir Trans Med Chir Soc London* 5, series 1:255–277.

633. Warrington, E.K. 1962. The completion of visual forms across hemianopic field defects. *J Neurol Neurosurg Psychiat* 25:208–217.

634. Warrington, E.K. 1965. The effect of stimulus configuration on the incidence of the completion phenomenon. *Br J Psychol* 56:447–454.

635. Weeks, J.E. 1940. Scintillating scotoma and other subjective visual phenomena. *Am J Ophthalmol* 23:513–519.

636. Weiss, S.A.; Fishman, S. 1963. Extended and telescoped phantom limbs in unilateral amputees. *J Abnorm Soc Psychol* 66:489–497.

637. Weinstein, E.A.; Kahn, R.L.; Malitz, S.; Rozanski, J. 1954. Delusional reduplication of parts of the body. *Brain* 77:45–60.

638. Wertheimer, M. 1912. Experimentelle Studien über das Sehen von Bewegung. *Z Psychol* 61:161–265.

639. West, P. 1975. The lightning-rod man: The migraine headache as heuristic tool. *J Gen Educ* 26:291–300.

640. Whiteman, J.H.M. 1956. The process of separation and return in experiences fully "out of the body." *Proc Soc Psych Res* 50:240–274.

641. Whitman, B.W.; Lipton, R.B. 1995. Oscillocusis: An unusual auditory aura in migraine. *Headache* 35:428–429.

642. Whitty, C.W.M. 1953. Familial hemiplegic migraine. *J Neurol Neurosurg Psychiat* 16:172–177.

643. Wickelgren, I. 1989. Images of pain: Headache art lends a hand to science. *Science News* 136:136–137.

644. Wicker, I. 1930. Ein eigenartiger Fall von räumlicher Orientierungsstörung. *Mschr Psychiat Neurol* 77:310–317.

645. Wilder, J. 1928. Über Schief- und Verkehrtsehen. *Dtsch Z Nervenheilk* 104:222–256.

646. Wiley, R.G. 1979. The scintillating scotoma without headache. *Ann Ophthalmol* 11:581–585.

647. Wilkinson, M. 1984. *The Art of Migraine, Parts 1 and 2.* London: Boehringer Ingelheim.

648. Wilkinson, M. 1986. The science and the art of migraine. In Bernstein, E., ed. *1986 Medical and Health Annual.* Chicago: Encyclopaedia Britannica, 6–23.

649. Wilkinson, M. 1986. Clinical features of migraine. In Rose, F.C., ed. *Handbook of Clinical Neurology, Vol. 48: Headache.* Amsterdam: Elsevier, 117–133.

650. Wilkinson, M.; Robinson, D. 1985. Migraine Art. *Cephalalgia* 5:151–168.

651. Willanger, R.; Klee, A. 1966. Metamorphopsia and other visual disturbances with latency occurring in patients with diffuse cerebral lesions. *Acta Neurol Scand* 42:1–18.

652. Wilson, P. 1980. National Migraine Art Competition. *Migraine Newsletter* August 1980, no. 3:11.

653. Wilson, S.A.K. 1916. Dysmetropsia and its pathogenesis. *Trans Ophthalmol Soc UK* 36:412–444.

654. Wilson, S.A.K. 1955. Migraine. In Wilson, S.A.K. *Neurology, 2nd ed., Edited by A.N. Bruce.* London: Butterworth, 1704–1725.

655. Winselmann. 1903. Kasuistische Mitteilungen: I. Zwei Fälle von subjektiven Farbenerscheinungen. *Ophthalmol Klinik* 7:17–18.

656. Winter, D. 1992. Portraits of pain: The art of headaches. *Pharmaceutical Executive* 12:34–40.

657. Wittich. 1863. Studien über den blinden Fleck. *Arch Ophthalmol* 9:1–38.

658. Wolff, H.G. 1963. *Headache and Other Head Pain, 2nd ed.* New York: Oxford Univ. Press.

659. Wollaston, W.H. 1824. On semi-decussation of the optic nerves. *Philos Trans R Soc Lond* 114:222–231.

660. Wollenberg, R. 1925. Über systematische Störungen der egozentrischen Orientierung bei Geistesgesunden. *Arch Psychiat Nervenkr* 74:337–349.

661. Wood, H.C. 1894. Epileptoid migraine.

Philadelphia: *Med News* 65:707–709.

662. Woodhouse, A.; Drummond, P.D. 1993. Mechanisms of increased sensitivity to noise and light in migraine headache. *Cephalalgia* 13:417–421.

663. Wray, S.H. 1995. Amaurosis fugax. In Tusa, R.J.; Newman, S.A., eds. *Neuro-ophthalmological Disorders: Diagnostic Work-up and Management.* New York: Marcel Dekker, 3–25.

664. Yarbus, A.L. 1967. *Eye Movements and Vision.* New York: Plenum.

665. Young, W.B.; Heros, D.O.; Ehrenberg, B.L.; Hedges, T.R. 1989. Metamorphopsia and palinopsia: Association with periodic lateralized epileptiform discharges in a patient with malignant astrozytoma. *Arch Neurol* 46:820–822.

666. Yram (pseudonym). 1965. *Practical Astral Projection.* New York: Samuel Weiser.

667. Zacher, T. 1892. Ueber einen Fall von Migraine opthalmique mit transitorischer epileptoider Geistesstörung. *Berl Klin Wschr* 29:694–697.

668. Zehender, W. 1867. Christian Georg Theodor Ruete: Nekrolog. *Klin Mbl Augenheilk* 5:187–209.

669. Zehender, W. 1867. Referat über Testelin, Notiz über Hemiopie. *Klin Mbl Augenheilk* 5:331–335.

670. Zehender, W. 1869. Diskussionsbemerkung zu Foerster, Amaurosis partialis fugax. *Klin Mbl Augenheilk* 7:429.

671. Zehender, W. 1895. Ueber einige subjective Gesichtswahrnehmungen. *Klin Mbl Augenheilk* 33:73–84.

672. Zehender, W. 1897. Das sichelförmige Flimmerskotom Listing's. *Klin Mbl Augenheilk* 35:25–27.

673. Zentmayer, W. 1912. A case of migraine with ring scotoma. St. Louis: *Ann Ophthalmol* 21:279–282.

674. Zimmer, D.E. 1989. Migräne. *Zeit Magazin* 5 May 1989, 19:74–80.

675. Zutt, J. 1953. "Außersichsein" und "auf sich selbst zurückblicken" als Ausnahmezustand. (Zur Psychopathologie des Raumerlebens.) *Nervenarzt* 24:24–30.

Subject Index

Index of Names

About the Authors

KLAUS PODOLL, MD, born in 1958, studied medicine and psychology in Düsseldorf, Germany. Having received training as a neurologist and psychiatrist in hospitals in Essen, Düsseldorf, and Aachen, he is now working as senior physician at the Department of Psychiatry and Psychotherapy of the University Hospital Aachen at RWTH Aachen University. He has written and coauthored numerous medical articles, book chapters, and two books on Migraine Art. Coeditor in chief of the *Migraine Aura Foundation* Web site, his current scientific interests focus on the neuropsychology and neuroesthetics of migraine auras, including the rare variety of persistent aura.

DEREK ROBINSON was born March 30, 1928, in Blaenavon, Wales, and died February 22, 2001, in London. From 1957 to 1993 he worked in various positions at Boehringer Ingelheim UK Limited in Bracknell, last as symposia and conference manager. In 1973 he founded the Migraine Art concept. Between 1980 and 1987 he organized four national Migraine Art competitions sponsored by the Migraine Action Association (formerly known as the British Migraine Association) and Boehringer Ingelheim UK Limited. Until his death in 2001 he was the curator of the Migraine Art collection. From 1985 he was the coauthor of numerous medical articles and one book on Migraine Art.